Intensive Mothering
The Cultural Contradictions
of Modern Motherhood

Intensive Mothering
The Cultural Contradictions of Modern Motherhood

edited by
Linda Rose Ennis

DEMETER PRESS

Copyright © 2014 Demeter Press

Individual copyright to their work is retained by the authors. All rights reserved. No part of this book may be reproduced or transmitted in any form by any means without permission in writing from the publisher.

Demeter Press
140 Holland Street West
P. O. Box 13022
Bradford, ON L3Z 2Y5
Tel: (905) 775-9089
Email: info@demeterpress.org
Website: www.demeterpress.org

Demeter Press logo based on the sculpture "Demeter" by Maria-Luise Bodirsky <www.keramik-atelier.bodirsky.de>

Printed and Bound in Canada

Library and Archives Canada Cataloguing in Publication

 Intensive mothering : the cultural contradictions of modern motherhood / edited by Linda Rose Ennis.

Includes bibliographical references.
ISBN 978-1-927335-90-1 (pbk.)

 1. Motherhood. 2. Mother and child. I. Ennis, Linda Rose, 1954–, editor

HQ759.I58 2014 306.874'3 C2014-907711-4

*To my cherished grandmothers,
Gittel Rabinowicz and Chaya Grina Tenenbaum,
both loving and empowering.*

Table of Contents

Acknowledgements
xi

Intensive Mothering: Revisiting The Issue Today
Linda Rose Ennis
1

PART I:
UNDERSTANDING AND ASSESSING INTENSIVE MOTHERING

Intensive Mothering as an Adaptive Response to
Our Cultural Environment
Solveig Brown
27

I Don't Know Where I End and You Begin:
Challenging Boundaries of the Self and Intensive Mothering
Lorin Basden Arnold
47

Status Safeguarding: Mothers' Work to
Secure Children's Place in the Social Hierarchy
Melissa A. Milkie and Catharine H. Warner
66

The Cultural Contradictions of Motherhood Revisited:
Continuities and Changes
Kim Huisman and Elizabeth Joy
86

The Ideal Mother Fantasy and Its Protective Function
Helena Vissing
104

From Intensive Mothering to Identity Parenting
Maya-Merida Paltineau
120

Using A Quantitative Measure to Explore
Intensive Mothering Ideology
Virginia H. Mackintosh, Miriam Liss and Holly H. Schiffrin
142

PART II:
INTENSIVE MOTHERING TODAY

State Intervention in Intensive Mothering
*Christi L. Gross, Brianna Turgeon, Tiffany Taylor
and Kasey Lansberry*
163

Is Attachment Mothering Intensive Mothering?
Charlotte Faircloth
180

Better Babies, Better Mothers:
Baby Sign Language and Intensive Mothering
Lisa M. Mitchell
194

How Contemporary Consumerism Shapes
Intensive Mothering Practices
Tatjana Takševa
211

CONTENTS

Intensive Mothering, Elimination Communication
and The Call to Eden
Madeline Walker
233

Intensive Grandmothering?
Social Policy, Social Class and Intensive Mothering
in Post-Communist Poland
Justyna Włodarczyk
247

PART III:
INTENSIVE MOTHERING: STAYING, LEAVING OR CHANGING?

The Best I Can: Hope For Single Parents
in the Age of Intensive Mothering
J. Lauren Johnson
267

The Cultural Contradictions of Fatherhood:
Is There An Ideology of Intensive Fathering?
Hallie Palladino
280

Skinny Jeans:
Perfection and Competition in Motherhood
Kristen Abatsis McHenry and Denise Schultz
299

Transpersonal Motherhood:
A Practical and Holistic Model of Motherhood
Faith Galliano Desai
313

Epilogue:
Balancing Separation-Connection In Mothering
Linda Rose Ennis
332

Contributor Notes
338

Acknowledgements

FIRST AND FOREMOST, I would like to thank all of the contributors to this volume, who through their thought-provoking research brought life and meaning to "intensive mothering". I am grateful for your enormous trust in me to make your work shine.

I am ever so grateful to Andrea O'Reilly for her unfaltering faith in my ability to tackle this critical issue. Your work has inspired me to contribute my bit to this important field of motherhood research. To Demeter Press and its editorial committee, much thanks and deep gratitude.

I wish to acknowledge Sharon Hays for her introduction of the term "intensive mothering" in her landmark book, *The Cultural Contradictions of Motherhood*.

I am deeply appreciative of my mentor, Dr. Otto Weininger's role in encouraging me to pursue the area of motherhood, as it relates to Early Childhood. I will always remember and be grateful for his influence on my psychoanalytic career.

With love, to my parents, Dina and William Tenenbaum, thank you for teaching me how to mother and be parented with love and care. To my daughters, Jessica and Jillian, with profound gratitude for your unfaltering love and pride in what I do. To sweet Nathaniel James, in appreciation for the privilege of revisiting the "mommy" space.

Last, but far from least, I thank my partner in life, Alan, for always being there for me, for being my fan club, for always taking an interest in my work, and for being the most encouraging person in my world. I love you.

Intensive Mothering

Revisiting the Issue Today

LINDA ROSE ENNIS

THIS IS A BOOK about "intensive mothering." The ideology of this model, as Sharon Hays explains, "is a gendered model that advises mothers to expend a tremendous amount of time, energy, and money in raising their children" (Hays). The "intensive mothering" philosophy is supported by the "new momism," which insisted that no woman is complete unless she has children, that women remain the best primary caregivers of children, and that a woman has to devote her entire physical, psychological, emotional and intellectual well-being, 24/7, to her children" (Douglas and Michaels). This type of gender essentialism, the new momism, "insists that if you want to do anything else, you'd better first prove that you're a doting, totally involved mother before proceeding" (22). The aim of this collection is to revisit and reexamine the ideology of "intensive motherhood" as a continuing, yet controversial representation of modern motherhood today, which has expanded to other Western cultures and evolved to include both genders and classes, albeit not equally. In order to understand the cultural contradictions of motherhood in the form of intensive mothering, Hays analyzed the history of ideas about child rearing, conducted a textual analysis of contemporary child-rearing manuals and conducted interviews with thirty-eight mothers of two to four year old children in San Diego, California in 1991. She concluded that intensive mothering was "the dominant ideology of socially appropriate child rearing in the contemporary United States," that it reflected "a deep cultural ambivalence about the pursuit of self-interest," and "helps to

reproduce the existing gender hierarchy" (Hays). This volume is a collection of eighteen chapters examining intensive mothering theoretically and practically with a look towards the future of this ideology. The collection draws on the work of international scholars from Canada, the United States, Poland, France, and England, who look at intensive mothering, utilizing both quantitative and qualitative methodology, through a psychoanalytic, sociological, psychological, economic, transformational, and feminist lense. In an attempt to extend Hays' conclusions and update them, it needs to be recognized that the backdrop for intensive mothering is consumerism, which co-existed in the mid-1990s at the same time as neoliberal offloading of social and fiscal support for families, especially mothers, who took on the responsibility of child care individually without choice but rather as a necessity. Hays noted that the intensive mothering ideology "helps to reproduce the existing gender hierarchy and to contribute, with little social or financial compensation for the mothers who sustain its tenets, to the maintenance of capitalism and the centralized state," which has only worsened in the last 20 to 30 years. As Andrea O'Reilly states, "The forces of neoliberalism and intensive mothering have created the perfect storm situation for twenty-first century motherhood, as mothers today must do far more work with far less resources" (*What Do Mothers Need?*). In this collection, we will zero in on the cultural contradictions of motherhood, namely the issue of self-interested gain versus the unselfish nurturance, among the cultural contradictions that Hays originally described, and will further explore whether, in fact, the unselfish nurturance of intensive mothering is a form of self-interested gain and how it is related to the economic needs of a patriarchal society.

In addressing the cultural contradictions of motherhood and how they have changed in the last two decades, intensive mothering will be considered here in terms of gender differentiation, professionalization of motherhood and the myth of choice, ethnicities, cultural contexts, and class status, taking into account neoliberalism and its negative impact on mothers. It cannot be underscored how significant the impact of neoliberalism is on mothering, as it entrenches "a neo-traditional family configuration—a "new"

sophisticated-looking family configuration that continues to place the responsibility of child-rearing on mothers, ultimately erodes many of the gains in the public sphere that unencumbered women enjoy, and lays the foundation to exacerbate rather than resolve the crisis" (Hallstein "When Neoliberalism Intersects").

While respecting the important need for connection between mothers and babies, that is prevalent in the teachings of Attachment Theory, as well as recognizing the cultural differences in the ways attachment between mothers and babies are enacted, this collection raises into question whether an over-investment of mothers in their children's lives is as effective a model as "intensive mothering" promotes in our society. In a world, which values independence, why are we still engaging in "intensive mothering," why does it prevail, and what other models are additional possibilities or alternatives? Are mothers overinvested in their children or is society not providing enough economic opportunities or social supports for families so mothers are left with no choice but to overinvest? Are there other factors at play that may shed light on this overinvestment in motherhood?

There are "two meanings to motherhood, one superimposed on the other: the potential relationship of any woman to her power of reproduction and to children; and the institution, which aims at ensuring that that potential shall remain under male control" (Rich). As a patriarchal institution, "intensive mothering" is promoted as an ideal of motherhood. However, as a relationship, it seems to alternatively thrive or be devalued, which makes this model very complex and in need of further examination and understanding. Is intensive mothering a reverie of blurred boundaries, and if so, why does it appear to continue throughout the life span? Is there something that is being gained by mothers who engage in intensive mothering?

I became interested in this topic both as a mother and researcher. My research areas have been in the study of combining motherhood with employment and paternal involvement and maternal employment, where I viewed these issues through a feminist-psychoanalytic lens. I wanted to understand how to effectively combine motherhood with employment and further understand the role that fathers play in the equation. Further to that, I was raising

two young children while I was working on this research and was applying "Attachment Theory" and "Early Object Relations Theory" to my mothering, since I was trained in these theories as an Early Childhood specialist. It is important for me to add that as a feminist and early childhood theorist, I was continually struggling with the compartmentalization of children's and mothers' needs into two camps that rarely intersected. As a result, I have always attempted to examine motherhood and child studies in an all-inclusive way. As a mother, however, when reflecting upon my style of mothering after the fact, it is not easy to clearly decide whether I was an intensive mother or not, and when I intensively mothered and didn't. I imagine this is the case with many mothers, as well. I am aware of my loyalty to Attachment Theory, Early Object Relations Theory, as well as Feminist and Relational Theory, as it informed my experience as a mother, as well as the research I have conducted for many years.

As a model of mothering, I was intrigued by mothers' over-investment in their children, the reasons for it and when, if ever, it came to an end throughout the mother-child relationship. I wondered if fathers intensively mothered and if so, was it the same or different than if mothers did. I thought about whether intensive mothering existed in all cultures or only Western society and questioned why. I speculated as to whether a mother could intensively mother one child and not the other. Could intensive mothering be a good thing or does it always have a negative connotation because it suggests excess in a society of overabundance? Can a mother be both an empowered mother, as well as an intensive mother? Does intensive mothering operate on a continuum? Finally, I began to think about the fall-out of intensive mothering, the long-lasting impact that it has on mothers and their children. I decided that I needed to officially speculate on these issues pertaining to intensive mothering and thus this edited collection was born.

CHILD-CENTERED MOTHERING AND INTENSIVE MOTHERING

Maternal attachment theorists, such as John Bowlby, Selma Fraiberg (Fraiberg, Adelson and Shapiro) and Early Object Relations theorists, such as Melanie Klein and Donald Winnicott speak of

the important need for connection between mothers and babies. Later attachment research included the significance of paternal involvement. The child needs a secure base, basic trust in his environment and the first connection is with mother, which is crucial to the survival of the child (Bowlby). Winnicott developed the term "good-enough mothering," however, to make the experience more manageable and to let mothers know they don't have to be perfect but effectively there. Having said that, he did stress that mothers' presence, in a meaningful way, is critical. There is no question that the relationship between mothers and children is crucial and that child development depends on it, despite the fact that children are resilient and can work around it with other effective adult models in their life. Not only that, children internalize the good-enough mother- child relationship and draw upon it in their future relationships with important others, especially with their children. So, if we realize how important it is to have a strong and caring mother involved with her child, what is the problem with intensive mothering? Perhaps it is the degree of maternal involvement, the balance. Parenting may need to focus on the child but not to the extent that no one else matters, such as other siblings, one's partner and oneself. Otherwise, the result may be children, teenagers, and young adults, who are self-centered and mothers, who are emotionally and physically drained.

CORE BELIEFS OF INTENSIVE MOTHERING

In our society, according to Sharon Hays, "If you are a good mother, you must be an intensive one." There are choices as to whether one decides to become a mother, but not how to mother, other than hiring a female caregiver, according to Hays. The three core beliefs that encompass intensive mothering are that children need constant nurturing by their biological mothers, who are solely responsible for their mothering; mothers rely on experts to help them mother their children; and mothers must expend enormous amounts of time and money on their children (Hays; O'Reilly, "Introduction"). In addition, intensive mothering requires that mothers hold their children and their schedules in their minds at all times, which has been described as "maternal thinking," but rather in a preoccupied

way. It is unclear why others, such as fathers, have to date, not adequately assumed this role, although many have, which will be further discussed in this volume (Paltineau, Palladino, Milke and Warner, in volume).

In breaking down intensive mothering, I have further identified concrete examples as to what constitutes intensive mothering for the purpose of demonstrating how intensive motherhood has evolved and become integrated into mothers' and families' lives. They include but are not limited to mothers doing homework for their children; mothers being friends with their children's friends; mothers' social lives revolving around their children; mothers encouraging children to continually phone or text them; mothers spending all their free time with their children; mothers always putting the children's needs before their own; mothers doing everything for their children such as laundry, driving, and lunches; mothers speaking for their children; all conversations with friends and family revolving around the children; mothers feeling empty after their children leave home for school or move out; mothers who won't allow their children to sleep over at friends' homes or go to overnight camp and/or children who won't leave home for any length of time (Ennis "Intensive Mothering"). The above characteristics support Hays' definition of intensive mothering as mothers who "are primarily responsible ... they put the children's needs first, and they invest much of their time, labor, emotion, intellect and money in their children" (130). To expand upon Hays' understanding of mothers' viewing their children's success as a reflection of their own, for many parents, there were not as many non-traditional choices of profession as there are for their children today and parents are encouraging and supporting their children's choice of entry into these non-traditional careers. Oftentimes, the non-traditional professions do not translate into a financially secure outcome, which parents have tried to provide for our children and to which they are accustomed. Why would mothers encourage and support their children in professions that may virtually leave them financially in need? Perhaps the answer lies in the fact that parents may feel that their creative side has not adequately been nurtured and they re-gain it through their children. Alternatively, do mothers hope that the creative child will

make for a better world in the future? Is it that mothers just want their children to be dependent upon them, which is an extension of intensive mothering? Is intensive mothering even about what is good for the children and more about mothers wanting to be an important part in their life? If mothers intensively mother to the extent that they communicate to their children that they are the only important person in the world and that they need to be the best at everything they try, why are these intensive mothers surprised and feel rejected when their children seek fulfillment outside of the family, and are preoccupied with themselves and their lives in their search for this ideal? Why are these intensive mothers, and to a more limited degree, fathers willing to sacrifice everything, emotionally and financially, to further their children's and subsequently their own dreams, which have now become intertwined? Alternatively, are children of intensive mothers finally trying to live their own lives apart from this maternal overinvestment and literally fleeing the nest? Can intensive mothering be a self-sacrificial exercise for mothers, who are predominantly by necessity, not choice, removed from the work culture and have taken on all of society's responsibilities for child-rearing, as well as a self-interested way for mothers to feel as if they are gaining status through their children?

Hays noted the "unselfish nurturing" that guides the behaviour of mothers in a society "where the logic of self-interested gain seems to guide behaviour" and considered this issue as one of the cultural contradictions of motherhood. She did, however, expand upon this issue by speculating, as mentioned above, that "in a connected way, mothers seem to understand their children's success as a reflection and enhancement of their own" (159). In addition, Hays noted that mothers were "demonstrating their own class status relative to mothers who cannot afford such luxuries" such as piano lessons and dance classes. This volume will clarify whether "unselfish nurturance" is still a contradiction in examining the motivations behind intensive mothering.

MOTIVES BEHIND INTENSIVE MOTHERING

If a behaviour persists, it is achieving a purpose. What is the

motive behind intensive mothering? Judith Warner referred to the "perfect madness" or frenzied perfectionism in American parenting, particularly mothering as a way to control an out of control world through one's children. Because there is no support from family, from government, from the workplace and from one another, mothers experience motherhood as an isolating existence and over-connect with their children (*Perfect Madness*). In the end, she noted that economic circumstances and attitudes have changed, to date, the result being that perfect parenting has gotten out of control (Warner "Bait and Switch"). Hays originally speculated that when middle-class mothers engage in intensive mothering, they are "grooming the children for their future class position by providing them with the appropriate cultural capital and demonstrating their own class status relative to mothers who cannot afford such luxuries or do not recognize them as an essential element of good child rearing" (159). Annette Lareau also noted that middle-class mothers were concertedly cultivating their children's talents, while the working class mothers sustained their natural growth. She explained that her work focused more on behaviour than Hays' did on attitudes and recognized that while "all mothers desire to be a good mother and to have their children grow and thrive," there were differences in "how parents enacted their visions of what it meant to be a good parent" (386). More recently, though, Nelson concurred that even though "professional middle-class parents want both to protect their children from growing up too quickly and yet push them to high achievement at an early age," mothers need to get their "helicopter" parenting under control because they "are exhausting themselves, undermining their communities and reproducing (and even intensifying) the extreme inequality in our society" (Nelson). The first section of this collection, entitled "Understanding and Assessing Intensive Mothering" will further examine the motives behind intensive mothering and why it persists (Brown, Milke and Warner, Vissing, in volume). It will further address whether motherhood is an experience of selfless nurturance in a patriarchal society where the pursuit of self-interest predominates.

We have internalized the working models that our families, societies and cultures have shown us. Ultimately, we walk through

this world with a mini-map of what is expected of ourselves as mothers and what we wanted as children from our mothers. We then re-enact these expectations with our children. On some deeper level, the desire to maintain the all-protecting and nurturing mother is still alive and well in its aim for mothers to work for the benefit of the sacred child. In addition, we all want to fit in somewhere because it brings us security and fitting into the "good motherhood" club that society portrays is appealing to mothers where all feel a sense of self-worth and agency, a form of denying the dominance by a patriarchal system. Through this collection of works on intensive mothering, we hope to open the dialogue further to include the competitive nature of intensive mothering (McHenry and Schultz, in volume), as well as to further elucidate the motives behind this mode of mothering.

NEOLIBERALISM AND INTENSIVE MOTHERING

The neoliberal model, which emerged in the 1980s and 1990s, is an individualized and economic one where mothers are "positioning children as social capital to be invested in" (Vandenbeld Giles). The inconsistency of this model entails a shift from social supports to individualized mothering under the guise of gender equality, feminist equality of all classes, offering little choice to women with children. The contradiction is especially apparent in the split between the way motherhood is portrayed in this philosophy between the classes. "While women with race and class privilege are encouraged to focus almost solely on self-sacrificial caregiving and are assumed to be wed mothers, the ideology of intensive mothering does not apply to marginalized women who are expected o be unwed, single parents who have made selfish, poor choices if they are not actively involved in the labour market" (Bloch and Taylor). This is the backdrop from which intensive mothering operates today, and will be further expanded upon in this collection.

MATERNAL EMPLOYMENT AND NEOLIBERALISM

It is a misconception that non-working mothers are the only

ones engaging in intensive mothering. However, it was originally thought that because of the guilt of being a working mother, the time that working mothers spend with their children is often intense, as well. It is a no-win situation where both sides feel guilty about "their choice." The common denominator is intensive mothering which helps to alleviate some of that guilt. There is enormous ambivalence regarding the roles women should take on, which is worked out through motherhood, specifically intensive mothering. More recently, it has been determined that working or not working is not so much the issue as women being dispossessed from the workplace due to inflexible work options, the result being the "professionalization of motherhood and domesticity through which they create what is, for them, a new and heightened identity as mothers" (Stone). We speak of equality in the workplace but there is still a discrepancy between the opportunities offered to mothers in comparison to men and to women without children. If mothers are working and are not feeling fulfilled in their careers, and are overworked without enough pay, one's value has to come from somewhere else. After all, if the ideal of motherhood says that it is the only place where a mother can truly shine, intensive mothering seems like the answer. It might even be a way for mothers to rule over a microcosm to compensate for their lost dreams. After all, as Hays says: "In a connected way, mothers seem to understand their children's success as a reflection and enhancement of their own" (159). The second section entitled "Intensive Mothering Today" will further elaborate upon how contemporary neoliberalism impacts mothering practices today (Takseva, Gross, Turgeon, Taylor and Lansberry, and Wlodarczyk, in volume).

EXPLORING OTHER FORMS OF MOTHERING

There have been other approaches to mothering that operate as a direct polarity to intensive mothering. *Bringing Up Bébé* is a book on French parenting from an American perspective, which examines how strict rules and controlling one's emotions have a critical part in French upbringing, as well as not making child-rearing an all-encompassing vocation (Druckerman). In addition, *Free-*

Range Kids condones instilling independence in young children, once again disputing intensive mothering (Skenazy). Both books introduce approaches that go completely contrary to the ideal of intensive mothering. It is interesting to note, however, that when independence is promoted as a form of mothering, there is a negative reaction, anger and resistance, which is what happened when Lenore Skenazy's book came out. This volume, in the last section entitled "Intensive Mothering: Staying, Leaving or Changing," will explore further other forms of mothering (McHenry and Schultz, Johnson, Palladino, Desai, Ennis, in volume).

THIRD WAVE INTENSIVE MOTHERING

Intensive mothering, according to feminist scholars is a "backlash against second wave feminist gains" (Douglas and Michaels; Hays). As O'Reilly has said: "Intensive mothering gives women powerless responsibility; it assigns mothers all the responsibility for mothering but denies them the power to define and determine their own experiences of mothering" (107). The struggle between an empowered feminist form of mothering and intensive mothering, Lynn O'Brien Hallstein has suggested, is a "uniquely 'postfeminist' third wave feminist mothering tension for contemporary mothers" ("Second Wave" 108). It does not necessarily follow that an empowered woman may engage in empowered mothering. As Hays argues, intensive mothering is the proper ideology of contemporary mothering that all women are disciplined into and judged against, across race and class lines even if not all women actually practice it (107). How to resist being an intensive mother and becoming an empowered one is not so much the issue until we understand why it has not fallen to the wayside. Intensive mothering is an ideology that has strengthened in the last twenty years, and we have to examine what is being gained in clinging to this model.

OVERVIEW OF CHAPTERS

To explore the issue of intensive mothering, this collection examines it through three lenses: Understanding and Assessing

Intensive Mothering; Intensive Mothering Today; and Intensive Mothering: Staying, Leaving or Changing. The first section will draw on academic research and theory in the area of intensive mothering to help further understand the phenomenon. The second section will explore the practical implications of intensive mothering in various scenarios and the last section will reflect upon the future implications of intensive mothering, and the possible adjustments or alternatives to it. This collection of essays has been written by academics from various disciplines, from different parts of the world, at different points in their careers. What brings them together is a keen interest in intensive mothering and its impact on our mothering styles, our children and our society, at large.

UNDERSTANDING AND ASSESSING INTENSIVE MOTHERING

The chapters in "Understanding and Assessing Intensive Mothering" examine intensive mothering through various theoretical lenses in order to understand its function, beginning with the purpose of intensive mothering as a response to the cultural and economic influences and ending with a chapter that quantitatively measures the phenomenon.

"Intensive Mothering as an Adaptive Response to our Cultural Environment," by Solveig Brown, assesses how the rise of our market economy has created specific cultural circumstances that drive intensive mothering norms. Based on in-depth interviews with middle-class and upper middle-class American mothers, this chapter illustrates how the United States relies on intensive mothers to bridge the gap between cultural change and its effect on childrearing. As the gaps continually expand, mothers feel increased pressure to use intensive mothering practices to buffer their children from the negative aspects of our culture, and to prepare them to thrive in our increasingly competitive culture.

In the analysis of maternal narratives regarding intensive mothering practices in "I Don't Know Where I End and You Begin: Challenging Boundaries of the Self and Intensive Mothering," Lorin Basden Arnold considers the complexity of the maternal role and how that impacts mothers as they negotiate societal and family

expectations. Utilizing understandings from dialectical theory, Arnold argues that motherhood challenges binary understandings of self and other, particularly with regard to the physical body, and that mothers make complicated selections from multiple ideological positions to create a vision of maternity that is functional in their unique instance. She stresses the importance of understanding and assessing intensive mothering practices in a way that honors the intricate philosophical and pragmatic work of mothers, rather than simplifying their complex experience.

In the theoretical chapter "Status Safeguarding: Mothering Work to Smooth Children's Lives and Secure Children's Place in the Social Hierarchy," Melissa A. Milkie and Catharine H. Warner help us understand how growing economic competition pushes mothers to engage in specific practices to further children's status achievement. This "status safeguarding" is a facet of intensive mothering likely to be increasingly common and oppressive, especially among middle class mothers. Moreover, the practice illustrates how intensive mothering may be less contradictory with capitalist ideologies than Hays claimed, as mothers who sacrifice their own earnings may be investing highly in children's class futures. This chapter highlights three types of status safeguarding, including academic safeguarding that pushes children to be "advanced," talent safeguarding which attempts to make children distinctive from others through their experiences in traveling, music, the arts, or sport; and emotional or happiness safeguarding that is intimately interconnected to children's persistence in activities and schooling. The authors show how the level and intensity of safeguarding varies by social class and ethnicity, employment status, and across national boundaries.

In "The Cultural Contradictions of Motherhood Revisited: Continuities and Changes" Kim Huisman and Elizabeth Joy, use a modified and updated version of Sharon Hays' interview guide. This study partially replicates Hays's research and examines the extent to which intensive mothering today compares and contrasts with intensive mothering two decades ago. In this chapter they examined several interrelated questions: To what extent are mothers accommodating and resisting the ideology of intensive mothering? How have intensive mothering practices changed over time? Is

intensive mothering becoming more intense, less intense, or some combination? To what extent is the ideology of intensive mothering being promoted and/or challenged in the top selling parenting books, blogs, magazines, and "mommy memoirs"? Their data came from 21 face-to-face structured interviews with women between the ages of 21 and 45, with an average age of 30. The interviews were conducted by thirteen undergraduate students enrolled in an upper-level undergraduate sociology course on motherhood. They found that intensive mothering persists in our culture and in their participants' lives. Yet, their participants also expressed agency by expressing ambiguity, offering their critiques about various aspects of intensive mothering, and claiming to actively reject popular discourse and expertise about motherhood.

In Vissing's chapter, contemporary psychoanalytic theories by Rozsika Parker and Jessica Benjamin are used to critically discuss Attachment Parenting philosophy. Drawing on Parker's elaboration of Kleinian theory and Benjamin's intersubjective theory, a contemporary psychoanalytic perspective on maternal subjectivity is presented. Through this perspective, the idealization of motherhood in intensive mothering and its consequences are examined. The analysis demonstrates how maternal subjectivity, ambivalence, and absence have become highly problematic, in themselves, in Attachment Parenting philosophy, leaving mothers at a loss in a culture that does not allow for open expression of ambivalence or negotiations of maternal subjectivity and space.

Maya-Merida Paltineau's chapter, "From Intensive Mothering To identity Parenting," is about a very special current transformation of "Intensive Motherhood" to "Identity Motherhood." An approach based on qualitative interviews with French mothers and fathers has shown that Intensive Motherhood has developed into Intensive Parenthood, which is a tool for individual identity assertion for mothers, as well as for fathers.

Finally, the last chapter, "Using A Quantitative measure To Explore Intensive Mothering Ideology" by Virginia H. Mackintosh, Miriam Liss and Holly H. Schiffrin, used the themes raised in Hays' collection of narratives as a foundation, to design the Intensive Parenting Attitudes Questionnaire (IPAQ), a quantitative measure of intensive mothering ideology. This chapter outlines the design

of the IPAQ, including its five factors based on the principle beliefs of Intensive Mothering: (1) women are inherently better at parenting than men (Essentialism); (2) parenting should be fulfilling (Fulfillment); (3) parents must provide high levels of stimulation for children to develop adequately (Stimulation); (4) parenting is hard to do (Challenging) and; (5) the needs of the child should be the highest priority (Child-centered). Studies with the IPAQ indicate that certain components of Intensive Mothering beliefs are related to negative maternal mental health outcomes.

INTENSIVE MOTHERING TODAY

In the section on "Intensive Mothering Today," we see how "intensive mothering" is played out today in Western Society, where we find it, and how we deal with it. In "State Intervention in Intensive Mothering: Neo-liberalism, New Paternalism, and Poor Mothers in Ohio," Christi L. Gross, Brianna Turgeon, Tiffany Taylor, and Kasey Lansberry speculate that not all women are given equal opportunity to choose the intensive mothering parenting style. Current welfare-to-work programs embrace ideologies of neoliberalism and new paternalism, ideologies which emphasize paid labor and de-emphasize social and reproductive labor. As such, low-income women receiving cash assistance through government welfare-to-work programs face state intervention in their decision-making concerning paid work and mothering. In this chapter, the authors use interview data from 69 welfare-to-work managers in Ohio to highlight constraints to the choices in defining quality parenting and good mothering for these low-income mothers.

"Is Attachment Mothering Intensive Mothering," by Charlotte Faircloth, uses the example of "attachment parenting" (in the UK context) to showcase one of the many permutations of intensive mothering today. Using an ethnographic, interview-based approach that focuses on the narratives of mothers who practice this form of care, the chapter explores how far "attachment mothering" can be considered "intensive mothering." Certainly, the long-term, embodied care typical of attachment parents seems to chime with Hays' definition ("child-centered, expert-guided, emotionally absorbing, labour intensive, and

financially expensive)" (8) but at the same time, the philosophy is distinctly anti-consumption, as well as anti-expertise. Some of these contradictions, particularly around the extent to which this is a 'child-centered' philosophy are explored here, arguing for a more relational understanding of mothering practices, which foregrounds maternal "identity-work."

"Better Babies, Better Mothers: Baby Sign Language and Intensive Mothering" by Lisa M. Mitchell notes that the practice of teaching sign language to hearing infants is gaining currency in some North American families. In this chapter, the author examines this emerging practice as an instance of recent intensive mothering (Hays) aimed at creating both "better" mothers and "better" babies. Her analysis of on- and off-line texts advocating and instructing baby sign language focuses on assumptions about the development of the infant body and self and what is promised to parents in the context of contemporary practices of intensive mothering. Mitchell argues that, as discursively framed by its advocates, training hearing infants to sign is not only about improving or accelerating infant development, but about creating particular sorts of infant and parents. In this respect, infant signing is a strategy of "body work" (Pilcher) by which adults/parents strive to create socially valued cultural dispositions and selves (Bourdieu) in their infants and in themselves.

"How Contemporary Consumerism Shapes Intensive Mothering Practices" by Tatjana Takševa relies on recent studies of globalization and the commercial forces that are increasingly shaping all spheres of life in developed countries. In this chapter, the author revisits Sharon Hays' claim that the ideology of intensive mothering emphasizes traits that contradict the dominant social and economic system based on the competitive pursuit of individual gain. While this contradiction may still hold some symbolic sway over cultural perceptions about mothering, she argues that mothering practices in the consumer age increasingly demonstrate that child-parent relationships are becoming firmly situated within the market logic and ideas governing corporate enterprise. Takseva shows that the increasing commercialization of motherhood and mothering not only narrows the perceived gap between the selfless, seemingly irreducible value of mothering and the cold world of capitalist

profit, but also that it significantly alters and shapes, in new ways, the "emotionally absorbing" and "financially expensive" aspects of intensive mothering.

"Intensive Mothering, Elimination, Communication and The Call to Eden" by Madeline Walker argues that today, a small but articulate minority of mothers romanticize childrearing in traditional or "primitive" cultures in their practice of Elimination Communication (EC), or responding to the infant's need to urinate or defecate rather than diapering baby. Examining books on EC by Laurie Boucke and Ingrid Bauer, and drawing on feminist theorist Cressida Heyes, Walker shows that this form of intensive mothering relies on linguistic essentialism and does not fully account for cultural and social differences between North American and EC's originating countries. Ultimately, claims Walker, practicing EC, or feeling pressure to practice it, can result in mothers feeling exhausted and inadequate as they search for the imaginary Eden of perfect parenting.

Finally, Justyna Wlodarczyk in "Intensive Grandmothering? Social Policy, Social Class and Intensive Mothering in Post-Communist Poland" examines trends in mothering practices and in social policy in contemporary Poland. This chapter identifies the correlation in time of the advent of the concept of intensive mothering in Poland, as an imported "Western" discourse, and the cutbacks in the availability of childcare, particularly for children under three years of age, after Poland's transition from communism to capitalism in 1989. The two phenomena strengthen each other and women are presented with very strong pressure to stay at home and devote themselves to mothering their children. At the same time, the economic reality prevents them from living out the ideal of "intensive mothering" and the lack of childcare facilities forces them to rely on their own mothers or mothers-in-law as childcare providers. A significant number of children are also left behind in Poland in the care of grandmothers when their parents emigrate to Western Europe. These practices result in feelings of guilt and inadequacy for both mothers and grandmothers. The article is based on interviews with mothers of young children and supported with an analysis of changing social policies.

INTENSIVE MOTHERING: STAYING, LEAVING OR CHANGING

Finally, this section discusses what the future brings for "intensive mothering," whether it will remain, decline or disappear in the future. Alternatives to this mode of mothering are discussed as other potential possibilities.

J. Lauren Johnson in "The Best I Can: Hope for Single Parents in the Age of Intensive Mothering" argues that the concept of intensive mothering as a social construction is changing—or, at the very least, ought to change—with the shifting family dynamics of modern parenting. As such, this chapter represents a theoretical, first person critique of intensive mothering from the perspective of a single mother and psychologist. Using research on attachment and childhood resilience, the author argues that child outcomes are influenced by many factors other than parenting style, and as such proposes the adoption of "The Best I Can" approach to single parenthood as a hopeful alternative to the dogmatic constraints of intensive mothering. In this way, she propose that parents and children may be better off when parents are given permission to set their own standards of what constitutes "best practices" within the confines of their particular cultural, personal, and contextual situations.

"The Cultural Contradictions of Fatherhood: Is There An Ideology of Intensive Fathering?" by Hallie Palladino describes the cultural pressures today's fathers face to be both ideal parents and ideal providers. She argues that when men buy into the cultural belief that good parenting means intensive parenting, standards merely escalate, often creating extra work for mothers. Because intensive parenting ideology is built on a belief that quality time with children is everything, this is where fathers understandably tend to focus their domestic energy, while the lesser valued work of household management is still mostly done by mothers, even when both parents work full time. The frustrating irony of this trend is that even though twenty-first century fathers spend more time parenting than any previous generation, a lopsided division of household work still persists. This chapter is based on a review of recent time use literature including a number of cross-national studies that highlight how policy differences may impact male in-

volvement in household work, in general, and paternal involvement in childcare in particular.

In "Skinny Jeans: Perfection and Competition in Motherhood," Kristina Abatsis McHenry and Denise Schultz investigate the way intensive mothering encourages competitive behaviour among mothers. Using feminist media content analysis of online blogs, magazines, and web sites that demonstrate elements of intensive mothering, McHenry and Shultz critique the way new momism is a tool of patriarchy. Using a lesbian theoretical analysis, they argue that Adrienne Rich's understanding of woman identification provides us with a conceptual ideal where mothers value their bonds with other mothers.

In the last chapter in this section, "Transpersonal Motherhood: A Practical and Holistic Model of Motherhood," Faith Galliano Desai, utilizing a combination of results from a classical phenomenological study (with semi-structured interviews) of first time mothers and relevant review of research to date, sheds light on the understanding of how motherhood provides tremendous opportunities for psychological and spiritual growth and counterbalances the contemporary cultural view of motherhood as demanding, oppressive, and stressful. It situates intensive mothering in the context of current culture and sheds light on the harm intensive mothering causes not only to mothers but also to their children and society in general. This chapter introduces the concept of "transpersonal motherhood," contrasts it with "intensive mothering" and makes a case that is it time to provide mothers with a more practical and holistic conceptualization of motherhood that locates intensive mothering as one small, albeit important, aspect of this expansive model of motherhood.

In the Epilogue, "Balancing Separation-Connection in Mothering," Linda Rose Ennis introduces the separation-connection model as a way to further understand intensive mothering. In seeking maternal empowerment as a redefinition of motherhood, an additional potential alternative to intensive mothering lies in bringing the separation-connection model into a sustainable balance, a state of equilibrium. Doing away with intensive mothering is not the answer but rather understanding its origins and why it persists, as well as relating to one's children in both a connected

and separate manner when and where the circumstances dictate. In addition, this model may be applied to an effective balance between the individual's needs and society's. This chapter will end with a review of the central issues in the book and speculate as to how it may be applied in future, both theoretically and practically.

CONCLUSION

Intensive Mothering: The Cultural Contradictions of Modern Motherhood is a collection of academic papers by noted academic researchers that revisits Hays' concept of "intensive mothering" as a continuing, yet controversial representation of modern motherhood. This book raises into question whether an over-investment of mothers in their children's lives is as effective a mode of parenting, as being conveyed by representations of modern motherhood. On this journey, we have explored the possibility that intensive mothering continues because it serves a purpose in mothering, which needs to be further explored. Further to that, as we have noted that early childhood and feminist strategies seem at odds oftentimes, we need to look towards reconciling this duality by making it more compatible by having the courage to build upon, expand, challenge, and bridge the theories we have in place. In addition, we, as mothers, need to look within ourselves for answers to mothering effectively in our own individual way, while fitting into society's mandate of what is considered effective mothering. We need to be particularly responsible in discussing this issue and to protect our mothers from being vilified for being a mother, whether they are intensive or empowered. In addition, it is important not to discuss "intensive mothering" as an elitist activity that only includes middle class mothers and further alienates working class mothers. Even though we realize that "this normative practice of mothering does now seem to be transcending geographical and class boundaries" (O'Reilly *Maternal Thinking* 34), we recognize that marginalized mothers do not have the choice as to how to mother, as it is imposed upon them by society's views and expectations of them, as especially noted in the United States.

What is left to examine in future is an understanding of the lived experience of all mothers from all classes for the purpose of hearing and understanding the motives behind intensive mothering. It is critical for us to hear the voices of welfare mothers, who may choose to intensively mother but do not have the option to do so. We need to speculate how intensive mothering plays out through the lifespan for mothers and their grown children when we will hopefully hear their actual voices. We need to understand why children increasingly crave friendships over family connection. Is this a reaction to intensive mothering or the cause of it? Being left in the empty space is especially painful for mothers, who have overinvested in their children and the guilt is likely to be excessive in their children for having flown the nest. Finally, we need to continue to seek alternatives to intensive mothering without totally negating it in our search for maternal empowerment and a "feminist ethic of care" (O'Reilly *What Do Mothers Need?*), which would "counter the individualized neoliberal model, one in which the needs of mothers and children are prioritized" (Vandenbeld Giles). In examining in this collection how intensive mothering is understood, assessed, and presents itself today, we can continue to look toward future potential alternatives and modifications to this mode of mothering in our pursuit to further empower mothers in the development of non-patriarchal maternity.

WORKS CITED

Bloch, Katrina and Tiffany Taylor. "Welfare Queens and Anchor Babies." *Mothering In The Age of Neoliberalism*. Ed. Melinda Vandenbeld Giles. Bradford, ON: Demeter Press, 2014. 199-211. Print.

Bowlby, John. *A Secure Base*. New York: Basic Books, 2005. Print.

Douglas, Susan and Meredith Michaels. *The Mommy Myth: The Idealization of Motherhood*. New York: Free Press, 2005. Print.

Druckerman, Pamela. *Bringing Up Bebe: One American Mother Discovers the Wisdom of French Parenting*. New York: Penguin Press, 2012. Print.

Ennis, Linda. "Motherhood and Employment." *Encyclopedia of*

Motherhood. Vol. 1. Ed. Andrea O'Reilly. Toronto: Sage, 2010. 343-346. Print.

Ennis, Linda. "Mommy Track." *Encyclopedia of Motherhood*. Vol. 2. Ed. Andrea O'Reilly. Toronto: Sage Publications, 2010, 793-795.

Ennis, Linda. "Intensive Mothering: Imperfect Madness." Paper presented at the MIRCI conference "Representing Motherhood: Mothers in the Arts, Literature, Media and Popular Culture," Ryerson University, Toronto, Ontario, 2010.

Ennis, Linda. *On Combining Motherhood With Employment: An Exploratory Study*. Toronto: University of Toronto Press, 1997. Print.

Fraiberg Selma, E. Adelson and V. Shapiro. "Ghosts in the Nursery." *Journal of the American Academy of Child and Adolescent Psychiatry* 14.3 (1975): 387-421. Print.

Hays, Sharon. *The Cultural Contradictions of Motherhood*. New Haven: Yale Press, 1996. Print.

Klein, Melanie. *Love, Guilt and Reparation*. London: W.W. Norton & Co, 1964. Print.

Lareau, Annette. *Unequal Childhoods*. Berkeley: University of California Press, 2011. Print.

Maushart, Susan. *The Mask of Motherhood*. New York: Penguin Books, 2000. Print.

Nelson, Margaret. "What Mothers Need: For Parenting To Get Under Control." *What Do Mothers Need?* Ed. Andrea O'Reilly. Bradford, ON: Demeter Press, 2012: 44-53. Print.

O'Brien Hallstein, Lynn. "When Neoliberalism Intersects with Post-Second Wave Mothering." *Mothering In The Age of Neoliberalism*. Ed. Melinda Vandenbeld Giles. Bradford, ON: Demeter Press, 2014: 297-315. Print.

O'Brien Hallstein, Lynn. "Second Wave Silences and Third Wave Intensive Mothering." *Mothering in ihe Third Wave*. Ed. Amber Kinser. Bradford, ON: Demeter Press, 2008: 107-116. Print.

O'Reilly, Andrea. "Introduction." *Mother Outlaws: Theories and Practices of Empowered Mothering*. Ed. Andrea O'Reilly. Toronto: Women's Press, 2004: 1-30. Print.

O'Reilly, Andrea. *Maternal Thinking*. Bradford, ON: Demeter Press, 2009. Print.

O'Reilly, Andrea. *What Do Mothers Need?* Bradford, ON: Demeter Press, 2012. Print.

Rich, Adrienne. *Of Woman Born: Motherhood As Experience and Institution.* 2nd ed. New York: Norton, 1986. Print.

Ruddick, Sara. *Maternal Thinking Towards a Politics of Peace.* Boston: Beacon, 1989. Print.

Skenazy, Lenore. *Free-Range Kids.* New York: John Wiley and Sons, 2009. Print.

Stone, Pamela. "Thoughts on the Implications of "Opting Out." *What Do Mothers Need?* Ed. Andrea O'Reilly. Bradford, ON: Demeter Press, 2012: 295-305. Print.

Thurer, Sherry. *Myths of Motherhood.* New York: Penguin Books, 2007. Print.

Vandenbeld Giles, Melinda. *Mothering in the Age of Neoliberalism.* Bradford, ON: Demeter Press, 2014. Print.

Warner, Judith. *Perfect Madness.* New York: Riverhead Trade, 2006. Print.

Warner, Judith. "Bait and Switch: Moving On From Mommy Madness." *What Do Mothers Need?* Ed. Andrea O'Reilly. Bradford, ON: Demeter Press, 2012: 53-63. Print.

Winnicott, Donald. *Maturational Processes and the Facilitating Environment.* London: Hogarth Press, 1965. Print.

Part I: Understanding and Assessing Intensive Mothering

Intensive Mothering as an Adaptive Response to Our Cultural Environment

SOLVEIG BROWN

IN *THE CULTURAL CONTRADICTIONS OF MOTHERHOOD*, Sharon Hays eloquently showed how the attributes of "intensive mothering" evolved over several centuries to become the dominant parenting ideology of our culture. This parenting model describes children as innocent and priceless, and assumes that mothers should be primarily responsible for using "child-rearing methods that are child-centered, expert-guided, emotionally absorbing, labor intensive, and financially expensive" (Hays 122). Recently, some scholars have suggested that women spend too much time and energy on their role as a mother, which has led to a generation of privileged children, exhausted mothers, and an overall decline in women's status (see Badinter; Druckerman; Kolbert; Levine).[1] The implicit "solution" offered by these criticisms is that mothers should simply stop being so intensive. Treating intensive mothering as if it were an individual "choice" women make does not address the underlying issues that have made mothering even more child-centered, time-consuming, labor-intensive, and emotionally absorbing for this generation of mothers. Instead, we need to examine the role larger cultural forces play in driving intensive mothering norms.

Sharon Hays observes that intensive mothering has risen in tandem with our market society, and symbolizes an opposition and implicit rejection of the values of a rationalized market society. She argues that intensive motherhood has become the central terrain in which we express our "fundamental and irreducible ambivalence about a society based solely on the competitive pursuit of self-interest" (18). In this scenario, mothers willingly devote their time, attention,

and financial resources to childrearing, even when the ideals of intensive mothering are at odds with the logic of the marketplace. I take Hays' argument further by suggesting that our market society has, directly and indirectly, created specific cultural circumstances that drive intensive mothering norms. In this chapter, I explore some of the ways in which intensive mothering has become an adaptive response to our changing cultural environment.

During 2007 and 2008, I conducted in-depth ethnographic interviews with 40 middle-class and upper middle-class mothers, and collected extensive survey data from 80 mothers residing in the Minneapolis-St. Paul Metropolitan area.[2] The sample included both working mothers and stay-at-home mothers. The majority of participants were white, college educated, married women, with household incomes above the national norm.[3] In other words, the women in my study are part of the demographic most likely to engage in intensive mothering. Even though individual women's parenting practices varied, they shared an underlying belief in the intensive mothering ideology, in that most mothers "always" or "usually" agreed with each component of Hays' definition, with the exception that 68 percent of the mothers only "sometimes" relied on experts to guide their childrearing practices.[4]

During the late 1950s, and early 1960s, anthropologists conducted a study of American mothers living in a New England town they called "Orchard Town" (Minturn and Lambert; Whiting and Edwards). When I read these classic ethnographies, I anticipated that mother-child interactions would be significantly different from today's style of parenting. I was surprised by how similar the descriptions of 1950s mothers' practices sound to today's middle-class intensive mothering norms. "Orchard Town" mothers had open communication with their children, and had friendly, playful interactions with them. They provided their children with educational toys, to bolster their achievement, and games to keep them occupied indoors. They praised their children's artwork, worried about their safety when they were outside, had snacks on hand for their children, and at times treated their children as equals.[5] I realized that current standards of mother-child interactions are not a total departure from the previous generation's mothering norms. Instead, our mothering

practices have evolved and intensified in response to changing circumstances within our culture.

Perhaps the biggest difference I noticed between today's mothers and "Orchard Town" mothers was the startling lack of self-reflexivity of the 1950s and 1960s mothers. "Orchard Town" was part of the Six Cultures Study of Socialization project, which included mothers from India, Japan, Kenya, Mexico, Republic of the Philippines, and the U.S. The Harvard study offered insight into the cultural and academic status quo of the time, and contributed an in-depth understanding of the cross-cultural diversity in childrearing and child socialization practices; however, there was no information on how women in any culture thought or felt about being a mother. As I embarked on my own research of present-day mothers, I realized that my interest in delving into women's self-reflective thoughts and feelings about being a mother spoke volumes about how our current cultural environment affected my research.

Sociologist Anthony Giddens characterizes this current era of late modernity as a time when all aspects of our society (including institutions and scientific knowledge) are subject to examination; as a result, individuals self-reflexively question what they should do, how they should act, and who they should be (70). He explains that market-driven cultures have created a heightened awareness of risk, which not only refers to recognizing new forms of danger, but also characterizes a way of thinking where people calculate their decisions or options in the present, in light of their perception of how a particular choice or action could potentially affect them in the future. As our political policies have consistently shifted to privilege the free market, we have cut funds for social services, and increased our emphasis on individual responsibility (Martinez and Garcia). Sociologist Anita Harris argues that this era of economic rationalism "has been accompanied by a shift to a new brand of competitive individualism, whereby people ... must develop individual strategies and take personal responsibility for their success, happiness, and livelihood by making the right choices is an uncertain and changeable environment" (3-4).

What does this mean for mothers? This means that mothers in our culture are not only responsible for their own present and future wellbeing, but also that of their child. Therefore, I think it is cru-

cial to recognize that American mothers feel enormous individual responsibility for making choices that will facilitate their child's physical, emotional, mental, and material well-being in an era of uncertainty. When I asked women what is the hardest thing about being a mother, many mothers spoke of feeling guilty because they frequently wonder if they are saying or doing the right thing, and nearly every mother reported feeling under pressure, or stressed. Lauren, a part-time working mother of three, exclaimed; "there's so much pressure it's insane!" Marie, an elementary school teacher, who has two children in middle school, believes that the mothers she interacts with everyday are under "enormous pressure" because mothers have so many "demands and expectations" with very little support. Most mothers take their responsibility for their child's well-being very seriously and strive to do the best for their child, often using intensive mothering practices.

MARKET ECONOMY CO-OPTS INTENSIVE MOTHERING NORMS

Anthropologists have shown that in smaller scale societies, cultural expectations are important for guiding individual mother's practices (Barlow "Critiquing," "Working Mothers"; Clark). The United States does not have clear, realistic expectations for mothers. Instead, as many scholars have noted, American mothers are subject to contradictory, idealized, and unrealistic norms.[6] When I asked women to describe mass media representations of mothers, many women described idealistic images of perfect mothers who can "do it all." One mother summed it up:

> *I think that good mothers in the media are always right there to listen and to comfort, and give good advice when the timing is just right. They're pretty, and they're put together, and they're not wearing dirty jeans and ragged t-shirts. They are fit, and they have it all. They are not lacking for anything in the money department or in the looks department.*

Other women echoed this sentiment, many laughing at how the media images are not what it is like for most women. Amy, a

part-time working mother of two, observed that the Moms on TV "are these super heroes that drive the mini van, and they've got all the kids, and everything looks so easy because they have this mini van and a Verizon cell phone so they can do it all."

Advertising images draw on intensive mothering norms to create an ideal of mothering perfection. These images simultaneously evoke insecurity and aspiration, a potent combination in creating consumer desire. The images of beautiful middle class and upper middle class, domestically entrenched mothers using products to make their life more manageable, generate billions of dollars in revenue for various corporate interests. Thus, it is in the market's best interest to continue to flood all forms of mass media with images of perfect supermoms as a constant reminder of how it is possible to "do it all."

Media research shows that most people "believe that *others are more strongly affected* by media portrayals than they themselves are" (Milkie 192, emphasis in the original). This "third-person effect" suggests that the media wields a powerful indirect influence in that it leads people to believe that media images influence the perspective of other people in one's community or social network (Milkie). I noticed that women did not judge other mothers based on unrealistic standards, but several women worried that others in their community would judge them against these standards. Media portrayals of perfect super-moms also reinforce broader neo-liberal cultural ideologies that emphasize individual responsibility. Thus, if a woman has trouble meeting the demands of simultaneously being an excellent mother, worker, and partner, we tend to look at it as an individual failure, and not a failure of workplace environments or government policies to address issues related to childcare.

INTENSIVE MOTHERING MEDIATES SAFETY AND COMPENSATES FOR A LOSS OF FREEDOM

During the last several decades, we have developed a heightened awareness of safety. One of the most consistent themes in my interviews was how the world feels so much less safe for children in this generation compared with a generation ago. The word

"freedom" came up countless times when women spoke about their own childhood.[7] The stories women told about their youth were remarkably similar in that they portrayed a time when the world was a safe place for children and teenagers to explore. The women in my study genuinely felt sad that their children do not have the same freedom they had as a child, but when they compared the stories of their childhood with today's standards, most women thought it was unimaginable to give their children the same kind of freedom that they enjoyed. Every mother thought that she worried about her children's safety, much more than her parents ever did. Sheila, a mother of two young boys, believes that even though statistically the incidence of bad things happening to children is lower than it is ever been:

Our perception of it is so heightened, from stranger danger, to getting hit by cars, and dying of accidents and illnesses. Kids' safety is at an all time high, and yet we think of it as at an all time low, and that's a curious cultural shift that I can't account for.

In *Selling Anxiety,* Caryl Rivers chronicles how the media intentionally sells anxiety to women because it is profitable in an era where the market influences the news media.[8] She states; "the news media today sell anxiety to women the way that advertising sells insecurity about their faces, body, and sex appeal" (1). The mothers in my study clearly show that being exposed to media stories that simultaneously emphasize childhood danger, and the importance of safety, have created deeply engrained worries and fears in the psyches of many mothers. Mothers worried about issues such as whether their child would have friends and "fit in" at school; the quality of education; the safety of schools; the environment; abduction; molestation; consumerism; physical safety; illness; instilling healthy habits; body image; drinking; drugs; sex; getting blown up in college; and a variety of other personal struggles that children may have to face in this culture. This is a huge contrast with "Orchard Town" mothers, who were most worried about "busy thoroughfares" (Whiting and Edwards 201).

Many women struggled with finding a balance between promoting safety, and allowing their children freedom. Abby, a stay-at-home mother of three, worries about the long-term effects of children and teens not having any freedom. She heard a piece on Minnesota Public Radio about

> ...how kids in America don't get any freedom. They're watched like a hawk, all the way through high school and they get to college and they're set free, and they go crazy. They drink, and they go to parties, and they don't study. They go crazy. They wonder if it's because we don't give them enough freedom as high schoolers.

These comments show the self-reflective way in which mothers even worry if the things they do to try to protect their child will ultimately be bad for their children.

The women in my study are mothering at an intersection where they feel sad that the world is no longer a safe place where children can be "free," while being uncertain about what the future holds for their children when they become adults. They share a belief that childhood is a special time, and as a result are consciously trying to provide their children with a "good" childhood. The challenge for parents has been to figure out ways to create a "happy" childhood for their children within the current cultural environment, which is sandwiched between an era of idyllic freedom and an uncertain future. Intensive mothering has filled many of the gaps caused by our perception that our culture is no longer safe for kids. The fact that most children are less likely to have neighborhood friends they can see on their own, and do not "naturally" get enough exercise from playing outside, has created extra work for mothers. For example, the mothers in my study reported that they keep close tabs on their children; arrange play dates; frequently play with their children; manage child's exercise habits, usually by signing them up for sports or lessons; oversee child's indoor activities; and limit screen time. Every social change we have experienced has created multiple ripple effects on childrearing, all of which we depend on mothers to manage.

INTENSIVE MOTHERING PREPARES CHILDREN
FOR OUR INCREASINGLY COMPETITIVE WORLD

In *Unequal Childhoods: Class, Race, and Family Life*, Annette Lareau shows that social class, regardless of race, creates specific socialization experiences for children. Lareau describes the dominant parenting model of African American and white middle class parents as emphasizing "concerted cultivation" of their children, which is different from lower class parents, who work hard to provide their children with necessities and assume that children will naturally grow and thrive (*Unequal Childhoods* 7). She observed that middle class and upper middle class families view their children as a "project." As a result, children's lives are often dominated by "organized activities established and controlled by mothers and fathers, ... [that] places intense labor demands on busy parents, exhausts children, and emphasize the development of individualism, at times at the expense of the development of the notion of the family group" (*Update* 1-2, 13).

Lareau's definition of "concerted cultivation" mirror the descriptions the women in my sample gave me about their children's experiences. The topic of children's activities, and in particular, their involvement with sports at such young ages, the intensity of sports, the time commitment of sports, and the expense of many sports, is a huge topic of conversation amongst mothers. Many mothers I spoke with express a love-hate relationship with these activities that fuse exercise, fun, safety, friendships, achievement, competition, and at times parental socialization. Emily, a mother of three children who all participate in sports outside of school, feels that we have "ramped up" children's sports because "we want our kids to succeed. We want to make sure we give them every advantage we can." She also feels that enrolling your child in sports becomes competitive in a "keeping up with the Jones' kind of way. If they're starting their kids at soccer at ten, maybe if we start at nine we'll have a little bit of an advantage. It just keeps going back until you have three-year-olds out there."

When the women in my study nostalgically described their own middle class childhood, their stories sounded remarkably like Lareau's depiction of current lower class parenting methods that

assume "natural growth." This suggests that one of the major changes in this last generation is that the middle class no longer believe that their children will "naturally" be okay in our society. Scholars have argued that a belief in the importance of providing children with ample enrichment opportunities "lies at the heart of liberal individualism" and therefore "concerted cultivation" is prevalent in other market-driven western countries, such as the United Kingdom (Ball 9; Vincent and Ball). Lareau suggests that "concerted cultivation" is a highly effective strategy in the U.S. today "precisely because our society places a premium on assertive, individualized actions executed by persons who command skills in reasoning and negotiation" (*Update* 133). In this sense, middle class parents are teaching their children the skills needed to be competitive in a market-economy. Furthermore, middle class and upper middle class children socialized in "concerted cultivation" or "soft" individualism are more likely to excel in school because the ideologies that inform every aspect of the school environment are grounded in middle class and upper middle class values, norms, and practices (Demerath; Kusserow; Lareau, *Update*).

Thus, the intensive mothering norms that define the middle class mothering style offer their children a tremendous class-based advantage for being successful in school and ultimately getting into the best college possible in this current competitive cultural environment. Eighty-nine percent of the mothers in my sample indicated they "always" or "usually" coordinated the lessons, classes, or sports activities in which their children participated. This has clearly added to the labor demands of mothers, as it is time-consuming to be in charge of wading through the myriad of enrichment opportunities for children, finding a time that works with the family's schedule, filling out the forms, and getting their child to the activity. It is also expensive to pay for lessons, classes, equipment, uniforms, costumes, transportation, and all of the necessities related to extra-curricular activities.

INTENSIVE MOTHERING BUFFERS CHILDREN FROM MARKET FORCES

One of the defining themes of the neo-liberal ideology is the value of the free market. Given our culture's traditional view that there

is a dichotomy between the "sacred child" and the "profane market," we have experienced a cultural shift because the "profane market" realizes that the "sacred child" is a potentially powerful and lucrative consumer (Vincent and Ball 4; see also Martens). Current estimates indicate that advertising and marketing targeted to children is now a $15 billion industry (Schor). Compared to European countries, the United States has done little to regulate children's advertising, even when government studies show that children's exposure to commercials increases materialism, racial stereotypes, obesity, and health problems (Ramsey). Who ends up dealing with the ramifications of our cultural policies that privilege the free market above all else, even when excessive commercial exposure poses known risks to children? Mothers end up *individually* dealing with the ramifications of the sophisticated advertising industry whose sole aim is to pique children's desire in order to make profit.

Every mother I spoke with felt that consumerism affects her children to varying degrees, depending upon her child's age, personality, exposure to television commercials, peer group, and the level of affluence in the community in which they reside. Mothers have developed tactics to counteract a child's consumer desire, and many mothers find the constant battle to be exhausting. Rachel, a mother of three, feels that teaching her children values amidst the backdrop of their wealthy community is her "single biggest personal challenge." She feels that as a parent you have to really work hard not to get sucked into it and stay firm to what you think is right and wrong." Overall, mothers' responses to consumerism fell along the continuum of feeling helpless against the broader forces of consumerism; feeling outraged that there is not greater regulation in marketing and advertising to children; and being an "anti-consumer terrorist."

Mothers are also consumers for their children. The task that 97 percent of the women in my study "always" or "usually" do, and the only task that no one reported sharing equally with a spouse or partner, was buying children's clothes. Sara Ahmed notes that the link between consumerism and individualism has made consumption the vehicle by which people express themselves, their "inner potential," and their "authenticity" (275). Elizabeth Chin

argues that "consumption is at its base a social process" and that the children in her study used it "in powerful ways to make connections between themselves and the people around them" (123). I observed many ways in which mothers struggled with finding a balance between practicality and allowing their children to express themselves through clothing, wanting their child to "fit in" by getting certain brand name products, and expressing affection through purchasing clothes for their children. Many mothers also felt pressure from other parents regarding consumption. Amy commented, "It's hard not to get caught up in the hype of, is your kid in this? Does she wear that? Where are you going on vacation?"

INTENSIVE MOTHERING CREATES FEELINGS OF CONNECTION IN OUR MARKET-DRIVEN CULTURE

One of the bi-products of our market-driven culture is a rise in feelings of "personal meaningless" (Giddens 9).[9] Anthony Giddens observes that in our culture people experience feelings of alienation, in part, because individuals have lost their perception "of historical continuity in the sense of a feeling of belonging to a succession of generations going back into the past and stretching forwards into the future. Against this backdrop, people hunger for psychic security and a—disturbingly elusive—sense of wellbeing" (171). For many women, the relationship they have with their children helps them resist feelings of alienation and meaninglessness. When I asked seventy-five mothers what the best thing about being a mother is, there was an amazing uniformity of responses such as "experiencing unconditional love and connection, watching children learn and grow, the hugs and kisses, the laughter and joy, spending time with children, teaching them, and being needed."

For example, Tara, a high level corporate executive and mother of two, told me her children have reaffirmed her belief in "something greater," and through them, she sees the continuity of the generations. Tara commented:

> *When my first child was born, I felt this sense of purpose to my life that feels so wonderful. This is what it's all about. In the end, this is what it is, it's love and passing*

on lessons, and continuity, and life, and the circle of life, and all of those things. Having children has confirmed for me that sense of a broader meaning to the world, which is how I've kind of thought about God, and so that all fits together for me and feels really good.

Every mother I spoke with believed mothering to be a profound part of her identity and life and nurtured close relationships with her children.[10] In this sense, mothers are motivated to do child-centered, emotionally-absorbing intensive mothering because it fosters feelings of love and connection.

INTENSIVE MOTHERING PROVIDES CHILDREN WITH SCARCE RESOURCES OF TIME AND ATTENTION

The concept of time, or lack of time, came up consistently throughout my interviews, and many mothers reported that the hardest thing about being a mother was not having enough hours in the day to get everything done. Mothers talked about spending "quality" time with their children, in conjunction with making an effort to "connect" with them. Jackie explained: "I connect with my kids. I'm interested. I look at them like you're the most important thing in the world to me. I hope that they walk away from childhood getting that." Abby makes a point of connecting with her children every day by: "talking about things they're interested in, getting their opinion, or doing an activity with them." Psychiatrist and behavioral economist George Ainslie observes that, "the ultimate scarce resource in life is the willingness of other people to pay attention to us," and argues that "the failure to meet this need will prove the most serious and enduring mental health problem of the future" (see Frank vii). Thus, middle class intensive mothering norms tend to prioritize giving their children two of our culture's scarcest resources, time and attention.

I observed that very specific circumstances would cause *some* mothers to be judgmental of another mother, such as when they felt the safety or overall social or psychological wellbeing of another child was at stake. However, I found that women were most often critical of mothers who are over-involved in their children's lives

or activities, and mothers who did not spend enough "quality" time with children, especially if it appeared that a mother was pursuing excessive material gain, or leisure pursuits, in lieu of spending time with her child. However, the women in my study were overwhelmingly sympathetic of single mothers, whom they did not judge for not spending time with a child, because they were providing essential resources for the family. Thus, spending time with a child is a good thing, only when there are enough resources to meet the family's basic needs.

Celeste, who grew up in an impoverished and dysfunctional home environment, commented that she feels that parents today are "way too involved." When she thinks about the time she spends monitoring her children's homework, she knows that her parents never spent that much time with her. She feels that in general; "we over-manage our kids, whether it is bringing them to too many sports, or too many activities, or doing things for them. We're not doing them any favors." She realizes that many parents think it is "great to be an involved parent, but there's a fine line between being an involved parent and being a too involved parent." Celeste is aware of the "Helicopter Mom syndrome" and thinks to herself, "Oh God, I hope I'm not being a Helicopter Mom because to me, that's taboo." On the other hand, Celeste was also critical of parents who did not spend enough time with their children. Celeste knows a wealthy family where the parents are both working intense jobs and then going out in the evening, leaving the kids in the care of nannies and babysitters most of the time. She felt that the children had behavioral problems because they did not get enough attention from their parents. Other women expressed similar judgments, which shows that mothers must walk the fine line between providing their child with the scarce resources of time and attention, without over-indulging a child with these scarce resources.

INTENSIVE MOTHERING AS AN ADAPTIVE RESPONSE TO OUR CULTURAL ENVIRONMENT

The reasons that middle class mothers invest so much time and energy into mothering are varied and complex. Most mothers do

not feel like they can sit back and relax their parenting standards because they have lost their faith that their children will "naturally" be okay in our market-driven, competitive society. Instead of creating public policies that support parents, as many other prosperous countries have done, the United States has relied on intensive mothering norms to bridge the gaps between cultural change and its effect on childrearing. The problem is that these gaps are continually getting bigger, which means that the demands on mothers are continually increasing, yet mothers' time and energy is finite. This puts a lot of pressure on mothers, and many women reported sacrificing their sleep, exercise, or leisure time to manage their "life loads."[11] The stakes of parenting are high in this era, and it would be difficult for individual mothers to simply quit being so intensive, when many feel that intensive mothering strategies buffer their children from the negative aspects of our culture, while also preparing their child to thrive in our increasingly competitive culture. This chapter has highlighted just some of the ways in which intensive mothering practices are entwined with our market-driven culture. If we want to reduce the pressure on mothers to compensate for our market economy, then we need to start thinking of creative cultural practices that can support all parents in raising happy, healthy children who will thrive in our culture.[12]

[1] Several books and articles assert that Americans are helicopter parents (Aslop; Druckerman); raising children who are spoiled (Kolbert); privileged (Levine); narcissistic (Twenge and Campbell; Twenge); and lazy (Arnold et al.). Furthermore, American women have also been told that it is still impossible to simultaneously have a successful career, marriage, and young children (Slaughter), in part because they are enslaved by oppressive childrearing norms (Badinter).

[2] The women were between 22 and 53, with an average age of 36; and their children ranged in age from four months to nineteen years, with a mean age of four. Ninety percent of the participants were married, or living with a partner; six percent were divorced; three percent were living with a female partner or spouse, and one

percent was single and had never been married.
[3]The demographic breakdown by reported race was six percent African American, four percent Asian American, 87 percent Caucasian; two percent bi-racial, and one percent Latino.
[4]Eight-eight percent believed that children were always or usually innocent; 99 percent believed that children were always or usually priceless; 88 percent believed that raising children is always or usually emotionally absorbing; 28 percent always or usually relied on experts (i.e. advice from books, magazines, psychologists, doctors) to guide their childrearing practices, and 68% only sometimes relied on experts.
[5]For example, Orchard Town mothers: 1) had "relatively high levels of information exchange and other kinds of reciprocal, friendly interaction" with their children (Whiting and Edwards 113); 2) taught "appropriate playful behavior in the context of play between an adult and a child," which they noted would be unheard of in other communities (114); 3) "encourage their child to play with 'educational' toys ... and provide countless toys and materials to engage the children in the kind of play that is considered precursory to skills rewarded in schools. Mothers take time to ask questions about their children's constructions and artwork; they praise their children's drawings and encourage them to show their 'work' to others.... The constant stream of verbal exchanges encourages the development of verbal skills that are important for interacting with teachers in school and for future life in a complex literate society" (115); 4) "treat their children at times as if they were their status equals," which would also be inconceivable in other communities (115); 5) "keep an eye on the children when they are outside to see that they do not get too near the busy roads or other environmental hazards" (211); 6) spend many hours confined in their house with a preschooler and therefore, "invest hundreds of dollars in purchasing objects and games to entertain the children and keep them from running around in the confined space" (211); 7) prepare snacks which they offer to keep peace among the yard children and their younger siblings" (211).
[6]See Arendell; Chodorow; Coll, Surrey and Weingarten; Douglas and Michaels; Hays; Weingarten; West.

[7] In *Habits of the Heart: Individualism and Commitment in Everyday Life*, Bellah, Madsen and Sullivan note that, "freedom is perhaps the most resonant, deeply held American value" (23).
[8] See Douglas and Michaels for a thorough analysis of how the news media has reported issues related to mothers over the last several decades.
[9] As Max Weber presciently observed over a century ago, "in the United States, the pursuit of wealth, stripped of its religious and ethical meaning, tends to become associated with purely mundane passions" (182).
[10] Nearly half of the mothers cried at some point during the interview while speaking about something relating to their child that was especially poignant to them.
[11] This is in line with recent reports that indicate that 35 percent of American adults are obese; sleep deprivation has become a public health epidemic, putting women at greater risk for depression, diabetes, and heart disease; and women's use of anti-depressants has gone up 30 percent in the last decade. Currently, a quarter of adult women take anti-depressants, and eleven percent of women take anti-anxiety medication, which is twice the rate of men (see Ogden et al.; Colten and Altevogt; Song; Pratt, Brody and Gu; Bindley).
[12] Michelle Obama's "Let's Move!" campaign is remarkable because it attempts to alleviate mothers from being *solely* responsible for keeping their child healthy by advocating that we all need to play a part in counteracting the cultural changes that have led to high rates of childhood obesity. She stressed the urgency of the issue when she stated at the launch of the *Let's Move* campaign, "the physical and emotional health of an entire generation and the economic health and security of our entire nation is at stake." This quote is interesting because it implies that the physical and emotional health of children alone is not enough of an impetus for change, but when it also affects U.S. economic security, it is worthy of national attention. The Let's Move! Website, states that "everyone has a role to play in reducing childhood obesity, including parents, elected officials from all levels of government, schools, health care professionals, faith-based and community-based organizations, and private sector companies." This is an example of how important it is to create new forms of cultural support that

benefit children, when the previous way of doing something is no longer viable. The Clinton Global Initiative in cooperation with the American Heart Association, and the NFL Play 60, have also taken on the issue of Childhood obesity and have partnered with Nickelodeon to create a public awareness campaign to advocate exercise and healthy eating.

WORKS CITED

Ahmed, S. *Strange Encounters: Embodied Others in Post-Coloniality*. London: Routledge, 2000. Print.

Arendell, T. "Conceiving and Investigating Motherhood: The Decade's Scholarship." *Journal of Marriage and Family* 62.4 (2000): 1192-207. Print.

Arnold, J., A. Graesch, E. Ragazzini and E. Ochs. *Life at Home in the Twenty-First Century: 32 Families Open Their Doors*. Los Angeles: Costen Institute of Archaeology Press, 2012. Print.

Alsop, R. *The Trophy Kids Grow Up: How the Millennial Generation Is Shaking Up the Workplace*. San Francisco: Jossey-Bass, 2008. Print.

Badinter, E. *The Conflict: How Motherhood Undermines the Status of Women*. New York: Metropolitan Books, 2012. Print.

Ball, S. *Education plc: Understanding Private Sector Participation in Public Sector Education*. London: Routledge, 2007. Print.

Barlow, K. "Critiquing the 'Good Enough' Mother: A Perspective Based on the Murik of Papua New Guinea." *Ethos* 32.4 (2004): 514-37. Print.

Barlow, K. "Working Mothers and the Work of Culture in a Papua New Guinea Society." *Ethos* 29.1 (2001): 78-107. Print.

Bellah, R., R. Madsen and W. Sullivan. *Habits of the Heart: Individualism and Commitment in American Life*. With a new preface. Berkeley: University of California Press, 1985. Print.

Bindley, Katherine. "Women and Prescription Drugs: One in Four Takes Mental Health Meds." *The Huffington* 16 Nov. 2011. Web. Accessed: 17 June 2013.

Chin, E. *Purchasing Power: Black Kids and American Consumer Culture*. Minneapolis: University of Minnesota Press, 2001. Print.

Chodorow, N. *The Reproduction of Mothering: Psychoanalysis*

and the Sociology of Gender. Berkeley: University of California Press, 1999. Print.

Coll, C., J. Surrey and K. Weingarten. *Mothering Against the Odds: Diverse Voices of Contemporary Mothers.* New York: The Guilford Press, 1988. Print.

Colten, H. R. and B. M. Altevogt, eds. *Sleep Disorders And Sleep Deprivation: An Unmet Public Health Problem.* Washington, DC: National Academies Press, 2006. Print.

Clark, G. "Mothering, Work, and Gender in Urban Asante Ideology and Practice." *American Anthropologist* 101.4 (1999): 717-29. Print.

Demerath, P. *Producing Success: The Culture of Personal Advancement in an American High School.* Chicago: University of Chicago, 2009. Print.

Douglas, S. J. and M. W. Michaels. *The Mommy Myth: The Idealization of Motherhood and How It Has Undermined All Women.* New York: Free Press, 2005. Print.

Druckerman, P. *Bringing up Bebe: One American Mother Discovers the Wisdom of French Parenting.* New York: The Penguin Press, 2012. Print.

Frank, R. *Falling Behind: How Rising Inequality Harms the Middle Class.* Berkeley: University of California Press, 2007. Print.

Giddens, A. *Modernity and Self-Identity: Self and Society in the Late Modern Age.* Palo Alto: Stanford University Press, 1991. Print.

Harris, A. *Future Girl: Young Women in the Twenty-First Century.* New York: Routledge, 2004. Print.

Hays, S. *The Cultural Contradictions of Motherhood.* New Haven: Yale University Press, 1998. Print.

Kusserow, A. *American Individualisms: Child Rearing and Social Class in Three Neighborhoods.* New York: Palgrave Macmillan, 2004. Print.

Kolbert, E. "Spoiled Rotten. Why Do Kids Rule the Roost?" *The New Yorker* 7 February 2012. Print.

Lareau, A. *Unequal Childhoods: Class, Race, and Family Life.* Berkeley: University of California Press, 2003. Print.

Lareau, A. *Unequal Childhoods: Class, Race, and Family Life, with an Update a Decade Later.* Berkeley: University of California Press, 2011. Print.

Levine, M. *The Price of Privilege: How Parental Pressure and Material Advantage Are Creating a Generation of Disconnected and Unhappy Kids.* New York: Harper, 2006. Print.

Martens, L. "Learning to Consume—Consuming to Learn: Children at the Interface Between Consumption and Education." *British Journal of Sociology of Education* 26.3 (2005): 343-57. Print.

Martinez, E. and A. Garcia. "What is 'Neo-liberalism'? A Brief Definition." *Global Exchange* February 26, 2000. Web. 15 March 2012.

Milkie, M. A. "Social Comparisons, Reflected Appraisals, and Mass Media: The Impact of Pervasive Beauty Images on Black and White Girls' Self-Concepts." *Social Psychology Quarterly* 62.2 (1999): 190-210. Print.

Minturn, L. and W. W. Lambert. *Mothers of Six Cultures.* New York: John Wiley and Sons, 1964. Print.

Ogden, C. L. et al. *Prevalence of Obesity in the United States, 2009-2010.* U.S. Department of Health and Human Services, Centers for Disease Control and Prevention, National Center for Health Statistics, 2012. Print.

Pratt, L., D. Brody and Q. Gu. "Antidepressant Use in Persons Aged 12 and Over: United States, 2005–2008." *Cdc.gov.* Center for Disease Control, n.d. Web. Accessed: 17 June 2013. Print.

Ramsey, W. A. "Rethinking Regulation of Advertising Aimed at Children." *Federal Communication Law Journal* 58.2 (2006): 361-392. Print.

Rivers, C. *Selling Anxiety: How the News Media Scare Women.* Lebanon, NH: University Press of New England, 2007. Print.

Schor, J. *Born to Buy: The Commercialized Child and the New Consumer Culture.* New York: Pocket Books, 2004. Print.

Slaughter, A. "Why Women Still Can't Have it All." *The Atlantic,* July/August 2012. Print.

Song, J. "Women's Health." *Sleep Loss Affects Women More Than Men.* Web. 17 June 2013. Print.

Twenge, J. *Generation Me: Why Today's Young Americans Are More Confident, Assertive, Entitled—and More Miserable than Ever Before.* New York: Free Press, 2006. Print.

Twenge, J. and W. K. Campbell. *The Narcissism Epidemic: Living in the Age of Entitlement.* New York: Atria, 2009. Print.

Vincent, C. and S. J. Ball. "Making Up the Middle Class Child: Families, Activities and Class Dispositions." *Sociology* 41.6 (2007): 1061-77. Print.

Weber, M. *The Protestant Ethic and the Spirit of Capitalism*. New York: WCharles Scribner's Sons, 1958. Print.

Weingarten, K. *The Mother's Voice: Strengthening Intimacy in Families*. New York: The Guilford Press, 1997. Print.

West, L. *Soccer Moms, Welfare Queens, Waitress Moms and Super Moms: Myths of Motherhood in State Media Coverage of Childcare*. Atlanta: Emory University Press, 2002. Print.

Whiting, B. B. and C. P. Edwards. *Children of Different Worlds: The Formation of Social Behavior*. Boston: Harvard University Press, 1992. Print.

I Don't Know Where I End and You Begin

Challenging Boundaries of the Self and Intensive Mothering

LORIN BASDEN ARNOLD

> I started to become resentful. I started feeling like she was sucking the life out of me. I wrote in a journal entry that I later tore to pieces, fearing she'd see it one day, that it felt like the only way for her to be happy was for me to be miserable. On my better days, I wondered if our happiness was simply mutually exclusive. On the hardest days, I literally felt that she fed on my misery, like some sort of freakish swamp-dwelling mold. (Hendrickson)

IN THIS NARRATIVE on her blog, Kristen Hendrickson provides a picture of the experience of a mother struggling with the demands of intensive motherhood and her own physical needs. It points to the complexity of the negotiation mothers make between the ideologies of individuality and intensive mothering.

As Susan Douglas and Meredith Michaels, Joan Peters, and Sharon Hays argue, recent ideologies of mothering in the U.S. require mothers to put aside the self in favor of a focus on the child. Mothers are expected to see the world through the eyes of the child, and thus to respond always from that subject position. The primary obligation of motherhood is a happy childhood and this, in combination with a celebration of "natural" mothering behaviors, such as co-sleeping, nursing, and baby-wearing, can create an expectation of near-constant connection between the bodies of the mother and child.

Various scholars have argued that psychological separation and boundary creation is a necessary component for psychosocial

development and sound psychological health (e.g. Laing; Mahler, Pine and Bergman). At the same time, a competing claim can and has been made that the notion of individual separateness is a faulty understanding of being rooted in specific cultural patterns (e.g. Callero; Keller). This question, however, is highly theoretical, as it addresses our epistemological understandings of humanness rather than the grounded day-to-day experience, and discussions of it may not adequately address the lived experience of mothers simultaneously attempting to maintain their own selfhood, help children with healthy development, and mother intensively.

In this work, I draw from maternal narratives of mothering to attempt to shed light on the complexity of body boundaries, or the sense of where self physically ends and others physically begin, in motherhood. I examine maternal discourse regarding physical practices of intensive parenting, through online narratives containing discussions of intensive mothering/parenting, attachment mothering/parenting, baby-lead weaning, babywearing, on-demand nursing, and co-sleeping. For this analysis, I focused on mother-published discourse addressing the maternal experience with intensive mothering practices and the body. I present the maternal discourse here in unedited format, with all language and typographical choices of the authors preserved, in order to more fully appreciate the individual voices of these mothers. Through this analysis of the discourse, I both challenge the binary understandings of self and other, and related arguments regarding individuation and psychological health, and consider everyday challenges faced by mothers attempting to fulfill these demands of motherhood.

THEORIZING INDEPENDENCE AND INTENSIVE MOTHERHOOD: DICHOTOMIES OF SELF

A variety of scholars of psychology and child development, from Bowlby to Mahler, Pine, and Bergman, have made arguments about the importance of individuation over the course of childhood. Such theorists argue that early childhood is characterized, both physically and psychologically, by relationships of dependence, and that a gradual separation from the parent, typically mother, is necessary for appropriate psychosocial functioning in adulthood.

In a similar vein, the importance of independence as a cultural indicator of success in the United States and other westernized cultures has been discussed by many theorists, including Hays in her seminal work on motherhood, and Bellah et al in their discussion of the "good society." In the U.S., we have a dominant ideology of success that prioritizes individual action and accomplishment over collective action and accomplishment, values socially appropriate behavior in support of individuality, and valorizes personal success.

These ideological concepts, as even our understandings of the science of cognitive maturation are ideology, suggest and promote the value of separation, personal success, and independence. Yet, as Hays argues, we simultaneously maintain an ideology of motherhood that is rooted in ideas of connection, service, and selflessness. This maternal connection, in its idealized form, is understood to be not only an emotional connection, but also a physical one. Even mothers who do not actively participate in some of the practices of intensive mothering often enact this ideology by embracing selected aspects of it or explaining/justifying their mothering practices vis-à-vis the lens of intensive mothering.

A STARTING POINT:
DISRUPTION OF THE PHYSICAL SELF IN PREGNANCY

While this work will primarily address mothering after birth, the process of becoming a mother and starting to negotiate the disruptions to the sense of physical self begins in pregnancy, as the mothering experience does not simply begin with the birth of the child. Various authors, including Jan Draper (747-748), Rosemary Betterton (257), and Paula Nicolson, Rebekah Fox, and Kristin Heffernan (577) have discussed pregnancy as being an experience of occupying the space of both self and other.

As Draper states, pregnancy "throws us into a very different relationship to our bodies, as two beings, the woman and the baby, lay claim to the one body" (747). This complicated relationship takes mothers from understanding their body as being their own (though we could also consider the extent to which patriarchal cultures promote even that sort of body individuality for women), to an understanding of the same physical body as containing two

people. In this time, the body ceases to "operate as a physical marker of individuality" (Bailey 340). Theoretically, after birth, the individuality of the body is again assumed, as the baby's body and mother's body physically separate.

As described by Virginia Schmied and Lesley Lupton in the article "The Externality of the Inside," past research has discussed the process of differentiation that occurs across a pregnancy and ends with a mother being fully differentiated from the infant, but mothers in their study indicate a complex relationship with this idea of self and other (33). Some mothers had little conceptualization of the fetus as other until birth (36), while others had a strong image of fetus as other, either as a companion or as an invading presence, throughout the pregnancy (36-37). Still other mothers may find that the view of the body as "belonging" to the fetus takes priority over maternal ownership, as choices regarding what to eat and not to eat, what to do and not to do, what medical procedures to have and not to have, and so on are largely premised upon the needs of the fetus.

The cultural medicalization of pregnancy can contribute to understandings of the fetus as owning the body, as pregnancy is presented often in public discourse as less about maternal experience and more about the successful production of a child. Ultrasound technology allows the removal of the mother from the equation. The in becomes out and the me disappears for the you (Mehaffy 181-183; Hadd 172). The maternal body is positioned as an "obstruction that disrupts an attempt to get a 'good' view of the baby" (Palmer 72), or as a cuddling/caretaking object for the fetus (Palmer 75).

Fetal care choices also indicate and support this understanding of the maternal role. Fetal surgical procedure rhetoric dismisses the maternal body/patient from the equation. Diagnostic and surgical techniques are positioned as the prevention of a future more serious problem for the child body without discussion of potential problems for the mother body. Benefit and risk discussion focuses exclusively on those directly related to the fetus (Van der Ploeg 173).

We might expect that the subjugation of the maternal-self in the interests of the child-self would cease at the time of birth, with the subsequent re-establishment of individual bodies for both mother

and child, and the severing of the tangible physical connection. However, this is not the case in mainstream understandings of maternity in the U.S.

BIRTH AND BEYOND: CHILD AS THE LOCUS OF MATERNAL EXPERIENCE

As Hays argued persuasively in her seminal work, the most dominant conceptions of mothering in the U.S. ask that mothers set aside individual needs, desires, and expectations and place priority instead on attending to the needs, desires, and innocence of the child (54). Good mothering is understood as proceeding from the subject position of the child, and maternal obligations are largely related to creating a childhood that creates happiness and security, and leads to a successful life for the child. As such, mothers are to remain constantly emotionally and connected to the child, in order to see and understand his/her needs, sometimes even before the child would know what those needs are. Because this style of maternity has been tightly connected to "natural" mothering behaviors, such as co-sleeping, nursing, and baby-wearing, mothers may feel an expectation of almost continual physical connection between maternal and child bodies.

Deirdre Johnston and Deb Swanson (517), Karen Christopher (91-93), Sharon Hays and others have found that mothers may construct intensive mothering differently, with some understanding it as constant accessibility, while others see it as quality time. However, regardless of these definitional distinctions, mothers appear to fairly consistently recognize the importance of basic intensive mothering concepts, including the importance of the mother, responsiveness to child needs, and the innocence of the child.

Mothers who have not been able to fully execute what they understand to be the ideal model of motherhood express strong feelings of guilt, shame, and failure. Mothers writing about this experience of feeling failure or shame poignantly describe their inability to follow what they see as the "best" form of mothering:

> *Despite the above, I am not breastfeeding.... What makes my breastfeeding failure so complete is the fact that of my*

five children, I successfully breastfed one of them. The problem is that this one moment of glory was not with Baby 5, which would have been redeeming in the eyes of my AP sisters, but rather was with Baby 3. We functioned in happy nursing bliss for almost two years before it was time to call time on the milk bar. And somehow, despite this success, I couldn't do the same for my last two babies. Epic. Fail. (White)

While many mothers invoke experts in their discussions of maternal practice, with Dr. Sears most frequently referred to as a primary expert, it is worth noting that the feelings of shame or failure they discuss are rarely positioned specifically as coming from an external source of castigation. Instead, mothers describe self-policing and self-evaluating with regard to mothering standards, and finding themselves lacking:

At one point, Dr. Sears stated that children who were attachment parented are more empathic than other kids. In that moment, I had to restrain myself from bursting into tears. I left the gym, and as I sat in the car in the parking lot in the pouring rain, I managed to convince myself that my sweet, loving, smiling daughter will undoubtedly become a psychopath by age 9. All because I yelled at her this morning. (Naumburg)

The worry and shame expressed in posts such as this are palpable. The rhetoric suggests that these mothers worry that failures to uphold intensive mothering practices will fundamentally harm their children. Even mothers who indicate that they have somehow rejected something they see as a basic tenet of intensive mothering still invoke the principles of this ideology, as they understand them, in order to justify, rationalize, or excuse their non-normative behavior. Those mothers also often express some sense of worry they may have failed:

…are Rob and i bad parents because we finally said enough is enough and moved April's crib out of our room and into

her own room at nine months, and let her cry it out for a few nights so that we could all start to get a more restful sleep? i'd like to think that the answer to that is no. and that's what i truly believe. yet attachment parenting has brought a new extreme into the parenting mix. their rules would say that we've failed, and our child is going to have brain damage from crying. or if we get off easy, she'll just have ADHD. in the world of AP your baby doesn't cry. you don't form a schedule. you feed them on demand. you wear them from the time you get up in the morning until they get their bath and then you tuck into bed (with you, obviously, since cribs are prison cells.) basically, your baby runs the show. and that show can work for some families, or in our case, it can be enough to drive one new mom (that's me) around the bend. (Em)

This description illustrates the impact of constant responsiveness required in the ideology of intensive mothering. Many mothers mentioned "losing" their minds, "going crazy," being extremely "stressed," becoming physically ill or depressed, and experiencing problems in their spousal relationships. These discussions, as a whole, imply that there can be negative maternal consequences of intensive mothering practices, but, moreover, they also suggest that it is only appropriate to consider setting aside some of the expectations of this mothering ideology in extreme cases of physical or emotional consequences.

RHETORICAL CONSTRUCTION OF MOTHERING AND THE BODY

In Schmeid and Lupton's 2001 study, mothers described the sharing of their bodies with nursing babies and how the boundaries between self and other blurred. Some women were comfortable with this, while most described it as a disrupting experience and indicated a loss of self and agency, with one saying "[I am] not my own person, I am *his* person" ("Blurring the Boundaries" 241). Similarly, in Schmeid and Barclay's 1999 study, more than 60 percent of the respondents expressed feelings of bodily disruption

and many expressed a desire for more separateness, in the face of the proximity required by nursing expectations (329-331).

Mothers, in their discourse, frequently describe the challenges of feeding on demand, or of breastfeeding, more generally. Most position nursing as a natural and best feeding strategy, and state their strong desire to engage in nursing. Some describe their "failures" at breastfeeding, primarily due to issues outside of their control. The causal factor most often described is a maternal body failure to adequately provide for the needs of the child, despite the mother's desire and intense efforts to do so.

> *I longed to breastfeed, but for medical reasons my milk only came in on one breast, and that one barely was producing. My daughter was frustrated and refused the breast pretty early. I imported medications not allowed in the country to lactate more, which totaled more then formula would. It also gave me horrible headaches and made me gain about 25 lbs. I pumped what I could every three hours at home and at work for over 6 months. I cried every night from total sleep depervation. (my daughter slept through the night at eight weeks adding insult to injury ... lol). My husband finally asked me if I would consider just using the formula, and after weeks of consideration I caved. I still feels like [I'm] poisoning her every time i feed her. but my daughter needed her mom and my husband needed his wife. i still feel guilty, but really i gave it every ounce of my strength.* (Jillian)

What becomes clear in this example, and many others, is the extent to which nursing, and more specifically on-demand nursing, is positioned as the natural and optimal choice for mothering. Mothers rarely broach any discussions of whether breastfeeding really is the best choice, how "natural" mothering options, such as nursing, have come to be prioritized, or what "natural" really means in the context of the twenty-first century.

Generally, breastfeeding issues are addressed either as something to be overcome in order to maintain intensive mothering for the needs of the baby, or as so extreme that they threaten the very life

or sanity of the mother. Grace, for example, states that, "on-demand breastfeeding was the worst thing I have ever done in my life as a parent ... it nearly destroyed me."

In those extreme cases, a decision to stop on-demand feeding is positioned as the best course of action, not primarily for the woman as an individual, but for her as a mother. To continue to breastfeed, in this way, is discussed as something that would ultimately decrease the mother's ability to parent intensively.

> *Sixteen months into it, my breastfeeding relationship with my son was starting to take a toll on our mother/child bonding relationship. You see, I was no longer happily breastfeeding, a lot of times I was just plain-ol' resentfeeding (I just made that word up, but you'll know it if you've done it).* (Kusek)

In Kusek's post, and similar others, challenges to the breastfeeding standard are primarily posited within the framework of intensive parenting. When nursing, or at least on-demand nursing, is given up, it is principally with the argument that the mother can parent more intensively if she ceases to breastfeed. Thus, even the decisions she makes not to share her body in this way are grounded in the needs of the child.

Similarly, the act of co-sleeping, which can be understood as sharing a bed or sleeping in an arrangement whereby the child is very close to the maternal bed, can create understandings of a shifting ownership of the maternal body. As Rowe found, decisions about co-sleeping represent mothering choices even during sleep, such that mothers must make decisions regarding to whom the maternal body belongs primarily, even at its most restful state (189-190).

> *I also had this experience—and it made my first year of parenthood unreasonably hard, and put a great deal of strain on my marriage.... We'd been co-sleeping—if you can call it "sleeping," which I wouldn't, as my son would doze for 30 to 40 minutes and then wake up to nurse all night long—for eight months, I'd been breastfeeding on demand, and not showering or really taking care of myself*

at all, ever. The only way my son knew how to receive comfort was by breastfeeding, which meant that no one could help me, even if they wanted to. I agreed to the sleep training, feeling horribly guilty as he cried. (Jill)

Jill's frustration with co-sleeping, but guilt about the "cry it out" process was expressed by many mothers in the same discussion of intensive practices on *Offbeat Mothers*. In the relative anonymity of the Internet, mothers even indicated times when they had lost control due to the sheer exhaustion:

By the time A was 6 months, she had been waking every 1-2 hours every night for 3 months, she only napped in the sling and I hadn't slept more than 3 hours straight since she was born. I felt like I was on duty 24/7 and was beginning to resent it. Something had to give. I realized this one night when, to my everlasting shame, I slapped her when she wouldn't stop crying (it was 2am and I'd only had 20 mins sleep since 5am the previous morn). To cut a long story short, we did sleep train A (I got my husband to do it cos I couldn't bear to hear her cry). We expected a rough ride but the very first night she woke up only twice (!!) and by night 4 she was sleeping 12 hours in her own room. (Doshdela)

As is clear in these posts, the ideology of intensive mothering is called upon, even when mothers experience significant challenges with some practices, as they position their movements "against" those practices as being in the best interests of the needs of the child.

Rarely, in the discourse I reviewed, do blogging mothers directly indicate their desire to reclaim their bodies as their own. In the instances when this does occur, however, the model of intensive mothering forms a backdrop in mothers' characterization of such desires/needs as "selfish" or "awful."

But I, selfishly, just want my body back. Sure, it's not the body I started with. There are certain, shall we say, downsides to childbirth. But it is still my body even if I'm never

again allowed to change its clothes, bathe it or sit it on the toilet with any degree of privacy. (Julie)

You'll think I'm World's Worst Mother but I felt so strongly about getting sick of not having my own body back that I decided to bottle feed my youngest. Totally selfish I know. But that's what I did and I loved it. (Scribbit)

Julie and Scribbit clearly express a sense of guilt or shame over the "selfish" desire to have their "own bodies back." That desire is situated in these posts and others as an inappropriate or un-motherly wanting of something that fundamentally should belong to the child/children. This image of selfishness, Hays argues, is a direct violation of the standards of intensive mothering (168).

Whether we should or should not understand the body as relating to the sense of self, most of us do. Therefore, it stands to reason that a belief that it is shameful to desire possession of one's own physical embodiment, or to feel conflicted about the need to share the physical body, could impact the overall sense of self.

IMPACT ON THE SENSE OF SELF FOR MOTHER OR CHILD

Individuality ... whether understood psychologically, morally, legally or even biologically, is not a pre-given ontological category, but always a contingent achievement. (Van der Ploeg 155)

Human individuality is not a pre-given category of being, but something that we create through our actions, interactions, and growth. As stated previously, there are multiple perspectives concerning how much individuality is ideal, and the extent to which understanding of self as an individual is a necessary part of good psychological health. However, regardless of what may be best or truly necessary, the ideology of individuality in U.S. culture is an important aspect of our understandings of the skills and beliefs that children need to develop over time. Simultaneously, our understanding of intensive mothering is one of dependence and connection, rather than independence and autonomy (Hays 97).

In the maternal discourse considered for this analysis, some mothers do address the need to gradually, over time, move toward increasing independence between mother and child. Such discussions remain grounded in intensive parenting philosophy in that they focus almost entirely on how the child's needs shift over time and that a good intensive mother would realize those changing needs and adapt to them by providing the child with greater independence, physically and emotionally:

> *It's appropriate and healthy for babies to need their Mom, or a trusted caregiver, constantly. You're not spoiling your baby by carrying her in a sling or nursing her when she is hungry, because babies' wants and needs are the same thing. Later, it's appropriate and healthy for a toddler to need the occasional support, encouragement, or intervention from a parent as she learns to navigate the playground. But as they get older, it is appropriate and healthy for children to want to do things on their own, and for parents to support and encourage them in their independence.* (Lauren)

In this example, Lauren supports the logic of intensive parenting, by reframing it with regard to the need for a child to gradually develop his/her own physical and emotional independence. Similarly, other mothers write about the extent to which good parents can recognize children's changing needs and adapt their parenting strategies to create opportunities for independence and autonomy to develop:

> *[B]abies grow up into bigger babies and toddlers and get more demanding and, IMHO, as a parent you need to switch the focus to different tools ... ones that gently encourage their increasing independence.... I almost want to say that some of AP is developmentally inappropriate for the older baby and toddler.... By that time I think a shift more towards The Dog Whisperer might work better ... you know, exercise, discipline, affection with the parent firmly in the role of "pack leader."* (theadequatemother)

> *I think breastfeeding can play an important role in teaching older children about relationships. By putting some boundaries on my daughter's breastfeeding, I am (hopefully!) helping her to understand that healthy attachment doesn't mean "ownership," but rather "relationship." If I say "no" to her, it doesn't mean our breastfeeding relationship is over—but I am guiding her towards respecting and interpreting my emotions and adjusting her behaviour a little.* (Anne)

Though mothers like Anne and theadequatemother note the changes needed in parenting across childhood, in order to meet the child's need for individual development, both maintain a perspective that resonates with intensive parenting concepts of careful parenting attention to the needs of the child, and the extent to which parenting decisions should be made on the basis of what will provide the most positive outcomes for the child.

A more limited group of mothers speak specifically about some of the problems with intensive parenting principles related to individuality, responsibility, and autonomy. Yet, even these posts tend to limit that discussion to how such practices may lead to problematic child behaviors and characteristics, such as selfishness, lack of empathy for others, and inability to self-soothe:

> *Attachment Parenting principles place emphasis on making your child "feel good." Gratification, limitless attention, limitless access to parents ... these are all purported to improve the "connection" between parents and children, which in turn is supposed to help your child feel loved, and from there help them develop into caring and compassionate individuals. But I think this is just as likely to lead to children who believe that the whole world revolves around them.* (Grace)

Similarly, Pybus notes that intensive parenting practices, such as on-demand nursing and babywearing, "create babies who can't fall asleep on their own and cry and cry until we pick them up." Grace, Pybus, and others express concerns that the physical con-

nection practices of intensive parenting may be less optimal for healthy child development, overall, than is sometimes assumed.

There were certainly some mothers in this group who invoked the individuality of the mother, herself, to raise concerns regarding the practices of intensive parenting. One mother, Carrie, writes about her belief that:

> *The child and the mother, whilst entwined at birth and through the physiologic acts of breastfeeding and attentive nighttime parenting (co-sleeping or sleeping in proximity), are actually separate human beings with distinct differences by virtue that one is the adult parent and one is the child with the consciousness of a child.* (Carrie)

Yet, for the most part, even when the individuality of the mother is addressed, the surrounding discourse bring us back to the idea that, if mothers don't attend to their own individual needs, they cannot be attentive wives and mothers, making good mothering choices.

> *I am not just a mother but I am also an individual. If I just focus completely on my role as a mother and completely ignore my personal development and self-growth by being a better business person or developing my passions and hobbies or working on my marriage with my husband, I might actually be short changing my children.* (Lim)

CONCLUSIONS

In her seminal work, Hays argues that the ideology of intensive mothering and the principle of a rationalized market represent oppositional but connected ideas, such that the force of intensive mothering expectations become even stronger as the rationalized market ideology grows more powerful (97). These contradictory forces require mothers to develop complex strategies that have an "emotional, cognitive, and physical toll" on mothers (149) and reflect a deep-seated "cultural ambivalence about a social world based on the motive of individual gain" (154). As such, she posits

that the logic of intensive mothering remains strong not "in spite" of its opposition to the logic of competition and individual profit, but because of it (171).

Similarly, the maternal discourse that I reviewed both utilized and rejected understandings of physical enactments of intensive mothering, often simultaneously, while positioning those rhetorical arguments both within and against the ideology of individuality. In the lives described, these mothers, through their various behavioral engagements of intensive mothering, made choices based on an underlying principle that careful, attentive, intensive mothering is needed to develop children who will be ultimately personally confident and successful. In this way, their dedication to intensive mothering efforts both rejected and supported a cultural ideology of individual autonomy and achievement.

The complexity with which these women present motherhood is not particularly surprising if considered from a lens of human dialectics.[1] Understandings that appear oppositional, on the surface, are often so intertwined in human experience that they call upon one another for existence (Arnold 77). Dialectics encourages us to see that human relationships are inherently messy and contradictory, and that is reflected in the discourse of these mothers. These mothers have not been duped into selecting physical parenting practices that are in contradiction to an ideology of individual success. Rather they are simultaneously, in ways that are complex and messy, making selections about mothering drawn from multiple ideological positions.

The discourse I examined certainly does not represent the entirety of mothering experience, even in the U.S., impacted as it is by individual and socioeconomic factors that would encourage or discourage participation in such online discussions of personal relationships. However, these examples do provide a glimpse into a common pattern of discussion of motherhood and the mothering experience. Perhaps it should not surprise us to see that, almost twenty years after the publication of Hays' text, we can still see evidence that motherhood, as revealed in the accounts of individual mothers, is characterized by "cultural contradictions." Such seeming oppositions may seem inexplicable on the surface, but are an everyday experience of our human relational lives that challenge

our simplified beliefs about the individuality and connection, self and other.

[1]Relational dialectics refers to "contradictory" pulls experienced by humans in interactions. The parts of a dialectic may seem in complete opposition, yet they can be seen to rely upon one another for understanding. A simple example of a conceptual dialectic is the extent to which the concept of "light" is only actively understood in its relationship to the idea of "dark." In relationships, we experience oppositional pulls such as connection and separation. We wish to be connected to our relational partners (the "we"), yet also remain individuals (the "me"). We engage various efforts to manage these contradictory beliefs/desires, including attempting to ignore one in service of the other, or developing understandings of how the two are interrelated under the same overarching principles. The idea of dialectics references the complexity of human existence, and calls upon us to understand that messiness and apparent contradiction is a part of that experience (Arnold 77-78).

WORKS CITED

Anne. "Breastfeeding Older Children, Nursing Manners, Mother-Led Weaning (And a Bit About Ditching the Dummy). *Dispelling Breastfeeding Myths*. 2012. Web. 15 May 2013.

Arnold, Lorin B. "10 Years Out: Presence and Absence in a Long-Term Online Mothers' Community." *Motherhood Online*. Ed. Michele Moravec. Toronto: Cambridge Scholars, 2011. 73-97. Print.

Bailey, Lucy. "Refracted Selves? A Study of Changes in Self-Identity in the Transition to Motherhood." *Sociology* 33.2 (1999): 335-352. Print.

Bellah, Robert N., Richard Madsen, William Sullivan, Ann Swidler, and Steven M. Tipton *The Good Society*. New York: Alfred A. Knopf, Inc., 1991. Print.

Betterton, Rosemary. "Prima Gravida: Reconfiguring the Maternal Body in Visual Representation." *Feminist Theory* 3.3 (2002): 255-270. Print.

Callero, Peter. *The Myth of Individualism: How Social Forces Shape Our Lives*. Rowman & Littlefield, 2013. Print.

Carrie. "Attachment Parenting: What's Going On." *The Parenting Passageway*. 2013. Web. 30 May 2013.

Christopher, Karen. "Extensive Mothering: Employed Mothers' Constructions of the Good Mother." *Gender & Society*, 26.1 (2012): 73-96. Print.

doshdela. "Attachment Parenting, Ideology, and the Mommy Wars." *Squint Mom*, 2012. Web. 15 July 2013.

Douglas, Susan J. and Meredith W. Michaels. *The Mommy Myth: The Idealization of Motherhood and How It Has Undermined Women*. New York: Free Press, 2004. Print.

Draper, Jan. "Blurring, Moving and Broken Boundaries: Men's Encounters with the Pregnant Body." *Sociology of Health & Illness* 25.7 (2003): 743-767. Print.

Em. "Are You Mom Enough?" *Mama Bear Roars*. 2012. Web. 1 June, 2013.

Foster, Elissa. "Desiring Dialectical Discourse: A Feminist Ponders the Transition to Motherhood." *Women's Studies in Communication* 28.1 (2005): 57-83. Print.

Grace. "Why I Am Anti Attachment Parenting." *Gracelings*. 2010. Web. 1 June, 2013.

Hadd, Wendi. "A Womb with a View: Women as Mothers and the Discourse of the Body." *Berkley Journal of Sociology* 36 (1991): 165-175. Print.

Hays, Sharon. *The Cultural Contradictions of Motherhood*. New Haven, CT: Yale University Press, 1996. Print.

Hendrickson, Kirstin. "Attachment Parenting, Ideology, and the Mommy Wars." *Squint Mom*, 2012. Web. 15 July 2013.

Jill. "I Feel Like Attachment Parenting is Detrimental to My Health: How Do You Define Your Boundaries?" *Offbeat Families*. 2012. Web. 10 May, 2013.

Jillian. "I Feel Like Attachment Parenting is Detrimental to My Health: How Do You Define Your Boundaries?" *Offbeat Families*. 2012. Web. 10 May, 2013.

Johnston, Deirdre D. and Deb H. Swanson. "Constructing the 'Good Mother': The Experience of Mothering Ideologies by Work Status." *Sex Roles* 54.7/8 (2006): 509-519. Print.

Julie. "I Think I'm Ready to Be Done with Breastfeeding." *Mental Tesserae*. 2007. Web. 15 May 2013.

Keller, Catherine. *From a Broken Web: Separation, Sexism, and Self*. Boston: Beacon Press, 1986. Print.

Kusek, Joy. "Mother-Led Weaning: How and Why I Gently Weaned My Son." *The Joy of This*. 2013. Web. 10 May, 2013.

Lauren. "Attachment Parenting Does Not Equal Helicopter Parenting: A Plea for More Understanding and Less Judging." *Mama Nervosa*. 2012. Web. 15 July 2013.

Lim, Violet. "Am I a Good Enough Mother?" *Maybe Baby*, 2013. Web. 1 July 2013.

Mahler, Margaret, S., Fred Pine, and Anni Bergman. *The Psychological Birth of the Human Infant: Symbiosis and Individuation*. New York: Basic Books, 1975. Print.

Mehaffy, Marilyn M. "Fetal Attractions: The Limit of Cyborg Theory." *Women's Studies* 29.2 (2000): 177-194. Print.

"Moms Still Make Social a Priority" *Emarketer.com*. eMarketer, 2003. Web. 15 Sept 2013.

Naumburg Carla. "Dr. Sears Made Me Cry." *Raising Kvell*. 2012. Web. 15 July, 2013.

Nicolson, Paula, Rebekah Fox, and Kristin Heffernan. "Constructions of Pregnant and Postnatal Embodiment Across Three Generations: Mothers', Daughters' and Others' Experiences of the Transition to Motherhood." *Journal of Health Psychology* 15.4 (2010): 575-585. Print.

Palmer, Julie. "The Placental Body in 4D: Everyday Practices of Non-Diagnostic Sonography." *Feminist Review* 93.1 (2009): 64-80. Print.

Peters, Joan K. *When Mothers Work: Loving Our Children Without Sacrificing Ourselves*. Reading, MA: Perseus, 1998. Print.

Pybus, Amy. "Don't Feel Bad When Your Crying Baby Makes You Crazy." *Sitting on the Baby*, 2011. Web. 15, July 2013.

Rowe, Jennifer. "A Room of Their Own: The Social Landscape of Infant Sleep." *Nursing Inquiry* 10.3 (2002): 184-192. Print.

Schmied, Virginia, and Lesley Barclay. "Connection and Pleasure, Disruption and Distress: Women's Experience of Breastfeeding." *Journal of Human Lactation* 15.4 (1999), 325-334. Print.

Schmied, Virginia, and Deborah Lupton. "Blurring the Boundaries:

Breastfeeding and Maternal Subjectivity." *Sociology of Health and Illness* 23.4 (2001): 234-250. Print.

Schmied, Virginia, and Deborah Lupton. "The Externality of the Inside: Body Images of Pregnancy." *Nursing Inquiry* 8.1 (2001): 32-40. Print.

scribbit. "I Think I'm Ready to Be Done with Breastfeeding." *Mental Tesserae*. 2007. Web. 15 May 2013.

theadequatemother. "Attachment Parenting, Ideology, and the Mommy Wars." *Squint Mom*, 2012. Web. 15 July 2013.

Tyler, Imogen. "Reframing Pregnant Embodiment." *Transformations: Thinking Through Feminism*. Ed. Sara Ahmed, Celia Lury, Jane Kilby, Maureen McNeil, and Beverly Skeggs. London: Routledge, 2000. 288-301. Print.

Van Der Ploeg, Irma. "'Only Angels Can Do Without Skin': On Reproductive Technology's Hybrids and the Politics of Body Boundaries." *Body & Society* 10.2-3 (2004): 153-181. Print.

White, Katie Spencer. "I Am An Attachment Parent and Am Not Breastfeeding." *The Audacity of Motherhood*. 2012. Web. 15 July 2013.

Status Safeguarding

Mothers' Work to Secure Children's Place in the Social Hierarchy

MELISSA A. MILKIE AND CATHARINE H. WARNER

IN THIS CHAPTER, we push the boundaries of the concept of intensive mothering ideology to discuss a new idea called "status safeguarding," showing how it both extends and, to some degree, complicates Sharon Hays' argument about cultural contradictions of mothering. We define status safeguarding as mothers' vigilant labor to prepare a child's pathway to the highest status achievable (Milkie, Warner and Ray; Warner). This idea focuses our attention on how mothers enact intensive mothering ideology: doing everything possible to ensure that a child's future social and economic status in a competitive marketplace is sustained or improved—in essence, weaving an individualized safety net. Status safeguarding reorients our thinking about intensive mothering as an ideology to focus attention on maternal labor, highlighting how this work perpetuates gendered inequalities (Collins; Cristin) and reinforces individualism (Hays).

Intensive mothering is a deeply felt cultural ideology that indicates children come first, and mothers should lovingly make sacrifices in their own lives in raising children (Hays). Attempting to live up to the cultural ideal of motherhood takes bountiful amounts of time and energy (Hays; Blair-Loy), creating acute conflicts with paid work. Indeed, as Hays argues in her insightful and now classic work, the logic of intensive mothering, and mothers' heavy investment in children, directly contradicts the logic of capitalism, in which self-interested actors pursue individual ends in the competitive marketplace. As she briefly mentions, and we argue has becoming increasingly central, intensive mothering can be in

the service of promoting children's success. Ironically, this "status safeguarding" work intimately ties mothers to the marketplace in a critical and complex way: rather than advancing in their own career and compensation, increasingly mothers' efforts take the form of work to insert children successfully into the competitive labor market system.

In the sections below, we first outline status safeguarding as the core work of intensive mothering today, arguing that it is a present-day oppressive force for mothers. We distinguish status safeguarding from concerted cultivation, a concept developed by Annette Lareau (*Unequal Childhoods* 31) to describe how middle-class parents "actively foster and assess children's talents, opinions and skills." Next, we discuss the context of parenting today, with increased uncertainty of a child's ultimate success in economic times fraught with relatively fewer good jobs and minimal state supports for raising and providing higher education for children. We help reorient Hays' argument about how intensive mothering fully contradicts "self-interest" in getting ahead in a rationalized labor market, given that mothers exert great safeguarding effort in order for offspring to succeed in this very system. Next, we highlight several potential variations in status safeguarding work across social location, employment and geography, and lay out three types of status safeguarding, including academic, talent, and emotional safeguarding. Finally, we delineate the consequences of safeguarding for children and mothers.

STATUS SAFEGUARDING AND INTENSIVE MOTHERING

Hays was right about how demanding intensive mothering is (Fox). In her focus on young children, it was clear that strong beliefs about a child's central place in mothers' lives could necessitate a huge investment of time, energy and emotion. Across social class and life circumstances, the mothers Hays interviewed consistently described fervent beliefs that mothers are uniquely suited to be children's caregivers, mothers should intimately know children's needs and desires at all times, spending their own time, energy and resources fostering offspring development, and mothers should protect sacred children from the competitive "dog-eat-dog world"

(Hays 124). To accomplish and celebrate caring, Hays argues, mothering requires a "moral condemnation of impersonal, competitive market relations" (Hays 65).

What is status safeguarding exactly? It is extensive maternal labor in the service of creating a thriving child who is distinguished as unique and, more fundamentally, over the many long years to adulthood, set to achieve a similar or better place in the social hierarchy compared with his parents. It involves mothers in constant work of anticipating potential problems and trying to forge a clear path for each child in the short and long term. It can be understood from the very basics of planning each day, to setting up weekly care arrangements that maximize a child's achievement and happiness, to negotiating the myriad of seasonal or yearly transitions that keep them on the road to success. Often, it takes the form of serious intervention if a child is falling off that path, whether not getting above average grades, not receiving appropriate attention from teachers, or not seeming happy with friends. It entails vigorously pursuing what is believed to be best for an individual child at every key juncture through anticipating and solving "status" problems. Elemental is the planning work of carefully considering the options available within structural constraints and mapping out optimal school, leisure, and emotional pathways as an attempt to guarantee that a child will have improved life chances.

The labor invested in status safeguarding can be framed within Pierre Bourdieu's (*Distinction*) conceptualization of social status distinction. Through status safeguarding, mothers aim to instill various types of cultural capital in children across several different social fields. Given that these social hierarchies are relational (Bourdieu *Distinction*), mothers' efforts to impart the "correct" cultural practices in children reproduce current power structures. Bourdieu (*The Logic, Distinction* 165) describes a "reproductive struggle" to accumulate capital that is structured by group beliefs in distinct sets of cultural practices; this system continually creates new layers of work for mothers as they seek to facilitate (but can never be assured of) children's social mobility. Other research situates parenting efforts within class-based analyses focused on how parents engage in specific cultural practices (e.g., Gillies; Lareau

Unequal Childhoods; Walkerdine and Lucey), but does not illustrate the ways in which mothers work to reproduce or improve class status within the theoretical framework of intensive mothering.

Status safeguarding work is a decades-long project. Long-term outcomes weigh heavily upon mothers, because their children's eventual success can be tightly tied to attending a "good" university, which is particularly challenging in the highly stratified system of higher education in the U.S. (Dwyer, McCloud, and Hodson; Freidman; Ramey and Ramey). Thus, safeguarding requires thinking about the big picture of a child's post-secondary education, even as he is very young. Attending to everyday details, such as matching leisure activities to a particular child's vagaries, checking homework to ensure the child is being challenged appropriately, or even surpassing his classmates, and knowing which new friends are positive influences for the child's achievement or moral values simultaneously carries the heavy weight of being viewed as imperative for long-term success. Mothers must also customize in such a way so that each individual child in the family is emotionally engaged in constructive activities that will enable him to independently and happily take the reins toward his own high status future. Despite mothers' huge investments over many years in attempting to create "measurable virtues" (Stevens), there is always the potential for problems, and adolescence can loom large even when children are very young.

Fathers may play a number of roles in status safeguarding: a resource to aid mothers with the huge workload of safeguarding a child's status, an advocate for pushing children's climb up the social hierarchy, a check on the intensity of status safeguarding, or perhaps no role at all. While modern fatherhood and diverse family structures point to a welcome rise in co-parenting children's daily activities (Cabrera et al.; Bianchi, Sayer, Milkie and Robinson), the labor that mothers perform for children, particularly organizing their lives and planning their next steps to protect their future remains fundamentally mothers' work (Craig and Mullan; Griffith and Smith; Palladino). As mothers perform status safeguarding, they likely act with a father's blessing, but often with minimal input, underscoring the gendered inequalities not only in mothers' shift away from their own career investments, but in this often

onerous, obscured, and emotionally exhausting labor on behalf of children's futures.

The concept of safeguarding builds from Lareau's (*Unequal Childhoods*) insightful ethnography of families of third graders, and complements Bonnie Fox's research on couples with babies, and Margaret Nelson's on parents of teenagers. According to Lareau, a large part of what middle-class parents do is structure their children's lives and intervene in institutions in order to customize their children's worlds. Lareau (*Unequal Childhoods*) argues that this "concerted cultivation" is deliberate in the developing of children's resumes, unlike the cultural milieu of the working-class, in which parents allow children an "accomplishment of natural growth." Surprisingly, Lareau links her ideas explicitly to intensive mothering only once in the text and in some endnotes, noting like Hays, that there is a new (intense) standard of childrearing, but that this standard is impossible for parents to achieve. Lareau's goal was to lay out class differences in the practices and logics of childrearing, which she saw as distinct from ideology (Lareau, personal communication).

Status safeguarding differs in emphasis from concerted cultivation in that the work 1) as discussed above, is gendered, highlighting how mothers, not parents, are overwhelmingly responsible for performing safeguarding work; 2) occurs across social classes in the precarious economic times characterized by a competitive global economy that has intensified in the years since Lareau and Hays collected data in the early 1990s; and 3) underscores labor that is as emotionally taxing as it is intensive, perhaps taking on even more urgency as children older than the preschoolers Hays focused on and the third graders Lareau studied enter the seemingly precarious and uncertain worlds of adolescence and young adulthood.

MOTHERS' SAFEGUARDING WORK AS SAFETY NET IN AN ERA OF ECONOMIC UNCERTAINTY

Why does intensive mothering ideology, perhaps more dominant than ever, increasingly play out as status safeguarding work? In the past two decades, fears about children's futures have become more

abundant, as the perceived competition for good jobs has become fierce in a global economy (Hollister; Kalleberg "Precarious"; Newman), and even a college degree does not seem to translate easily into "the good life." Moreover, even middle class families are in a precarious position, with fragile safety nets and rising inequalities (Sullivan, Warren and Westbrook) making the future setting for their offspring's adulthood uncertain (Brownstein). The fact that there are no guarantees for the intergenerational transfer of status underscores the often frantic nature of safeguarding. Being born into the middle class does not allow one to assume a middle class status for the child (Beller and Hout), nor does intensive mothering on the margins of poverty guarantee that a child will be able to pull out of dire economic straits. Given that the success of status safeguarding is unpredictable, and competition for good jobs is perceived to be fiercer than ever, the emotional strain associated with this form of maternal labor is very high today. Notably, women are harsh critics of mothers, and being a mother is seen to be very difficult today compared with the past (Pew).

Status safeguarding complicates our understanding of the logic of intensive mothering as fully contradictory to capitalism and mothers' drive to pursue their own careers in the modern era. Of course, motherhood creates conflict and can derail careers or additional education for women. Yet, in another sense, when a key aspect of mothering is status safeguarding work, mothers are investing in their offspring's future success through inserting children into the competitive marketplace. Mothers work to maintain the family's status into the future and to protect themselves from societal repercussions of a "failed" or less than successful child. As cultural expectations about mothers frame children as an extension of women, then working to secure a child's best interest by preparing him for market competition is, in some limited way, self-interest for mothers. Ironically, though Hays argued that mothers want to protect children, who they view as untainted, moral, and precious, from the competitive "dog-eat-dog" world, status safeguarding work pushes children squarely into this competition.

Viewing safeguarding as pursuing self-interest, even in a limited way, is complicated though, because mothers may have little choice in the matter. The combination of cultural expectations, distinct

social hierarchies, and increasing economic insecurity leaves mothers with little option as to whether they will pursue the heavy labor of status safeguarding. And, as noted later, the breadth of potential status safeguarding work across social contexts (academic, talents, and emotional) necessitates attention even from mothers that may wish to avoid or reduce such investments.

In sum, we argue that today, the core work stemming from intensive mothering ideologies is status safeguarding. Safeguarding is mothers' urgent, sacrificial, protective work in the goal of reproducing or improving class status. For mothers, safeguarding seems necessary, but even when seemingly doing it well, it carries anxiety inherent in its ultimate insufficiency to guarantee success.

VARIATIONS IN THE INTENSITY OF SAFEGUARDING

How mothers engage in status safeguarding varies by key characteristics, such as social class and ethnicity, mothers' employment, and cultural and geographical context. Those most likely to enact intensive mothering through safeguarding are middle-class mothers. This is particularly important for those who might enjoy relatively high education levels or incomes but do not have wealth to pass along to children (Lareau *Unequal Childhoods*). These mothers also have more resources to facilitate the constant planning and supervision that go into status safeguarding, and they too worry a great deal about children's futures (Nelson). Working-class mothers' safeguarding also is oriented to moving children into a position higher than their own, through education and significant emotional investments (Gillies; Hays). In a study of working-class mothers in England and Scotland, Val Gillies finds that when problems arise in a school setting, these mothers engage in extensive emotional labor and work outside the school to reassure children despite the negative messages they may receive within the educational system. Low-income parents internalize intensive mothering ideology and sacrifice to give their children advantages they lacked (Elliott, Powell, and Brenton), holding high expectations for children's futures even if financial problems limit the activities or support parents can provide (Chin and Phillips). Tiffani Chin and Meredith Phillips argue that

regardless of class status, parents hold common values for the ways children will occupy their summer hours; however, limited financial resources can place severe constraints on exactly how these values will be enacted. For some low-income or working class mothers, safeguarding work may take the form of attempts to keep children from falling off track in schooling and in difficult neighborhoods (McCormack). Mothers of different classes are differently regulated by mothering ideologies (Walkerdine and Lucey) and thus alternately affected by status safeguarding.

Race and ethnicity may shape the ways in which mothers approach status safeguarding. Mothers of middle-class white boys in the U.S. may feel a special urgency that their sons are on the path to success to take on their privileged place in society, even though they may not be fully aware of pressures that encourage them to foremost protect sons' status (Singh). For mothers of racial/ethnic minority children, living in a society where discrimination is a threat, there are other nuances to consider as they attempt to secure a child's future, taking into account racial identity, cultural expectations, and extended family ties (Lacy; Warner). These mothers may find that children's contexts require additional considered planning as children embark on their academic careers. For example, mothers carefully consider the racial composition of a given school, daycare, playgroup, or team as well as preview how a school is responsive to parental concerns, and how teachers interact with minority students. Often, mothers of African-American children face concerns about their families' proximity to struggling neighborhoods, the role of peer influences, and how to foster positive racial identities (Patillo; Lacy and Harris). Such concerns about safety and peer influences on racial/ethnic identity are likely an issue for mothers of minority group children in general. Furthermore, the kind of racial identity work that parents may pursue to ensure their children's success varies significantly by class status, location in the city or suburbs, as well as residential location (Lacy 50).

Mothers' employment status also affects the level of safeguarding. While Hays highlights the pervasive culture of intensive mothering regardless of employment status, recent research suggests that employed mothers more willingly embrace the personal fulfillment

they gain from working (Christopher). Despite their straying from the idealized selflessness of intensive mothering, these mothers emphasize the organization, planning, and overall responsibility they hold for their child's well-being (Christopher). Although status safeguarding may involve delegation, it is work mothers perform regardless of employment status. Still, stay-at-home mothers may be the most intensive in safeguarding practices, because daily and longer term goals and labor are focused more exclusively on their children.

Finally, national, cultural and geographic contexts of mothering matter. National context is important; for example, safety nets are especially thin in the U.S. and more labor may be called for, as parents cannot count on a secure future for children that will include health care, a decent income and so on (Sullivan, Warren and Westbrook). Mothers in the U.S. spend more time with children than similarly situated Canadians (Ramey and Ramey), perhaps monitoring their time and activities more intensely due to the increased competition of a stratified higher education system that has infiltrated downward into the lives of secondary and even primary students (Ramey and Ramey). Virginia Caputo finds that mothers in Canada also are confined by the boundaries of an intensive mothering ideology and prescribed definitions of "good mothering," but they have greater social supports compared to mothers in the United States. The level of the wage penalty may also matter in redirecting mothers' economic efforts toward social reproduction in the family: cross-nationally, mothers in over 60 percent of developed countries, especially Canada, the United States, the UK, Ireland, Austria, Germany, the Netherlands, and Luxembourg earn at least 30 percent less than childless women, experiencing a significant motherhood wage penalty (Budig, Misra, and Boeckmann). Within country cultural context matters as well. For example, within the U.S., those on the East coast or in urbanized areas may be in a culture which emphasizes the urgency of high status more than in other areas. Finally, mothers in urban environments may pursue different goals for their children compared with those in rural areas, given wide differences in social comparisons, proximity to events or activities, and the availability of school choice.

TYPES OF STATUS SAFEGUARDING

By its nature, status safeguarding occurs across multiple realms as children regularly intersect with new social institutions as they grow. We outline three milieu in which mothers foster children's advancement—academically, talent-wise, and emotionally. Mothers' work in each of these areas is likely to overlap, as individual talents shape academic life and children's happiness and emotional well-being shape attainments in school and other social institutions.

One fundamental aspect of status safeguarding is academic safeguarding. The process of academic safeguarding begins early, as mothers struggle with school choice and residential decisions, often noting that they are the primary decision-makers for the school a child attends (Billingham and Kimelberg). In issues such as school choice, neoliberalism shifts authority to parents, whether they seek that responsibility or not (Patillo et al.). Parents must make sense of their options, sometimes simply registering at the neighborhood school and sometimes actively selecting a school by energetically consulting social networks (Lareau "Schools"; Patillo, Delale-O'Connor and Butts). Once children are attending primary school, the work continues. Middle-class mothers, often in urban districts, are highly involved in school "improvement" efforts, not just organizing auctions or events, but also writing grants and conducting strategic planning (Billingham and Kimelberg; Cucchiara and Horvat; Lareau and Munoz). Lareau (*Unequal Childhoods*) discusses how mothers intervene when necessary for children having problems, though class status may dictate the extent to which mothers find success through these interventions. Safeguarding involves an overwhelming amount of work for mothers as they customize, distinguish and build the child's intellectual experiences at each developmental juncture and plan for the future. Academic safeguarding is not simply reactive, but largely proactive and involves a great deal of thought, active mapping out of options, and research with friends, neighbors and family members. It then involves consistently analyzing whether a child has the right teacher, an appropriately challenging curriculum, acceptable homework material, and able and appropriate

peers, and adjusting where needed and to the extent possible.

A second aspect of safeguarding is talent safeguarding. Here, it is imperative for mothers to make certain that each child has unique talents and experiences, perhaps literally something to write about on a college application that distinguishes the child's life outside school. These talents and experiences may be developed through extracurricular activities, work in the community or with religious organizations, or with the family through traveling to new places. Doing so is very intensive, and requires testing out many different proclivities of a child to see which ones become passions or talents. At one extreme, there is the "Tiger Mom," made famous by the author Amy Chua, who forced her children to practice piano for hours each day in order to make them prodigies, likely in the service of college admissions (Zhou and Lee). On the other hand, some mothers may actively resist the competitive nature of safeguarding and some working-class mothers with fewer options for children to choose from, may try to emphasize one sport at which the child excels. Hilary Friedman outlines the increasingly competitive nature of American society, particularly given rising levels of education, increased income inequality, and an ever growing emphasis on credentials. In order to secure children's futures, parents enroll children in competitive sports and activities, thus securing "competitive kid capital" where children learn to perform under pressure (Friedman). As these talents are pursued, mothers work through multiple decisions on a regular basis about when one talent is developed enough, or should be abandoned. This occurs in conjunction with assessing how the intensity of an activity that requires a long drive or several practices each week weighs against the "talent" that the child demonstrates now and potentially can convert to future status.

A third form of safeguarding, which is linked intimately to academic and talent safeguarding, is emotional safeguarding (Warner). Mothers make extensive efforts to protect children's happiness and self-esteem, while also reducing any anxieties a child might experience. Emotional safeguarding work is also tied to the emotional resources mothers have at their disposal and the extent to which mothers are able to successfully navigate institutional interactions (Gillies). Mothers actively seek positive environments and encoun-

ters for their children, such as a warm music teacher or academic work that is challenging, but not too challenging. In some cases, emotional safeguarding may be considered more important than academic or talent safeguarding. If a child experiences racism at school, mothers may work to move a child from an academically prestigious institution to one more likely to secure a positive racial identity. In the end, the goal of emotional safeguarding is to instill a sense of enjoyment in daily life, particularly school, that will translate to long term success and economic mobility (Warner). However, this too is fraught with dilemmas, given that happiness is an extremely elusive goal (Greenfeld).

STATUS SAFEGUARDING'S EFFECT ON CHILDREN

Safeguarding, no doubt, helps individual children stand out and succeed in ways that are emotionally comfortable to them. However, it may exhaust them and have many psychological consequences. Safeguarding may eliminate children's ability to enjoy what they are doing in the moment as they become "in it to win it" during certain sports or activities (Friedman). For example, children may start out enjoying participating in Girl Scouts, but over time may be pressured into continuing the activity as labor in the service of achievement to put onto a college application. Or, as children advance through schools, which can structure curricula narrowly, mothers may become preoccupied with high stakes reading and math grades and test scores, causing children to lose enjoyment in broader interests in literature, art or science. Safeguarding can also translate mothers' anxiety about a child's competitive strengths, especially when a child is just doing "average," into anxiety for the child. Tensions between mothers and children can run high (Lee and Zhou). Among the middle class, as mothers have time and financial resources to vehemently pursue multiple competitive options for children in order to distinguish them from peers, children can be depleted. Among those with fewer resources, mothers' efforts may lead to high pressure on children as the perceived need for success at any one activity may be great.

In addition, status safeguarding over the long term means

middle-class children may feel entitled, not only to intervene in institutions as Lareau (*Unequal Childhoods*) describes, but to be happy and never bored. As mothers advocate for their child's success, happiness and engagement at school, on teams, or with peers, children become accustomed to maternal intervention and positive outcomes as a result. The pursuit of happiness fits with the ideology of individualism and free choice, but carries high risk for depression in young adulthood when seemingly endless choices keep them frozen and thinking there are better, more happiness-inducing opportunities elsewhere (Greenfeld). In other cases, children may come to rely too much on mothers' status safeguarding efforts, finding that they have few resources of their own to cope with challenges, disappointments, and rejections. Finally, safeguarding may enhance privileged children's insensitivity to oppression. As mothers facilitate children's ability to achieve distinction in a competitive society, these children may be unaware that the hard labor and resources of others helped create their success. As a result of believing that they have worked to climb the ladder to success rather than reaping the rewards of a wealthy birthright (Khan) and the labor of their mothers, privileged adolescents feel at ease when they navigate middle-class social contexts. Thus, as mothers make their lives a little bit easier to slide into success with every transition, more privileged adolescents may come of age with a lack of awareness of the deep inequalities in society and the hardships that others face.

STATUS SAFEGUARDING'S EFFECTS ON MOTHERS

While status safeguarding may in some ways benefit children, as it prevents them from falling behind, or helps to make them distinct in a way that will get them to a well-regarded university or fulfilling career, it is problematic for mothers. Specifically, not only are mothers' work lives often sacrificed, but mothers' energy can be depleted to exhaustion over long periods of time as they become an individualized safety net because social supports providing for a secure future are so thin. Some mothers may be unwilling participants in status safeguarding, but do so because there seem to be few other pathways to protecting a child's future. Because of

the relational nature of class hierarchies, the more mothers labor to build children's portfolios, the harder it becomes for any one child to stand out, pushing the cultural bar for what counts as unique achievements even higher (Bordieu *Distinction*). The exhausting labor begins early and continues for years. Fox describes the negative effects on mothers of young children as they spend their limited energies in doing what is perceived as the culturally correct investment in the care of babies. In the elementary years, mothers' great energies are invested as the child's talents become more urgently needing to be revealed (Friedman; Lareau *Unequal Childhoods*). In the high school years, mothers struggle to manage an adolescent's safety (Elliott and Aseltine) and resume, and face the additional labor of strategizing about, applying for and visiting universities (Nelson). Even into adulthood as children prolong their stays in parents' homes (Newman), safeguarding can be emotionally and physically exhausting work.

While some safeguarding is a necessary part of mothering or parenting work, status safeguarding is often excessive, as cultural expectations of mothers set few boundaries on what mothers should sacrifice for children, state supports for childrearing and post-secondary education are minimal, and the uncertainty of children's success in a global competition collude to oppressively demand mothers' extreme efforts. Fear of failure and guilt from a child's problems is another big cost for mothers. Sinikka Elliott, Rachel Powell and Joslyn Brenton suggest that intensive mothering, and the safeguarding work that accompanies the ideology, come at a great cost to low-income mothers' mental and physical health as they may experience the failure of efforts to safeguard a child's future even as they sacrifice their own scarce resources for their children in attempting to create a safety net based in future status. Status safeguarding has no guarantees and is not complete for many years when a child takes on adult roles. Because the weight of societal judgments for a child's current and future success falls extremely heavily upon mothers, particularly when there are behavioral or academic problems (Singh) or addiction and incarceration (Elliott, Powell and Brenton), mothers' feelings of guilt and responsibility for being the one individual who could have made the child's life "right," and her status secure, can be

overwhelming. The fact that safeguarding a child's happiness in an era where people are increasingly intolerant of even minor life difficulties is a near impossible feat is worthy of mention. The common cultural mantra in which mothers' suggest that they "just" want their child to be happy may actually reinforce both intensive mothering and an oppressive focus on happiness. The difficult thing about "just" wanting a child to be happy is that it pushes mothers to be hyper vigilant in the form of safeguarding and yet it is vague and an always elusive goal.

Some mothers resist status safeguarding and protect themselves and their children from a life that is too pressured or competitive. As Karen Christopher notes, employed mothers of varying social statuses increasingly defend the benefits of time away from a child, while continuing to value their role as mothers. Perhaps if consumed with their paid work, they are simply unable to be extreme in their approach (Christopher). Other mothers resist as they find that participating in many aspects of status safeguarding is a near impossible task and urge a greater simplicity in their approach to childrearing (Nelson).

In sum, the endless vigilant labor to safeguard the child's future that is the work of intensive mothering ideology today comes at a high cost to mothers' careers, physical and emotional health, and guilt. The fact that restructuring so that the state, workplaces, and fathers become more responsible for the future livelihoods of all children is largely absent from political and cultural discourse helps maintain views that individual mothers should continue their exhaustive investments.

CONCLUSION

Status safeguarding represents extensive labor on the part of mothers intending to protect their child's present and future. Mothers work extremely hard in attempting to safeguard children academically, in developing special skills in a distinct way to showcase talents, and emotionally, in creating an easier and more comfortable climb to a secured future. It is clear that mothers feel compelled to guard their child's status in a proactive, vigilant way, not only for their child's perceived future, but for their success as mothers.

This aspect of intensive mothering complicates how mothers negotiate ideologies as they push the "self-interest" of children in trying to secure daughters' and sons' positions in a competitive marketplace. Although mothers are not always working toward their own career and income, they are working intensely to secure the future status of their children, who are culturally an important extension of themselves.

As economic conditions become more difficult and secure employment in a changing global landscape more uncertain, status safeguarding may take on a new urgency, with detrimental effects on mothers' time, and emotional and physical exhaustion. This is particularly true in the U.S. where dramatic wealth inequalities and a shrinking middle class heighten mothers' concerns for status and intensify safeguarding practices. As a neoliberal ideology emphasizing a free market, personal choice, and less government regulation deepens, mothers may find themselves increasingly burdened with the responsibility to manage their child's future alone. The lack of government support providing a safety net to citizens oppresses mothers as they individually labor on behalf of their children. Indeed, it should be the responsibility of the state, not just individual mothers, to safeguard all young children as they grow toward stable, secure and successful adulthoods.

The authors thank Kathleen Denny and the editor for thoughtful comments.

WORKS CITED

Beller, Emily and Michael Hout. "Intergenerational Social Mobility: The United States in Comparative Perspective." *The Future of Children* 16 (2006): 19-36. Print.

Berhau, Patricio, Annette Lareau and Julie E. Press. "Where Families and Children's Activities Meet." *At the Heart of Work and Family: Engaging the Ideas of Arlie Hochschild.* Ed. Anita Ilta Garey and Karen V. Hansen. New Brunswick, NJ: Rutgers University Press, 2011. 43-60. Print.

Bianchi, Suzanne M., Liana C. Sayer, Melissa A. Milkie and John P.

Robinson. "Housework: Who Did, Does and Will Do It and How Much Does it Matter?" *Social Forces* 91 (2012): 55-63. Print.

Billingham, Chase M. and Shelley McDonough Kimelberg. "Middle-Class Parents, Urban Schooling, and the Shift from Consumption to Production of Urban Space." *Sociological Forum* 28 (2013): 85-108. Print.

Blair-Loy, Mary. *Competing Devotions: Career and Family Among Women Executives*. Cambridge, MA: Harvard University Press, 2003. Print.

Bourdieu, Pierre. *Distinction: A Social Critique of the Judgment of Taste*. Cambridge: Harvard University Press, [1984] 2002. Print.

Bourdieu, Pierre. *The Logic of Practice*. Stanford: Stanford University Press, 1990. Print.

Brownstein, Ronald. "The American Dream: Under Threat." *National Journal*, 2013. Web.

Budig, Michelle, Joya Misra, and Irene Boeckmann. "The Motherhood Penalty in Cross-National Perspective: The *Importance* of Work-Family Policies and Cultural Attitudes." *Social Politics: International Studies in Gender, State and Society* 19 (2012): 163-93. Print.

Cabrera, Natasha J., Catherine S. Tamis-LeMonda, Robert H. Bradley, Sandra Hofferth, and Michael E. Lamb. "Fatherhood in the Twenty-First Century." *Child Development* 71 (2000): 127-36. Print.

Caputo, Virginia. "She's from a 'Good Family:' Performing Childhood and Motherhood in a Canadian Private School Setting." *Childhood* 14 (2007): 173-92. Print.

Chin, Tiffani and Meredith Phillips. "Social Reproduction and Child-reading Practices: Social Class, Children's Agency and the Summer Activity Gap." *Sociology of Education* 77 (2004) 185-210. Print.

Christin, Angele. "Gender and Highbrow Cultural Participation in the United States." *Poetics* 40 (2012) 423-43. Print.

Christopher, Karen. "Extensive Mothering: Employed Mothers' Constructions of the Good Mother." *Gender & Society* 26 (2012): 73-96. Print.

Collins, Randall. "Women and the Production of Status Cultures." *Cultivating Differences: Symbolic Boundaries and the Making*

of Inequality. Edited by Michele Lamont and Marcel Forunier. University of Chicago Press, Chicago, 1993. 213-31. Print.

Craig, Lyn and Killian Mullan. "How Mothers and Fathers Share Childcare: A Cross-National Time-Use Comparison." *American Sociological Review* 76 (2011): 834-61. Print.

Cucchiara, Maia Bloomfield and Erin McNamera Horvat. "Perils and Promises: Middle-Class Parental Involvement in Urban Schools." *American Educational Research Journal* 46 (2009): 974-1004. Print.

Dwyer, Rachel, Laura McCloud, and Randy Hodson. "Debt and Graduation from American Universities." *Social Forces* 90 (2012): 1133-55. Print.

Elliott, Sinikka and Elyshia Aseltine. "Raising Teenagers in Hostile Environments: How Race, Class, and Gender Matter for Mothers' Protective Carework." *Journal of Family Issues* 34 (2013): 719-44. Print.

Elliott, Sinikka, Rachel Powell and Joslyn Brenton. "Being a Good Mom: Low-Income, Black Single Mothers Negotiate Intensive Mothering." *Journal of Family Issues* (forthcoming). Web.

Fox, Bonnie. *When Couples Become Parents: The Creation of Gender in the Transition to Parenthood*. Toronto: University of Toronto Press, 2009. Print.

Friedman, Hilary Levey. *Playing to Win: Raising Children in a Competitive Culture*. Berkeley: University of California Press, 2013. Print.

Gillies, Val. "Working Class Mothers and School Life: Exploring the Role of Emotional Capital." *Gender and Education* 18 (2006): 281-93. Print.

Greenfeld, Liah. *Mind, Modernity and Madness*. Cambridge, MA: Harvard University Press, 2013. Print.

Griffith, Alison I. and Dorothy E. Smith. *Mothering for Schooling*. New York: RoutledgeFalmer, 2005. Print.

Hays, Sharon. *The Cultural Contradictions of Motherhood*. New Haven, CT: Yale University Press, 1996. Print.

Hollister, Matissa. "Employment Stability in the U.S. Labor Market: Rhetoric versus Reality." *Annual Review of Sociology* 37 (2011): 305-24. Print.

Kalleberg, Arnie. *Good Jobs, Bad Jobs: The Rise of Polarized*

and Precarious Employment Systems in the United States, 1970s-2000s, 2011. Print.

Kalleberg, Arnie. "Precarious Work, Insecure Workers: Employment Relations in Transition." *American Sociological Review* 74 (2009): 1-22. Print.

Khan, Shamus. *Privilege: The Making of an Adolescent Elite at St. Paul's School*. Princeton: Princeton University Press, 2011. Print.

Lacy, Karyn. *Blue Chip Black: Race, Class, and Status in the New Black Middle Class*. Berkeley: University of California Press, 2007. Print.

Lacy, Karyn and Angel Harris. "Breaking the Class Monolith: Understanding Class Differences in Black Adolescents' Attachment to Racial Identity." *Social Class: How Does it Work?* Ed. Annette Lareau and Dalton Conley. New York: The Russell Sage Foundation, 2008. 152-78. Print.

Lareau, Annette. "Schools, Housing, and the Reproduction of Inequality: Experiences of White and African-American Suburban Parents." *Choosing Homes, Choosing Schools*. Ed. Kimberly Goyette and Annette Lareau. New York: The Russell Sage Foundation, 2014. 169-206. Print.

Lareau, Annette. *Unequal Childhoods: Class, Race, and Family Life*. Berkeley: University of California Press, 2003. Print.

Lareau, Annette and Vanessa Lopes Munoz. "'You're Not Going to Call the Shots': Structural Conflicts between the Principal and PTO at a Suburban Public Elementary School." *Sociology of Education* 85 (2012): 201-18. Print.

Lee, Jennifer and Min Zhou. "The Success Frame and Achievement Paradox: The Costs and Consequences for Asian Americans." *Race and Social Problems* 6 (2014): 38-55. Print.

McCormack, Karen. "Stratified Reproduction and Poor Women's Resistance." *Gender & Society* 19 (2005): 660-79. Print.

Milkie, Melissa A., Catharine H. Warner and Rashawn Ray. "Current Theorizing and New Directions in the Social Psychology of Social Class Inequalities." *Handbook of the Social Psychology of Inequality*. Ed. Jane McLeod, Edward Lawler and Michael Schwalbe. New York: Springer, forthcoming. Print.

Nelson, Margaret K. *Parenting Out of Control: Anxious Parents*

in Uncertain Times. New York: New York University Press, 2010. Print.

Newman, Katherine S. *The Accordion Family: Boomerang Kids, Anxious Parents, and the Private Toll of Global Competition*. Boston: Beacon Press, 2012. Print.

Pattillo, Mary. *Black Picket Fences: Privilege and Peril Among the Black Middle Class*. Chicago: University of Chicago Press, 1999. Print.

Pattillo, Mary, Lori Delale-O'Connor and Felicia Butts. "High Stakes Choosing: How Parents Navigate Chicago Public Schools." *Choosing Homes, Choosing Schools*. Eds. Annette Lareau and Kimberly Goyette. New York: The Russell Sage Foundation, 2014. Print.

Pew Research. "Motherhood Today: Tougher Challenges, Less Success." May 2, 2007. Web.

Ramey, Garey and Valerie Ramey. "The Rug Rat Race." *Brookings Papers on Economic Activity Spring* (2010): 129-176. Print.

Singh, Ilina. "Doing Their Jobs: Mothering with Ritalin in a Culture of Mother-Blame." *Social Science and Medicine* 59 (2004): 1193-1205. Print.

Smith, Sandra Susan. "Race and Trust." *Annual Review of Sociology* 36 (2010): 453-75. Print.

Stevens, Mitchell L. *Creating a Class: College Admissions and the Education of Elites*. Cambridge: Harvard University Press, 2009. Print.

Sullivan, Teresa A., Elizabeth Warren and Jay Lawrence Westbrook. *The Fragile Middle Class: Americans in Debt*. New Haven: Yale University Press, 2000. Print.

Walkerdine, Valerie and Helen Lucey. *Democracy in the Kitchen: Regulating Mothers and Socialising Daughters*. London: Virago Press, 1989. Print.

Warner, Catharine H. "Emotional Safeguarding: The Nature of Parents' Involvement in Children's Schooling." *Sociological Forum* 25 (2010): 703-24. Print.

Zhou, Min and Jennifer Lee. "Assessing What is Cultural about Asian Americans' Academic Advantage." *Proceedings of the National Academy of Sciences, Early Edition* 111 (2014): 8321-8322. Web.

The Cultural Contradictions of Motherhood Revisited

Continuities and Changes

KIM HUISMAN AND ELIZABETH JOY[1]

IT IS CLEAR that there are more voices challenging intensive mothering today than there were twenty years ago, these voices reflect a wider variety of standpoints, and more room is being made for them both in the literature and in the general public. However, what is less clear is the extent to which these counter-narratives are successfully challenging intensive mothering on a larger scale or on the ground in our community.

We—a college professor and a recent college graduate—are also mothers of young children. We both have had the recent experience of living through several intensive and exhausting years of balancing the demands of work/school with the needs of young children, years that we both characterize as being in "survival mode," a mode that required to do what we needed to do to get through the day. This mode might be partially explained as the active experience of participating in a culture that is characterized by cultural contradictions of motherhood. Although we are educated women and sociological thinkers, this mode left little time for self-reflection about who we were as mothers, what intensive mothering means today, and whether or not we were engaging in it. Last year, we both decided to take a step back to examine ourselves and our community in relation to these topics. Kim, the professor, decided to teach a course entitled "The Social Construction of Motherhood," and Elizabeth, the recent college graduate, decided to do her senior thesis on the topic.

In preparing for the class, Kim revisited Sharon Hays' book, *The Cultural Contradictions of Motherhood*, and decided to develop a

class project that required students to partially replicate Hays' study on intensive mothering. Her first foray into the literature left her feeling hopeful that there had been a cultural shift in constructions of motherhood. Numerous academic titles challenged intensive mothering and a cursory glance at top-selling popular books and blogs on mothering even suggested that the mask of motherhood had been pulled back to reveal the ambiguities and challenges of mothering. Best-selling titles such as *Good-Enough Mother: The Perfectly Imperfect Book of Parenting* (Syler and Moline); *Confessions of a Scary Mommy: An Honest and Irreverent Look at Motherhood—The Good, The Bad, and the Scary* (Smokler); and *Motherhood Comes Naturally (and other Vicious Lies)* (Smokler) appeared to challenge traditional and patriarchal conceptions of motherhood while calling for shared parenting, work/life balance, and maternal autonomy.

Further research revealed that indeed, over the past two decades there has been a proliferation of books, magazines, websites, and blogs on motherhood (Brown 123). The books run the gamut from glorifying and essentializing motherhood to challenging the ideology of intensive mothering to advocating for both empowered and feminist mothering and promoting the choice not to mother at all.

Using a modified and updated version of Sharon Hays' interview guide, this study partially replicates Hays' research and examines the extent to which intensive mothering today compares and contrasts with intensive mothering two decades ago. In this chapter we examine several interrelated questions: To what extent are mothers accommodating and resisting the ideology of intensive mothering? How have intensive mothering practices changed over time? Is intensive mothering becoming more intense, less intense, or some combination? To what extent is the ideology of intensive mothering being promoted and/or challenged in the top-selling parenting books, blogs, magazines, and "mommy memoirs"? To what extent are people reading them?

DATA AND METHODS

Data came from 21 face-to-face structured interviews with women between the ages of 21 and 45, with an average age of 30. Interview-

ers used a modified and updated version of Sharon Hays' interview guide. The interviews were conducted by thirteen undergraduate students enrolled in an upper-level undergraduate sociology course on motherhood.[2] With the exception of two students, each student conducted one interview. Elizabeth Joy, co-author of this chapter, conducted seven interviews as part of her undergraduate thesis, and another student conducted two interviews. Six of the students enrolled in the class opted not to include their interviews in this chapter (participation was optional for both students and interviewees). A purposive sample was used in which the students invited subjects to participate. Students interviewed acquaintances, friends, relatives, former teachers, co-workers, and neighbors.

Interviews were conducted in participants' homes (52 percent), interviewers' homes (29 percent), and public places (19 percent), were tape recorded, and lasted an average of 42 minutes. Interviewers recorded field notes immediately following the interview, in which they noted their observations and interactions that took place before and after the interview. In order to more closely replicate Hays' study, additional data come from content analysis of four parenting books, which include two of the newest versions of books that Hays had analyzed, and two of the top-selling books today. To update the study, two popular mommy blogs were also included for analysis.

SAMPLE AND SETTING

All of the interviews were completed in Maine, with the majority taking place in central Maine. The rural and somewhat isolated nature of this location provides a unique perspective on the topic under question, and limits the generalizability of the findings. Central Maine is a sparsely populated corner of the United States that tends to lag behind the rest of the county in popular culture and other trends. Incomes lag behind national averages, and many communities are negatively impacted by high rates of poverty and drug addiction. The state is widely known as the "whitest state in the union," one of the least religious, and is characterized by a wide variety of alternative viewpoints and trends. For example, pockets are often found within the state with strong propensities

towards certain movements. In the authors' community, for example, these movements include home birth, homeschooling, and a newer trend called radical unschooling. Though our location did not offer much opportunity for us to explore race or class diversity, there certainly was opportunity for diversity of opinions among our participants.

Students employed the convenience sampling method to recruit participants in that they relied on subjects that they had access to such as friends and acquaintances, family members, and colleagues. Though a major drawback to this methodology is that it can result in a lack of representativeness, the resultant sample did reflect many of the characteristics of the larger population of the area. All of the participants (though not all of their children), were white; a reflection of both the interviewers choosing them and the larger social context in this area. Again in dual reflection, most of the participants were middle to lower class. All of the participants lived in rural towns or small cities. Just over half of the participants were married (n = 11). The other half represented a variety of relationship statuses; four told us only that they were single, three were partnered with their children's fathers but not married at that point, two had partners that were not a father to their children, and one was divorced.

The motherhood requirement for the sample was only that they had at least one child under the age of seven. The average age of all of the participant's children was seven. The youngest child of a participant was eleven weeks, and the oldest was 27. Our mother participants had an average of two children, and all had between one and four kids that they parented. At least two were expecting in the very near future. All participants had biological children. One also had an adopted child, and three were also stepmothers.

There are two primary limitations to the methods used in this study. First, due to the time constraint of completing the interviews in one semester, we had to rely on personal contacts for obtaining interviewees. As such, the social characteristics of the sample largely reflect those of the interviewers, and no efforts were made to diversify the sample in terms of age, social class, sexual orientation, geographic location, nor racial or ethnic variables.

Second, during the data analysis stage of this research, the authors realized that they should have modified Sharon Hays' interview questions further to include questions that would allow mothers to reflect more openly about the larger culture. For example, if we had asked interviewees pointedly what they thought about societal expectations at the end of the interview, we would have invited their criticism directly rather than trying to glean it from comments on other topics. Many of the mothers shared strong criticisms of our society once the recorder was off and/or the interviewer shared the topic of our study with them. Although we did not ask any follow up questions to explore why some participants were more frank when the recorder was off, we suspect that they may have felt more comfortable voicing their criticisms "off-record." Perhaps this was due to the fact that mothering is something that they are actively participating in, and since they may have been invested in coming across as a "good mother," they may be less critical for fear of negatively impacting their social status as mothers. For example, Whitney, a stay-at-home mother of two, added at the end of the interview: "I would add that our society is guilt-ridden for mothers. It doesn't seem to matter what we do ... if we're not working, then we're not contributing ... we're not as important to society. If we are working, we're somehow letting our family down ... everything.... It's so many mixed signals that mothers get in our society!"

This leads us to believe that the questions asked by Hays, and in turn by us, may have inadvertently encouraged mothers to appear more compliant to intensive mothering than they actually are, an issue we will address later.

FINDINGS

Contemporary Advice

In her content analysis of the four top selling parenting books in the 1990s, Sharon Hays analyzed Dr. Spock's *Baby and Child Care,* Penelope Leach's *Your Baby and Child,* and two books by T. Berry Brazelton, *Toddlers and Parents* and *Infants and Mothers.* Hays found that all four books, though distinctive in format and tone, are very similar in messages. They present an image of the

children as sacred, born good and able to communicate their desires. According to the three authors, it is a *mother's* job to interpret and fulfill these desires. Although mothers come by their maternal instincts and feelings naturally, they need to be told exactly how to mother by experts. The methods required to fulfill their instructions are child-centered, intensive, expensive, and relatively permissive. Finally, the sacrifices required will feel rewarding to the mother, and will benefit the good of the larger society, thus circumventing the market-driven aspect of our society.

Today, none of these four books made it in the top ten of best-selling parenting books, and only one made to the top 20 ("Parenting"). None of our participants mentioned any of them as books that they own or refer to. However, sixteen (76 percent) of our participants owned or referred to the top selling book *What to Expect When You're Expecting* by Heidi Murkoff and Sharon Mazel. This book and its many variations (e.g., *What to Expect the First Year)* are well known. It is in its fourth printing, it's title has been used as the title of a feature film released in 2012, and it is consistently listed on the *New York Times* bestseller list in the paperback advice category, where it currently stands at number eleven (November 2013). Furthermore, the book is ranked 19th on the list of *USA Today*'s 25 most influential books of the past 25 years with the subscript stating "boomer parents ditched Dr. Spock in favor of this accessible baby guide." According to Amazon.com, there are more than 14.5 million copies of the book in print and it "is read by more than 90 percent of pregnant women who read a pregnancy book." As Carolyn, a stay-at-home mother of three, who occasionally works, states: "You know, of course everyone has those 'What To Expect When You're Expecting [books].'"

A few mothers claimed they did not have or read any parenting books. These were the exception, however. Several of our interviewees spoke of parenting books intended for specific populations, varying from religiously-based books such as James Dobson's *Bringing Up Boys,* to more popular culture books such as *Skinny Bitch Bun in the Oven* (Freedman and Barnouin). As a sign of the times, many mothers interviewed also discussed internet-based information-seeking. One third of respondents

regularly sought answers about parenting on Google (n = 7), 43 percent relied on WebMD (n =9), and more than half (57 percent) reported participating in Facebook discussions related to mothering. Almost half (48 percent) read mommy blogs and one participant reported that she regularly views video blogs (VLOGS) related to parenting.

Though these newer sources of information and differing popular titles offer the opportunity for change in social messages regarding motherhood, this opportunity appears to be largely missed by our participants. New and alternative voices are fighting against the growing popularity of more mainstream baby books that are simultaneously growing *more* gendered. The most popular title, *What to Expect*, is the least progressive of the four titles analyzed. For starters, very little of the text or images in the books analyzed contained material related to fathers. Only 2.5 percent of the images in the *What to Expect* books we analyzed had male figures present. Interestingly, three of the books did have a presence of ambiguously-gendered images (14.9 percent of total images). This could be analyzed as an attempt to present a less gendered picture of parenting; however, even these far outnumbered the images of males, found in just 5.7 percent of total images. The books also had some text dedicated to fathers (a nine page chapter in *What to Expect the First Year*), but the material solely for mothers was consistently much longer and more in-depth (a 50-page chapter in *What to Expect the First Year*). As with Hays' findings almost twenty years ago, the message to fathers is that their parenting role is secondary to mothers.

Simultaneously, other aspects of intensive mothering are presented as even more intense. Time and time again, they mention the time-consuming nature of raising children. The brand of parenting they present leads to physical and mental exhaustion that they refer to multiple times. The text clearly indicates that they expect childrearing to be child-centered and financially expensive. Three of the books contain lists of things to buy for the baby, the most extensive weighing in at 24 pages. Additionally, the books incorporate new, more intensive aspects of mothering, such as the third shift of body work, one of the most recent developments of intensive mothering. As Lynn O'Brien Hallstein and others have

demonstrated: "bouncing back after pregnancy is central to pregnancy advice" today (117). *What to Expect* dedicates extensive material to a mother's expected dietary and exercise habits (58 pages in the pregnancy book), including instructions on accommodation of your changing body during exercise and how to stay looking good as your body changes forms. The books present a view of parenthood that is more gendered, further multi-faceted, and more intensive.

Intensive Mothering
Sharon Hays (8) defined intensive mothering as an ideology that requires mothers to take primary responsibility for their children, and as a form of childrearing that is child-centered, expert-guided, emotionally absorbing, labor-intensive and financially expensive. Mirroring what we found in the academic and some of the mainstream literature, our findings indicate that there are both continuities and changes within our participants' experiences related to each area of Hays' definition of intensive mothering. Mothers still view themselves as the primary caregivers for their children, and some hang onto this notion whole-heartedly. At the same time, fathers are also more involved in raising their children, a fact many mothers expect and/or desire *and* daycare is playing a larger role in participants' lives. Child-rearing is still child-centered, but mothers also negotiate this to be child-empowering. Additionally, our interviewees occasionally allowed aspects of empowered and feminist mothering to peak through in our interviews when they discussed putting their own needs in parallel to or above that of their children, expecting more from their partners, ignoring experts, and rejecting financially-expensive child-rearing methods. Experts continue to weigh in heavily, as science progresses and information is disseminated more easily. However, these same truths allow more room for alternative voices to be heard. Child-rearing remains labor intensive and financially expensive, but our sample and their context allow for flexibility in these areas as well.

In 2013, with the high percentage of women in the workplace, and 76 percent of our interviewees working, in school, or some combination thereof, we were surprised to learn that 76 percent

of the interviewees described the ideal childcare arrangement as the mother staying at home. However, maternal ambiguity was evident even when discussing who should be caring for children. Carolyn, who is currently staying-at-home but has worked in the past, stated: "I'm kind of stuck in between, honestly, I love being home but I get bored." The overarching theme, however, was that in an ideal world "[mothers] would stay home forever," as stated by Mary, a married mother of an infant.

As such, many of the participants shared many concerns about daycare. A primary concern was that the children would not get enough attention. Another expressed that it would be too much time away from the parents. Mothers were concerned about other people raising their children. Worries about "germs" also came up frequently when participants were asked about concerns that they had about daycare. As could be expected, participants often listed many combinations of these and other worries. Jennie, a stay-at-home mother of one, with another on the way, stated:

> *It is about a 35-minute drive to get to the town that has the best preschools that we are interested in ... it was more of a logistical thing, and also that he was not even two. So it was just too early and too far ... so many other different children, from so many different families ... there is so much exposure, at such a young age, to so many different things, and I'm not able to filter any of that—because ... you leave them there, you know. That includes language, and, you know, customs that children learn at home, behavior—but also germs.*

Taken in context, Jennie and other participant's concerns about the quality of daycare are not completely unfounded. In 2013, there were 2008 licensed childcare facilities in the state of Maine. Out of these, only 161 (eight percent) of these received a "step 4," the highest quality rating in the state (Berkowitz, McCannand McCann).

Surprisingly, very few of our participants discussed cost as a barrier or negative aspect of daycare. In Maine, 116,000 children lived in low-income homes in 2013, but assistance for daycare

through vouchers or subsidies was received for less than 13,000 of them. Additionally, it was estimated that only 28 percent of age and income eligible children were participating in free Head Start programs, though these programs were at capacity (Berkowitz, McCann and McCann). Given this information and the social location of our participants, it is perplexing why the cost of childcare is not mentioned more frequently in this context.

Instead, other mothers, and sometimes even the same mothers, pointed out some of the more positive aspects of daycare. Even mothers who indicated that having the mother as a primary caregiver was ideal often discussed the benefits of daycare for socialization, learning, and school readiness, perhaps in light of recent literature and media coverage touting the benefits of daycare and preschool. Occasionally, they even suggested that daycare and other caregivers were beneficial to offer them "a nice little break," a deviation from Hays' findings.

The ambiguity continues in our participant's view of the role of fathers. A few mothers openly engage in maternal gatekeeping to minimize their children's father's role. Single, working mother, Carrie, said: "I take primary responsibility for her. But that's the thing I've chosen, so I prefer it to be that way." At least two interviewees have children who have intentionally not met their fathers. Alternatively, several women indicate that they believe caretaking should be "split between a mother and father." Single dads and stay-at-home dads are mentioned several times. Among our sample, there were several single mothers whose children's fathers see them regularly. A few of the partnered women stated that their partners were as involved in their children's lives as they are. Yet, many also indicated that they wish their partners were more involved. While many participants feel that they want to be primary caregivers, they also want more involved partners.

The notion that both mothers and fathers should be providing more intensive care for their children is indicative of the increasingly child-centered nature of childrearing today. Felicia, a 21-year-old student, exemplified this transition in telling us what she learned from her own mother: "I don't think she had the mindset that it had to be all about her kids. She was a little bit self-centered. So I think what I learned the most from her

was that spending time with your children, undivided attention... that's most important." Mothering, both in our sample and in larger context, is often defined as centering yourself around your children. To do otherwise is literally perceived as self-centered. However, some of the child-centered opinions in our sample could also be interpreted as child-empowering. Defined as giving children "personal power and responsibility," Colleen Mack-Canty and Sue Marie Wright list child empowerment as a feminist family value (155). When Anna, a 27-year-old mother of four, tells us: "There is nothing more rewarding than seeing my kids develop into the people they are" and that one of her primary activities is "finding a groove with [my] kids ... respecting them as people," it is hard to clearly draw the line between the child-centered and child-empowering.

Another area in which a clash can be seen is between our participant's opinion and handling of experts. Both who they view as experts and how they view these experts, is wrought with contradiction and complexity. As discussed previously, changes in the dissemination of information means that our participants literally have access to "experts" 24 hours a day and many of them utilize this ability. Within our sample, there was a notion that in order to be a true expert, one must have educational training *and* be a mother. Anna, for example, views her children's pediatrician as an expert because "she has five kids herself." Conversely, many mothers interviewed actively rejected the public experts. Jennie told us that these "experts" are "mostly just filling people's head with garbage." Technological changes also offer mothers the opportunity to access many private sphere voices instantaneously, both through the Internet and through their own social networks. Regarding other mothers, our interviewees often claimed to revere both their peers and prior generations as experts. However, they also referred to their advice as "crazy" and qualified that they didn't "look to them for advice specifically, just to talk."

Finally, worth noting, was the lack of the presence of references to the financially-expensive side of intensive mothering. There was not evidence within our interviews that the participants were spending extreme amounts of money on their children. Instead, conversations around money were centered on how quality time

with their children was more important than the financial piece. There was the implication that with enough resources, many mothers would stay home with their children and "travel" or "do private classes." However, there were also instances where mothers directly stated that they had chosen to forego expensive things for their children in order to purchase something more beneficial to themselves. There is a high likelihood that this is related to the current economy in the United States, the local economy, and the social class of our participants. In this area, as well as the previously discussed topics, the dichotomy and struggle seen in the way that our participants view and engage in intensive mothering, makes sense when considering the larger social context that they are operating within.

DISCUSSION

While the participants both accommodated and resisted the ideology of intensive mothering, our findings indicate that the majority of our participants had, to some degree, internalized the ideology of intensive mothering, and subscribed to the ideology that to be a "good mother" requires mothers to be the person primarily responsible for her children and that good mothering should be child-centered, expert-guided, emotionally absorbing, and labor-intensive. As with Hays' respondents, most of our participants rejected that the "experts" had all of the answers, but they still tended to refer to the messages from experts and judge themselves based on them. The only dimension of intensive mothering that our participants largely rejected was the belief that raising children should be financially expensive, which we argue is a reflection of the social class of our sample and also possibly due to the rurality of the state.

These findings are not very surprising since our participants' primary source of information came from the best-selling parenting book, *What to Expect When You're Expecting*, a source that largely upholds the ideology of intensive mothering. Therefore, despite the expanding discourse about motherhood outside of academic literature (e.g., mommy blogs, mommy memoirs, and some parenting books) since the publication of Sharon Hays' book

in 1996, with the exception of blogs, most of our participants were not accessing these sources, possibly because these alternative conceptions of motherhood are overshadowed by the ideology of intensive mothering and the attendant essentialist notions of gender that remain normative in the larger culture. It's also important to note that the ideology of intensive mothering is occurring within a within a larger sociocultural context of neoliberalism. Since the advent of neoliberalism in the 1980s, there has been an erosion of the social safety net for families and an attendant shift toward increased privatization and individual responsibility. Thus, neoliberalism places increased economic pressures on families and obscures structural inequalities. What often is framed as a choice, is often not a choice at all.

However, we are very hesitant to conclude that our participants fully subscribe to the ideology of intensive mothering. This is because in asking our participants about mothering, we, like Hays, relied on what people said and obtained very little information about what they actually did. As such, our participants talked about their *ideas* rather than their *practices* of mothering. Thus, our concern is that participants provided us with the answers that they assumed were the culturally correct ones, thus reflecting the cultural ideals about motherhood rather than their actual practices of mothering. This was evident when our participants talked about work. Although the majority of our participants did work, a majority also said that being a stay-at-home mother was the ideal, even among those who reported that they enjoyed working outside the home. Mary, a 25-year old college student reasoned that this was because "mother knows best." This disconnect between our participants' ideas versus their practices may be a reflection of the bind that the ideology of intensive mothering places them in. Our participants had to work out of necessity, and thus, their range of choices were limited. However, because neoliberalism reduces everything to individual choices, participants may have been reluctant to question whether or not their decision to work outside the home was, in fact, a choice at all. In sum, we conclude that our findings may reflect more about the ideals of motherhood rather than the reality, as we will now discuss.

Impression Management and the Persistent Mask of Motherhood

In *The Mommy Myth,* Susan Douglas and Meredith Michaels state that "to be a remotely decent mother, a woman has to devote her entire physical, emotional, and intellectual being, 24/7, to her children" (4). This myth is perpetuated by the messages contained in the top selling parenting books, as discussed earlier. Thus despite increased ambiguity and changes to conceptions of mothering in the U.S., it is still very important among mothers to be perceived as a "good mother." Jessica Collett writes, "a woman may become a mother by giving birth, but she truly takes on a mother identity by playing a socially defined, publicly visible role" (328). Mothers are among the most judged in our society, which puts a lot of pressure on them to perform motherhood in accordance with socially prescribed standards of a "good mother." Thus, the very ideology of intensive mothering may have led participants to perform motherhood in a particular way, one that is consistent with their perception of what it means to be a good mother.

Today, mothers are still "seen as ultimately responsible for the way their children turn out" (Collett 328). The majority of our participants felt that mothers are blamed when their kids turn out bad, and although most participants recognized that this was wrong, many also admitted to doing it themselves. As Mary stated: "I do think that moms get blamed a lot. And I've even probably blamed moms before and sometimes *it is* moms' responsibilities for things that happen, the way kids turn out…. But also, sometimes it's outside influences outside of the home."

We are left wondering about the extent to which participants were engaging in impression management during the interviews, managing their appearance by performing a socially defined role of motherhood. Erving Goffman describes impression management as "accentuating certain facts and concealing others" (65). Because we relied on what people said versus what they actually do, it is very possible that mothers may have presented a version of themselves that they deemed as most socially acceptable. Because the majority of our participants had read *What To Expect When You're Expecting,* they had been exposed to certain ideas of what constitutes a good mother. Furthermore, as Collett points out,

motherhood has a "unique nature as both a personal and social identity" (328). Drawing on David Snow and Leon Anderson she writes, "When an individual views an identity as central, he or she is likely to engage in behavior that reinforces that identity to self and others" (330). All of the participants in this study viewed motherhood as a central identity and most of the participants reported the importance of selflessness and sacrifice in childrearing.

In the end, we are left with unanswered questions about the extent to which participants were engaging in self-presentation tactics. Though we do not know the extent to which this occurred, we feel this is an important question to raise for future research.

Neoliberal Focus on Choice that Celebrates the Individual

The pressure to conform to socially acceptable conceptions of motherhood is exacerbated by the rhetoric of individual choice that permeates every aspect of U.S. culture. Raising children is largely defined as a private arrangement that parents choose and thus are fully responsible for managing. This rhetoric of choice obscures larger social forces while instilling the idea that individuals have autonomy and freedom. Just about everything gets reduced to individual choices. This rhetoric is embedded in motherhood myths and ideologies, and there is very little analysis about how choices are constrained by larger external factors such as social class, neoliberal economic pressures that emphasize the individual responsibility and privatization, and the persistent wage gap between men and women. Deirdre Johnston and Debra Swanson (23) write that our culture "attributes responsibility for the condition of motherhood to the individual, not to the system." Participants in our study often echoed these prevailing ideas about choice and individualism. Mia, a mother of four, explains: "It really wasn't worth it to work outside the home ... we chose and decided to make that financial sacrifice in order to raise the children." Many reported choosing to be the primary caregiver for their children. As Carrie, a single, working mother of one stated: "I take primary responsibility for her. But that's the thing I've chosen, so I prefer it to be that way." When things get reduced to individual choices, it can make it difficult to think critically about the larger culture.

However, it is a double-edged sword. When asked if it is fair for

mothers to be held responsible for how their children turn out, Theresa, a 26-year-old mother responded: "You cannot control another person. As much as you may want to, or as much as you try." In addition, Calypso stated, "A child is their own person and they are responsible for their own actions and they do make their own choices." This sentiment was echoed by Jenna, who said: "They are little individuals, they are their own people, and you can't be held a hundred percent accountable for all of their choices." In these cases, a child's individual actions and choices are actually used to *relieve* a mother of the weight of her responsibility.

Additionally, criticism of the society was often reframed by mothers and identified as their not having a choice. Mia said, "if there is a choice, I would rather raise my child than have somebody else raise my child. But, there isn't always that choice obviously." Lori said: "Well, if a woman has to get out and work she really doesn't have a choice, so she has to make everything work." Pepper, when discussing whether to combine childrearing and career or focus only on one stated: "Not everyone has that choice."

SO WHAT? ARGUMENTS/CONCLUSION

Upon reflection of our interviewees' experiences as well as our own, we conclude that intensive mothering persists in our culture and in our participants' lives. Yet, our participants also expressed agency by expressing ambiguity, offering their critiques about various aspects of intensive mothering, and claiming to actively reject popular discourse and expertise about motherhood. A major shortcoming in our research design, and we argue, in Hays' before us, is that we asked participants about their ideas rather than their practices and we did not explicitly ask them what they thought about the ideology of intensive mothering. As a result, we may have inadvertently silenced their resistance to the ideology of intensive mothering. Given the pressures to conform to the ideal of a "good mother," questions remain about the extent to which our participants presented a culturally acceptable face of motherhood.

Although there are more voices in the mix today, the loudest voices tend to favor intensive mothering (e.g., *What to Expect When You're Expecting*) and as a result, may be drowning out

alternative conceptions of motherhood. Although "mommy blogs" provide mothers with opportunities to challenge intensive mothering from the private sphere to the public sphere, and create more opportunities for parallel dialogue among mothers, this is taking place within a larger climate in which there are a growing number of "experts" and an increasing number of ways that these "experts" can impinge upon mothers' lives. The mothers we spoke to often accommodated aspects of intensive mothering that have actually *increased* over time, such as the idealization of the stay at home mother and child-centered practices, while simultaneously resisting and negotiating through other aspects by empowering their children, literally discarding the experts in some cases, occasionally expecting more from fathers/ partners, and rarely, yet unapologetically, putting their own needs above their children's.

[1] The co-authors names are listed alphabetically.
[2] The authors wish to acknowledge and thank the students who conducted and transcribed the interviews for this study: Laura Amey, Kara-Beth Farrell, William Otto, Joshua Morse, Daniel Tarsetti, Brittney Chase, Emily Atwood, Lanette Bryant, Abigail Szotkowski, Brooke Oliver, Ashlyn Boyle, and Tyler Evans.

WORKS CITED

"25 Books That Leave a Legacy." *USA Today* 4/9/2007. Web.

"Advice, How-To and Miscellaneous." *New York Times Book Review*. 10 November 2013: 57. Print.

Abbey, S. and A. O'Reilly. *Redefining Motherhood: Changing Identities and Patterns*. Toronto: Second Story Press, 1998. Print.

Berkowitz, C., McCann, B., and McCann N., comps. *Maine Kids Count 2013*. Augusta ME: Maine Children's Alliance, 2013. Print.

Collett, J. L. "What Kind of Mother Am I? Impression Management and the Social Construction of Motherhood." *Symbolic Interaction* 28.3 (2005): 327-347. Print.

Dobson, J. *Bringing Up Boys*. Carol Stream, IL: Tyndale Momentum, 2001. Print.

Douglas, S. J. and M. Michaels. *The Mommy Myth: The Ideal-*

ization of Motherhood and How It Has Undermined Women. New York: Free Press, 2004. Print.

Freedman, R. and K. Barnouin. *Skinny Bitch Bun in the Oven: A Gutsy Guide to Becoming One Hot and Healthy Mother*. Philadelphia: Running, 2008. Print.

Goffman, E. *The Presentation of Self in Everyday Life*. New York: Doubleday and Company, 1959. Print.

Hallstein, D. L. O'Brien. "She Gives Birth, She's Wearing a Bikini: Mobilizing the Postpregnant Celebrity Mom Body to Manage the Post-Second Wave Crisis in Femininity." *Women's Studies in Communication* 34 (2011): 111-138. Print.

Hays, S. *The Cultural Contradictions of Motherhood*. New Haven: Yale University Press, 1996.

Hathaway, S., A. Eisenberg, and H. Murkoff. *What to Expect the First Year*. New York: Workman Publishing, 2010. Print.

Johnston, D. and D. Swanson. "Invisible Mothers: A Content Analysis of Motherhood Ideologies and Myths in Magazines." *Sex Roles* 49.1 (2003): 21-33. Print.

"[ljbestsellers]: Parenting." *Library Journal* 188.8 (5/1/2011): 208. Print.

Mack-Canty, C. and S. Wright. "Feminist Family Values." *Feminist Mothering*. Ed. Andrea O'Reilly. Albany: SUNY, 2008. 143-159. Print.

Murkoff, H. and S. Mazel. *What to Expect When You're Expecting*. New York: Workman Publishing, 2008. Print.

Smokler, J. *Confessions of a Scary Mommy: An Honest and Irreverent Look at Motherhood - The Good, The Bad, and the Scary*. New York: Gallery Books, 2012. Print.

Smokler, J. *Motherhood Comes Naturally (and Other Vicious Lies)*. New York: Gallery Books, 2013. Print.

Syler, R. and K. Moline. *Good-Enough Mother: The Perfectly Imperfect Book of Parenting*. New York: Simon Spotlight Entertainment, 2007. Print.

The Ideal Mother Fantasy and Its Protective Function

HELENA VISSING

THE INTENSIVE MOTHERING IDEOLOGY appears continually present in the public debate. The judgments of the rightness of different mothering styles are debated at the expense of acknowledging maternal subjectivity. Mothers' subjective experiences are lost in the ideology discourses and with that the voice of the individual mother's intrapsychic experience and conflicts. Mothers and their mothering are discussed as objects rather than subjects with lived experiences. Drawing on Rozsika Parker's elaboration of Kleinian theory (*Mother Love*) and Jessica Benjamin's (*Bonds of Love*) intersubjective theory, a contemporary psychoanalytic perspective on maternal subjectivity is presented. The mechanisms of the maternal ideal fantasy must be understood through an examination of the mother's emotional life. It is argued that maternal ideals of unity and presence found in Attachment Parenting philosophy is expressive of a protective fantasy of the perfect mother. Parker's concept of maternal ambivalence can be used to illuminate the complexity of the mother's inner world and particularly how she is at a loss in a culture that does not invite openness about the challenging emotions of motherhood. As the child is faced with the strenuous task of containing ambivalence in order to relate to the mother as a whole person, so must the mother integrate both her hatred and love for her child. Current representations of the intensive mothering ideology seem to lack sincere and uncensored accounts of maternal ambivalence and the need for maternal space. The psychological function of the maternal ideal is to block out fear of negative feelings and their

destructive power; essentially a defense against ambivalence.

INTENSIVE MOTHERING AND PSYCHOANALYTIC THEORY

Studying mothers and mothering inevitably raises a significant challenge about the subject in question: who is she, what does she do, and how do we grasp her inner life? The issue of the subjectivity of the mother has been intensively debated in disciplines like psychoanalysis, feminism, gender studies, philosophy, and psychosocial studies. Feminism has argued for theorizing mothers as autonomous subjects with rights, and feminist psychoanalysis has gone further and argued that children need their mothers to be subjects in their own right (Hollway 2; Benjamin "Omnipotent Mother" 135). The maternal is a subject position so conflictual that it has been proposed as a theoretical question in itself (Baraitser et al. 1). From a feminist psychoanalytic perspective, maternal subjectivity is the exigent question for the intensive mothering ideology. Can mothers be viewed as subjects of interest in their own right in a child-focused philosophy like intensive mothering?

The level of conflict in current mothering ideology debates are concerning, namely in light of the problems with maternal subjectivity. When the rightness of different mothering styles are debated in a judgmental atmosphere, there is little, if any, room for acknowledgment, honest expression, and exploration of diverse maternal subjectivity. A mother's subjective position will turn into a defensive ideological argument instead of an account of a subjective lived experience in its own right. In a debate about conflicting ideologies and philosophies, descriptions of personal experiences will be perceived as underpinnings for arguments. Full accounts of mothers' subjective experiences are thus lost when debates become belligerent.

Rozsika Parker is a notable psychoanalytic scholar who thoroughly examined the inner life of the mother and put her perspective to the forefront. She took issue with the entire worldview of developmental psychology, stating that "life is looked at from the position of a child to the detriment of our understanding of adult maternal development" ("Maternal Ambivalence" 18). She focused in particular on the conflictual aspects of mothers' inner

life with the purpose of illuminating the creative role of maternal ambivalence and possibilities for maternal subjectivity. Parker advocated for using psychoanalytic theory in maternal studies with the argument that it holds unique explanatory potential regarding questions like maternal development, ambivalence, and subjectivity, but *only* if we "reframe, realign, and rewrite theory to illuminate this theme from a maternal perspective" ("Maternal Ambivalence" 18). Her re-reading, discussion, and development of psychoanalytic theory combined with her qualitative research with mothers, offer an important critical approach to understanding Western motherhood discourses.

Jessica Benjamin (*Bonds of Love*) has contributed with an original framework for understanding female and maternal development through her intersubjective development of psychoanalytic theory. Her work is central to the intersection between feminism, contemporary psychoanalysis, and maternal subjectivity. Benjamin's examination of the maternal ideal in Western culture is particularly relevant to the questions of maternal subjectivity and Parker's theory on ambivalence. Her intersubjective theory offers an analysis of maternal development followed by possibilities for the expansion of maternal space. This potential is crucial for a mother's assertion of her maternal subjectivity. In this way, Benjamin outlined a psychology of how maternal ambivalence can become productive through a mother's assertion of her own space and assume the creative role Parker suggested it holds.

This chapter is inspired by Parker's and Benjamin's works about mothers; their inner lives and particular developmental phases, their struggles with ambivalence, and the specific challenges they face in their transition to maternal subjectivity. Their analyses of how cultural representations of the maternal ideal interact with maternal intrapsychic dynamics offer a critical understanding of the psychological effects of the current intensive mothering ideology. In an ideology of motherhood that idealizes the mother and her presence and demonizes her ambivalence, the possibilities for maternal subjectivity are limited and women are forced to cope with their ambivalence under pressure, often resulting in a reproduction of the ideology. Furthermore, recent research on the connection between maternal mental health and parenting attitudes

by Kathryn Rizzo, Holly Schiffrin, and Miriam Liss suggest that intensive mothering may have a negative impact on mothers' mental health (619). Informed by these perspectives and findings, I will discuss the philosophy of Attachment Parenting and point out its problematic lack of space for negotiation of cultural and personal maternal ideals. The focus will be the philosophy as it is practiced in Western parenting cultures, as there are cultural differences in the way attachment theory has been applied. I question whether there are true possibilities for maternal space in Attachment Parenting philosophy in Western culture because of its idealization of the mother and her constant presence. My aim with this paper is to demonstrate how the sway toward the cultural idealization of motherhood fuels contemporary intensive mothering ideology, and that a critical theory of intrapsychic maternal dynamics is necessary for understanding the psychological consequences of intensive mothering.

THE CULTURAL MATERNAL IDEAL

The role of the maternal ideal is central to Parker's analysis in that she argued that ideal representations of motherhood in late twentieth-century significantly intensify maternal ambivalence, often to an unbearable degree (*Mother Love* 21). The maternal ideal functions on cultural and personal levels, although with an intrinsic interplay in that we all help to maintain the cultural prescriptive and normative ideals of mothering. Cultural representations of good and bad mothering then continue to interact with personal meanings of mothering. Benjamin argues that there is a strong idealization of motherhood in Western culture in that the ideal mother is an "all-giving, self-contained haven" (*Bonds of Love* 211). Parker referred to Benjamin's notion of the idealized mother in Western culture as a central influence because it elicits shame in the individual mother. The shame is in itself isolating because it is taboo, making mothers keep it to themselves or repress it. In this way, there is limited cultural expression of the experiences of mothering that are different from the ideal, which again reproduces cultural maternal excellence. Concerning the cultural reproduction, Arnold also argued that

myths about motherhood not only permeate our culture, but are also the lens through which we discuss mothering (1). The very language of mothering is problematic for the acknowledgment of maternal subjectivity; it is not readily acknowledged that mothers are female subjects with "their own needs, interests and obligations" (Arnold 1). Parker distinguished between the cultural ideal of oneness and women's descriptions of ideal moments in their lived experience of mothering (*Mother Love* 24). Her work emphasized how becoming a mother inevitably entails dissonance and tension between lived subjective experiences of mothering and normative ideals of motherhood (2).

Parker and Benjamin are not alone in their belief that late twentieth-century Western culture is wedded to maternal perfection. Parker referred to Kristeva's idea that maternal idealization in culture is not just of the mother herself, but of the *relationship* to her, making it conflict-free, in other words; free of ambivalence (qtd. in *Mother Love* 35). In the ideal mother-child relationship, aggression is absent, and this ideal mother is hate-free and thereby constant (21). The cultural maternal ideal is a fantasy of oneness and symbiotic unity of mother and child. A mother's ambivalence and negative feelings are either shameful or objects of disbelief (Parker "Maternal Ambivalence" 17). Strong negative feelings like hatred are not accepted as normal, let alone necessary, but warded off by pathologizing. The cultural ideal of mothering is also in conflict with a woman's possibilities for subjectivity outside of the maternal. Hays' landmark work demonstrated how the expectations for mothers contradict the expectations for women in the workforce by juxtaposing the history of ideas about child rearing and the social contexts in which they emerge (Hays 3). She pointed out how the cultural values of contemporary mothering directly opposes the values of good business practices, and that, paradoxically, motherhood culture has become increasingly demanding and intensive as women have continued to expand their roles in the workforce. Hays identified three tenets of intensive mothering: that mothers are better parents than fathers, that mothering should be child-centered, and that children are inherently fulfilling to parents (8). These three tenets confluence with the presented psychoanalytic theory. Parker and Benjamin's

theory offer psychological explanations for how a child-centric and intensive ideology of motherhood develops.

Benjamin ("Omnipotent Mother") describes the universal fantasy of maternal omnipotence of an all-powerful mother, arguing that the real problem is the ideal of motherhood as a self-sufficient family guarded by an omnipotent angel of the house (218). The ideal of the omnipotent mother makes it impossible for the mother to be a separate subject. When ideal motherhood is viewed as a state of dyadic unity, separation is seen as destructive and dangerous (143). The idea of the mother as separate challenges the core assumption in intensive mothering that motherhood is essentially a constant focus on the baby. Nancy Chodorow and Susan Contratto also examine the fantasy of the perfect mother in feminist theory and the consequences of the cultural maternal ideals. They argue that idealization of the mother and blaming of her are two sides of the belief in the omnipotent mother ("Perfect Mother" 65). Chodorow and Contratto demonstrate how the fantasy of the perfect mother is expressed in literature on mothering, including feminist writing, through the assumption that children's needs are legitimate, necessary, and absolute, indicating that a mother can be perfect if she accommodates the child fully (82). This notion captures the assumptions in intensive mothering as described by Hays, especially the tenet that parenting should be child-centric. The ideal of unity also causes maternal isolation: the idealization of the mother-child dyad psychologically and physically isolate them from the rest of the world (62). With the fantasy of "maternal perfectability" (the very idea that a mother can be perfect) follows that responsibility of the child's development is ultimately placed on the mother (80). This reflects the basic assumption in intensive mothering that mothers are inherently better parents than fathers. With the perfect mother fantasy comes its harsh negative counter-pole: the idea of the bad or terrible mother who can be blamed for her child's sufferings or failures. This flipside of maternal idealization of the mother is psychological determinism and reductionism that explains everything as an outcome of mothering (64). Any negative feelings to which the mother contributes, affects the mother-child relationship adversely, thereby becoming dangerous

because of their high destructive potential. Ambivalence cannot be integrated with the ideal of unity.

As seen in these accounts, there is substantial agreement that cultural idealization of motherhood is pervasive in both its impact on women's perceptions of what mothering is and the way it restricts possibilities for subjectivity and expression of ambivalence. It is through the cultural idealization, as well as denigration of the mother, that maternal ambivalence is defended against in a way that, paradoxically, promotes it (Parker *Mother Love* 21). Hays' identification of the three tenets of intensive mothering captures the issues that according to Parker and Benjamin arise in a culture of maternal idealization. Parker and Benjamin's psychological analyses of late twentieth-century mothering can arguably be read as critiques of intensive mothering. They argue that a child-centric ideology of motherhood with limited, if any, room for maternal subjectivity must have components of emotional conflict in its underlying causes. Their theories elaborate on how institutional maternal idealization reproduces an ideology of motherhood that influences women deeply on the personal level.

IDEALIZATION ON THE PERSONAL LEVEL

Referring to clinical experience, theory, and her own qualitative research, Parker stated that it is a common fantasy in women that motherhood will heal the shortcomings of one's own childhood (*Mother Love* 23). The descriptions of ideal moments of mothers' experiences that Parker collected in her research were about mutuality and shared warmth between the mother and child. On the conscious level, this fantasy is about not repeating the mistakes of one's parents, but striving to do a better parenting job. On the unconscious level, women's fantasies of ideal motherhood are about a shared warmth, a fantasy of oneness where the mother is fulfilled through gratification of the child's needs. Again we see one of the tenets of intensive mothering in the idea that mothering is inherently fulfilling in itself. There is a dual identification in which the infantile self is healed through the fantasy of ideal mothering of the child (24). In these ideal moments of mothering, both mother and child are satisfied and important reparation of

the mother's own wounds is made possible. However, it is a central challenge for mothers to negotiate their lived experience of motherhood with cultural maternal ideals (34). Parker found that Western culture does not allow women to express and negotiate the conflicts of mothering in constructive ways because maternal conflict is categorized as failure (198). Ambivalence is felt like an inability to love, and hatred or resentment is often closely linked to abandonment and rejection. Parker's thesis was that maintenance of the fantasy of the ideal mother within the individual, as well as society, functions as a defense against maternal ambivalence. On the personal level, ambivalence is a threat to the hope of healing one's childhood wounds (Parker *Mother Love* 21). As the child must give up the fantasy of the ideal mother in order to develop frustration tolerance and object constancy and move towards maturity, the mother must relinquish the fantasy of being a perfect mother. This is an inevitably painful process, accompanied by loss (17).

The question of how cultural maternal ideals are affecting mothers has become a topic for scientific inquiry. Rizzo, Schiffrin, and Liss have studied the discrepancy between parenting expectations and mental health outcomes, also known as the parenthood paradox (614). Research on parenthood effects on parents' mental health is inconclusive; there are various studies demonstrating both positive, neutral, and negative effects on mental health (614). Rizzo, Schiffrin, and Liss identified the specific ways of parenting as an under-investigated variable and aimed to examine how particularly intensive mothering, as defined by Hays, is related to mental health outcomes through an online survey (615). Intensive mothering beliefs correlate with several negative mental health outcomes, and the results made the researchers conclude that negative maternal mental health outcome may be accounted for by the endorsement of intensive parenting attitudes (619). Negotiation of lived experiences of mothering and the cultural maternal ideals is evidently difficult in a culture that is immersed in a maternal ideal of conflict-free unity between mother and child. In the child-focused intensive mothering philosophy, the possibilities for such a conflictual negotiation decrease as maternal ideals intensify. It appears that maternal ambivalence in itself is incompatible with intensive mothering.

MATERNAL AMBIVALENCE

Parker defined maternal ambivalence as "the experience shared variously by all mothers in which loving and hating feelings for their children exist side by side" (*Mother Love* 2). Parker's definition builds on the assumption that all mothers do experience hateful feelings for their children. Her definition establishes negative maternal feelings as normal and thereby non-pathological. They are frequently denied or shamed, or only partly acknowledged, for example through humor (Parker "Maternal Ambivalence" 17). Parker distinguished between manageable and unmanageable ambivalence (21). The unmanageable ambivalence arouses intolerable guilt and anxiety because the love is not felt to be strong enough to mitigate the hate. Manageable ambivalence is related to what Parker, re-reading Klein's concept of the depressive position, constituted as the *maternal* depressive position: "It is the mother's achievement of ambivalence the awareness of her coexisting love and hate for the baby that can promote a sense of concern and responsibility towards, and differentiation of self from the baby" ("Maternal Ambivalence" 20). This presentation of ambivalence as an important developmental dynamic points to the potential damage that denial and shaming of it can cause. However, it also posits ambivalence as an achievement and thereby something a mother can fail at.

Hays' brought up the issue of ambivalence as an explanation for the reproduction of intensive mothering ideology. She argued with her research that the contradictions between the values of family life and the values of economic and political life especially impacts our cultural idea of motherhood in a way that makes it impossible to get it right (18). Hays demonstrated how both traditional stay-at-home mothers and working mothers are faced with the cultural contradictions of motherhood and the ambivalence that follows. The striking dynamic Hays then pointed out is that *both* groups turn to the logic of the intensive mothering ideology to deal with their respective ambivalence, thereby reproducing it (134). Both stay-at-home mothers and working mothers deal with their ambivalence by pointing out to all the reasons why they are in fact good mothers for staying home or for working. They all

seek explanations in the contradicting cultural values that can confirm the rightness of their choices, always with a focus on proving one's worth as a good mother. This fuels maternal idealization. The ideological work mothers use to resolve their ambivalence all point to intensive mothering (Hays 16).

Although Parker focused her analysis on the intrapsychic maternal development, she also acknowledged that culture plays a decisive role in mothers' struggles with guilt because of the taboo of maternal ambivalence (*Mother Love* 1). Again, her work critically intersects with intensive mothering. As with Hays, Parker suggested that the maternal ideals are contradictory, and she argued it is a consequence of the societal denial, shaming, and condemnation of maternal ambivalence. She then stated two main concerns: mothers' anxiety increases to often unmanageable levels because of the inevitable guilt, and this cultural taboo hinders full discussion and examination of the creative potentials and developmental necessities of maternal ambivalence (1). Parker claimed a "specifically creative role for manageable maternal ambivalence" (*Mother Love* 6). It is important to notice Parker's distinction between manageable and unmanageable ambivalence. Although Parker contended that maternal ambivalence is not just a by-product of the separation-individuation process, but an important and necessary element of it, fueling a mother's creative reflections about her relationship to her child (134), it requires significant integration before it becomes creative. Thinking about and reflecting on one's baby is essential in mothering and the suffering of ambivalence can promote thought (7). However, as Parker also stated, it is the *reflective* work and the *awareness* of ambivalence that promote a mother's differentiation of herself from the baby ("Maternal Ambivalence" 20). It is through integration of love and hate for the other that we recognize them as whole and thereby differentiated. Comprehensive handling of ambivalence is therefore necessary for the development of maternal subjectivity.

Parker and Hays' views on maternal ambivalence complement each other in their different emphasis. Hays' focused on how the contradicting values of motherhood sustain the reproduction of the intensive mothering ideology regardless of the style of mothering. Parker's psychoanalytic approach contributed with a comprehen-

sive analysis of the cycle of anxiety about maternal ambivalence, how it increases guilt and denial, and how the increased denial produces more unbearable ambivalence. She demonstrated how a lack of appreciation of the creative and developmental purpose of ambivalence fuels the idealization of motherhood and reproduces an intensive mothering ideology. However, Parker's theory also brings up the question of when ambivalence becomes manageable and conducive to mothering. If maternal ambivalence is or ideally should be an achievement understood as constructive and consciously integrated, it must start out as unmanageable before it becomes manageable. A mother's simple acknowledgment of her ambivalence does not in itself ensure her an empowered maternal subjectivity.

ATTACHMENT THEORY, ATTACHMENT PARENTING AND THE ISSUE OF MATERNAL ABSENCE

Parker's perspective on maternal ambivalence is radically different from that of the original attachment theory, which current intensive mothering ideologies like Attachment Parenting is largely informed by. The pioneer of attachment theory, John Bowlby, recognized maternal ambivalence, but was hesitant to mention it (qtd. in Parker *Mother Love* 65). He recognized that ambivalence is inevitable, but considered it to be an *impediment* to attachment, developing a theory of "maternal deprivation" (qtd. in Parker *Mother Love* 131). Bowlby explained maternal deprivation as the infant's separation from or loss of the mother, as well the failure to develop a secure attachment (11). Based on his research, Bowlby concluded that disruption of attachment would result in severe negative outcomes for the infant (15). Bowlby believed that appropriate childcare would minimize ambivalence in children, which would, in turn, minimize ambivalence in parents. Bowlby believed that a mother's mere presence could minimize a child's experience of conflict and explained ambivalence as a consequence of the mother's absence. The solution for Bowlby was to minimize ambivalence by minimizing absence. This understanding of mothering as child-centric is not just a matter of ensuring good mothering, but also about avoiding potentially severe outcomes

for the infant. In this way, intensive mothering ideology builds on the combination of scientific authority and fear.

Attachment Parenting (AP) is a parenting philosophy directly built on attachment theory and research. Founder William Sears applied Bowlby's value of presence in a number of the main tenets of AP, particularly baby wearing and co-sleeping. Mothers practicing AP are wearing their babies many hours a day, breastfeeding on demand, and taking their babies with them wherever they go. It is a philosophy of the more, the better: infants cannot be spoiled during the first months of life, but will benefit from indefinite time of physical closeness with the parents and particularly the mother. Sears encourages mothers to adapt themselves to the infants' needs instead of expecting the infant to adapt to her needs, especially with regards to physical presence. Concerning the intensity of the demands of AP, Sears claims that "instead of feeling tied down, mothers feel tied together with their babies" (15), directly confirming the tenet of children as inherently fulfilling to mothers. From the ideals imbedded in this perspective, maternal absence is inherently problematic, and practicing AP will give mothers a feeling of unity with their babies that will supersede the burdens.

From Attachment Parenting International's (API) principles, the principle of Providing Consistent and Loving Care, handling parental absence in relation to caregiving is addressed. The importance of continuity and consistency of care is emphasized, and several constructive ideas of how to increase awareness of and sensitivity to the attachment process are offered. However, the first general principle on the topic is to "explore a variety of economic and work arrangement options to permit your child to be cared for by one or both parents at all times" (API). The general ideal is clearly stated as full-time parental care. It is directly stated that the most ideal practices are listed first. Subsequently, ideas on how to handle caregiving by other than the parents are offered. It is mentioned that minimizing the number of hours in non-parental care as much as possible provides the best opportunity for a child to build secure attachments with parents. The realities of working parents are acknowledged, but the general ideal of limiting absence is clearly stated. As it shows, API's philosophy involves limiting absence in

order to facilitate healthy attachment development. The problem is, if the ideal of full-time parental care is not possible, it is not clear exactly how much absence a child can handle, and what kind of balance could be considered acceptable.

As seen in Attachment Parenting philosophy, absence is, in a sense, always problematic in itself, as Bowlby contended. This fuels the cultural ideal of oneness through the unequivocal belief in physical presence as healthy and absence as problematic. It does not allow for much negotiation of the mother's need for separation. A mother's need for physical space is not considered legitimate, compared to the child's need for closeness. When examining these ideals of presence and closeness in AP, a paradox emerges, that mothers know best. The biological naturalness of the infant's drive to attach and the mother's intuitive understanding of that drive is the wish to accommodate it. Simultaneously, mothers are held up to clearly articulated standards and ideals of how to facilitate the best attachment through physical closeness and minimizing of absence. These standards lean heavily on scientific evidence and insight from attachment research. However paradoxical, this fits well in an intensive mothering ideology that is largely expert-guided (Hays 121).

Rizzo, Schiffrin, and Liss' research on how parenting attitudes directly affect mothers opens up the question of scientific authority. If intensive mothering is in fact detrimental to mothers' mental health, it challenges the general scientific arguments of Attachment Parenting. Rizzo, Schiffrin, and Liss concluded that the results of their study suggest that the negative maternal mental health outcomes associated with parenting may be accounted for by women's endorsement of intensive parenting attitudes (619). Furthermore, the researchers suggest that these results demonstrate that it is not just being a parent alone that affects a woman's mental health, but specifically the *way* of parenting and the attitude she endorses (618). Because there is substantial evidence that children of mothers with poor mental health generally are at higher risk for negative outcomes, the ideals of mothering presented in intensive parenting philosophies like AP may have the opposite effect of what is intended. In light of Parker's and Benjamin's research and theory, this is not surprising given the dynamics of maternal ambivalence

and the tension mothers experience between cultural maternal ideals and their lived experience.

CONCLUSIONS

Hays tenets of intensive mothering intersect with the presented issues of the cultural and individual maternal ideals, ambivalence, possibilities for maternal subjectivity, and the mother's absence. The very notion of maternal subjectivity challenges the assumption in intensive mothering that motherhood entails constant focus on the baby. The idealization of the mother both lays the ground for the understanding of women as inherently better parents than fathers and places extreme responsibility for the outcome of child-rearing on the mother. The demonizing of ambivalence solidifies the idea that children are inherently fulfilling for parents. Parker viewed the idea that children provide the foundational fulfillment of a mother's needs, and not the father's, as a culturally imbedded ideal that makes it very difficult for mothers to acknowledge their ambivalence and thus hinders the development towards maternal subjectivity ("Maternal Ambivalence" 36). Maternal ambivalence is an important element in the necessary separation-individuation dynamic of both mother and child (Parker *Mother Love* 134). However, it must be acknowledged and consciously processed in order for a mother to expand her sense of self and her identity as a mother. The idea that mothering should be child-centered raises the problem of maternal subjectivity in particular. A child-centered approach to mothering creates an imbalance in the delicate building of what Benjamin calls the intersubjective space of mutual recognition and understanding (*Bonds of Love* 92). Benjamin suggests that the solution to the omnipotence dilemma namely lies in mutuality and differentiation within the maternal space (*Bonds of Love* 92), which emphasizes maternal subjectivity as crucial to the child's development. Benjamin contends that it is developmentally necessary for a child to recognize that a mother has her own needs (*Bonds of Love* 24). If a mother stifles her own needs, she cannot be fully empathic with her child. It is not enough to mirror the child; the mother must offer the experience of engaging with another autonomous being if the child is to develop a sense of self.

Benjamin states: "Only a mother who feels entitled to be a person in her own right can ever be seen as such by her child" (*Bonds of Love* 82). She believes that the mother's leaving and returning is crucial for the mutuality between mother and child. When doses of absence are then followed by reunion and repair, both mother and child can recognize each other as subjects. Parker's and Benjamin's ideas on maternal ambivalence, maternal subjectivity, and their connection show how the ideal of presence in AP philosophy is problematic for both maternal and infant development.

It is entirely possible that a mother may feel empowered by AP philosophy to assert her subjectivity through parenting choices and enabled to express the full range of her emotional experience. However, in line with Parker, I would argue that would be possible only after thorough negotiation of the maternal ideals, both cultural and personal, and individual mothering experiences. The question then remains if women truly have spaces for that conflictual negotiation in a child-centered ideology that is infused with maternal ideals established on scientific and expert authority. I find the consistency between Parker and Benjamin's comprehensive theoretical frameworks and Rizzo, Schiffrin, and Liss' research indicative of how limited acknowledgement and expression of maternal ambivalence is in contemporary intensive mothering and how it directly stifles authentic maternal identity development. In addition to this, I also question the possibilities for mothers to create spaces, emotional as well as physical, for subjectivity in an ideology that regards a mother's absence as inherently problematic. From an intersubjective and matricentric perspective, this lack of space for maternal ambivalence and subjectivity is highly concerning for both mother and child.

WORKS CITED

Arnold, Abby. *The Rethoric of Motherhood*. The Mothers Movement Online, December 2003. Web. Accessed: 10 October 2013.

Attachment Parenting International (API). *Provide Consistent and Loving Care*. Web. Retrieved 16 November 2014.

Baraitser, Lisa, Sigal Spigel, Rosemary Betterton, Polona Curk,

Wendy Hollway, Tracey Jensen, Gavin Miller, Tina Miller, Rozsika Parker, Kate Pullinger, Joan Raphael-Leff, Tracey Reynolds, Lena Simic, Alison Stone and Imogen Tyler. "Editorial. Mapping Maternal Subjectivities, Identities and Ethics." *Studies in the Maternal* 1.1 (2009). Web. Accessed: 10 October 2013.

Benjamin, Jessica. *The Bonds of Love: Psychoanalysis, Feminism, and the Problem of Domination*. New York: Pantheon Books, 1988. Print.

Benjamin, Jessica. "The Omnipotent Mother: A Psychoanalytic Study of Fantasy and Reality." *Representations of Motherhood*. Ed. Donna Bassin, Margaret Honey, and Meryle Mahrer Kaplan. New Haven: Yale University Press, 1994. 129-146. Print.

Bowlby, John. *Maternal Care and Mental Health*. Geneva: World Health Organization, 1951. Print.

Chodorow, Nancy and Susan Contratto. "The Fantasy of the Perfect Mother." *Rethinking the Family: Some Feminist Questions*. Ed. Barrie Thorne with Marilyn Yalom. Boston: Northeastern University Press, 1992. 54-75. Print.

Hays, Sharon. *The Cultural Contradictions of Motherhood*. New Haven: Yale University Press, 1996. Print.

Hollway, Wendy. "From Motherhood to Maternal Subjectivity." *International Journal of Critical Psychology* 2 (2001): 13-38. Print.

Parker, Rozsika. *Mother Love/Mother Hate. The Power of Maternal Ambivalence*. New York: BasicBooks, 1995. Print.

Parker, Rozsika. "The Production and Purposes of Maternal Ambivalence." *Mothering and Ambivalence*. Eds. Wendy Hollway and Brid Featherstone. London: Routledge, 1997. 17-36. Print.

Rizzo, Kathryn M., Holly H. Schiffrin and Miriam Liss. "Insight into the Parenthood Paradox: Mental Health Outcomes of Intensive Mothering." *Journal of Child and Family Studies* 22 (2013): 614-620. Print.

Sears, William D. and Martha Sears. *The Baby Book: Everything You Need to Know About Your Baby from Birth to Age Two*. Boston: Little, Brown, 2003. Print.

From Intensive Mothering to Identity Parenting

MAYA-MERIDA PALTINEAU

A FEW YEARS AGO, as I had just finished a piece of research about women who do not want to have children (Paltineau *Femmes*), I was wondering, what question could be the continuity of my reflection, and be as interesting and relevant as the previous one. The theme of motherhood covered issues that will have to be tackled in the next few years, and I was looking for a topic on which we needed to improve our knowledge, and thus, our understanding about ourselves. I surrounded myself with an international literature on the topics of family and motherhood, when I started reading Sharon Hays' book. *The Cultural Contradictions of Motherhood* appeared to me as a revelation. I instantly understood that her work was carrying the essence of a very accurate, relevant and promising question. I had understood that she pointed a major question for sociology: Intensive Motherhood.

Focusing on mothers' role in our current societies seemed decisive. If sociologists want to understand how family changes over time, they have to consider women's role, and especially through Intensive Motherhood, this relatively new tendency, consisting of focusing on the child's well-being. Mothers' devotion is not exactly new, but the way it translates since the end of the twentieth century is (Winnicott *The Child; Babies; Talking to Parents*). Sharon Hays suggested that it was worth analyzing the new ways in which mothers incorporate the new mothering practices, and the way women consider their maternal roles today (see also Kniebiehler *Histoire; Maternité*).

From these considerations emerged the problematic of my Ph.D. research. How does intensive motherhood enable mothers to define, or redefine, their role as women? Why and how have women been giving increasing attention to their role as mothers? Why is the value of motherhood increasing? What behaviors make it that much more valuable? Last but not least, what does intensive motherhood teach us about our societies, about the family, gender, and work dynamics?

Well-equipped with *The Cultural Contradictions of Motherhood*, I thus started my way on the Ph.D. journey. I had a strong theoretical basis,[1] and I was ready to conduct an exciting piece of research on a new empirical field, France in the 2010s.

METHODOLOGICAL CONSIDERATIONS

I have decided to conduct my research in France, in order to understand if intensive motherhood existed in my own country, and if so, how it translated and what consequences it had on the society as a whole.[2] Beyond my theoretical research and the preliminary approach to my field, I have started my work with an exploratory interview with a key-person in the world of intensive mothering: a lactation consultant. This interviewee has played a decisive role in my further understanding of the issues around intensive motherhood. Indeed, she works with intensive mothers on a daily basis, and she gave me precious information on how to get to know such mothers. She also helped me get an initial understanding of my topic by describing to me several practices related to it.

After this first interview, I have contacted mothers following the ideology of intensive motherhood and a few who did not. I met the investigated people through several ways: I hung posters in strategic places, such as mothers' coffee houses, childcare equipment stores, birthing houses, by going to events meant for parents and by asking people on social networks. I managed to conduct seventy-two qualitative interviews with 59 mothers, three fathers, and ten people working in childcare services. Even if this research focuses on how intensive motherhood is experienced from the inside, the latter interviews enabled me to understand how intensive mothers were included in the complex parenting system, and

what place is given to them by the French healthcare system. It has been very important for me to gather a deep understanding of the birth sphere and to include several perspectives additionally to the parents' experiences.

The methodology I used is based on empirical research with longitudinal qualitative interviews. The interviews lasted between one and three hours, were conducted individually or in very rare cases with the parenting couple, and had a semi-structured interview format with the following topics: biographical journey, pregnancy, birth, parenting practices, father's role, and parenting representations. Of course, for each one of the interviewees, I gathered information on the interviewees and partners' marital status, socio-economic categories, age, education and living conditions. The individual profiles I have established enabled me to understand the French parenting landscape and to put in perspective the collected data.[3] I have followed the principles described by Emile Durkheim in 1894 in *The Rules of Sociological Method*, which have been developed and improved by many sociologists since.

In addition to these qualitative interviews, my work includes *in situ* observations (in maternity wards, birthing houses, and during parents' gatherings), as well as the analysis of mothers' blogs and social networks accounts. I wanted to include this perspective into my reflection, because the internet is a media where women feel very confident about expressing their inner feelings as mothers.

My research relies on the above-mentioned 72 qualitative interviews, observations, and the analysis of 15 blogs and related social networks accounts. Based on an inductive approach, consisting of scientific observations to build on theories, I wanted to confront the observations Sharon Hays made in 1996 in 2010 France. I intended to verify if intensive motherhood as described by Hays existed in France, if this social trend was significant, and if it had the potential to transform current society.

HOW *THE CULTURAL CONTRADICTIONS OF MOTHERHOOD* TRANSLATES IN FRANCE

First of all, the situation in France in the 2010s should be clarified. The country experienced a major economic crisis, which made the

unemployment rates raise, the GDP and the purchasing power sink. Employment, and especially women's employment, has become more rare and more unstable (INSEE). This economic and financial recession is being experienced in all Western countries, and in the French context, it explains (at least partially) the growing interest in family and the private sphere in comparison to the professional world (Montel-Dumont). In this bad economic climate, eventful French politics are adding to the generally dark mood of the population, leading to a re-focus on individuals' identities.

As far as demography is concerned, France has been one of the European leaders in birth rates for many decades. Indeed, at the beginning of 2010, the fertility rate had been above two children per woman for several years (Pison). Furthermore, the French policies include a large range of subventions for stay-at-home mothers, and also invest huge amounts of money in early child care. In France, primary school starts when the child is two and a half, and it is entirely free of charge. Before that age, the parents can receive a state subvention if they stay at home,[4] or they can receive financial help to cover day-care facilities expenses. This very generous family allowance plan should be kept in mind as a background for the following analyses (Montel-Dumont).

During my work on the current French parenting, I verified many aspects of intensive mothering as described by Sharon Hays in 1996, especially devotion to the child and the dichotomy between private and professional lives. As she says, "Constant nurture, if that is what the child needs, is therefore the child's right-even if it means the mother must temporarily put her own life on hold" (111). First, French mothers are very devoted to their children. Focusing on the child's well-being instead of the mother's is a permanent feature of French-style mothering, since all the interviewed parents consider the child's interests to be more important than their own. As an example, one of my respondents told me that she carries her three-month-old baby in her arms almost all day long: *"At the beginning, my stepmother used to tell me, 'You never put him down?' I don't put him down if he doesn't want."*[5]

According to the intensive motherhood ideology, the child must be pampered and protected from the outside world. He represents the future of mankind and the parents see it as a project they have

to carry on in a proper way for the sake of the whole society. This responsibility principle involves the parents, putting them in a position to educate the child properly, so that he or she becomes a good citizen, and a responsible human being. This education strategy generally means overprotecting the child, and keeping him or her in a rather closed family sphere, until he or she is about two years old and can go to pre-school. The respondents tend not to bring the child out of the house too much, and whilst at home, the child is often carried, whether in the arms or in a wrap, even if he/she is over one year old. The child is the center of attention, and taking care of the child means so much because it represents a universe of possibilities. Intensive mothering is a central role inside of the family and it actually is at the center of the society as a whole.

The child's status has changed significantly since the middle of the twentieth century. The health condition of children has improved, their mortality rate has dramatically decreased, child labor has been banished, education has been made compulsory, law in favor of children has improved, and progress in birth control has made the child become expected and wanted (Ariès; Leridon). As a result, the expectations of parents, and especially of mothers, have changed too. The ideology of intensive motherhood relies on these transformations in that the mothers' role has adapted, and keeps adapting to the new status of the child.

The parents adapt their rhythm to the child's. They would never expect the child to adapt to theirs. This idea translates into the fact that the parents, and especially the mother, shape their schedule on the activities of the child. Nathalie states:

> *I breastfed G. for 22 months ... and her sister, a little bit longer.... It lasted long because she didn't sleep much until she was 18 months old. Sleeping much, I mean.... Well, she only slept if she was in bed with us. If she was in her bed next to ours, she wouldn't have slept.... These are my pregnancy stories, with my babies sleeping in our bed, and I have carried on, the three of them have been carried very, very, very much.... I had one in the baby-wrap, one in the trolley and one holding my hand. But I carried them in my arms as much as possible. So outside, I used the baby-wrap,*

but at home, I carried them in my arms, on my hip, I used to cook with them in my arms ... S., even now, I carry her, she's seven, and there is still this need of carrying them.[6]

The interviewed mothers even quit their jobs during their pregnancy, and generally stop working until the children go to school, at the age of three. Their devotion means being available for their children during their young age and giving less importance to their jobs, even if this may compromise their careers.[7]

This brings us to another characteristic of the intensive motherhood as described by Sharon Hays—the dichotomy between private and professional lives: "The cultural contradiction between home and world has a long history.... Over the past two hundred years, Western society has been juggling the contradictory logics of appropriate behavior at home and appropriate behavior in the outside world" (3).

Women are assigned to a double constraint, that of being a good mother and having a successful work life at the same time. This double assignment has been verified throughout my whole study. Additionally, I have observed, just like Sharon Hays, that the good mother injunction has slowly overstepped any professional assignment. The intensive motherhood ideology, by focusing on the child's development, encourages the mothers to give less value to their careers, and on this point, our observations on the current French women absolutely concord with what has been described in *The Cultural Contradictions of Motherhood*. For example, I would like to quote one of my respondents: *"At some point, I asked myself, 'What is your priority?' and with my husband, we wanted to have a big family, so it was clear: whether we had only one child and I could keep working, or we had several children, and I would quit my job.... Well, it's really a more comfortable life for all of us."*[8]

HOW OBSERVATIONS ON CURRENT FRENCH MOTHERS OVERCOME THE INITIAL HYPOTHESES

Sharon Hays described intensive motherhood as an ideology known by everyone, even if it was not necessarily adopted by all. This

ideology is a kind of social normativity, an injunction for women to be good mothers and place the well-being of their child at the centre of their preoccupations. As Hays says, "Child-centered child rearing means doing what is best for your child rather than what is convenient for you as the parent; it means concentrating on what you can do for them rather than on what they can do for you. And this, many mothers tell me, is the way it *should* be" (114-115). However, while my research gave to this normativity as much importance as Sharon Hays did, the people I have interviewed described practices that were going beyond my first hypotheses, such as the fact that intensive mothering existed in France, and beyond the facts observed in *The Cultural Contradictions of Motherhood*.

I observed that intensive motherhood, when followed literally, was giving mothers the opportunity to develop several distinctive behaviours. By adopting some or all of these practices, French intensive mothers strengthen their ideological adhesion, and assert their belonging to the good mother injunction.

I will describe the practices that I have observed in order to give form to the model of French intensive mothering ideology. These practices show the way in which the interviewed women see themselves as mothers. To start, there are several practices surrounding the baby that codify the way the baby must be taken care of, the more emblematic ones being the use of a babywrap, co-sleeping, and extended breastfeeding.

The mothers I met express the desire to be close to their child by integrating the practices mentioned above in their daily routines. They think the infants need physical contact with their mothers, and that moments when they are left alone, if they are too frequent, hinder their psychological development. This leads intensive mothers to use a babywrap on a daily basis, at home as well as outside. Co-sleeping is motivated by the same reasons. According to this ideology, the child, especially in the months following the birth, needs its mother's proximity to grow in a balanced way. The sudden transition from the mother's uterus to a world where the child is left alone (for instance in a baby bed) is too brutal, and must be avoided (Sears and Sears). Finally, breastfeeding is a significant symbol of current French intensive motherhood.[9] Intensive mothers give breastfeeding a primordial place in their

mothering practices, because of the proximity to the child that it provides, for the psychological and physical development of the baby, and for the sake of the mother-child relationship.

The women I met love breastfeeding, and think that the child should not be deprived of it because this practice might be constraining for the mother. One mother said,

> *It is really complicated. And then, to have one day off, you cannot pull out your milk for a whole day, otherwise it gets really.... It's totally weird, because the baby doesn't see the breast anymore, he only gets to see a baby bottle, so I don't see the point of always showing him a baby bottle, and never a breast.*[10]

While this enthusiasm for breastfeeding is to be found outside of intensive parenthood households, the duration of breastfeeding is typical for intensive mothers. Interviewed women breastfeed for several months, even for several years, sometimes until the child goes to pre-school (at the age of three), and sometimes even beyond that age. Extended breastfeeding distinguishes intensive parents from other parents, and because breastfeeding is a controversial society issue in France (Badinter), intensive parents are using it as a distinctive symbol of their ideology, and defend it as their flagship.

The parents I have interviewed sometimes have other additional specific behaviours, such as the use of washable diapers, natural infant hygiene,[11] unschooling,[12] and skin to skin contact (which consists of holding the naked baby against the mother's naked chest), that I cannot expand upon here, but which contribute to the articulation of the parental system inside of the ideology of intensive motherhood.[13]

Besides, intensive mothers that I have met have an interest for ecological questions, which Sharon Hays did not seem to have observed, certainly because the 1990s American society was not yet strongly preoccupied by this matter. Indeed, the interviewees distinguish themselves by adhering to ecological and natural preoccupations. Beyond their parental practices, intensive parents are particularly attentive to protecting the planet and respecting the environment. This translates into refusing to use a car, integrating

many organic products and food into their daily lives, and other sustainable actions. This ecological and naturalistic ideology is very often combined with intensive motherhood. For example, babies are fed with maternal milk with the perspective of coming back to the nature and natural products whereby older children are fed with organic food and home-cooked dishes (industrial products are banished as much as possible). Emilie says,

> *I generally do [the baby food], but I don't always have fruits, because you need season fruits.... On the other hand, the salted baby-food, I do it myself. Salted food, we never buy.... When I prepare the food, the vegetables, really, are 50 percent organic, and about the fruits, I would say a bit more, 80 percent are organic.*[14]

For example, using washable diapers presents the double advantage of protecting the baby's skin and the environment. Babywraps are preferred to trolleys, since they seem more natural and are also closer to the values of warm family love. This also shows that intensive parents tend to give less value to material ownership. They do not want to own as many childcare devices as before. I have indeed observed, beyond the ecological interests of intensive parents, a quite strong enthusiasm for economical decrease.[15] This trend, spreading quite rapidly in western societies as a response to the economic crisis, finds a very accurate place inside the ideology of intensive motherhood. Seeking of something better through the "less is more" motto enriches intensive motherhood by making sense of the parent-child relationship, by insisting on the child being a family member in its own right and a carrier of possibilities for a better world.

This need for authenticity and proximity with nature is also to be found during the follow-up of the pregnancy and the labour. My research has revealed that most of the intensive mothers opt for an out-of-hospital follow-up and a birth that is as natural as possible. The childbirth classes often occur with alternative medicine therapists, or professionals who were not involved in the childbirth system before, such as sophrologists, haptonomists, antenatal yoga and singing teachers. As far as labor is concerned, many of the

interrogated people had a home birth (even if it remains a very seldom practice in France, as it stands for less than one percent of the births) (Brocas). The others refused the epidural anesthesia most of the time, as well as the use of modern medicine techniques. This naturalistic approach of pregnancy and labor is very specific for intensive motherhood as it is understood by French women, who want to differentiate themselves from the rest of the society through these practices, and thus assert the value they give to their mothering role. On this matter Violette's point of view is interesting:

In their opinion, I was totally irresponsible just because I had considered [home birth]. But it actually was the opposite; as I had read it somewhere, a girl was saying that [homebirth] is the best way of being responsible. You are irresponsible when you want to go lie on a table and you tell the doctors, "Go ahead, handle it yourself, get this baby out." This is irresponsible. Responsible, it's rather, "I am going to calm down, do my best, and do it normally, like it has been done for thousands of years, I'm not going to die." It's quite the opposite, you have to experience it fully and the beauty of this experience can be overwhelming.[16]

These practices have been little or not at all observed by Sharon Hays, and their importance among French mothers reveals a step forward from the ideology described in *The Cultural Contradictions of Motherhood*. The behaviors surrounding birth certainly represent a completion of the trend observed in the 1990s.

Moreover, if the people interviewed by Sharon Hays often used to have a job, the evolution of the ideology established by my study shows that in France, nowadays, intensive mothering exists only outside of the professional world. As a matter of fact, all the mothers I have interviewed stopped working during the pregnancy, remaining at home for several months or years after the birth of the child. My study led me to slightly different conclusions from Hays's: it pointed out that when the ideology of intensive motherhood was integrated, women stopped working for as long as possible. The application of this ideology does imply staying at home in this context. This different conclusion can be explained

by the use of a different method: Sharon Hays wanted to analyze how the injunction of intensive mothering is understood by women, and I wanted to see how it is applied. However it can also be explained as an evolution of the ideology, and I will come back to this point in the next part of this chapter.

Another evolution that I have observed are the changes in the father's role. The father status has indeed changed a lot in the past years (Castelain-Meunier), but according to my study, it has changed the most within the ideology of intensive motherhood. The study has indeed revealed that when the woman was an intensive mother, the result was obvious on the father, who easily became an intensive father himself. The project of having a baby was increasingly experienced by both parents equally, from the pregnancy to the child raising, and lived with the same intensity by both parents. In the families I have met, the father accompanied the mother to the childbirth classes, was always present during the birth, supported the mother throughout the event, sometimes substituted for the midwife, carried the child in a wrap as much as the mother did, and participated in all the steps of the child-rearing. This research has pointed out an essential transformation in the ideology of intensive motherhood: we can now speak about an intensive fatherhood, and intensive parenthood, and not only of an intensive motherhood.

At last, the present research has revealed another aspect of intensive mothering that could not have been studied in 1994: the use of internet as a tool for parental assertion. Nowadays, mommy-blogs flourish online, as well as mothers' accounts on Facebook and Twitter. These profiles are a sort of showcases for the maternal identity, since being a mother also means presenting herself and showing her opinions and practices online. Internet is indeed used to develop a personal image, in a large context, and it is the perfect tool for the identity assertion of parents, even if blogs are generally anonymous. Cécile says:

> *I personally like the internet to be anonymous, I like the idea of being able to exchange ideas with a lot people who I do not know, I think it's nice. And as a matter of fact, there are very few people who know me in real life and*

know about my blog ... [my blog] is my own little world.[17]

This shows that mothering has changed, and that it has adapted to its time, in its contemporaneity. Another point showed by the presence of mothers online is that intensive mothering is growing in networks: the intensive mother is seldom alone, since the blogs and the social networks create a dense solidarity among intensive mothers. Thanks to the Internet, the new ideology of intensive motherhood is better shaped, and becomes more legitimate (see Mecklé). This leads me to believe that the trend will still develop, that the multiple forms that it takes nowadays could further diversify and thus give new dimensions to this trend.

REACHING A NEW CONCEPT: IDENTITY MOTHERING

The differences between the practices observed by Sharon Hays and those observed during my research have made me question the representations of the intensive parents, as I suspected a paradigm change as far as the symbolic importance of parenthood is concerned. As a matter of fact, if all the interrogated people had integrated the ideology of intensive motherhood (sometimes even without realizing it), their behavior always oversteps the injunctions of the initial ideology, as well as the intensity of the practices observed in 1994. This made me understand that we were experiencing a major evolution in the initial theory as developed by Sharon Hays.

My analysis has pointed out that the interviewed parents applied the practices I described earlier with a new goal: identity work. From their points of view, pregnancy and birth are so important that they shape their identities as men and women. Their total involvement in these events is their way to seize parenthood as an element of self-transformation and self-assertion. They all talk about the choices they made: motherhood and fatherhood are chosen, and intensity and extreme behaviors are part of their choices as a personal process. Violette again explains her choices regarding the next time she will give birth:

I want to do the same thing [as the first time], by myself....

I really want a minimal intervention, I mean, I want to be able to do it myself.... I just want to be the one who gives birth, and that the other person just assists me if I need it.[18]

The interrogated parents experience identity work while becoming a parent: the part of their identity they intentionally focus on the most (if not the only one they focus on) during a certain period of time is their identity as parents. This identity work could be seen as therapy, since people really become who they are while becoming parents. It is a real maturation process, which deeply changes their lives, in a non-reversible way. And the key point is that they decide to let parenthood change their lives and identities as individuals. Obviously having a baby changes one's life (Cicchelli), but the mechanism for intensive parents is stronger, since it is consciously desired, chosen and fully invested. For example, extended breastfeeding intensifies the mother's role, and makes her self-assert through it. Besides, all the interrogated women have said to prefer giving birth in a natural way, so that they can experience the labor pain: this pain is seen as a rite of passage, with a very strong maturation function. Indeed, experiencing pain makes the woman actively participate to the birth of her child, giving her the feeling of a personal achievement, and therefore making her grow as a person. Experiencing labor pain is not new, but choosing to experience it is, especially when modern medicine provides all kind of pain killing techniques. Under these conditions, we can consider experiencing labour pain as identity work: women seize the opportunity to give birth naturally in order to feel (literally and symbolically) the process of becoming a mother. They intend to actively participate in birth so that they can become another woman, a woman who asserts herself through her mother role.

In this respect, it seems that we can not only talk about intensive motherhood but about identity mothering instead, even about identity parenting, since fathers seem to follow this ideology as well. Identity parenting is self-assertion through the role of parent, and investing strongly the parent's role in order to assert oneself as an individual. Therefore, identity parents are adults who chose to invest their parenting roles at the fullest, and who use intensive parenting as an expression of their own identity assertion. In this

respect, intensive parents are people who use intensive parenting practices, but identity parents are intensive parents who are accomplishing a reflexive work on their behaviors and treat them as a material for their individual self-assertion. Interestingly enough, intensive parenting can be practiced alone (as shown by Sharon Hays), but identity parenting emerges only from intensive parenting, and does not exist without it. According to my study, identity parenting is the next step after intensive parenthood.

This self-assertion is a maturation process, a self-revelation, a way to be closer to whom you really are, but it is also an assertion towards society. Identity parents are generally in conflict with the majority of people, who for example think that using baby bottles or epidural anesthesia are improvements meant to make your lives easier, and on which you should not give up. This contradiction between the identity parents' way of life, just like any other contradiction (see Becker), strengthens their self-assertion. Because there is a conflict with normativity, identity assertion through parenthood carries a stronger and a more relevant message.

In a certain way, we can say that identity mothering is the continuity of intensive mothering, that it is a dramatization of its original intent. Identity mothers follow the ideology of intensive motherhood, and go beyond it in order to reach an identity assertion. Identity mothering is another ideology, which completes the initial ideology investigated by Sharon Hays with a set of new radical behaviors. Furthermore, Hays' theory can be nowadays completed with the intensive/identity fathering and parenting. Indeed, my research has shown that women are not the only ones interested in self asserting by their parental roles, and that this trend should now be understood as a couple action, a joint process between the mother and the father.

Identity parents live the arrival of a baby in an intense way, as they internalize all the processes and changes. They consider this event as a transition, as an active process of assertion. Identity parenting is chosen parenting, lived from the inside of the individual, fully, actively and with commitment. The main difference with the process described by Sharon Hays is in the end the fact that identity parenting is a process experienced for oneself, and not mainly for the sake of the child's well-being anymore. One of my respondents

put it very nicely: *"I have made this choice, and I am very happy about it. It's a big adventure, the biggest adventure I have ever made!"*[19] Even if the whole process is led by the devotion to the child, the identity parenthood is above all an individual identity work, whose main purpose is to enable adults to self assert.

CONCLUSION

Thus, the identity parenthood trend includes mothers and fathers, and enlarges the interest on child to a collective awareness about the quality of the relationship between parents and their children. The focus is not exactly on the child anymore, but rather on the parenting process.

Of course, not all French women are intensive or identity mothers, but some signs show that this trend is developing and getting acknowledged by a so far reluctant population, as French traditional feminism has quite a strong impact on mentalities and it criticizes motherhood and women's investment in their maternal roles. Some noticeable changes have occurred during the past ten years, such as the perception of breastfeeding in public, which is now better tolerated, or the fact that French hospitals adapt their offer to please mothers attracted by natural births practices. In the future, more studies need to be done on the perception of intensive/identity parenting, and the investigation should be led on a broader population, including mainly non-intensive mothers this time. A quantitative study on maternal practices would also bring a much better understanding of the range intensive parenting has spread in the population so far, and repeating such a quantitative research would allow to follow its development.

If the current study reveals that this ideology exists in France, it is developing in many other western countries, such as the U.S., Australia, and several western European countries (Faircloth). Just as intensive motherhood has spread worldwide, identity parenthood is currently transforming many societies. We could consider it as a political stance or even a revolution, since this phenomenon is included in societies that are transforming socially and economically, and at the same time it changes the societies where it exists. For the past few years, family has gained a new symbolic signifi-

cance: it is a shelter during the struggles caused by the economic crisis. It is a shield and a resource, since it enables its members' internalization and introspection, making the ties between them stronger than ever (Montel-Dumont). We are moving on from a society of having to a society of being, where we emphasize more and more the individual well-being, instead of the economic wealth (Castelain-Meunier). Indeed, many authors[20] have raised the questions of resource scarcity and sustainability in the current context of economic and ecological crisis, pointing out that we need to rethink the human role on earth. The current societies are in a quest for meaning, and identity parenting perfectly fits into this trend. Self-construction and assertion through one's parental role lets the individuals refocus on themselves, on their families, and on a certain idea of what is essential.

Alternatively, society also reacts to the ideology of identity parenting. Institutions change: in France, for example, hospitals adapt their services to mothers who want to give birth naturally (Brocas; Paltineau "Identity Work"). Norms soften and State structures start changing in order to help the individual in his or her quest for a more meaningful life. French laws are also slowly changing, for example regarding birthing houses, which were forbidden a few years back, and which now have the permission to exist as an experimental institution (CIANE).

We are now at a turning point, in which the individual, affected by an extreme economic growth, finds himself seeking authenticity and asserting her/his identity by new means. As a matter of fact, society is answering rather positively to this attempt, and major changes are surely yet to come.

[1]See Hays; Thurer; Rich; MacDonald Strong; Bourdieu; Touraine; Butler; Scott.

[2]On this point, the reader should be warned that my research is quite different from Pamela Druckerman's *Bringing Up Bébé*. First, she made a journalistic work, whereas I conducted a sociological research, which obviously implies different methods, that will be described further. A journalistic perspective means to discuss a phenomenon, whereas sociology intends to explain

social behaviors, structures, norms, and trends. My investigation does not discuss French parenting styles per se, but it focuses on perinatal issues and puts parenting in perspective with the French institutional framework. My analysis does not only give a representation of parenting behaviors, but it also offers an understanding of the French medical system, family policies and economic context. The present work can be seen as complementary to Druckerman's work, since the methods are different and the research purposes as well.

[3] The intensive mothers I have interviewed are between 26 and 44 years old, but most of them are in their thirties. All are married or live in a marital relationship. And all of them stopped working during the pregnancy and took a parental leave after the birth. Most live in Paris or in the Paris region, but I have included some interviewees living in rural areas too. They all belong to middle or upper classes, and their partners all have a stable job with a relatively high income.

[4] Any of the parents can take a parental leave for a maximum of three years, and will receive a child allowance.

[5] Interview conducted on the 01.31.2011, with Pauline, 29, living in Paris, mother of one, Masters of Art History, not working at the time of the interview *("Ma belle-mère, au début, elle me disait ça. Tu ne le poses jamais ? Je ne le pose pas s'il a pas envie.")*

[6] Interview conducted on the 01.19.2011, with Nathalie, 37, living in Versailles, mother of 3, working as a doula at the time of the interview. *("G., je l'ai allaitée 22 mois ..., et sa sœur, un peu plus de deux ans. Ca a duré longtemps, car elle n'a fait ses nuits qu'à 18 mois, et ses nuits, ça voulait dire... Enfin, elle ne dormait que si elle était dans le lit avec nous. Si elle était dans son lit à côté de nous, elle ne dormait pas.... Donc voilà mes histoires de grossesse, avec mes bébés qui dorment dans le lit, et puis j'ai continué, pour les trois, ils ont beaucoup, beaucoup, beaucoup été portés.... J'en avais un dans le porte-bébé, un dans la poussette, et un à la main. Mais autant que possible, c'était dans les bras. Alors dehors il y avait le porte-bébé, mais à la maison, il y avait sur la hanche, je faisais la cuisine avec eux dans les bras ... S., même encore maintenant, je la porte, elle a sept ans, il y a encore ce besoin de porter.")*

[7]Generally the partner keeps working, which provides the family with a safe income and financial stability. Interestingly, all the intensive mothers I interviewed were living in a marital relationship, which leads to wonder if intensive mothering can be adopted by single moms. Further studies are needed to answer this question, but it is definitely a very interesting point to tackle.

[8]Interview conducted on the 06.19.2011, with Annabelle, 30, living around Paris, mother of two, primary school teacher, not working at the time of the interview. (*"A un moment je me suis dit 'Quelle est ta priorité?' et avec mon mari, on voulait avoir une famille nombreuse, donc c'était clair: soit on avait un seul enfant, et je continuais à travailler, soit on en avait plusieurs et j'arrêterais de travailler.... C'est un meilleur confort de vie pour tout le monde."*)

[9]This is relatively new, since French women have generally been against breastfeeding since the last decades of the twentieth century. Breastfeeding has been criticized by the feminists of the second wave (led by Simone de Beauvoir), and French women have just started practicing it fiercely again.

[10]Interview conducted on the 01.26.2011, with Marjolaine, 27, living in Paris, mother of one, Master Degree in Psychology, not working at the moment of the interview. (*"C'est vraiment compliqué. Et après, pour se libérer pour une journée, on ne peut pas tirer son lait pour une journée, sinon on devient carrément... C'est carrément bizarre, parce que le bébé il ne voit plus le sein, il ne voit plus qu'un biberon, donc je ne vois pas quel est l'intérêt de lui montrer un biberon, et jamais un sein."*)

[11]This consists in raising the baby without diapers, according to the idea that it has the innate ability to communicate its elimination needs. For more information on this topic, see Bauer.

[12]Unschooling is a child-centered homeschooling method, with no curriculum or master plan (see also Griffith; Martin).

[13]For further information about this practices, see Sears and Sears.

[14]Interview conducted on the 05.05.2011, with Emilie, 28, living around Paris, mother of one, language teacher, not working at the time of the interview. (*"Je les fais en général, mais je n'ai pas toujours les fruits, car il faut des fruits de saison.... Par contre, les petits pots salés, je les fais moi-même. Salé, on n'achète pas....*

Quand je fais les préparations, les préparations de légumes, c'est vrai que c'est 50% de bio, et les fruits, je dirais un peu plus, 80% de bio.")

[15] This trend can also be related to as degrowth, no-growth or anti-growth. See *State of the World 2010: Transforming Cultures — From Consumerism to Sustainability* published by the Worldwatch Institute.

[16] Interview conducted on the 06.14.2011, with Violette, 32, living around Paris, mother of two, Master Degree in Anthropology, not working at the time of the interview. (*"Pour elles, j'étais complètement irresponsable, de même vouloir considérer ça. Alors qu'au contraire, comme j'avais lu, c'était une nana qui disait que c'était justement le summum de la responsabilité. Là où on était irresponsable, c'est de vouloir aller se ... sur une table de billard, et de dire aux médecins 'Bien, allez-y, démerdez-vous, sortez-moi le bébé.' Ca c'est irresponsable. Responsable, voilà, c'est juste: 'Je vais me calmer les nerfs, et je vais prendre sur moi, et je vais juste faire ça normalement, comme on a fait ça pendant des dizaines de milliers d'années, voilà, ce n'est pas la fin du monde.' Et au contraire, il faut vivre pleinement, et ça peut être une expérience complètement bouleversante de beauté."*)

[17] Interview conducted on the 12.29.2011, with Cécile, 31, living in Strasbourg, mother of 3, primary school teacher, not working at the time of the interview. (*"Moi, j'aime bien l'anonymat du web, voilà, j'aime bien l'idée de pouvoir échanger avec plein de monde, et en même temps ne pas les connaître, je trouve ça sympa. Et en fait, il y a très peu de monde, qui me connaît dans la vraie vie, et qui connaît ce blog ... c'est mon petit monde à moi."*)

[18] Interview conducted on the 06.14.2011, with Violette, 32, living around Paris, mother of two, Master Degree in Anthropology, not working at the time of the interview. (*"Je veux faire tout comme j'ai fait, par moi-même.... Je veux vraiment une intervention minimale, euh, je veux pouvoir le faire.... Je veux juste que voilà quoi, que ce soit moi qui accouche, et que la personne soit là en tant qu'aide si besoin est."*)

[19] Interview conducted on the 12.13.2011 with Elisabeth, 33, living in Toulouse, mother of one, graphic designer. (*"J'ai fait ce choix, et je suis très contente. C'est une grande aventure, c'est la plus*

grande aventure que j'ai jamais faite!")
[20]Cynthia Scott, Tammy Esteves, Paul Ariès, and Gabor Zovanyi, just to name a few.

WORKS CITED

Ariès, Paul. *La simplicité volontaire contre le mythe de l'abondance.* Paris: La Découverte, 2011. Print.

Ariès, Philippe. *L'Enfant et la vie familiale sous l'Ancien Régime.* Paris: Seuil, 1975. Print.

Badinter, Elisabeth. *Le conflit: la femme et la mère.* Paris: Flammarion, 2010. Print.

Bauer, Ingrid. *Diaper Free! The Gentle Wisdom of Natural Infant Hygiene.* New York: Natural Wisdom Press, 2001. Print.

Becker, Howard. *Outsiders.* New York: Free Press of Glencoe, 1963. Print.

Beneytout, Christelle. *Les couches lavables, ça change tout !* Sète: Editions La Plage, 2008. Print.

Bourdieu, Pierre. *La Distinction : Critique Sociale du Jugement.* Paris: Les Editions de Minuit, 1979. Print.

Brocas, Anne-Marie, ed. «Les maternités en 2010: Premier résultats de l'enquête nationale périnatale.» *Etudes et Résultats* DREES 776 (October 2011): 1-8. Web.

Butler, Judith. *Gender Trouble: Feminism and The Subversion of Identity.* New York: Routledge, 1992. Print.

Castelain-Meunier, Christine. *La place des hommes et les métamorphoses de la famille.* Paris: Presses Universitaires de France, 2004. Print.

Castelain-Meunier, Christine. *Le ménage: la fée, la sorcière, et l'homme nouveau* Paris: Stock, 2013. Print.

Collectif Interassociatif autour de la Naissance (CIANE), ed. *Rapport moral et d'activités du CIANE 2013*, Paris, 2013. Print.

Cicchelli, Vicenzo. "La construction du rôle maternel à l'arrivée du premier enfant." *Recherches et prévisions* 63 (2001): 33-45. Print.

Druckerman, Pamela. *Bringing Up Bébé.* New York: Penguin Books, 2012. Print.

Durkheim, Emile. *The Rules of Sociological Method.* Paris: Revue Philosophique, 1894. Print.

Faircloth, Charlotte. "Mothering as Identity-Work: Long-Term Breastfeeding and Intensive Motherhood." *Anthropology News* 50.2 (2009): 15-17. Print.

Frydman, René. *Les secrets des mères*. Paris: Le Livre de Poche, 2008. Print.

Gaskin, Ina May. *Birth Matters: A Midwife's Manifesto*. New York: Pinter & Martin, 2011. Print.

Griffith, Mary. *The Unschooling Handbook: How to Use the Whole World As Your Child's Classroom*. Roseville: Three Rivers Press, 1998. Print.

Goffman, Ervin. *Stigmate*. Paris: Les Editions de Minuit, 1975. Print.

Hays, Sharon. *The Cultural Contradictions of Motherhood*. New Haven: Yale University Press, 1994. Print.

Institut National de la Statistique et des Etudes Economiques (INSEE). «Des effets de la crise sur le chômage.» *INSEE Faits et Chiffres*. Paris: INSEE, 2013. Print.

Knibiehler, Yvonne. *Histoire des mères et de la maternité en Occident*. Paris: PUF, 2000. Print.

Knibiehler, Yvonne. *Maternité, affaire publique, affaire privée*. Paris: Bayard, 2001. Print.

Leridon, Henri. *De la croissance zéro au développement durable*. Paris: Fayard, 2009. Print.

MacDonald Strong, Shari. *The Maternal is Political*. Berkeley: Seal Press, 2008. Print.

Martin, Dayna. *Radical Unschooling: A Revolution Has Begun*. Madison: CreateSpace, 2011. Print.

McKie, Linda, and Samantha Callan. *Understanding Families. A Global Introduction*. London: Sage, 2012. Print.

Mecklé, Pierre. *Sociologie des réseaux sociaux*. Paris: Editions La Découverte, 2011. Print.

Montel-Dumont, Olivia, ed. «Comment va la famille ?» *Cahiers français* 371 (novembre-décembre 2012): 25-32. Print.

Paltineau, Maya-Merida. *Femmes sans Enfants*. Sarrebruck: Editions Universitaires Européennes, 2011. Print.

Paltineau, Maya-Merida. "The Identity Work and Health of Intensive Motherhood." *Health, Culture and Society* 3.1 (2012): 171-183. Print.

Pison, Gilles. "France 2012 : fécondité stable, mortalité infantile en

baisse." *Population et Sociétés* INED 498 (March 2013): 1-4. Web.

Rich, Adrienne. *Of Woman Born*. New York: Bantam, 1976. Print.

Scott, Cynthia and Tammy Esteves. *Leadership for Sustainability and Change*. Oxford: Do Sustainability, 2013. Print.

Scott, Joan. *Gender and The Politics of History*. Revised ed. New York: Columbia University Press, 1999. Print.

Thurer, Shari L. *The Myths of Motherhood*. New York: Library of Congress, 1994. Print.

Touraine, Alain. *Le monde des femmes*. Paris: Fayard, 2006.

Van Gennep, Arnold. *Les rites de passage*. Paris: A. et J. Picard, 1909/1981. Print.

Winnicott, D.W. *The Child, The Family, and The Outside World*. Cambridge: Perseus Publishing: 1992. Print.

Winnicott, D.W. *Babies and Their Mothers*. Cambridge: Da Capo Press: 1992. Print.

Winnicott, D.W. *Talking to Parents*. Cambridge: Da Capo Press: 1994. Print.

Worldwatch Institute. *State of the World 2010: Transforming Cultures — From Consumerism to Sustainability*. New York: W. W. Norton & Co., 2010. Print.

Zovanyi, Gabor. *The No-Growth Imperative: Creating Sustainable Communities Under Ecological Limits to Growth*. New York: Routledge, 2012. Print.

Using a Quantitative Measure to Explore Intensive Mothering Ideology

VIRGINIA H. MACKINTOSH, MIRIAM LISS AND HOLLY H. SCHIFFRIN

With what price we pay for the glory of motherhood.
—Isadora Duncan

SHE IS THE EVER PATIENT PROVIDER of love and care, helping children with creative art projects while canning her own home-grown tomatoes. She is the so-called "super mom," running the boardroom as efficiently as she manages the household. What these cultural icons are not is cranky, tired, overwhelmed, or depressed. As Sharon Hays pointed out in her seminal work, *The Cultural Contradictions of Motherhood*, women are bombarded with mixed messages. Concurrent with more women actively pursuing careers, there has been a shift toward more "emotionally demanding, financially draining, labor-consuming child-rearing" (4). With these competing demands of professional success and the responsibility of guiding children to their full potential, whether she works outside the home or not, a mother feels guilty. If at work, she worries that her children are being harmed by her absence. If at home, she questions whether she is failing to contribute to the family's financial needs or live up to her own potential. As the other chapters in this book describe, the beliefs that Hays dubbed *Intensive Mothering* (IM) remain a dominant discourse of motherhood, but for the most part these attitudes have been studied through qualitative methods. The narratives collected and analyzed by Hays and others provide rich illustrations of maternal attitudes, but it is not clear what impact the assumptions and beliefs around motherhood have on the psychological health of women.

To further explore how these beliefs relate to assessments of mental well-being, a quantitative measure was developed. The Intensive Parenting Attitudes Questionnaire (IPAQ) (Liss et al. 635), based primarily on the work of Hays, provides a way to operationalize the components of IM and analyze how the ideology relates to other psychological constructs.

INTENSIVE MOTHERING IDEOLOGY

Based on the narratives collected from 38 mothers of two- to four-year-olds, Hays outlined three overarching themes of intensive mothering ideology. The first she called *the responsibility of individual mothers* (Hays *Cultural Contradictions* 98). The women expressed feeling pressured to live up to the cultural ideals of highly involved parenting. They saw themselves as responsible for every aspect of their children's lives, not trusting their partners to adequately care for the children in their absence. Typically, the issue was not unwillingness on the fathers' part to care for the children, but rather the mothers' assessment that their husbands were not capable of providing adequate care. Women found fault with the level of attention that dads paid to the children, failing to engage with them and provide structure. The mothers were torn between wanting more help from their male partners, and concern that the children would be harmed by lower quality care. For example, one mother said, "the way [my husband] takes care of [our son] is, he's like, I think he's *mindless*, to tell you the truth. He won't wipe his face off, he won't wash his face, he won't put his shoes on. I have to tell him to feed him or whatever" (Hays *Cultural Contradictions* 101). Studies have shown that these beliefs that mothers have of their superiority in child rearing lead to inhibiting the level of fathers' involvement, a concept known as *maternal gatekeeping* (Gaunt 374). Women are not always consciously aware of the extent to which they take on the managerial role of running the household. However, when they supervise the activities of the father, he ends up assigned the role of helper rather than equal partner (Gaunt 375).

Women feel deeply ambivalent about taking on so much of the responsibility around the home. While motherhood might be

viewed as 'natural,' it is not seen as easy. Under Hays' second theme, *intensive methods* (*Cultural Contradictions* 108), mothers spoke of the constant nurturing required to meet each child's individual needs, which take precedence over everything else. For example, one mother said, "I pay a lot of attention to my daughter. I make it very clear to her that she's very important.... I take the time to be with her and to listen to her and to do what she wants to be doing" (112). The children's needs are the hub around which the household revolves, with mothers saying things such as, "I let them establish their own schedule" (113), or "We work really hard to please him" (114). Furthermore, mothers felt directly responsible for assuring their children receive the proper level of stimulation, often engaging the children in expensive activities designed not just to entertain, but to promote positive emotional, cognitive, and social development. Not trusting themselves to adequately meet all of the requirements of parenting without guidance, the women felt the need to turn to expert advice. Hays summed up these intensive methods as "*child-centered, expert-guided, emotionally absorbing, labor-intensive,* and *financially expensive*" (8).

While in the midst of meeting these overwhelming demands of motherhood, the women expressed the belief that parenting should be joyful and fulfilling, a theme that Hays called *sacred children, sacred mothering*. Children were seen as precious and sanctified. Whether working outside the home or not, the mothers saw themselves as ultimately in charge of the care and protection of the most cherished of all beings. Historically, motherhood has been seen as sacrosanct, idealized to mythical proportions (Hare-Mustin and Broderick 114). Thus, the traditional view has been of the endlessly warm and caring mother as protectorate of the priceless offspring.

Other researchers have studied Hays' intensive mothering attitudes using similar qualitative approaches. Jackie Guendouzi interviewed both working and non-working mothers and found both groups were very traditional in their definitions of a "good mother." She is expected to be *protective, nurturing, caring, socializing, proud,* and *organized* (20). Some of the mothers in this study acknowledged their difficulty living up to the ideals of the 'good mother' and, instead, subscribed to the discourse of the "good enough mother," which Guendouzi defined as one "who copes de-

spite adversity" (27). Whether striving to live up to the ideal of the IM principles, or actively resisting them, the IM ideology impacted the way the women felt about themselves. This pressure to live up to the mythical, perfect mother begins even before a woman has children. Pyl Choi and colleagues found that new mothers have expectations that are strongly influenced by intensive mothering beliefs, and that the disparity between their expectations and the reality of actual parenting leads to feelings of inadequacy.

Thus, the ideology of intensive mothering can lead to shame, guilt, and worry. Part of a mother's worry is that if she fails to meet the expectations of IM, her children will not reach their intellectual or emotional potential. Using qualitative methods, Wall found that the cultural discourse on the importance of early brain development in infants has led mothers to believe that they must provide a high level of stimulation and engagement with their offspring to ensure children's proper cognitive development. Women are motivated to follow the intensive methods outlined by Hays, believing that they are ultimately in control of their children's developmental outcomes. For example, a mother in Glenda Wall's study stated; "I am very aware of that [importance in brain development in the early years]. As a result, reading and input into her brain. Right from the day she came home from the hospital, I was talking to her constantly, reading to her" (257). It is difficult for mothers to relax when each moment represents an opportunity to encourage optimal development. In the Wall study, this pressure to promote brain development led to feelings of guilt, angst, and exhaustion. Mothers felt badly when taking time for things other than stimulating their children, saying things like, "When I do need a break and I need to set her down in front of the TV for an hour, just to give myself some time to do something in the house or to give me a mental break, I feel guilty about that" (258).

Of course, not all the narratives collected in these studies are negative. Parenting can be a source of tremendous joy and pride, and the mothers in Hays' 1996 study reported that their lives would be "empty," "lonely," and "missing something" without children (109). However, it is difficult in a qualitative study to parse out exactly how these IM attitudes impact women's well-being, either positively or negatively. And, while Hays found that both working

and non-working mothers subscribe to the IM ideology, the two groups felt different pressures from conflicting societal messages. To better understand how various aspects of IM beliefs relate to women's mental health, a well-validated quantitative measure was developed.

THE DEVELOPMENT OF THE INTENSIVE PARENTING ATTITUDES QUESTIONNAIRE (IPAQ)

To create the IPAQ, we began with the themes Hays outlined in her 1996 book and the narratives of the mothers interviewed for her study and created 56 items rated on a scale from one (*strongly disagree*) to six (*strongly agree*). Hays' theme of *responsibility of mothers* was explored through questions such as "Mothers are best at organizing children's activities" and "Men are unable to care for children unless they are given specific instructions about what to do." For *Intensive Methods*, we wrote items such as "The child's schedule should take priority over the needs of the parents" and "Parenting is exhausting." For *Sacred Child/Sacred Mother*, we included items such as "Being a parent brings a person the greatest joy he or she can possibly experience."

Data were collected from 315 mothers on the full 56-item scale. An exploratory factor analysis indicated that 25 of the original items, grouped into five scales, formed a coherent measure of intensive parenting. A confirmatory factor analysis was conducted on a second sample of 280 women and confirmed the factor structure and the items on the measure, showing that the final 25 questions consistently held together into the five-factor model. The five scales expressed the ideas that (1) women are natural and superior parents to men (*Essentialism*), (2) parenting should be ultimately fulfilling and satisfying (*Fulfillment*), (3) children should be cognitively stimulated by parents in order to help them reach their optimal potential (*Stimulation*), (4) mothering is extremely difficult (*Challenging*), and (5) parenting should center around the needs of the child rather than those of the parent (*Child-Centered*).

Though the five scales relate to many of the themes first described by Hays they do not strictly follow all of her designations. Our measure of Essentialism closely parallels Hays' findings of the individual

responsibility of mothers. Three of our scales—Child-centered, Challenging, and Stimulation—overlap with Hays' writings on the *intensive methods* of parenting. Our fifth scale—Fulfillment—measures some of the qualities that Hays describes under *sacred child/sacred mother*, with women endorsing statements about the rewards and joys of having and loving children. Questions about children's innocence and need of protection, however, did not map on to any of our scales and were omitted from the final measure. It is possible that either the tone of these questions was too religious or the concept was too abstract for the participants to coherently endorse.

To test the validity of the five scales of the IPAQ, we compared it to related measures of parenting attitudes. No existing measure looked at intensive parenting per se, but three explore related constructs and allowed for both concurrent and discriminative validity. For concurrent validity, we looked to see if the IPAQ correlated well with items on existing measures that explore similar constructs, while discriminative validity involves assuring that the IPAQ differed enough from those measures to be exploring distinct elements of intensive parenting. The first measure was the Parental Investment in Child questionnaire (PIC) (Bradley et al.). The PIC assesses both behaviors and attitudes that parents have toward raising their children. It has four scales that assess *Acceptance of the Parenting Role, Delight, Knowledge/Sensitivity,* and *Separation Anxiety*. The scale is designed so that higher scores in each of the categories are seen as positive investments in parenting. In 1998, Hays criticized the PIC for its "perpetuation of a series of powerful yet outdated cultural assumptions regarding the "proper" relationship between mothers and children" ("Fallacious Assumptions" 782). She felt it pressured parents by equating appropriate parenting with the unrealistic expectation that parents always delight in the role, pine for their children when separated, and never resent the demands of accommodating the needs of their offspring. The PIC focuses on the benefits of parental investment without considering the costs associated with intensive parenting attitudes.

The relationships between the PIC and the different scales of the IPAQ revealed that intensive parenting attitudes have both positive and negative aspects. For example, the Child-centered, Fulfillment,

and Stimulation scales of the IPAQ were generally positively related to the PIC. However, the Essentialism scale was positively related to parenting delight and to separation anxiety, but negatively related to acceptance of the parenting role. This indicated that women who believed that mothers are natural parents and fathers are inferior at parenting were on the one hand, delighted with their children and anxious when separated from them, but, on the other hand, expressed frustration with their role as a parent. Similarly, the Challenging scale exhibited a pattern in which women who felt parenting was challenging also reported more delight with their children and more separation anxiety, but less acceptance of the parenting role.

Other measures used for construct validity were *The Parenting Sense of Competence Scale* (PSOC) (Johnston and Mash), and *Beliefs about the Consequences of Maternal Employment for Children* (BACMEC) (Greenberger et al.). The PSOC is a measure of parenting self-esteem, with the two underlying constructs being parental satisfaction and efficacy. The BACMEC is made up of two subscales: (1) benefits and (2) costs of maternal employment. The correlations between these measures and the IPAQ again indicated both positive and negative aspects to intensive parenting beliefs. For example, the Fulfillment scale was related to a sense of parenting satisfaction and efficacy, but the Challenging scale was related to lower levels of both measures of parental competence. The relationship between the IPAQ scales and women's perceptions of the cost and benefit of employment also presented a mixed picture. While the Essentialism, Fulfillment, Child-centered, and (to a lesser extent) Challenging scales were all related to perceiving a cost when women work, the Stimulation scale was actually related to perceiving a benefit. Thus, while intensive parenting ideology generally suggested benefits when mothers stay at home (e.g., make their life child-centered), the Stimulation scale was related to perceiving benefits when women work. We speculate that additional income relates back to Hays' notion that parenting is expensive. The benefit of working is being able to afford stimulating activities, such as piano lessons and travel soccer, which parents perceive as promoting optimal development.

As our findings and the narratives from Hays' 1996 book sug-

gest, intensive mothering is a mixed bag. The ideology includes the belief that parenting is both extremely rewarding and that it is extremely difficult. A mother may feel important and overwhelmed at the same time by the idea of being central to running the household. The emotions women have around the issue of parenting are multifaceted and complex. The five scales within the IPAQ all had a moderate positive correlation with each other (ranging from .24 to .51), confirming Hays's notion that intensive parenting beliefs are mutually reinforcing of each other. However, a total IPAQ score could paint a false view of parenting attitudes as uni-dimensional. For this reason, we suggest that results from the IPAQ are best understood using the five individual scales, rather than compiling a "total IPAQ" composite score.

USING THE IPAQ TO EXPLORE WORK STATUS AND DIVISION OF HOUSEHOLD LABOR

People might think that women who work outside the home are less likely to embrace the tenets of IM, but that is not the case. Hays found that women participating in the labor force felt just as responsible for the day-to-day needs of their children and were just as likely to "take primary responsibility for *every* child-rearing duty..." (99). The need to work and the need to center life around their children puts women in a difficult position because they feel "it is simply impossible to *pay* someone enough to love your child. And that love is absolutely crucial" (112).

Our work with the IPAQ supports Hays' assertions that IM beliefs are held by both working and non-working mothers, though they embraced different components. Essentialism was more strongly embraced by the stay-at-home mothers, whose identities are more likely to be tied directly to their role as parents (Johnston and Swanson). Stay-at-home mothers were also more likely to endorse the view that parenting is Challenging, which is consistent with the idea that they are the ones who must engage in highly intensive methods without getting much of a break. In contrast, mothers in the work force scored higher in Stimulation. Again, it may be that working mothers, who tend to have higher levels of disposable income, may have more opportunity to engage

their children in intellectually stimulating activities that come with a financial cost. In two of the IPAQ scales, Child-centered and Fulfillment, we did not find differences between working and non-working mothers.

Despite increased participation in the workforce, women continue to do a disproportionate amount of the household tasks and childcare (Coltrane; Lachance-Grzela and Bouchard). Inequity in household labor is higher among people who have more traditional gender role beliefs (Gaunt), but its relationship to IM ideology has not been explored. In our work, we found that an unequal division of household responsibilities and childcare was related to the scales of Essentialism, Fulfillment, and the belief that parenting is Challenging. It is possible that a belief in Essentialism leads to greater inequity through maternal gatekeeping (i.e., mothers prohibiting fathers' participation because they believe women are naturally better parents), or that doing more of the household chores and childcare contributes to mothers' views that being a mother is hard (Challenging). As our data are correlational, we cannot determine the direction of the effects. While past research has found that beliefs in maternal essentialism were associated with adolescents' greater anticipation of labor inequity (Bjarnason and Hjalmsdottir), our data suggest that belief in Essentialism is associated with actual inequity in household responsibilities.

INTENSIVE MOTHERING BELIEFS AND MENTAL HEALTH OUTCOMES

Using the IPAQ, we have begun to explore the impact that intensive mothering ideology has on women's mental health. In past studies, there have been mixed findings about the effect of parenting on well-being. Some studies have found that parenting is associated with negative outcomes such as depression (Evenson and Simon; Nomaguchi and Milkie), high levels of perceived stress (Nomaguchi and Milkie), and lower levels of overall happiness (Baumeister; Nomaguchi and Milkie). Other research has suggested that parenting actually increases mental well-being (Nelson et al.).

A possible explanation for these mixed findings may be that it is not parenting itself that determines well-being, but rather the

attitudes people bring to raising children. It could be that certain aspects of intensive parenting attitudes may be more related to negative mental health outcomes than others. Using the IPAQ, we examined how intensive parenting beliefs related to family social support, depression, life satisfaction, and perceived stress in a sample of 181 women with children up to the age of five-years-old (Rizzo, Schiffrin, and Liss). Three of the IPAQ scales were related to the mothers' mental well-being.

Women who endorsed high levels of Essentialism reported lower levels of life satisfaction and had higher stress scores. Higher Essentialism also correlated with lower family social support. Thus, women who felt more alone in having to care for their children felt greater strain from the burden and were less content with their lives. What is unclear is the direction of this relationship, whether being on her own brings about essentialist belief in mothers, or mothers who see themselves as the only worthy care providers reject aid from others. Do women who do not have social support believe they are better parents (e.g., "I'm doing it by myself, so I must be a good mother")? Alternatively, is it that holding essentialist beliefs is associated with refusing help from others? Given the known relationship between lack of social support and decreased well-being (Lyubomirsky, King, and Deiner), we also analyzed whether Essentialism was related to mental health variables above and beyond the effects of social support. We found that the more mothers held essentialist beliefs, the less satisfied they were with their lives. Even after the effects of social support were taken into consideration, believing that women are better parents may decrease well-being. This finding is counterintuitive in some ways. It would seem that if women think they are better at parenting, then they should feel good about themselves. However, our data suggest that essentialist beliefs, although they may sound complimentary to women, are related to lower maternal mental health.

Higher scores on the Challenging scale also were related to less life satisfaction and more stress. Women who found parenting especially hard also had higher levels of depressive symptoms. This relationship is likely to be bi-directional with women who are depressed finding parenting more challenging, as well as the

challenges leading to lower satisfaction and greater despair (Bell). Furthermore, believing that parenting is challenging was related to high levels of stress and depression even after the effects of family social support were controlled. Thus, the belief that parenting is difficult also poses a risk for women's mental health.

Finally, the Child-centered scores were also negatively correlated with life satisfaction, suggesting that women whose lives revolve around the needs of their children were less content. However, this relationship no longer held when the amount of family support was taken into consideration. As Hays found, women are pulled in many directions. Women who focus their lives on the responsibilities of motherhood may feel shortchanged in other areas of their lives, but active support from other family members can ameliorate these stressors.

The Fulfillment and Stimulation scales did not relate to the maternal mental health measures in our study. Perhaps a sense of fulfillment in the mothering role acts as a buffer against the stressors of intensive parenting, with the joys offsetting the challenges. It is more difficult to interpret the lack of relationship with the stimulation scale. The stimulation scale had the lowest reliability of the five scales in our measure, so more research is necessary to determine the relationship (if any) between the perceived pressure to stimulate children's cognitive development and maternal mental health. Again, these findings illustrate the need to consider the IPAQ scales individually, rather than calculating a composite score.

MOTHERS VERSUS NON-MOTHERS AND THE IPAQ

We were also interested in the formation of IM attitudes even before a woman has children. Therefore, we administered the IPAQ to a group of women who have not had children and found it to be a reliable measure of their parenting attitudes (Liss et al.). We found that non-mothers had views similar to mothers regarding children being fulfilling, but they differed from mothers on the other four scales. Non-mothers had higher scores than mothers on the Stimulation and Child-centered scales, suggesting that they think it is important for mothers to adapt their schedules to their children's and remain continuously engaged with them. Not surprisingly,

mothers were more likely than non-mothers to endorse the idea that parenting is hard. Mothers also scored higher in Essentialism. Prior research has found that women have high expectations of their parenting before having children and feel badly when they fail to live up to those unrealistic beliefs (Choi et al.). Our findings fit with this idea that young women anticipate being able to center their lives around their children, but that mothers actually juggling home, career, and family have to adjust to the reality of conflicting demands.

MOTHER, FATHER, OR PARENT?

One of Hays' ("Fallacious Assumptions") criticisms of the PIC was that, even though the measure referred to "parents," it is really mothers who will take primary responsibility for raising children. Therefore, we conducted an experiment to determine whether peoples' intensive parenting beliefs differed for mothers, fathers, or parents in general. We randomly assigned 322 college students to one of three versions of the IPAQ—one using "mother," one using "father," and one using "parent" as the referent for questions. However, we did not change the referent on the Essentialism scale because those items specifically measured the idea that women were more capable parents than men. As predicted, mothers were not found to be significantly different from parents on any of the five IPAQ scales. However, being a father was rated as being less challenging than being a parent. There were also differences between how mothers and fathers were rated. Although we hypothesized that intensive parenting ideologies would be most strongly endorsed for mothers, we actually found participants indicated more agreement when the Fullfilment and Child-centered items were asked about fathers. Upon examining the items on these two scales, we noticed that many asked whether fathers *should* be fulfilled by their children or *should* make their lives child-centered. Thus, this finding may reflect a hesitancy to prescribe a greater level of involvement for mothers than mothers already have as well as a hope that fathers would be more involved than they currently are.

We also examined whether male and female participants differed in their views of intensive parenting. Overall, women scored higher

on the IPAQ then men, specifically on the Fulfillment, Challenging, and Stimulation scales. Thus, intensive parenting ideologies were more strongly endorsed by young women, whether it was referring to a mother, a father, or a parent. If women think that parents should be more intensively involved with children than men do, they may end up doing more of the childcare when they become parents because prior research has found that individuals who have higher standards generally do most of the work (Alberts, Tracy, and Tretheway 26). For example, young women may end up doing the majority of activities with their children when they become mothers because they place higher value than men on the importance of providing stimulating activities. The notion that the women in this sample will likely take on a disproportionate amount of childcare was supported by data on their ideal life plans. The majority of women anticipated taking off significant time after the birth of a child, while the majority of the men anticipated only having a minor interruption to their work after a child was born.

The results of this study present a paradox in terms of the expectations of young men and women. Although participants endorsed aspects of intensive parenting more strongly for fathers than mothers, there was evidence from our study that the goal for fathers to be intensively involved with their children may not be realized for a couple of reasons. First, young women more strongly endorsed intensive parenting attitudes than men, which has been associated with doing more childcare in samples of mothers. Second, women had greater expectations that they would interrupt their work after the birth of a child, whereas men expected little to no interruption. It was encouraging that neither the male nor female participants strongly endorsed essentialism, which has been associated with inequity in division of household labor in prior research. Thus, the idea that women should take on the majority of the childcare work appears to be falling out of favor among young men and women who will likely become parents in the next five to fifteen years. However, one of the consequences of intensive parenting beliefs may be to keep childcare primarily in the hands of women, which may ultimately serve to replicate essentialist attitudes about gender and impede equality in childcare.

NEXT STEPS

Through the development of the IPAQ, we were able to confirm the three key tenets of intensive parenting identified by Hays and discovered that further distinctions within the theme of *intensive methods* are meaningfully related to some outcomes (e.g., the belief that parenting is challenging was negatively related to maternal mental health, while believing intellectual stimulation is important was not). We have found that women, both mothers and non-mothers, still seem to ascribe to intensive parenting beliefs suggesting that it continues to be the dominant discourse of motherhood (Arendell). In addition, we confirmed Hays' qualitative findings that both working mothers and stay-at-home mothers hold themselves to the intensive parenting ideal, but may implement it differently by emphasizing different aspects of it. We also have found some concerning evidence that intensive parenting beliefs may exacerbate gender inequality in the division of childcare, limit women's social support, increase their stress, and reduce their satisfaction with life.

However, there is still much to learn about intensive parenting attitudes. The majority of participants in our studies have been white, non-Hispanic women from relatively high socioeconomic backgrounds. Although this is the group most likely to utilize intensive parenting methods, future research should explore the universality of IM beliefs across populations in terms of racial, ethnic, and socioeconomic diversity. In addition, further exploration is necessary to examine how intensive parenting beliefs impact maternal stress levels and, ultimately, children's outcomes. Studies have indicated that parental stress can influence children's level of stress, which has been associated with the development of psychopathologies. The relationship tends to be indirect, with the quality of parents' interactions with their children moderating the effect between stress and poor developmental results (Crnic and Low 258). Thus, any study of the impact IM attitudes and child outcomes would have to look beyond the *beliefs* that mothers have about parenting and consider how those beliefs translate into actual parenting behaviors. Finally, we have not yet considered how characteristics of the children (e.g., developmental disabilities) impact IM beliefs. Different children make different demands on

their parents. Mothers of children with special needs may feel especially pressured to provide stimulation, and to take on the bulk of the caregiving responsibilities for their offspring.

The narratives collected by Hays reflect the stress and anxiety mothers may experience when trying to live up to the demands of work and parenting, but her work was limited to a small group of women with preschool aged children. Though they provide a rich source of information, interviews are time consuming to conduct, transcribe, and analyze. The questionnaire format of the IPAQ allows us to see how IM manifests over larger and more diverse groups of women (e.g., different races/ethnicities and SES). In addition, it allows people to examine the relationship between IM and many other constructs that have well validated measures (such as mental health outcomes and child outcomes). We hope that the IPAQ will provide quantitative data that complements the qualitative research being conducted to shed light on the influence of this ideology on behavior (such as the division of household labor and childcare) and well-being (life satisfaction, stress, and depression). By exploring various elements of intensive mothering ideology, we can gain further insights into the joys and the challenges of being a parent.

Appendix

The Intensive Parenting Attitudes Questionnaire

1. Both fathers and mothers are equally able to care for children.
2. Although fathers may mean well, they generally are not as good at parenting as mothers.
3. Parents should begin providing intellectual stimulation of their children prenatally, such as reading to them or playing classical music.
4. Although fathers are important, ultimately children need mothers more.
5. Parents never get a mental break from their children, even when they are physically apart.
6. Ultimately, it is the mother who is responsible for how her child turns out.

7. Being a parent brings a person the greatest joy he or she can possibly experience.
8. Parenting is exhausting.
9. It is important for children to be involved in classes, lessons, and activities that engage and stimulate them.
10. Parenting is not the most rewarding thing a person can do.
11. The child's schedule should take priority over the needs of the parent's.
12. Men do not recognize that raising children is difficult and requires skills and training.
13. Child rearing is the most demanding job in the world.
14. Holding his or her baby should provide a parent with the deepest level of satisfaction.
15. Being a parent means never having time for oneself.
16. Women are not necessarily better parents than men.
17. Men do not naturally know what to do with children.
18. A parent should feel complete when he or she looks in the eyes of his or her infant.
19. Children should be the center of attention.
20. Men are unable to care for children unless they are given specific instructions about what to do.
21. Finding the best educational opportunities for children is important as early as preschool.
22. It is harder to be a good parent than to be a corporate executive.
23. To be an effective parent, a person must possess wide ranging skills.
24. Children's needs should come before their parents'.
25. It is important to interact regularly with children on their level (e.g. getting down on the floor and playing with them).

Scale Coding
Items are presented on a scale from 1 = (*strongly disagree*) to 6 = (*strongly agree*)

Essentialism: 1, 2, 4, 6, 12, 16(r), 17, 20
Fulfillment: 7, 10(r), 14, 18
Stimulation: 3, 9, 21, 25
Challenging: 5, 8, 13, 15, 22, 23
Child-Centered: 11, 19, 24

WORKS CITED

Alberts, Jess K., Sarah J. Tracy, and Angela Trethewey. "An Integrative Theory of the Division of Domestic Labor: Threshold Level, Social Organizing and Sensemaking." *Journal of Family Communication* 11 (2011): 21-38. Print.

Arendell, Terry. "Conceiving and Investigating Motherhood: The Decade's Scholarship." *Journal of Marriage and the Family* 62 (2000): 1192-1207. Print.

Bell, Richard Q. "A Reinterpretation of the Direction of Effects in Studies of Socialization." *Psychological Review* 75 (1968). 81-95. Print

Bjarnason, Thoroddur, and Andrea Hjalmsdottir. "Egalitarian Attitudes Towards the Division of Household Labor Among Adolescents in Iceland." *Sex Roles* 59 (2008): 49-60. Print

Bradley, Robert H. et al. "Parents Socioemotional Investment in Children." *Journal of Marriage and the Family* 59 (1997): 77-90. Print.

Choi, Pyl, Carol Henshaw, S. Baker, and J. Tree. "Supermum, Superwife, Supereverything: Performing Femininity in the Transition to Mother." *Journal of Reproductive and Infant Psychology* 23 (2005): 167-180. Print.

Crnic, Keith, and Christine Low. "Everyday Stresses and Parenting." *Handbook of Parenting, Volume 5: Practical Issues in Parenting*. Ed. Marc Bornstein. MahWah, nj: Lawrence Erlbaum Associates (2000). 243-267. Print

Evenson, Ranae J. and Robin W. Simon. "Clarifying the Relationship Between parenthood and Depression." *Journal of Health and Social Behavior* 46 (2005): 341-358. Print.

Gaunt, Ruth. "Biological Essentialism, Gender Ideologies, and Role Attitudes: What Determines Parents' Involvement in Child Care." *Sex Roles* 55 (2006): 523-533. Print

Gaunt, Ruth. "Maternal Gatekeeping: Antecedents and Consequences." *Journal of Family Issues* 29 (2008): 373-395. Print.

Greenberger, Ellen. et al. "Beliefs About the Consequences of Maternal Employment for Children." *Psychology of Women Quarterly* 12 (1988): 35-59. Print.

Guendouzi, Jackie. "The Guilt Thing": Balancing Domestic and

Professional Roles." *Journal of Marriage and Family* 68 (2006): 901-909. Print

Hays, Sharon. *The Cultural Contradictions of Motherhood.* New Haven: Yale University Press, 1996. Print.

Hays, Sharon. "The Fallacious Assumptions and Unrealistic Prescriptions of Attachment Theory: A Comment on 'Parents' Socioemotional Investment in Children.'" *Journal of Marriage and Family* 60 (1998): 782-795. Print.

Johnston, Charlotte, and Eric J. Mash. "A Measure of Parenting Satisfaction and Efficacy." *Journal of Clinical Child Psychology* 18.2 (1989): 167-175. Print.

Johnston, Deirdre D. and Debra H. Swanson. "Constructing the "Good Mother": The Experience of Mothering Ideologies by Work Status." *Sex Roles* 54 (2006): 509-519. Print.

Liss, Miriam, et al. "Development and Validation of a Quantitative Measure of Intensive Parenting Attitudes." *Journal of Child and Family Studies* 22 (2013): 621-636. Print.

Lyubomirsky, Sonja, Laura King, and Ed Diener. "The Benefits of Frequent Positive Affect: Does Happiness Lead to Success?" *Psychological Bulletin* 131 (2005): 803-855. Print

Nelson, S. Katherine, et al. "In Defense of Parenthood: Children are Associated with More Joy Than Misery." *Psychological Science* 24.1 (2012): 1-8. Print

Nomaguchi, Kei M., and Melissa Milke. "Costs and Rewards of Children: The Effects of Becoming a Parent on Adults' Lives." *Journal of Marriage and the Family* 65 (2003): 356-374. Print.

Rizzo, Kathryn M., Holly H. Schiffrin and Miriam Liss. "Insight into the Parenthood Paradox: Mental Health Outcomes of Intensive Mothering." *Journal of Child and Family Studies* 22.5 (2013): 614-620. Print.

Wall, Glenda. "Mothers' Experience with Intensive Parenting and Brain Development Discourse." *Women's Studies International Forum* 33 (2010): 253-263. Print.

Part II:
Intensive Mothering Today

State Intervention in Intensive Mothering

Neo-liberalism, New Paternalism and Poor Mothers in Ohio

CHRISTI L. GROSS, BRIANNA TURGEON, TIFFANY TAYLOR AND KASEY LANSBERRY

IN 1996, IN HER BOOK, *The Cultural Contradictions of Motherhood*, Sharon Hays postulated that "intensive mothering" is the ideology that now governs mothering within the United States, and thus serves as the ideal form of parenting that differentiates 'good' and 'bad' mothers. Even when mothers lack the resources to enact this form of motherhood, the intensive mothering ideology plays a role in how women of various social positions understand their mothering experiences (Arendell "Hegemonic Motherhood" 21; Brown 8; Buzzanell, Waymer, Tagle, and Liu 213; Damaske 441; Kirkman, Harrison, Hillier, and Pyett 291). Yet, ultimately, underlying constructions of intensive mothering is the image of white, middle-class women (Collins 62-64; Johnston and Swanson 26), as the cultural contradictions surrounding present-day mothering have been found to vary by race and social class (Arendell "Conceiving and Investigating Motherhood" 1201; Sutherland 312; Taylor 900).

As such, while intensive mothering is held on a pedestal as an ideal form of parenting, not all women have an equal opportunity to enact it. One subset of women in the United States who are largely blocked from opportunities to engage in intensive mothering represents women who participate in state run welfare-to-work programs. Utilizing primary data from open-ended telephone interviews with Ohio welfare-to-work program managers (N=69), in this chapter we aim to explore how welfare-to-work program managers conceptualize what constitutes "good" motherhood for welfare recipients.

THE RISE OF NEO-LIBERALISM AND NEW PATERNALISM

Welfare programs in the United States, as originally conceived under New Deal policies, were intended to provide a social safety net for white, female widows with children, a population for which dependency was thought to be culturally acceptable (Misra, Moller, and Karides 485). As such, these early variations of welfare were marked by paternalism, in the sense that policy makers believed white widows with children required (and deserved) governmental protection (Neubeck and Cazenave 45). However, during the 1950s, large-scale welfare rights protests and legal challenges prompted the federal government to expand welfare accessibility to additional populations, namely, racial and ethnic minorities; this change, in turn, resulted in a shifting of our cultural depiction of dependency (Misra, Moller, and Karides 485).

This changing cultural depiction of dependency coincided with the rise of neo-liberalism in the U.S during the 1980s and 1990s. Neo-liberalism can be defined as an ideology that rewards free-market workers, specifically those individuals who have made the "life choices", such as delaying pregnancy and educational investment, that allow them to adequately compete in the free-market place (Soss, Fording, and Schram 21). In other words, the ideology of neo-liberalism reinforces the belief that the U.S. operates as a meritocratic system in which upward mobility is attainable via hard work and proper life choices (Baker 11-13). Championed by such political conservatives as Ronald Reagan, the ideology of neo-liberalism served to shape the public discourse concerning the government's responsibility to non-workers (i.e., the poor), subsequently influencing social service delivery to those populations who depend on welfare programs for financial assistance (Cassiman 1692).

This individualistic neo-liberal rhetoric, along with race and gender-based stereotypes regarding welfare recipients, led to the rise of the image of the "welfare queen" in the 1980s, an image which serves to attribute blame for poverty on poor individuals [women], effectively redirecting attention away from the systematic causes of inequality (Gilens 67; Neubeck and Cazenave 136; Hancock 12; Foster 167). Classist, racist, and sexist images of

welfare recipients, underpinned by the ideology of neo-liberalism, culminated in the passage of the *Personal Responsibility and Work Opportunity Reconciliation Act* (PRWORA) in 1996.

PRWORA ushered in a host of new welfare policies, including Temporary Aid for Needy Families (TANF), a revised version of the cash assistance program that stresses "welfare-to-work" in the form of enforced work requirements. Adult TANF recipients are overwhelmingly women; for example, in the fiscal year 2010 (i.e., our data collection period), over 85 percent of recipients were women (U.S. Department of Health & Human Services). Thus, because having at least one child is a condition of TANF receipt, when we discuss welfare clients, we are typically referring to welfare *mothers*. And although PRWORA policies were designed with the two-family parent in mind (Schram 57), almost 90 percent of adult TANF recipients in 2010 identified as the head-of-household (U.S. Department of Health & Human Services). Therefore, not only do mothers comprise the vast majority of TANF clients, but many TANF clients are also single mothers.

As such, the new welfare policies under PRWORA disproportionately impact women, including the penalization of mothers who give birth to additional children while receiving TANF (i.e., otherwise known as the "family cap"), the penalization of mothers who could/would not establish paternity for their children and/or pursue child support, and the provision of financial incentives for mothers who married while receiving assistance (Neubeck and Cazenave 159; Hays *Flat Broke* 66-68). As is evident in such policies as the family cap, researchers have argued that the TANF program under PRWORA adopts a social services delivery philosophy based on the idea that recipients are incompetent or lack the capacity for personal responsibility (Ben-Ishai 43). To this end, TANF programs under PRWORA have been described as a form of "new paternalism," with the "new" label applied to indicate that the PRWORA mandated programs are reminiscent of earlier paternalistic public assistance programs (Neubeck and Cazenave 136; Ben-Ishai 50). In other words, in the new paternalism service delivery mode, clients are seen as incapable of making rational decisions on their own and as such, it is both necessary and desirable for the state to intervene in recipients' decision-making. By constructing clients in

this way, these ideologies disempower them, stripping them of much of their agency. New paternalism similarly influences child welfare policies and practices by drawing on parental "incompetence" to disempower parents and children alike (Swift 125).

The new paternalism underlying the PRWORA welfare programs has resulted in a social service delivery approach that is supervisory and intrusive in nature. Examples of state intrusion and supervision in mothering under PRWORA include regular meetings with welfare caseworkers, mandatory vaccinations for children, and punitive consequences (such as a loss of TANF benefits) for mothers for their child's school truancy (Chavkin 478; Hays *Flat Broke* 76). Reflecting the prominence of the neo-liberalism perspective in our conceptions of "dependency", the ideology of new paternalism also advocates that many of the social problems that plague citizens can be overcome via work and civic engagement (Bruch, Ferree, and Soss 221). As viewed through the lens of neo-liberalism, the new paternalism of PRWORA aims to "teach" dependent populations how to function as productive, free-market workers.

Thus, current U.S. welfare programs are based on "conditionality", in which clients must behave in a certain way (as dictated by the State) in order to receive benefits (Ben-Ishai 45). As previously noted, one such way in which welfare mothers must behave in order to receive benefits as dictated by the state includes completing a certain amount of work participation hours per week. Regardless of a client's career goals or aspirations, clients must complete these weekly hours, with alternative forms of labor, such as stay-at-home motherhood, discouraged (Limoncelli 82; Hays *Flat Broke* 92). In this way, current welfare-to-work programs emphasize paid labor and de-emphasize social and reproductive labor (Limoncelli 82; Ben-Ishai 61). Unsurprisingly, this privileging of paid work over unpaid work is consistent with the ideologies that underscore both capitalism and neo-liberalism (Rothman 13-14; Taylor 900).

Because of this state intervention and intrusion in their decisions about balancing unpaid mothering work with paid work (Collins and Mayer 116; Taylor 900), welfare mothers may experience increased constraints in their ability to engage in intensive mothering regardless of their parenting preferences. Current welfare programs, grounded in neo-liberal ideology, push the "idealized" version of

motherhood onto their clients through an array of programs and institutionalized language, in that mothers should be in the paid labor market, providing a model for their children, and should be able to accrue the financial resources necessary to support their family independent of government assistance.

These constraints have also been documented by Hays in *Flat Broke with Children: Women in the Age of Welfare Reform*. In the period following welfare reform, Hays conducted field research at the welfare offices in two U.S. cities in an effort "to uncover the implicit and explicit message of welfare reform regarding work and family, dependence and independence, and competitive individualism and commitment to others" (*Flat Broke* 28). According to Hays, there are two competing messages sent by welfare reform: the "Work Plan" and the "Family Plan", with the "Work Plan" placing emphasis on paid labor as a pathway to self-sufficiency, and the "Family Plan" placing emphasis on stability of family life (i.e., marriage) as a viable alternative to paid labor (*Flat Broke* 19). However, Hays observed that welfare case workers at both sites rarely emphasized this "Family Plan," with much of the focus being directed toward paid labor as the most effective means to attain self-sufficiency (*Flat Broke* 33).

In this way, welfare mothers' struggles to balance work and home mirror the struggle of all mothers in our society with respect to balancing paid work and parenting (Hays *Flat Broke* 76). The expectations associated with intensive mothering, coupled with neo-liberal expectations for all members in society to be productive create a "cultural contradiction" that places mothers in a situation in which they cannot win (Hays *Cultural Contradictions* 9). However, as previously noted, researchers have suggested that these "cultural contradictions" may vary by class and race (Arendell "Conceiving and Investigating Motherhood" 1201; Sutherland 312; Taylor 900). For example, working- and lower-class mothers face additional contradicting expectations, as they are pressured to work outside of the home in order to be able to support their family financially independent of government assistance, and to serve as a role model for their children as our next generation of workers (Arendell "Hegemonic Motherhood" 4; Bloch and Taylor 207; Kennelly 169; Chavkin 477-478; Taylor 900).

In this chapter, we analyze interview data from Ohio welfare-to-work program managers in order to explore how program managers conceptualize the mothering experiences of their clients. We expand on the concept of intensive mothering by focusing on a group of mothers who are often constrained by both their lack of resources and state policies in their efforts to meet the stringent standards of "good" mothering. We specifically look at how the ideologies of neo-liberalism and new paternalism influence the way that program managers talk about and evaluate their clients' roles as mothers.

METHODS

To examine state intervention in intensive mothering, we use telephone interviews conducted with program managers from the Ohio Works First (OWF) program in Ohio (USA). OWF is Ohio's welfare-to-work TANF program, and is administered at the county level. In 2010, there were 65,672 adult TANF recipients in Ohio, with ages ranging from under 20 years old (6.3 percent), 20-29 years, (55.8), 30-39 years (25.6 percent), 40-49 years, (10.2 percent), and over 49 years (2.1 percent). These adult recipients identified as white (59.0 percent), African American (37.3 percent), Hispanic (2.6 percent), Native American (0.1 percent), Asian (0.7 percent), and Multi-Racial (.04 percent). Over 80 percent of these adult recipients were women (U.S. Department of Health & Human Services). Having at least one child is an eligibility requirement for receiving TANF as an adult in Ohio, with the additional eligibility criteria of maintaining custody of the child/children (Ohio Department of Jobs and Family Services).

Our sample includes 69 of the 88 counties in Ohio, which accounts for around 75 percent of the population. There is little diversity among program managers administering Ohio Works First. Of the 69 managers, 53 (77 percent) are women and 16 (23 percent) are men. With respect to race, 65 managers identified as white or Caucasian, one manager identified as African American or Black, 1 manager identified as Latino/a or Hispanic, and two managers declined to answer the question. The interviews were conducted in 2010-2011, are semi-structured, and range from

under an hour to almost two and a half hours. Program managers for Ohio Works First perform a wide range of administrative duties, some of which include supervising and integrating the work experience program, ensuring program requirements are fulfilled, coordinating with other local service-providers, and in some instances caseworker duties.

For this analysis, we draw quotations from our data that highlight the ways in which OWF program managers talk about motherhood for welfare clients. Specifically, we bring forward examples that illustrate how the ideologies of new paternalism and neo-liberalism frame how program managers talk about welfare and about the mothers receiving welfare. To do this, we systematically analyzed the data through a process that allowed us to uncover patterns in the data. Identification numbers were randomly assigned to the counties in order to protect the confidentiality of the respondents.

RESULTS

With respect to Ohio welfare-to-work program managers' conceptualizations of motherhood for welfare clients, two primary themes emerged in our data: (1) a paternalistic approach to service delivery; and (2) an emphasis on paid labor as a core component of good motherhood (i.e., "good" mothers work).

A Paternalistic Approach to Service Delivery

Consistent with prior research in this area (e.g., Neubeck and Cazenave 136; Ben-Ishai 54), paternalism is a prevalent theme in our data. In many instances, paternalistic language is evident in the way that program managers discuss the need to "teach" welfare mothers. Underlying the beneficent appearance of the goal to teach these women skills is the logic that as a dependent population, welfare mothers lack knowledge about work and everyday life. For example, when discussing the goal of welfare-to-work programs, a female manager states:

> *You know we want, it's all about teaching them soft skills it's about reminding, getting people back in the work force*

> *knowing that they have to get up and go to work every day, that they have to be on time, that they learn how to follow directions.* [County 10]

Another common paternalism theme in our data relates to the need to "hand-hold" clients through the welfare process, which corresponds with the new paternalism approach to service delivery that assumes that service recipients are incapable of making proper decisions. These types of assumptions often attribute failure to succeed in the program to "personal motivation," which reveals the overarching presence of neo-liberalism, as well as how neo-liberalism and new paternalism jointly influence program managers' conceptions of motherhood. To illustrate, a male program manager suggests that expanded case management services would greatly benefit his clients:

> *I think we, most of my clients need more case management ... because obviously, with me being one caseworker, I have six hundred and forty clients. Um, I can't do case management, so, you know, they wouldn't, they, they would probably, you would looking at, you would need some kind of agency that would do case management. Do an actual, you know, um would help motivating people to do what they're supposed to. A lot more hand-holding. I'm not able to do the hand-holding.* [County 1]

In addition to demonstrating a paternalistic approach to service delivery, this quote also shows a desire to increase the levels of surveillance, involvement, and supervision in the lives of welfare mothers. In essence, this type of new paternalism approach constructs welfare mothers as unable to manage on their own, and as such, in need of "motivating ... to do what they're supposed to."

The Emphasis on Paid Labor as a Core Component of Good Motherhood

Emphasis on paid labor as a core component of "good" motherhood is an additional prevalent theme in our data. This theme shows the prominence of neo-liberal ideals in constructing the

motherhood of women on public assistance. In an illustration of this, when asked what makes some clients more successful than others in achieving self-sufficiency, a female program manager replied:

> *...that's the biggest thing, someone that truly wants to work. And, and sometimes, you know, people will tell you they want to work but there are other issues fighting that desire. And it could be mental, it could be physical, it could be a boyfriend in the household that just gives you grief when you're not there. You know, it could be lots of different things. It could be your mother yapping at you that you're not a good mom unless you stay home and take care of your kids. Which according to my mother that's, you know, that was her goal in life, to stay home and take care of kids. I'm like, are you kidding me? She doesn't know where I got my, I mean I love my two little brats but you know, I'd go nuts if I stayed home with them. She says why would you want to work? You know, you stay home and take care of your family. I said my family is doing just fine, mom. To her, her ideal situation is to have some nice man with a good job that would enable her to stay home. That's not my ideal situation. My ideal situation is me having a job that I take care of myself and my kids if I need to without him.* [County 78]

From this example, it is clear that this program manager defines good motherhood for both herself and welfare clients as occupying a position in the paid labor market. This quote also reflects the "cultural contradictions" of motherhood by illustrating contrasting expectations of what motherhood should look like. Additionally, this quote shows an ideology consistent with intensive mothering, in that the primary goal of working in the paid labor force should be the financial support of one's children, rather than the personal fulfillment or satisfaction of the mother. By differentiating her mothering philosophy with her own mother's parenting philosophy, this program manager also highlights how conceptions of good motherhood have shifted over the last few

generations. Furthermore, we again see the influence of neo-liberal ideals—specifically the ideals of individualism and of hard (paid) work leading to success—on how program managers talk about welfare mothers. For this program manager, her valuation of paid labor over unpaid labor aligns perfectly with the ideology of neo-liberalism.

A male program manager also describes working in the paid labor market as a fundamental component of good parenthood:

> *Yeah, and another thing is some people, you know, just like in anything else, some people can't do certain things, you know. And those jobs are all being shipped overseas. You know the jobs that those people—you know—they'd be able to do. You know what I mean? There's uh, when it comes down to it, either you're gonna flip burgers or go on welfare. Those are your choices. And I know what my choice would be if I had, if I was faced with a situation like that. I would work two, three different jobs, do what I had to do to feed my family.* [County 18]

This quote reflects the ideologies of intensive mothering and neo-liberalism by suggesting that welfare clients should do what is necessary in order to provide financially for their families. Moreover, this program manager also expresses an assumption compatible with new paternalism in that welfare mothers do not sufficiently value paid labor, and because of a lack of marketable skills, will be unable to secure stable positions in the paid labor market.

As working mothers and fathers, many of the program managers frequently couched their parenting/work philosophy from a place of "if I have to do something, then clients should have to as well." For example, contrasting a welfare client's work ethic with her own work ethic, a female program manager maintained:

> *And, you know, we had one gal that was working in here, um, husband had some mental issues, and um, she just kept missing work and missing her hours. But yet we can back it up if he was seeing a counselor and their local counseling*

services organization, and um, and the kids are then having problems at school and she gets called into the school. So we are able to document those things. And so I don't have a problem with that. I know life happens. But um, but we try to let them know too that a lot of people that are sitting here working today in our office have problems too going on out there, but they're here today. So trying to teach them that, you know, there's a balance and you know? [County 86]

Expressing a similar sentiment regarding sanctioning leeway, a female program manager replied:

Really gets frustrating on our end because, it's like, we would like to tell them: "You know, we have to go to work every day, if we didn't show up to work we would get fired." And you know that boss never has to take us back. [County 72]

In this way, our data is consistent with the observations advanced by Hays, in that welfare mothers' struggles to balance work and home mirror the struggle of all mothers in our society with respect to balancing paid work and parenting (*Flat Broke* 76). In an effort to assuage some of these struggles, one of the key changes ushered in by the passage PRWORA was the expansion of state-run subsidized child care programs. And although state-run subsidized child care programs present with a multitude of problems for welfare mothers (Hays, *Flat Broke* 76), program managers frequently referred to the availability of subsidized child care as a primary way in which TANF allows mothers to enter or re-enter the paid labor market. For example, a female manager dismissed welfare mothers' concerns about placing their children in child care by stating:

I'll come and introduce you to two hundred women in this office right now that have their children in daycare and I don't think they wanted to do it either. [County 11]

In other words, "good" mothers (like welfare program managers)

satisfy neo-liberal demands by working in the paid labor market, and "good" mothers need to be willing to leave their children in daycare in order to do so.

An additional facet of the theme of emphasizing paid labor as a core component of good motherhood, concerns mothers serving as role models for their children. Importantly this "role model" status is only realized once one is working in the paid labor market. A female program manager demonstrates this idea when asked to describe the ideal participant for the Ohio Works First program:

Actually [I am] someone who [pause], I'm trying to choose my words here [pause], someone who truly wants to become successful. And again, not by the almighty dollar sign but by being able to be self-sufficient, and take care of themselves and their family. And be, um, a good role model for their kids. Those tend to be the people that are more likely to become self-sufficient too. [County 25]

This logic that stipulates that serving as a good role model for children depends on a mother's ability to function as a productive worker reflects the ideologies of intensive mothering, neo-liberalism, and new paternalism. This particular quote reflects the ideology of intensive mothering by placing caring for the family at the center of the desire to work. Thus, "good" motherhood not only requires productive labor, but also mandates that the productive labor be motivated by child/family-centered concerns. Consistent with the ideals of new paternalism and neo-liberalism, this quotation also illustrates that role models will be necessary in order for clients' children to learn how to work productively.

Other program managers did express an understanding of some welfare mothers' preferences for remaining at home with their children. However, given Ohio's economic climate during the period of our data collection (with unemployment ranging from 10.0 percent in 2010 to 8.6 percent in 2011 [Bureau of Labor Statistics]), these program managers positioned stay-at-home motherhood as an unrealistic and impractical option. For example, a female program manager claimed:

You know we all would have loved to stay at home with our children. You know and that has not changed. You know in today's economy unfortunately it doesn't allow us to do that but there seems to be that mindset, well I want to stay home with my children. Well, you know, it's not always possible, especially in their situation. [County 13]

Ohio welfare-to-work program managers infrequently referenced the "Family Plan" in our interviews. A few programs managers mentioned family planning (e.g., the dangers of teen pregnancy and having children by multiple fathers), but there were no instances in which managers positioned marriage as the preferred path to self-sufficiency. In this way, our data is consistent with Hays' observation that the focus of welfare program managers tends to center on promoting the "Work Plan" as the most viable avenue for mothers to attain self-sufficiency (*Flat Broke* 84).

DISCUSSION

Consistent with previous research in this area (see e.g., Neubeck and Cazenave 136; Ben-Ishai 54), our results suggest that TANF programs in Ohio are shaped by the ideologies of new paternalism and neo-liberalism. These ideals, in turn, interfere with the ability of welfare mothers to enact intensive mothering. First, as a result of their socioeconomic location, welfare mothers lack the financial assets required for a resource-intensive style of mothering. Second, because of TANF work requirements—and the influence of neo-liberal ideology, poor mothers are pressured to work outside of the home in order to provide financially for their children, simultaneously serving as role models for the next generation of paid laborers (Arendell, "Hegemonic Motherhood" 4; Bloch and Taylor 207 ; Kennelly 169; Chavkin 477-478; Taylor 900).

However, poor mothers often receive mixed messages about working outside of the home. On the one hand, poor mothers in the paid labor market are praised as role models and financial providers, but on the other hand, working outside of the home calls into question a mother's commitment to a child-centered

parenting model. In this way, the obstacles that welfare mothers face in balancing paid work with motherhood mirror the struggles faced by all mothers in U.S. society (Hays *Flat Broke* 76). However, welfare mothers, relative to other mothers, face a unique constraint in their ability to enact intensive mothering in the form of supervisory and intrusive TANF policies.

As demonstrated by our data, the supervisory and intrusive TANF policies under PRWORA are rooted in the ideologies of new paternalism and neo-liberalism. With respect to new paternalism, TANF is structured from the perspective that welfare mothers lack the capacity for proper decision-making, which justifies the use of such policies. In order to receive their TANF check, welfare mothers must be compliant with a number of requirements, including "volunteering" their time at work placement sites, and cooperating fully with paternity/child support programs.

With respect to neo-liberalism, little value is placed on welfare mothers performing unpaid/domestic labor consistent with intensive mothering, with TANF instead requiring that these mothers devote their time and energy toward participating in the paid work force. The expectations of intensive mothering disadvantage all mothers in the U.S.; once coupled with the demands of intrusive and disempowering welfare policies, the expectations of intensive mothering create criteria for "good" motherhood that welfare mothers are unlikely to meet.

WORKS CITED

Arendell, Teresa. *Hegemonic Motherhood: Deviancy Discourses and Employed Mothers' Accounts of Out-of-School Time Issues.* April 1999. TS Center for Working Families Working Paper No. 9, University of California, Berkeley. Print.

Arendell, Teresa. "Conceiving and Investigating Motherhood: The Decade's Scholarship." *Journal of Marriage and Family* 62 (2000): 1192–1207. Print.

Baker, Joanne. "Great Expectations and Post-Feminist Accountability: Young Women Living up to the 'Successful Girls' Discourse." *Gender and Education* 22 (2010): 1-15. Print.

Ben-Ishai, Elizabeth. *Fostering Autonomy: A Theory of Citizenship, the State, and Social Service Delivery*. University Park: The Pennsylvania State University Press, 2012. Print.

Bloch, Katrina and Tiffany Taylor. "'Welfare Queens' and 'Anchor Babies': An Intersectional Analysis of Race, Gender, Class, Nationality and Motherhood." *Mothering in the Age of Neoliberalism*. Ed. Melinda Vandenbeld Giles. Toronto: Demeter Press, 2014. 199-210. Print.

Brown, Emma J. "Good Mother, Bad Mother: Perception of Mothering by Rural African-American Women Who Use Cocaine." *Journal of Addictions Nursing* 17 (2006): 21-31. Print.

Bruch, Sarah K., Myra Marx Ferree, and Joe Soss. "From Policy to Polity: Democracy, Paternalism, and the Incorporation of Disadvantaged Citizens." *American Sociological Review* 75 (2010) : 205-26. Print.

Bureau of Labor Statistics. "Unemployment Rates for States." *Local Area Unemployment Statistics*. United States Department of Labor, 2013. Web. 25 September 2013.

Buzzanell, Patrice M., Damion Waymer, Maria Paz Tagle, and Meina Liu. "Different Transitions into Working Motherhood: Discourses of Asian, Hispanic, and African American Women." *Journal of Family Communication* 7 (2007): 195-220. Print.

Cassiman, Shawn A. "Resisting the Neo-liberal Poverty Discourse: On Constructing Deadbeat Dads and Welfare Queens." *Sociology Compass* 2 (2008): 1690-1700. Print.

Chavkin, Wendy. "What's a Mother to Do? Welfare, Work, and Family." *American Journal of Public Health* 89 (1999) : 477-79. Print.

Collins, Patricia H. *From Black Power to Hip Hop: Racism, Nationalism, and Feminism*. Philadelphia: Temple University Press, 2006. Print.

Collins, Jane L. and Victoria Mayer. *Both Hands Tied: Welfare Reform and the Race to the Bottom of the Low-Wage Labor Market*. Chicago: The University of Chicago Press, 2010. Print.

Damaske, Sarah. "Work, Family, and Accounts of Mothers' Lives Using Discourse to Navigate Intensive Mothering Ideals." *Sociology Compass* 7 (2013): 436-44. Print.

Foster, Carly Hayden. "The Welfare Queen: Race, Gender, Class,

and Public Opinion." *Race, Gender & Class* 15 (2008) : 162-179. Print.

Gilens, Martin. *Why Americans Hate Welfare: Race, Media, and the Politics of Antipoverty Policy.* Chicago: University of Chicago Press, 1999. Print.

Hancock, Ange-Marie. *The Politics of Disgust: The Public Identity of the Welfare Queen.* New York: New York University Press, 2004. Print.

Hays, Sharon. *The Cultural Contradictions of Motherhood.* New Haven: Yale University Press, 1996. Print.

Hays, Sharon. *Flat Broke with Children: Women in the Age of Welfare Reform.* New York: Oxford University Press, 2003. Print.

Johnston, Deirdre D. and Debra H. Swanson. "Invisible Mothers: A Content Analysis of Motherhood Ideologies and Myths in Magazines." *Sex Roles* 49 (2003): 21-33. Print.

Kennelly, Ivy. "'That Single Mother Element' How White Employers Typify Black Women." *Gender and Society* 13 (1999): 168-92. Print.

Kirkman, Maggie, Lyn Harrison, Lynne Hillier and Priscilla Pyett. " 'I Know I'm Doing a Good Job': Canonical and Autobiographical Narratives of Teenage Mothers." *Culture, Health, and Sexuality* 3 (2001): 279-94. Print.

Limoncelli, Stephanie. "'Some of Us are Excellent at Babies': Paid Work, Mothering, and the Construction of Need in a Welfare-to-Work Program." *Work, Welfare and Politics: Confronting Poverty in the Wake of Welfare Reform.* Ed. Frances Fox Piven, Joan Acker, Margaret Hallock, and Sandra Morgen. Eugene: University of Oregon Press, 2002. 81-94. Print.

Misra, Joya, Stephanie Moller, and Marina Karides. "Envisioning Dependency: Changing Media Depictions of Welfare in the 20th Century." *Social Problems* 50 (2003): 482-504. Print.

Neubeck, Kenneth and Noel A. Cazenave. *Welfare Racism: Playing the Race Card Against America's Poor.* New York: Routledge, 2001. Print.

Ohio Department of Jobs and Family Services. "ODJFS Fact Sheet-Ohio Works First." *Ohio Department of Jobs and Family Services.* Ohio Department of Jobs and Family Services, December 2011. Web. 16 March 2014.

Rothman, Barbara Katz. *Recreating Motherhood*. New Brunswick, NJ: Rutgers University Press, 2000. Print.

Schram, Sanford. "Postindustrial Welfare Policy: Just Say No to Women and Children" *Review of Radical Political Economics* 26 (1994): 56-84. Print.

Soss, Joe, Richard C. Fording, and Sanford F. Schram. *Disciplining the Poor: Neoliberal Paternalism and the Persistent Power of Race*. Chicago: The University of Chicago Press, 2011. Print.

Sutherland, Jean-Anne. "Mothering, Guilt and Shame." *Sociology Compass* 4 (2010): 310–21. Print.

Swift, Karen. *Manufacturing 'Bad Mothers': A Critical Perspective on Child Neglect*. Toronto: University of Toronto Press Incorporated, 1995. Print.

Taylor, Tiffany. "Re-examining Cultural Contradictions: Mothering Ideology and the Intersections of Class, Gender, and Race." *Sociology Compass* 5 (2011): 898-907. Print.

U.S. Department of Health and Human Services. "Characteristics and Financial Circumstances of TANF Recipients, Fiscal Year 2010." *U.S. Department of Health & Human Services, Administration for Children & Families, Office of Family Assistance*. U.S. Department of Health and Human Services, 8 August 2012. Web. 25 September 2013.

Is Attachment Mothering Intensive Mothering?

CHARLOTTE FAIRCLOTH

THIS CHAPTER PROFILES RESEARCH with women in London who are members of La Leche League (LLL), an international breastfeeding support organisation founded in 1956 in the United States to support "mothering through breastfeeding." The text focuses on the accounts of a small but significant population of mothers within LLL who practise "attachment mothering." Attachment parenting, now a global movement with roots in the UK and the U.S., uses an evolutionary rationale of a "hominid blueprint" for care, which advocates long-term proximity between caretaker and infant as a means of optimizing child development. Typical practices amongst attachment parents include breastfeeding until the child "outgrows the need," often for a period of several years; breastfeeding "on cue," whenever the child shows an interest; "bed-sharing," until the child decides to move to their own bed; and "baby-wearing," carrying the baby with the use of a sling or similar. Within this volume, this paper therefore provides a unique perspective, by focusing on an urban European setting, exploring the relationship between intensive motherhood, feeding practices and capitalist culture.

Feeding, arguably the most conspicuously moralized element of mothering, was the focus of the study. Because of its vital importance for the survival and healthy development of infants, feeding is a highly scrutinized domain where mothers must counter any charges of practicing unusual, harmful or morally suspect feeding techniques (Murphy).

The World Health Organization (WHO) states that breastfeeding

in developed countries should be exclusive for six months and continue "for up to two years, or beyond" in conjunction with other foods. There are no statistics for the number of children breastfed beyond a year in the UK, though by six months 75 percent of children are totally weaned off breastmilk, and only two percent of women breastfeed exclusively for the recommended six months (Department of Health 2005, the most up to date figures at the time of research). Women breastfeeding to full term are non-conventional, inviting critical engagement with the "accountability strategies" they undertake to explain why they do what they do (Strathern). Typically, these mothers narrate their decision to continue breastfeeding as "natural": "evolutionarily appropriate," "scientifically best," and "what feels right in their hearts" (Faircloth). Attention to "identity work" (Goffman), the narrative processes of self-making that mothers engage in as they raise their children, is part of an argument that for certain middle-class parents in the UK, parenting has become a key means by which mothers (and fathers) develop their own identities.

Indeed, these mothers provide a case study by which to explore the recent "intensification" of mothering. This is a trend identified by a range of scholars writing about mothering in both the UK and the U.S., as well as beyond (Arendell; Douglas and Michaels; Faircloth, Hoffman and Layne; Hays; Lee; Lee, Macvarish and Bristow; Warner; this volume). According to these scholars, the social role of mothering has expanded in recent years to encompass a range of tasks beyond the straightforward rearing of children. Above simply feeding, clothing and sheltering, parents do much more for their children today: it is this "more" that is of interest here (Hays 5). Parenting is now an occupation in which adults, particularly mothers, are expected to be emotionally absorbed and become personally fulfilled; it is also a growing site of interest to policy makers who see it as a key area for neutralising the effect of poverty and improving social mobility (Lee, Bristow, Faircloth and Macvarish). "Ideal" parenting is financially, physically and emotionally intensive, and parents are encouraged to spend a large amount of time, energy and money in raising their children, often with the aid of "experts" who have increasingly colonised this area of family life (Hays; Furedi).

What follows in the chapter is a discussion of how far "attachment mothering" can be considered "intensive mothering," as per Hays' definition: "child-centred, expert-guided, emotionally absorbing, labour intensive, and financially expensive" (8). Certainly, the long-term, embodied care typical of attachment parents seems to chime with this definition, but at the same time, the philosophy is distinctly anti-consumption, as well as anti-expertise, and some of these contradictions are explored here.

ATTACHMENT PARENTING

There are many possibilities for parents in the UK today as to how they raise their children, though these can arguably be divided into styles that are "structured," and those that are, putatively at least, "unstructured." The former might be characterised by scheduled feeds, formula feeding and separate sleeping, where "unstructured" models are typified by more relaxed styles of care, often characterised by practices like long-term, on-cue breastfeeding, a family bed and "positive" discipline (Buskens 75).

Yet as the growing popularity of attachment parenting shows, fashions in parenting are also best understood as barometers of wider cultural trends, which—in the UK, at least—have recently seen a growing validation of the "natural" way of doing things in issues as diverse as what we eat, how we learn, and how we treat illness. There is an enduring conviction in this position that "nature" is a force to be trusted and respected, and with respect to parenting, deference to the "natural" bond between mother and child, which attachment parenting certainly validates (Bobel 11; Faircloth "Culture").

In the mid-1970s, the author Jean Liedloff aimed to reintroduce a style of "traditional" parenting to the "modern" world (see Bobel 61). Based on the time Jean Liedloff spent with the Yequana of Venezuela, *The Continuum Concept* method of childcare expounds a "chain of experience of our species which is suited to the tendencies and expectations which we have evolved" (22-3). It was not until the 1980s, however, that William and Martha Sears coined the term "Attachment Parenting" (AP) in *The Baby Book*. Like Leidloff, they argue that AP is:

IS ATTACHMENT MOTHERING INTENSIVE MOTHERING?

...an approach to raising children rather than a strict set of rules. Certain practices are common to AP parents; they tend to breastfeed, hold their babies in their arms a lot, and practice positive discipline, but these are just tools for attachment, not criteria for being certified as an attachment parent.... Above all, attachment parenting means opening your mind and heart to the individual needs of your baby and letting your knowledge of your child be your guide to making on-the-spot decisions about what works best for both of you. In a nutshell, AP is learning to read the cues of your baby and responding appropriately to those cues. (*The Baby Book* 2)

Drawing on historical arguments they say that this is really just "common-sense" parenting "we all would do if left to our own healthy resources" (Sears and Sears, *The Baby Book* 2). They provide the following "tools" of attachment parenting:

Table 1: The Tools of Attachment Parenting

THE ABC'S OF ATTACHMENT PARENTING

When you practice the Baby B's of AP, your child has a greater chance of growing up with the qualities of the A's and C's:

A's	B's	C's
Accomplished	Birth bonding	Caring
Adaptable	Breastfeeding	Communicative
Adept	Babywearing	Compassionate
Admirable	Bedding close to baby	Confident
Affectionate	Belief in baby's cry	Connected
Anchored	Balance and boundaries	Cuddly
Assured	Beware of baby trainers	Curious

Source: Sears and Sears, *Attachment Parenting* (4)

Using evolutionary evidence of primates and "primitives" (whether in the fossil record or as represented by contemporary hunter-gatherer groups) attachment parenting is endorsed as both a traditional and "adaptive" form of care (Sears and Sears *Attachment Parenting*). The argument is that children have evolutionary expectations (such as an extended period of breastfeeding) that must be met if they are to mature into happy, healthy adults. Women clearly do not "ape" all aspects of the hunter-gatherer lifestyle of course (they use the internet, for example), and a certain amount of cherry-picking goes on (Faircloth *Militant Lactivism*).

Today, Attachment Parenting International (API), a non-profit organization founded in the U.S. in 1994, is a global movement, existing to support parents who practice AP, with over 19,000 members in 70 cities worldwide. Drawing heavily on the work of Sears and Sears, API's website states:

> API provides parents with research-based information, tools and support that affirms positive, healthy parenting, and helps parents create the kind of legacy that they can be proud to bequeath to their children: family strength, reduced conflict, feelings of love and being loved, trust and confidence. A legacy of love.

The API's eight principles read:

- Prepare for Pregnancy, Birth, and Parenting
- Feed with Love and Respect
- Respond with Sensitivity
- Use Nurturing Touch
- Ensure Safe Sleep, Physically and Emotionally
- Provide Consistent and Loving Care
- Practice Positive Discipline
- Strive for Balance in Your Personal and Family Life.

METHODS: ACCOUNTING FOR ATTACHMENT

During the empirical element of this research, participant observation at ten local LLL groups was complemented by 22 semi-struc-

tured interviews and 25 questionnaires with individual women.[1] Mothers were in the vast majority white, middle-aged (on average, 34), well-educated (to university level or equivalent), not currently working, and married. Those that were identified as "full-term" breastfeeders and attachment parents made up just over half of the sample, and it is their accounts I focus on here.[2] Certainly not all mothers in the organization breastfeed to full term, though I engage particularly with the accounts of those who do, and with the values they promote and enact. In taking their feeding practices to an extreme, they magnify mainstream issues around motherhood and the construction of the self. These accounts do not represent official LLL philosophy, but are rather particular women's understandings of their breastfeeding experiences, equally influenced by broader philosophies of "natural" or "attachment" parenting.

FINDINGS

Child-centred?

Attachment parenting can easily be read as child-centred, and it was certainly the case that women's "accounting" for their decision to breastfeed (either at all, or long-term) focussed on the benefits of this for the child. In the questionnaire conducted with my informants, the three most cited reasons for feeding one's child with breastmilk were that it was "best," that it provided immunity from illness, and that it was "most natural." This response from Alice—a 47-year-old mother to 25- and 15-year-old sons, and a five-year-old daughter, whom she had just weaned—was typical (if somewhat more extensive than others):

> *Questionnaire:* Why was it important to feed your child with breast milk?
>
> *Alice: It was the food made especially for my baby. Breastfeeding brought us closer together and helped us get to know one another. It taught my child to trust me and feel safe. I only wanted the best for my child. I couldn't give my baby a substitute knowing I was withholding the best. I believe it is a child's birthright. I wanted to give my child the best*

food available. I wanted them to have healthy immune systems, good dental formation, and general good health. I wanted my children to be mentally and socially healthy. I wanted to be able to feed my child whenever he needed to be fed. I could not bear [sic] the thought of him being distressed waiting. I am aware of the dangers of artificial feeding. I want my children to have healthy attitudes to food for life. This involves them being active rather than passive feeders from birth.

She continues:

Questionnaire: Was it important for you to feed your child at the breast?

Alice: Yes. It is what nature intended and any other way of feeding is a very different experience for a child. I don't know what adverse effects there could be for a child not breastfeed, and was not going to take the responsibility of denying them the experience.

Emotionally absorbing?

Similarly, that attachment parenting (and particularly breast-feeding) is emotionally absorbing for the women I worked with hardly needs reiterating:

Questionnaire: How would you describe breastfeeding your child?

Amelia [33, breastfeeding her almost three-year-old son]: Indescribable to me, but an oasis of calm.

Jane [Leader Applicant, 25, breastfeeding her 16-month old-son]: Too amazing to begin to even describe.

The comfort that *both* mother and child receive in the process of breastfeeding was something my informants talked of as a mutual endeavour—and one which was particularly poignant in

the pre-verbal stage. Many mothers were comforted, for example, by being able to comfort their child, despite not knowing exactly what it is they want. Valerie echoed this reciprocal benefit when she talked about breastfeeding as being "embraced in love":

Questionnaire: Was it important for you to feed your child at the breast?

Valerie [33, breastfeeding her eleven-month-old son]: Yes... Important for us to bond. A natural feeling and emotion to be close and embraced in love while nursing. So I could just sit and watch the baby and fall in love with him. Base human emotion of protecting and doing the best for him.

Labour intensive?

Many mothers talked about attachment parenting as the "natural" "enjoyable" and "easy" thing to do. However, they also talked about the diligence, attentiveness and effort that this form of parenting required (the two are, of course, not mutually exclusive). The strain of this effort was evident at some LLL groups, where women occasionally arrived at a meeting, and promptly burst into tears. They would talk about how they were utterly shattered from not sleeping properly over a period of years (particularly the case if they continued to share a bed with their child, as was typical). One woman told me that she hadn't slept for a period of more than four hours since the birth of her daughter, five years ago. This might also be the case with some parents who do not co-sleep or breastfeed to "full-term," but the embodied maternal labour inherent to this approach is important to recognise.

The Sears, who gave attachment *parenting* its name, now include a seventh "tool" in their list—Balance—after seeing too many cases of what they call "mother burn-out" (Sears *Attachment Parenting* 112); not, interestingly, "parent burn-out." At meetings, women would be met with much sympathy by other mothers, and shared stories of broken sleep. "You are doing a wonderful job" they were usually told. Yet the counsel was generally to persevere. They were reassured that it was normal to feel this way and that in time, it would pass.

Expert guided?

On first reading, attachment parenting appears to be anti-expertise. The mothers I work with consider *themselves* the experts on their own children, and talk about "following their instincts" rather than the advice of experts. Education and support for mothers are key concepts for LLL, and fit well with their feminist orientation. The use of science is held to increase women's authority – a belief reflected in the growing amount of clinical evidence in League publications, and used by attachment parents to defend their choices (Faircloth "What Science Says"). Other scholars have drawn attention to the contradiction of the co-option of the language of science by breastfeeding advocates—ironic, because their usual discourse is that of *anti*-rationality, medicalization or expertise.

There is, of course, an important distinction between medicalization and scientisation that we should be careful to note here (Hausman). Whilst promoting mother-to-mother support, the League is clear that it is not a replacement for health care professionals, though it does urge women to be upfront about the care they wish to receive, and offers them support in doing this. "A doctor should be there to help not direct," says one leaflet advising pregnant mothers. Thus this is not a simple distillation of the intensive mothering injunction to look to experts; rather, it is a challenge to the notion of professionalized parenting. If anything, LLL encourages women to question expertise.

Ironically, however, in conjunction with this, there is a burgeoning market of attachment parenting gurus (the Sears being the most famous) who aim to help mothers "tune into their instincts." Thus far from being free from this aspect of contemporary parenting culture, AP is subject to a similar commercialisation to many other parenting approaches.

Financially expensive?

In many ways, attachment parenting can be seen as a rejection of capitalist or consumer-goods based parenting, which is considered typical of more "mainstream" approaches to care, where branded goods have come to define a particular orientation towards child-rearing (the "bugaboo" being the classic example). However, as Russell's work on attachment parenting and baby

wearing makes clear (forthcoming), this "natural" parenting has also been "enterprised up" in recent years, with a baffling array of products available to the new parent.

The women I worked with often favoured what appears to be the "low-tech," "sustainable" or "natural" options in running their family life (and not only in relation to parenting). For example, they often used cloth nappies for their children, which were said to be cheaper and better for the environment (though some women disagreed and said that the detergents used to wash them were just as harmful, not to mention that nappies were more financially and energy expensive when the cost of washing was calculated). Similarly, many families would eat primarily organic, local, whole foods if they could, and would not wear synthetic fabrics if possible, although these were often more expensive than the high-street equivalents.

DISCUSSION: INTENSIVE PARENTING?

As noted, there are many ways of caring for children "intensively" (such as with methods that advocate the strict timetabling of feeding, sleeping and so forth, and these are just as prevalent as the "attachment" parenting focused on here). The philosophy of "attachment parenting" that validates attentive, embodied care for infants offers women *one* set of norms by which to structure their "identity work" in congruence with an overarching framework of intensive mothering. There are points of congruence and points of departure with this framework, as I have explored. Certainly, AP does appear to be intensive to the extent that it is child-centred, emotionally absorbing, labour intensive and—to a greater or lesser extent—"expert" guided and financially expensive.

What emerges from this analysis, however, is that as a form of "intensive mothering," attachment mothering exacerbates the cultural contradiction faced by most contemporary mothers in the capitalist context. Following Hays (*Cultural Contradictions*), it is suggested that ideals around "good motherhood" are in opposition to the social and economic context of post-industrialised societies.

Numerous anthropologists and historians have shown how in-

tensive caregiving carried out by biological mothers in the private sphere is a result of modern economic and political arrangements, inherent to capitalist modes of production (Ariès; Badinter; Engels; Blaffer Hrdy). More so than advocates of other methods of infant care, proponents of "natural" or "attachment" parenting seem "blissfully unaware" (Buskens 79) of the social differences between a hunter-gatherer society and those of mothers in contemporary Britain. Petra Buskens shows how mothering as a post-enlightenment practice has intensified through the emphasis on "good mothering," but this has taken place in a context of diminishing support with the loss of coherent community. The approach eclipses the social surroundings of women—and the presence or otherwise of alloparents, who share the job of parenting. Sarah Blaffer Hrdy, for example, points out that where possible, mothers "in African societies" may seek to extend infant and child care to helpers (including fathers) so that they might improve their own productivity. Yet a gendered split in British society has rendered motherhood an isolated business for mothers.

Early childhood *is* a period of high emotional and physical dependency. This is not just an invention of an "intensive parenting" culture. As Buskens argues, "infants do require a long period of intensive, embodied nurture. *The problem is not the fact of this requirement but rather that meeting this need has come to rest exclusively, and in isolation, on the shoulders of biological mothers.* This historically novel situation is precisely what is left unsaid and therefore unproblematized in popular accounts of "natural" parenting" (81, emphasis in original). The expectation of "natural" styles of parenting in a society that lacks traditional structures is to force a "cultural contradiction" on women, since one cannot, argues Buskens, live comfortably outside the dominant values of their social structure.

At the same time, it would be too simplistic to see these mothers as either duped or oppressed when it comes to their parenting practices. Alice (who speaks about why she breastfeeds) clearly has her child at the centre of her parenting. It is not the case, however, that this style of mothering is *only* "child-centered" as it has a critical role in how Alice understands herself, as a mother. Indeed, whilst I do not elaborate on it here, "child-centred" approaches

to parenting, might better be understood as part of these mothers' struggle for self-identity, and a prominent part of their "identity work" as social agents. The concept of being "attached" to a child is not necessarily experienced by these mothers as a restriction to their individualised selves. Instead, it is seen as an extension of agency, understood through a more relational model (see Faircloth *Militant Lactivism*). What's more, the fact that this is difficult in modern society is internalised by these mothers as part of their "fight" for identity.

Of course, managing this contradiction is affected by socio-economic status, and this clearly has implications for the intersection between a generalised intensive parenting culture and the growing popularity of attachment parenting. That almost all women interviewed were with a partner, white and well-educated, and over half were not working outside of the home, tells us yet again that more is at stake in debates about mothering (and gender) than a simple exercise of choice.

[1]Parallel research was also conducted in Paris, though these data are not referred to here.
[2]These are women who practice an "attachment parenting" philosophy in addition to being members of LLL. Classification is based on statistics and responses derived from the questionnaire—that is, those women breastfeeding their children beyond a year—as well as the author's observations at groups meetings and interviews. All names have been anonymised.

WORKS CITED

Ariès, P. *Centuries of Childhood; A Social History of Family Life.* New York: Vintage Books, 1962. Print.

Arendell, T. "Conceiving and Investigating Motherhood: The Decade's Scholarship." *Journal of Marriage and the Family* 62 (November 2000): 1192-1207. Print.

Attachment Parenting International (API). *8 Principles of Attachment Parenting,* 2009. Web. Retrieved 23 March 2009

Badinter, E. *The Myth of Motherhood: A Historical View of the*

Maternal Instinct. Trans. Roger De Garis. London: Souvenir Press, 1981 [1980]. Print.

Blaffer Hrdy, S. *Mother Nature: Maternal Instincts and the Shaping of the Species*. London: Vintage, 2000. Print.

Bobel, C. *The Paradox of Natural Mothering*. Philadelphia: Temple University Press, 2002. Print.

Buskens, P. "The Impossibility of "Natural Parenting" for Modern Mothers: On Social Structure and the Formation of Habit." *Journal of the Association for Research on Mothering* 3.1 (2001): 75–86. Print.

Department of Health (DH). *Maternal and Infant Nutrition*. London: Department of Health, 2005. Web. Retrieved 7 December 2005.

Douglas, S. and M. Michaels. *The Mommy Myth: The Idealization of Motherhood and How It Has Undermined All Women*. New York: Free Press, 2004. Print.

Engels, F. *The Origin of the Family, Private Property and the State*. New York: Pathfinder, 1972 [1884]. Print.

Faircloth, C. "'Culture Means Nothing to Me': Thoughts on Nature/Culture in Narratives of 'Full-Term' Breastfeeding." *Cambridge Anthropology* 28.2 (2009): 63-85. Print.

Faircloth, C. "What Science Says Is Best: Parenting Practices, Scientific Authority and Maternal Identity." *Sociological Research Online*, Special Section on "Changing Parenting Culture" 15.4 (2010): n.p. Web.

Faircloth, C. "It Feels Right in My Heart: Affect as Accountability in Narratives of Attachment." *The Sociological Review* 59.2 (May 2011): 283–302. Print.

Faircloth, C. *Militant Lactivism? Attachment Parenting and Intensive Motherhood in the UK and France*. Oxford: Berghahn Books, 2013. Print.

Faircloth, C., D. Hoffman and L. Layne, eds. *Parenting in Global Perspective: Negotiating Ideologies of Kinship, Self and Politics*. London: Routledge, 2013. Print.

Furedi, F. *Paranoid Parenting: Why Ignoring the Experts May Be Best for Your Child*. Chicago: Chicago Review Press, 2002. Print.

Goffman, E. *The Presentation of Self in Everyday Life*. New York: Doubleday, 1959. Print.

Hays, S. *The Cultural Contradictions of Motherhood.* New Haven: Yale University Press, 1996. Print.

Hausman, B. *Mother's Milk: Breastfeeding Controversies in American Culture.* London: Routledge, 2003. Print.

Lee, E. "Living with Risk in the Age of "Intensive Motherhood': Maternal Identity and Infant Feeding." *Health, Risk and Society* 10.5 (2008): 467-47. Print.

Lee, E., J. Macvarish, and J. Bristow. "Editorial: Risk, Health and Parenting Culture." *Health Risk and Society* 12.4 (2010): 293-300. Print.

Lee, E., J. Bristow, C. Faircloth and J. Macvarish. *Parenting Culture Studies.* New York: Palgrave Macmillan, 2014. Print.

Murphy, E. "Risk, Responsibility and Rhetoric in Infant Feeding." *Journal of Contemporary Ethnography* 3 (2000): 291-325. Print.

Russell, N. "Babywearing in the Age of the Internet." *Journal of Family Issues,* Special Issue, "Parenting: Kinship, Expertise and Anxiety." Forthcoming. Web.

Sears, W. and M. Sears. *The Baby Book: Everything You Need to Know About Your Baby.* Boston: Little Brown, 1993 [1982]. Print.

Sears, W. and M. Sears. *The Attachment Parenting Book: A Commonsense Guide to Understanding and Nurturing Your Baby.* London: Little, Brown and Company, 2001. Print.

Strathern, M., ed. *Audit Cultures: Anthropological Studies in Accountability: Ethics and the Academy.* London: Routledge, 2000. Print.

Warner, J. *Perfect Madness, Motherhood in the Age of Anxiety.* London: Vermilion, 2006. Print.

World Health Organization(WHO). *Global Strategy on Infant and Young Child Feeding.* Geneva: WHO, 2003. Web. Retrieved 27 September 2007.

Better Babies, Better Mothers

Baby Sign Language and Intensive Mothering

LISA M. MITCHELL

Familiar with a scenario like this? At 3:00 am your ten-month-old baby is crying inconsolably at night. "What's wrong?" you ask, wishing you REALLY COULD understand her thoughts and attempts to vocalize to tell you what she wants.

3:00 am quickly becomes 4:00 am, 5:00 am...

Now, imagine THIS scenario:

Around 3:00 am you ask your ten-month old infant "what's wrong?"; she immediately forms her hands to sign "teddy bear!" (Tapping her chest with both hands signifies the act of cuddling a teddy bear or other soft toy.) You hand her Mr. Teddy, and gratefully, your baby grabs and squeezes her comforting little bear buddy, and immediately lies back down to sleep. Yes this is truly possible! ("Babies and Sign Language" 1)

SO READS THE TEXT on the opening pages of the website "Babies and Sign Language." Captivated by these promises to "really understand" their child, alleviate their distress, and stimulate their intellectual development, growing numbers of Canadian and American hearing parents are teaching sign language or gestural communication to their hearing infants. Parents are urged to introduce signing to their infants at about six to eight months old, beginning with simple signs. If parents are patient and follow the advice to use signs repetitively, consistently, and "always in a fun way", they can expect their infant to be signing about their needs

and experiences within a few months. Children can continue to be taught new signs even as they become verbal toddlers, pre-schoolers, and school-age children. Advocates of baby sign language suggest there are multiple benefits including improved communication between parent and child, enhanced self-esteem, earlier acquisition of verbal skills, and improved IQ and reading ability in the later child, and an enriched parent-child bond (Acredolo and Goodwyn 5-6; Nelson, White and Grewe 475).

Whatever its value for infant development and communication, the social practice of teaching hearing infants to use sign language brings into view significant "cultural beliefs, values, and social orders" (Schieffelin and Ochs 183) shaping contemporary parenting. In this chapter I consider infant signing as a parenting technique which exemplifies the North American cultural logic and labour of "intensive mothering" (Hays 69), particularly in its contemporary "scholarized" form in which interactions with infants are viewed as opportunities to enhance and stimulate that child's development. I argue that, as discursively framed by its advocates, training hearing infants to sign is not only about improving infant cognitive and linguistic skills, but about creating particular sorts of infants and parents. In this respect, infant signing is a strategy of "body work" by which adults/parents strive to create socially valued cultural dispositions and selves in their infants and in themselves.

In her ground-breaking analysis, Hays characterised childrearing advice to parents in the decades just preceding the 1990s as dominated by an ideology of intensive mothering. This "unremunerated task of child rearing ... [is] child-centred, expert guided, emotionally absorbing, labour intensive, [time consuming] and financially expensive ... and primarily the responsibility of the individual mother" (Hays 69). Further, this childrearing approach is culturally constructed as separate from and unconcerned with the values of efficiency, instrumental rationality and productivity that are central to the North American workforce and labour market (Hays 65). As she argued persuasively, the "socially constructed logic" of this ideology creates profound contradictions, distress, and challenges for women both as stay-at-home mothers and as mothers employed outside the home (69, 149).

Today, intensive mothering aligns closely with other historically and socially constructed priorities in contemporary parenting including the recent "scholarization" trend (Mayall 158; Quirke 400-402) in which more and more of an infant's and toddler's time is to be directed at intellectual activities. As parents are feeding, bathing, playing with and otherwise caring for their pre-school child, they are also expected to be stimulating that child cognitively and verbally. Parents are urged to constantly teach, talk to, and interact with their infant thereby bolstering his/her chances at school and in the workforce (Quirke 391, 400). Scholarized infant care "redefines the baby as a learner, reworks adult-baby relationships as teacher-learner relationships and transforms learning into the consumption of ... goods and services" (Hughes 34). Within the context of this contemporary "cognitively intensive" mothering (Quirke 390), signing promises to create parents able to intensively mother and infants able to communicate in ways that further their development.

In this chapter, in order to elucidate the cultural ideas and social distinctions of value which make infant signing appealing in the context of contemporary intensive mothering, I highlight how infant bodies and selves are represented in guidebooks and websites extolling the benefits of infant signing. I approach teaching hearing infants to sign as an example of what Pilcher calls "body work" (215) through which adults seek to shape and regulate children's bodies in order to create particular kinds of subjects. Body work is prefaced on the idea of "bodies as unfinished, corporeal–cultural entities" (Pilcher 215) and echoes Bourdieu's notion of *habitus* or the inculcation of a "system of structured, structuring dispositions ... constituted by practice" (52). Anthropological and sociological research by Kusserow, Pilcher, Yafeh, Ben-Ari, among others, underscores the inculcation in children of particular bodily practices as socialisation strategies in particular ideologies of self, gender, nationalism, and class. I argue that baby signing is also a form of body work through which parents seek to inculcate in their infants a subject who is both responsive to and participating in scholarized intensive mothering, that is, oriented towards self-regulation, socially appropriate interaction, and articulating their needs and desires. Further, I suggest that infant signing also encourages the

creation of socially desirable parental subjects, that is, parents able to understand their child's particular needs and wants and to respond efficiently so as to further their development.

My discussion is based on my thematic textual analysis of several of the many parent manuals, websites, and media articles on infant signing. I gathered websites by searching through Google for "infant signing" and "baby sign language," focussing not on scholarly sources but on sites aimed at or speaking directly to parents. I found the titles of popular parent manuals on infant signing at local bookstores and on-line through Amazon. I also surveyed articles in scholarly journals claiming or critiquing the purported benefits of infant signing. Focussing on hard copy guidebooks on infant signing and the retrieved websites, I looked closely at descriptions of and anecdotes about signing and non-signing babies and parents, at claims about the benefits of signing, and at suggestions for how to teach and use signing. Throughout, I paid particular attention to the discursive framing of infant bodies and to infants and parents as subjects. Guidebooks and websites cannot tell us what parents are thinking about infant signing or how they are putting signing into practise, yet they do offer a sense of how this practice is discursively positioned for potential parent signers.

MAKING SIGNS

Guidebooks on infant signing began appearing in the 1990s; two of the most widely read and cited guides are *Baby Signs: How to Talk to Your Baby Before Your Baby can Talk* by child development experts Linda Acredolo and Susan Goodwyn and *Sign With Your Baby: How to Communicate with Infants Before They can Speak* by American Sign Language interpreter and instructor Joseph Garcia. Today there are hundreds of instructional resources including guidebooks, websites, signing videos and DVDs, sign charts, flash cards, "reminder placemats" ("Sign to Me") and infant board books. In some communities, parents can enroll in infant signing classes or work with a signing consultant.

Infant signing methods are not standardized: some programs utilise American Sign Language gestures (Garcia), others employ specially created signs, including those invented by infants and

parents (Acredolo and Goodwyn 1996). The Baby Signs originators suggest parents introduce signs when the infant is about nine months of age, "as soon as your baby seems to want to 'talk' about things" (Acredolo and Goodwyn 34). Some authors urge parents to begin signing with infants as young as five or six months of age or simply "the sooner the better" (Douglas E7). Beginner signs are suggested and parents are instructed to use signs repeatedly and in conjunction with the spoken word, and to offer enthusiastic praise as infants begin to imitate and then initiate signing. Articles and websites offer encouragement with heartwarming testimonies from parents and anecdotes about infants mastering signs, being delighted with their new found ability to communicate, and, especially, stories of reduced parental frustration when faced with a distressed and crying infant.

Not surprisingly websites and guidebooks on signing assert multiple benefits. Among the most common claims are that in comparison to non-signing infants, signing infants demonstrate "stronger command of language and are more motivated to learn to speak" (Fixell and Stafford 2), "communicate complex things earlier ... [which] enhances the building of brain circuitry" (Jarvis 10), as well as enhanced IQ and reading ability in the later child, greater confidence and self-esteem in the infant (Babies and Sign Language; Acredolo and Goodwyn 7). In response to parental concerns that infant signing will delay speech acquisition, advocates of signing argue that using signs "speeds up the process of learning to talk" by helping children to think conceptually and increasing their vocabulary (Acredolo and Goodwyn 5).

The idea of teaching hearing infants to sign builds upon the emphasis in contemporary childhood development research on the interaction between parent and child as powerfully shaping a child's capacity for social interaction, self-awareness, perceptual skills, cognitive development, and language acquisition. The dominant model in this research is one of dyadic communication in which "the organisation of behaviour in infancy is a property of the mother infant system rather than of the individual" (Beebe, Lachman and Jaffe 135). Thus, even newborns are seen to be "engaged in highly complex interpersonal interactions" (Beebe and Lachman 65), in which both infant and mother initiate in-

teraction, organise experience, and influence one another (Beebe, Lachman and Jaffe 135). This focus on intense parent-infant interaction dominates scholarly research and is especially characteristic of relatively affluent families in North America. In this interactional style, adults "desire to engage the child frequently as a conversational partner" (Schieffelin and Ochs 174) in a face-to-face manner, using child-oriented topics and "a simplified [linguistic] register" (de León 133). Linguistic anthropologists, however, point out that this interactional mode is not a universal script but historically, culturally and socially variable (Schieffelin and Ochs 224). Nor is infant signing free from debate among researchers in child development and language acquisition (Pizer). One review of 32 websites promoting infant signing found "no credible research evidence to support the[se] frequent claims" (Nelson, White and Grewe 490).

MAKING BETTER PARENTS

As noted earlier, teaching gestural communication to hearing infants is characterized as useful to parents. Signing as a strategy to make better parents is prefaced on the assumption that the parent-infant interaction without signing or prior to an infant learning to sign is problematic.

> It is difficult to pinpoint what an infant needs sometimes. Mothers learn to recognize certain signs and crying as indicating something particular such as hunger, or a wet diaper that is uncomfortable. But it is still a guess.... [With Baby Sign Language] there will be no need to try and interpret crying or facial expressions. You will know much earlier and through sign language what Baby wants at that very moment. Baby Sign Language saves parents a lot of time. When an infant cannot communicate needs or feelings, parents spend a lot of time trying to figure out what their child wants.... One of the greatest baby signing benefits is the time saved in satisfying your infant's needs. If your baby wants an apple, he can sign and tell you he wants specifically an apple. (Babies and Sign Language)

The idea that parents' failure to understand their non-signing preverbal infant causes infant distress and parental anxiety figures prominently in signing guidebooks and websites. In the first few pages and under the heading "911 ... to call or not to call," one guidebook introduces this issue as follows:

> As a parent, I found that there was nothing more frightening, frustrating, or heartbreaking than when my young toddler came to me crying and I had no idea what was wrong. I can remember being a toddler and not understanding why the rest of the world did not know how I was feeling. (Garcia 11)

As a response to what is framed as a lack of communication with distressing or even potentially harmful consequences, infant signing is positioned as a way to truly know what your child is feeling and understand what they are trying to express. Once learned, the signing gestures are assumed to be a direct and unambiguous reflection of the infant's desires and "a window into your child's mind and personality" (Briant 11; Acredolo and Goodwyn 5). In contrast, parental experiential knowledge or what is described as "guessing" at what an infant needs is positioned as problematic and wasteful. Further, the acquisition of speech or verbal communication previously just a normal and natural stage of infant development is reconfigured as time-consuming, slow, and wasteful:

> ... considering how slowly babies learn even easy words like *ball* and *doggy*, let alone words like *kangaroo* and *zebra*, there is no doubt that the result of waiting would be months and months of wasted time. (Acredolo and Goodwyn 3)

Significantly, what is being "saved" by infant signing is not just "time," but the emotional well-being of the infant who, if dealing with an inefficient non-signing parent, might cry "too long" or be distressed by being misunderstood.

> Imagine how your life would change if your baby could tell you when she wanted milk, when she was too hot, or

if she just wanted to show you something you missed like a flower! (Baby Sign Language)

While Hays argued that "intensive parenting" was constructed as outside of and separate from the rationality and efficiency models of workplace production, the discursive framing of infant signing clearly engages ideas of both productive parenting (developing children's potential) and efficient parenting (responding to infants in an economical fashion). Yet the suggestion that baby signing is "just" about enhancing intelligence is carefully tempered. In an interview for the New York Times, one of the founders of Baby Signs offers:

> It's not a "better baby" gimmick.... We really feel the gift is to the parent-infant relationship. The main reason to do it is to enable the baby to communicate what they need and see, to share their world with you. (Acredolo cited in Berck)

In addition to the promise of an emotionally secure, that is, understood and less disruptive, infant, parents who teach their infants to sign are promised "a richer and closer relationship with your baby" (Briant 11; Chafin ix). Extensively critiqued in feminist analyses as conceptually vague and socially conservative, the concept of an intense emotional "bond" between parent and infant is a late twentieth-century invention that powerfully reinforces the labour absorbing, child-focussed caretaking minutiae of intensive mothering (Eyer). In both scientific and popular thinking, bonding theory encourages parents and particularly mothers to take every opportunity to cultivate this relationship with their child. As Thornton notes, bonding creates a "sense of urgency": "every affectionate interaction between mother and child as well as every instance of failure to provide such interaction has a potentially permanent effect" (411). Signing with your infant is claimed to yield not only an emotionally secure child, but "affection and satisfaction that can last a lifetime" (Acredolo and Goodwyn 18), and a way to "weave your family unit closer together" (Chafin ix). Even fathers assumed to be "working during the first year of baby's life" can bond with their infants through signing (Jutras). Proponents of

signing suggest it will in fact enhance bonding because the infant values the parent who understands him or her. Thus, signing leads to "a higher level of trust from your baby because he or she knows that you understand what they are trying to tell you" (Jarvis 10).

MAKING BETTER BABIES

Infant signing promises not only to make better parents, but to create better babies. Once trained to use its hands to sign, infants are said to be able to communicate both their interests and desires, what is causing them distress, and to make visible their personality. Signing advocates suggest further that this bodily communication enables parents to appreciate the sophistication of their child's cognitive and perceptual abilities. Thus, signing "allows you to see just how smart your baby really is" (Briant 12), and enables parents "to take full advantage of your baby's hidden talents" (Acredolo and Goodwyn 18). Particular emphasis is placed on the idea that the infant "has lots to say ... [and] loves to be able to tell you what they know" (Savory 2004; Acredolo and Goodwyn 17), but is stymied in its efforts to do so. What is holding up or preventing that infant's communication?

> ... the brain is actually ready to produce language earlier than the tongue and vocal mechanisms are able to allow the child to express it. (Janet Jamieson cited in Savory)

> Imagine how it must feel to be a baby who has many specific needs and feelings to express, but no effective way to make those needs and thoughts understood. At times it must be frustrating for those small and socially dependent beings to live with those limitations (Garcia 10)

> Since babies do not have the oral motor skills to communicate vocally, they can use their hands to express their needs and feelings. (Babies and Sign Language)

Sign language, thus, enables the infant to transcend or bypass the limits of its own immature physiology, specifically vocal phys-

iology. While there is some acknowledgement that the very young infant (before four months of age) lacks the manual motor skills to form signs, that same infant body is, from the perspective of signing advocates, naturally inclined to use gestures. Babies are assumed to be "natural" signers, using and creating gestural signs spontaneously to communicate long before they can speak. In teaching their infants to sign, adults simply need to recognize this tendency, and then enhance it.

Not only is the young infant represented as hampered and frustrated by their immature physiology, but the infant without signs is regarded as lacking agency, described repeatedly as merely a "passive observer" of the world. Infant signing, it is claimed, enables agentive capacity in several ways. The infant who signs can self-regulate and is no longer fully dependent on others to manage their behaviour, body, and emotions. In contrast to the non-signing infant, the signing baby can initiate conversations, tell parents what they are seeing, express food preferences, and avoid excessive emotion.

> Signing enables a child to be an active communicator at much earlier age. He can initiate communication exchanges instead of being a passive observer. (Sign with Me)

> Imagine if your six-month-old told you she wanted to nurse *without* crying, or your 11-month-old told you he saw a dog across the street *without* grunting, or your 14-month-told you the side walk was too hot for her bare feet *without* screaming! (Baby Signs Canada)

> These small communication barriers can produce a great deal of frustration for a child and can lead to socially inacceptable [sic] behaviours like temper tantrums and aggression. Signing bridges that communication gap and creates an emotionally secure social environment for the child. (Babies and Sign Language)

Infants who sign are deemed to be empowered, to have more "control" over and "input" into their lives, greater self-esteem,

and the ability to "lead" and "teach" parents rather than merely follow them (Acredolo and Goodwyn 65). Particularly valued is an infant's ability through signing to make choices which are right for them as individuals:

> ...the first time she does a sign and I understand what she's asking for she's going to get what she asks for and I think it's really empowering for her just be able to have that input into her life a little bit. (Rima, a mother quoted in Savory)

> At lunchtime, your eight-month old can instantly make hand signs to indicate that he is *thirsty,* and wants *milk* (instead of *juice* or *water*) with his lunch.... Imagine avoiding that potential meltdown due to immediately understanding that your 13-month-old is signing that he wants to wear *red* socks (yes, specifically the color red!); and not the blue socks you have already picked out! (Babies and Sign Language)

> It makes her feel that she's more in control of a situation and has choices. (Jacqueline Turner cited in Berck)

Signing, thus, enables a particular kind of infant; one who is self-regulating, able to articulate his/her preferences, and uses signs not just to be social but to act in socially appropriate ways. The list of signs which one site says every infant should know is particularly instructive: "eat, change (diaper), help me, please, milk, and bedtime" (Sign with Me). Writing for a publication aimed at child care workers, one researcher describes how preverbal infants and toddlers use signs to comfort themselves, to regulate their behaviour by "talking" to themselves, to initiate interaction with caregivers, and "to communicate with caregivers about what will comfort or reassure them" (Vallaton 33). "Infant signs", she concludes, "allow children to take self-regulation into their own hands" (Vallaton 34).

DISCUSSION

The recent trend to teach hearing infants to sign exemplifies key

elements of contemporary intensive mothering. Baby signing continues the idea that a mother's interaction with her infant is essential to that child's successful development. It reproduces the notion that mothers must be constantly available for and interacting with their infant, attuned to and responsive to his or her every need, and continually stimulating their infant's development. Both contemporary intensive mothering and baby signing construct infancy as a period ripe for intense and continual instruction by parents. Baby signing promises not only to develop the child's linguistic and cognitive skills and potential, but holds out to parents the reward of both an emotionally secure, well behaved child and the satisfaction of a rich bond with that child. Beyond these similarities, I argue baby signing is distinctive in positioning the infant as both a more equal partner in mother-child interactions and as a central actor in directing both that interaction and its own development. In Hayes' conceptualization of intensive mothering, the infant is the object of a mother's childrearing labour, consuming and benefitting from it, and, through it, becoming a more contented and successful child. In baby signing, the infant is reconfigured as an agentive subject, able to communicate directly and in an unambiguous manner not only its basic needs but particular desires, pleasures, and interests. Baby signing not only reproduces the child-centric aspects of intensive mothering, it also transforms the child into an agentive subject whose communicative abilities can in fact teach women to be better mothers and to shape childrearing.

The creation of this infant subject who can benefit from, fully participate in and even direct intensive mothering is prefaced on the assumption that pre-verbal infancy is not just a natural developmental stage, but is a technical problem that can be solved with expert-guided maternal effort. The current popularity of baby sign language speaks to adults' unwillingness to allow babies to live "outside" of society; their preverbal bodies are seen to be problematic and insufficiently socialized. Baby signing, by transcending the physiological limits of an infant's vocal physiology, enables the infant to develop and to communicate a desired *habitus*, that of sociable, intentional, self-regulating, individualized subject. While there is ample evidence of adults seeking to the bodies of children in order to inculcate cultural and social distinctions of value con-

cerning gender, class, religion, and other identities (Yafeh; Pilcher; Ben-Ari), teaching hearing infants to sign is a particular kind of body work. Baby signing promises not only socialization of the infant but revelation, that is, revelation of the child's distinctive personality, interests and desires.

Although there is little data on which parents are taking up infant signing, the claim that it enables an infant's happiness and the expression of his/her particular character and desires may hold particular appeal for upper middle class parents. In research with American families of preschool children, Adrie Kusserow found that relatively affluent parents with post-secondary degrees and professions tended to regard each child as special and unique, a small but distinctive person with their own tastes, desires, needs and wants (81). Further, those parents tend to regard a child's happiness as essential to that child's successful development (Kusserow 83; see also Lareau 2011). Other research with affluent American parents indicates a communicative style with infants driven by a strong desire by adults to figure out what even "unintelligible or incomplete utterances" might mean and to "help a child get his/her intentions across" (Schieffelin and Ochs 175). Within these cultural and social priorities, the preverbal child may no longer be regarded simply as a developmental stage but as problematic or deficient, a hindrance both to the infant seeking to express its individuality and to the parent who must stimulate that individual to ensure success, achievement, and leadership in a competitive late capitalistic society.

Contemporary intensive mothering and baby signing are inseparable from the consumption of an array of books, toys, and other products deemed essential to parenting and child development. The claims made in guidebooks about the impact of signing on infant intellectual development are similar to those made for commodities such as the Baby Einstein, Baby Genius, and Bilingual Baby series (Hughes). Significantly, "in a consumer society, firms sell not material products, but a promise … to satisfy a particular dissatisfaction" (Dowdy cited in Hughes 35). The "dissatisfaction" is that babies cannot communicate and are both unhappy with that state and limited in their development. The promise is that by enabling communication, sign language will enable not only

smart, emotionally secure babies who have rich relationships with their parents, but who can also display and self-author his or her identity. In contemporary neoliberal political economies, forged at the nexus of consumption, identity making, and communication, is a view of the self as "a compilation of represented assets and skills that constantly require attention and enhancement to remain competitive" (Gershon 867, 873). The idea of infants who can communicate directly their desires, interests, skills, and character reproduces the social value placed on individuality "as something that will accelerate the maximization of potential and the mobilization of human capital for economic (productive) ends (Thornton 405). Further, the infant "empowered" through signing to communicate to others its distinctive character is primed to learn how to monitor that self-presentation and adapt flexibly to specific circumstances and conditions.

CONCLUSION

In this chapter I've sketched out infant signing as a form of body work freighted with culturally and socially shaped assumptions about infants and parents. Sign language has historically been associated with individuals who are hearing impaired and has been viewed as a sign of social exclusion. In its new form appropriated by hearing parents for use with hearing children, sign language is rebranded and revalued as a sign of intellectual progress, sociality, and bodily control as well as a self-authoring tool for even the very young infant. As I move forward with research in this area, it will be to focus on parents' views and practices of infant signing. I am curious why some parents may embrace signing as a significant communicative mode and why many, as I've heard anecdotally, choose to introduce and use only a very few signs. Further, what do parents regard as the forms of social and bodily competence enabled/acquired by their infants through gestural communication? To what extent do they see signing as enabling the development and expression of the infant self, as a means of transcending the limitations of the immature infant body, or as offering important skills? Does signing generate forms of infant agency that parents may regard as undesirable or as

enabling infants to express resistance to parental preferences? In depth interviews with parents and observations of their day to day signing practices with their infants will contribute to our understanding of infant-adult communication and offer a much needed perspective on how parents conceptualize infancy, the infant self and body.

WORKS CITED

Acredolo, Linda and Susan Goodwyn. *Baby Signs: How to Talk to Your Baby Before Your Baby can Talk*. Chicago: Contemporary, 1996. Print.

Babies and Sign Language. , "Social Benefits of Signing With Your Baby." Web. Accessed 20 March 2011.

Baby Sign Language. Web. Accessed 15 September 2013.

Baby Signs Canada. Web. Accessed 20 March 2011.

Beebe, Beatrice and Frank M. Lachmann. *Infant Research and Adult Treatment: Co-constructing Interactions*. New York: Routledge, 2013. Print.

Beebe, Beatrice, Frank Lachmann, and Joseph Jaffe. "Mother-Infant Interaction Structures and Presymbolic Self and Object Representations." *Psychoanalytic Dialogues: The International Journal of Relational Perspectives* 7.2 (1997): 133-182. Print.

Ben-Ari, Eyal. *Body Projects in Japanese Childcare: Culture, Organization and Emotions in a Preschool*. Richmond, UK: Curzon, 1997. Print.

Berck, Judith. "Before Baby Talk, Signs and Signals." *New York Times* 6 January 2004. Web. Accessed 19 September 2013.

Bourdieu, Pierre. *The Logic of Practice*. Trans. R. Nice. Stanford, CA: Stanford University, 1990 [1980]. Print.

Briant, Monta. *Baby Sign Language Basics: Early Communication for Hearing Babies and Toddlers*. Carlsbad, CA: Hay House, 2004. Print.

Chafin, Suzie. *Baby Sign Language: A Step-by-step Guide to Communicating with your Little One*. Guildford, CT: Globe Pequot, 2010. Print.

Douglas, Ann. "Baby, Give Me a Sign: Opening Up a world of

Communication Between Parents and Youngsters." *Toronto Star* Feb. 1, 2012: E7. Print.

Garcia, Joseph. *Sign with Your Baby: How to Communicate with Infants Before They Can Speak*. Seattle: Sign2Me and Bellingham: Stratton-Kehl, 2002. Print.

Gershon, Ilana. "Un-Friend My Heart: And Heartbreak in a Neoliberal Age." *Anthropological Quarterly* 84.4 (2011): 865-94. Print.

Eyer, Diane. *Mother-Infant Boding: A Scientific Fiction*. New Haven: Yale University Press, 1992. Print.

Fixell, Andrea and Ted Stafford. *Baby Signing: How to Talk with Your Baby in American Sign Language*. New York: Penguin Group, 2006. Print.

Hays, Sharon. *The Cultural Contradictions of Motherhood*. New Haven: Yale, 1996. Print.

Hughes, Patrick. "Baby, It's You: International Capital Discovers the Under Threes." *Contemporary Issues in Early Childhood* 6.1 (2005): 30-40. Print.

Jarvis, Jane. *Teach Yourself: Baby Signing*. London: Hodder Education, 2008. Print.

Jutras, Roz. "Fathers Bonding with Baby Sign Language". Babies and Sign Language. Web. Accessed 20 March 2011.

Kusserow, Adrie. *American Individualisms: Child Rearing and Social Class in Three Neighbourhoods*. New York: Palgrave MacMillan, 2004. Print.

de León, Lourdes. "The Emergent Participant: Interactive Patterns in the Socialization of Tzotzil (Mayan) Infants." *Journal of Linguistic Anthropology* 8.2 (2000): 131-161. Print.

Lareau, Annette. *Unequal Childhoods: Class, Race, and Family Life, With an Update a Decade Later*. 2nd ed. Berkeley: University of California Press, 2011. Print.

Mayall, Berry. *Towards a Sociology for Childhood: Thinking from Children's Lives*. Philadelphia: Open University, 2002. Print.

Nelson, Lauri H., Karl R. White and Jennifer Grewe. "Evidence for Website Claims about the Benefits of Teaching Sign Language to Infants and Toddlers with Normal Hearing." *Infant and Child Development* 21 (2012): 474-502. Print.

Pilcher, Joy. "Body Work: Childhood, Gender and School Health

Education in England, 1870-1977." *Childhood* 14.2 (2007): 215–33. Print.

Pizer, Ginger. "Baby Signing as Language Socialization: The Use of Visual-Gestural Signs with Hearing Infants." *Texas Linguistic Forum* 47 (2004): 165-171. Print.

Quirke, Linda. "'Keeping Young Minds Sharp': Children's Cognitive Stimulation and the Rise of Parenting Magazines, 1959-2003." *The Canadian Review of Sociology and Anthropology* 43.4 (2006): 387-406. Print.

Savory, Eve. "Baby Signing." *CBC News* 10 March 2004. Web. Accessed 24 February 2011.

Schieffelin, Bambi and Elinor Ochs. "Language Socialization." *Annual Review of Anthropology* 15 (1986): 163-191. Print.

Sign with Me. Web. Accessed 15 September 2013; 14 October 2013.

Thornton, Davi Johnson. "Neuroscience, Affect, and the Entrepreneurialization of Motherhood." *Communication and Critical/Cultural Studies* 8.4 (2011): 399-424. Print.

Vallatton, Claire. "Infants Take Self-Regulation Into Their Own Hands." *Zero to Three* (September 2008): 29-34. Print.

Woodhead, Martin, Ronnie Carr and Paul Light, eds. *Becoming a Person: Child Development in Social Context*. Vol. 1. London: Routledge, 1991. Print.

Yafeh, Orit. "The Time in the Body: Cultural Construction of Femininity in Ultraorthodox Kindergartens for Girls." *Ethos* 35.4 (2007): 516-553. Print.

How Contemporary Consumerism Shapes Intensive Mothering Practices

TATJANA TAKŠEVA

WHILE THE IDEOLOGICAL NATURE of intensive mothering as described by Hays still rings true in today's contexts, powerful global shifts and their influence on mothers over the last two decades render the contradictions of motherhood Hays identifies less tenable. Intensive mothering emphasizes the mother's nurturing, selfless qualities, a set of traits that as defined by Hays contradict the dominant social and economic system based on the competitive pursuit of individual gain (18). In her account, the ideology of intensive mothering on the one hand, and the economic and socio-cultural context of capitalism on the other, stand as opposing ideologies with irreconcilable differences.[1]

While the contradiction identified by Hays' may still hold some symbolic sway over contemporary cultural perceptions about mothering, I argue that mothering practices in the consumer age increasingly demonstrate that child-parent relationships are becoming firmly situated within the logic of the marketplace and corporate enterprise. Rather than existing outside the pervasive logic of the marketplace, the relationship between mother and child in today's Anglo-American contexts is increasingly being shaped by a consumerist ideology. I aim to show that the increasing commercialization of motherhood and mothering not only narrows the perceived gap between the selfless, seemingly irreducible value of mothering and the cold world of capitalist profit, but also that it significantly alters and shapes in new ways the "emotionally absorbing" and "financially expensive" categories of intensive mothering.[2]

Hays discusses intensive mothering as a historically constructed and gendered ideology, exhorting mothers "to expend a tremendous amount of time, energy and money in raising their children" (x). The logic of intensive mothering is represented in the idea that correct and desirable childrearing requires "professional-level skills and copious amounts of physical, moral, mental and emotional energy on the part of the individual mother," as well as great financial expense (4). This style of mothering still espoused by the majority of contemporary mothers, including the professionally employed, focuses on "enrichment" such as taking children to swimming, ballet, zumba, or judo classes, to orthodontists, psychiatrists and attention deficit disorder specialists, enrolling infants in a various "mother-baby" programs or preschoolers in French-immersion camps, as well as seeking out increasingly expensive and/or original ideas for children's birthday parties.

Andrea O'Reilly points out the relationship between professional, highly educated mothers and the recent strengthening of the ideology of intensive mothering with its emphasis on "enrichment." On the one hand, when professional women return to their careers, intensive mothering "as practiced in the evenings and weekends is the way a working mother, consciously or otherwise, compensates for her time away from her children; it bespeaks the ambivalence working mothers may feel about working and enjoying the work they do" (42). On the other hand, she locates the emergence of this focus on "enrichment" in its present form to the increased number of mothers who have their own income and who have a say in how the household income is spend (O'Reilly). According to national statistics data in Canada, the U.S. and the UK, the percentage of women in the workforce ranges from 60 percent in Canada in 2009, to 69.9 percent in the U.S. in 2013, and 67.2 percent for the UK in 2014.[3] Economically, with respect to the relationship between intensive mothering practices and the cost of raising children, intensive mothering thus operates as a privileged ideology, assuming that the majority of mothers have a disposable income they will choose to spend on their children. However, working-class mothers and poor mothers, while financially unable to provide all or some of the above activities and services for their children, continue to view the same as desirable

and somehow beneficial to children as well (cf. Hays; Takševa).

Contrasting the values associated with mothering and the traditionally sacrosanct relationship between mother and child to the capitalist values of self-interested gain, leads Hays to identify "the cultural contradictions of contemporary motherhood" (x). With increases in wage equality and career opportunities for women, rather than assimilating the logic of the marketplace, most women have remained committed to the emotionally demanding and labor-consuming model of child-rearing, eager to preserve the distinction between home life and the cold, calculating world outside. This orientation seems to stand in opposition to the fact that most Americans would "assume that it is human nature to be self-interested; almost none would claim that it is human nature to give priority to the needs and desires of others" (9), as mothers are expected to do at home with regard to their children's needs. Childrearing manuals treat children as "outside of the market logic" and portray childrearing as "a practice that stands in opposition to the self-interested, competitive pursuit of personal gain" (64). In other words, "just as the 'nature' of children stands in contrast to the outside world, so the methods of child-rearing contradict the practices of corporate enterprises and the centralized state. In child-rearing, love is the foundation" (Hays 64). In a society whose primary activity seems to be the "instrumentally rational pursuit of self-interested material gain in a situation of limited resources" and individualistic competition with others calculating the best possible gain (5), the ideology of intensive mothering, practiced by working and stay-at-home mothers in equal numbers, appears to exist in a discreet but somehow inviolable context of its own.

However, the economic and cultural landscape has changed significantly since the late 1990s. The turn of the century was marked by the large-scale synchronized international flows of goods and services, the increase in international capital that fuels global economic and social expansion, and the increasing deregulation of the advertising industry. Over the last two decades, the exponential development of globalization, and advertising as one of its tools, have contributed to the development and increased promotion of the culture ideology of consumerism, which extends the language and practices of the market into spheres of

life previously considered immune from its influences, such as mothering and childrearing (cf. Takševa). Consumer consumption has always been the driving force of a capitalist economy, but in the last two decades the magnitude and scale have changed. While in a pre-globalized capitalist economy it may have been possible to retain a sense that some spheres of life are untouched by the drive for profit, due to global policies and the exponential growth of aggressive advertising, practices and behaviors that are not commercial by nature have become commercialized and are beginning to be defined in terms of commerce and consumption. Consumerism has become a defining cultural trait of capitalist societies, constitutive of the dominant worldview that influences not only actions and behavior but also emotions, including how we feel about ourselves as mothers and our children (Takševa 135). This means that commercial and profit-driven policies are increasingly defining mothering and child-parent relationships in terms of their commodity value, blurring the boundaries between marketplace capitalist logic and the tenets of intensive mothering.

The human desire to consume is not new in itself. Cultural and intellectual historians locate the emergence of the consumer society in Europe between the fourteenth and seventeenth centuries, when the "members of the bourgeoisie became interested in their relationship with the material world" (Belisle 4). Social historians see the late nineteenth century as the time when consumer culture formed, when all members of the aristocratic, bourgeois and working classes enter the marketplace as consumers, since prior to the nineteenth century only the aristocracy and the bourgeoisie were wealthy enough to consume goods (Belisle; cf. Giles). What is new with the onset of globalization as it began to take shape in the late 1990s is the scale on which the pressure to consume and the packaging of desirable lifestyles is now taking place via aggressive marketing and mass-media driven strategies. What is also recent is the global promotion of forms of conspicuous consumption as a desirable way of life for all social groups, not just the wealthy and not just in the developed world. Consumerism thus "describes a society in which many people formulate their goals in life partly through acquiring goods that they clearly do not need for subsistence or for traditional display. They become

enmeshed in the process of acquisition—shopping — and take some of their identity from a [possession] of new items that they buy and exhibit" (Stearns viii).

Based on the free market economic theory and the unfettered global exchange of goods and services, and propelled by the self-perpetuating desire for profit, the consumerist worldview depends on producing and reproducing a desire for variety and emphasizing the idea of "choice" (Nethersole 642). Consumer-centric marketing strategies and aggressive but sophisticated advertising have emerged as effective tools to teach us how to consume, and to transmit the culture-ideology of consumerism, in the special sense of creating and satisfying induced wants (Sklair 166). Rather than being purely informational in nature or simply redistributing consumption patterns, and thus acting as a mirror of existing cultural values, there is strong evidence to show that advertising increases people's overall desire to consume:

> it promotes and normalizes a whole host of behaviors, attitudes and values ... it manipulates individuals on a subconscious level, both children and adults ... and ... it is so pervasive in modern society as to make the choice of opting-out from exposure virtually impossible. (Alexander, Crompton, and Shrubsole 18)

As members of a society whose values are increasingly being shaped in accord with the consumer ethos, and fueled by their adherence to the demands of intensive mothering, over the last two decades mothers themselves have come to participate actively in the consumer culture in ways that commercialize childrearing and children's perceived needs and desires. Rather than existing outside the capitalist marketplace logic, as Hays observed in the early nineties, today's mothers have come to act "as good capitalists" (12) in a variety of ways. While some mothers may be critical of capitalism and may seek ways of resisting some of its aspects, it is impossible to systematically opt out of a cultural and economic system in which we work, live and raise children, or stay immune to its dominant or even implicit ideologies.

One of the reasons mothers themselves have come to participate

in the consumer culture that commodifies childrearing and their mothering practices is that the commercialization of mother work has appropriated, exploited and depends for its success on the perpetuation of many of the deeply embedded cultural types of mothering, such as intensive mothering, and the New Momism, its recent extension. These types of motherhood operate as "a set of ideals, norms and practices, most frequently and powerfully represented in the media, that seem on the surface to celebrate motherhood, but which in reality promulgate standards of perfection that are beyond your reach" (Douglas and Michaels "Momism" 620). Both ideologies promote the idea that good mothering entails that mothers bring to childrearing a combination of selflessness and professionalism, bombarding anxiety-induced mothers with reassurances that they can produce bright, motivated, focused, fun-loving, confident, successful, cooperative contented children, just like the sparkling clean, obedient ones on the cover of parenting magazines (cf. Douglas and Michaels "Momism" 622).

While the degree to which mothers internalize socially accepted ideals may reveal some variances, maternal work can be seen as resting on the three universal demands identified by philosopher Sara Ruddick as the mothers' desire to raise children aiming for their preservation, growth and social acceptance (17). The demand for social acceptance in particular implies that mothers will shape their mothering practices in response to and often in accordance with dominant social discourses concerning their children's "proper" upbringing, thus increasing the children's chances for personal and professional success in the outside world. In the recent context of global flows of goods and services, consumerism has become one such dominant social discourse. Advertising, the industry that drives the consumer ethos, aggressively promotes the adoption of cultural values scholars have termed "extrinsic." In contrast to intrinsic cultural values, based among other things on the desire to nurture one's affiliations and have satisfying personal relationships, feel self-acceptance, feel competent and autonomous, extrinsic values are those that are contingent upon the perceptions of others—they relate to envy of 'higher' social strata, admiration of material wealth, or power, and concern for conformity, i.e., fitting in with others of a similar social status (see Alexander, Crompton, and Shrubsole

27-36). There is evidence to show that advertising that promotes extrinsic values in many ways strengthens consumer attachment to those values (Alexander, Crompton, and Shrubsole). In addition, a very influential advertising strategy has become the appeal to intrinsic values (those commonly unrelated to money or shopping) in order to exploit them; that is, to suggest that the purchase of certain products can provide for their meaningful pursuit. In this case, the mothers' love for their children, their commitment to their children's wellbeing, and their desire to be "good mothers," are all being exploited in order to further profit, consistent with the capitalist marketplace logic.

The extent to which many mothers comply with these expectations is revealed in recent market research studies showing that mothers whose household income ranges between $38,000 and $64,000; "spend $18,510 on miscellaneous items for the average child from birth to age eighteen," which includes spending on entertainment reading material, VCRs, summer camps and lessons" (cit. Bailey 38). According to these studies, "the average child will cost $338,000 by the time they finish public college" (Bailey 39). The outside world, which in the child-rearing manuals of the eighties and early nineties was defined as "impersonal ... competitive ... unnatural, false and therefore bad" (Hays 66), as well as the values it stands for, has now found a way into the home and increasingly defines the relationships between mothers and children.

In a consumer culture such as ours, acquiring and displaying products has become a means of demonstrating not only one's success in terms of wealth and purchasing power, but also demonstrating more subtly one's lifestyle, and one's beliefs and values. In this way, the capitalist logic behind consumerism seeks to define not only people's relationship to things, but also the relationships between people themselves. Semioticians tell us that everything we do is read as "message" and that we are always sending these messages to other people, just as others are always sending these messages to us. The messages are sent by our body language and facial expressions but also increasingly by our purchasing decisions aimed at displaying our lifestyle, our clothes, cars, homes, (Asa Berger 24-25) and I argue, our children and how we define ourselves as mothers. In today's society, consumerism profoundly shapes the

practice of intensive mothering as an ideology that still frames the discourse of "good" mothering. This influence carries to the extent that the culturally correct versions of intensive mothering are now being shaped in accordance with various consumption trends, turning mothers into willing participants as well as active agents in the capitalist marketplace arena.

As mothers and consumers, we are caught up in desiring and purchasing objects and services related to childrearing as a means of proving our worth as good mothers and validating ourselves and our abilities to look after our children in a socially desirable way. Market research specialists today advise marketing executives to appeal to mothers as the "new super consumer." In the words of one such specialist, "we are here to say that the best way to mom's heart is through her children. Whether she has an infant, tween or teen, a mom today wants to be the best mom she can possibly be for that child and that means an awful lot of what she does, what she buys, and what she demands of her family is centered around her children" (Coffey, Siegel and Livingston ix). Because "the relation between mother and child may be the most genuine, natural, spontaneous and exquisite love there is" (Thurer 333), and because women are likely to "associate their own sense of self-worth with how they provided for and brought up their children" (Cohen 73), in a commercialized world propelled by manufacturing needs and desires that tap into our psyches, mothers make the perfect consumer. A mother's self-esteem becomes bound up in achieving her children's happiness and proving to herself and to those around her that she is a good mother, which in a consumer culture is achieved to a large degree through purchasing. Mothers themselves participate in this process. Consumer studies addressed to companies indicate that mothers today are not only powerful consumers who purchase products, but that they also influence the decision making of their peers with the use of new digital media through, with which they "carry [the corporate] brand message into online communities, social networks, blogs and beyond" (Bailey 3).

In today's consumer culture, while the ideology of intensive mothering remains the dominant cultural view of correct mothering, "childrearing has given expression to material longings (both

of adults and their children," as children become valves of their mothers' consumer desire. Recent research into children's habits of consumption reveal the existence of a multimillion dollar advertising industry aimed at children and youth, making them the direct targets of many, now increasingly deregulated, advertising campaigns. These campaigns manipulate children's emotions in order to convince them that they need a style of clothing or a brand of shampoo to feel good about themselves and fit in with their peer group; the same campaigns show that children are "key players in their families' spending habits" (Doyle Roche 31-32). Marketing professionals today exploit the dominant cultural model of good mothering according to which children are seen as "innocent and priceless," whose care should be focused on their needs, with costly methods informed by the experts. The apparent contradiction between "priceless" children and the costly methods required for their good upbringing now exist merely in concept. It is the very fact that children are marketed as "priceless" that seems to warrant spending untold of amounts of money on their needs and wants. In their marketing strategies, advertisers rely on the so-called "nag factor" as the way in which children influence their parents, and mothers in particular, to make certain purchasing decisions, or to unwittingly equate the purchase of an object with showing care for their children and their "needs." Intensive mothering has thus become a commercial opportunity exploited by corporations for the sake of profit. In fact, over the last three decades motherhood has become one of the biggest obsessions and fixations in the media in general, bombarding women with an "ever-thickening mudslide of maternal media advice, programming and marketing that powerfully shapes how we mothers feel about our relationship with our own kids, and indeed, how we feel about ourselves" (Douglas and Michaels "Momism" 621). Today, motherhood in many circles means "big business" and an industry in its own right.

While children themselves remain "priceless," the expression of mother love and the celebration of their innocence and value seem to come with an increasing price tag. Mothers will spend money on their children to evoke the children's delight, and enable the expression of their "innocent" selves, which meets both the

mother's and the children's self-validating needs, but also awakens in children a similar desire and rationalizes pleasure-seeking consumption (Cross 18-19). These realities point to the fact that children too, alongside their mothers, collude albeit unknowingly in the construction of motherhood and mothering as a consumerist practice. At the same time, spending money on their children helps create the belief within mothers that they are increasing the ways in which they respond to and fulfill children's needs, and approaching the ideal of the "good," "sacrificial" mother who puts her children's needs ahead of her own, who is the enabler of their wellbeing and future success.

The mothers interviewed by Hays almost twenty years ago "all tended to share a set of specific ideas about good child-rearing" (xii). Although faced with a "plethora of advice" regarding child-rearing, all of them expressed a marked degree of confidence about their own version of intensive, "good" mothering. Sorting through child-rearing advice, according to one of the mothers, was like sorting through the mail: "you take the junk mail and throw it away, and you take the good mail and save it" (71). In sorting through advice, interpreting it, and deciding what is worth, individual mothers actively engaged in reshaping the social ideology of appropriate child-rearing (72). The cognitive process the mothers used implies reliance on a form of common sense and self-assurance that the "right" advice is recognized, adapted to and adopted into the mother's existing approach. While many mothers today use similar strategies to navigate through the maze of mothering advice (see Horwitz 2011), the sheer ubiquity of cultural images, advertising and texts bombarding mothers with what it means to be a "good mother" have created cultural conditions in which many mothers devalue the importance of instinct, or knowledge derived from their own family elders, and feel deep-seated insecurities about their own mothering practices. The amount of surveillance that parents and children are subjected to has also doubled, as the state has acquired a number of mechanisms of surveillance and an army of professionals "tasked with monitoring and regulating family life" (Timimi 12). This state of affairs increases the likelihood that mothers will leave guidance to the "expertise of professionals, as surrounded by a discourse that paints childhood

and childrearing as loaded with risk, they lose confidence in their own abilities" (Ibid.). Based on her practice as psychologist, Shari Turer recently notes: "I cannot recall ever treating a mother who did not harbor shameful secrets about how her behavior and feelings damaged her children. Mothers do not take easy pride in their competence" (331).

Mass media messages and advertising strategies tap directly into this form of motherly insecurity. Covers of parenting books and magazines daily question us, "Are you a sensitive mother?" "Is your child eating enough?" or, "Is your baby normal?" A growing number of ads promise parents brighter, more successful children through the purchase of a computer, an educational video game, or attendance of a for-profit learning and tutorial center. Editorials in parenting magazines urge parents, but mainly mothers who are the main target audience, to "read on to find out how [they] can develop the genius in [their] child, from her performance in school to how a trip to the store can be a chance to build vocabulary, math skills, and money smarts."[4] While many mothers do understand the persuasive intent of advertising they still may continue to wonder whether there is perhaps some truth in these injunctions and something more that they could be doing to help their children in an increasingly competitive world (Doyle Roche 33). Whatever the mother's present efforts in this regard, the language of advertising makes them appear lacking or inadequate, thus fueling her desire to compensate for this perceived inadequacy in some way, which often takes the form of consumption.

This kind of consumer culture, fueled by the purpose of advertising to manufacture desire and to make us want things that we do not have as means of achieving greater personal validation and success, in subtle ways taps into the suspicion of mothers that "we are not cut out" for mothering and that we cling to the romantic, idealized image of the perfect mother, "a chilling reminder of our own inadequacy" (Thurer 333). It also taps into whatever feelings of guilt many working mothers experience because they are not there with their children full-time, as a "good," self-sacrificial mother should be. Acquiring various products that promise to make us better mothers than we are, and to ensure that our children grow up more perfectly loved and cared for, seems to fulfill a deep

psychological need and assuages feelings of self-doubt. In order to satisfy the demands that intensive mothering places on mothers, to express the love they feel for their children, and to assuage the guilt that maybe they are not mothering well-enough, mothers adopt consumption patterns aimed at complementing or replacing their perceived inadequacy. This kind of consumerist logic redefines the meaning of nurturing and care, in that both nurturing and care are no longer actions that can take place in a domestic context merely by virtue of the mothers' presence without any reference to the outside world. On the contrary, "good" nurture and care today depend on a series of goods and services aimed at defining and "enhancing" these relational behaviors.

The language of child-rearing advice offered to mothers in books and magazines fuels the ideology of intensive mothering—that good mothering entails expending time, energy and money—taps into consumerist values, and normalizes the capitalist marketplace logic. The time and energy mothers spend seeking not only the best professional advice on childrearing, but also the best services and products for their children is only equaled by the amount of money some are willing to spend to facilitate what they believe to be the optimal development conditions for their children to succeed in a world dominated by the pursuit of personal gain, wealth and power. Thus mothers never entirely act outside the dominant social, cultural and economic context, but rather use the means available to them within those contexts to further their children's success and to validate their efforts as mothers.

In addition to the self-actualization that is part of mothers' relationship to consumption, an important aspect of consumption is that it often takes place within a competitive context, mirroring the competitive logic of winners and losers that drives the capitalist marketplace. This competition takes place on a number of levels and in a variety of ways. Sometimes it is linked to the desire to assert oneself as a good mother in a status-symbol way—owning the most expensive childrearing equipment, having children who are always spotlessly clean and sporting the latest fashions by prominent designer labels, attending the best schools in the area, or developing various expensive tastes through their after-school activities, such as horse-back riding and skiing. Some mothers

who adopt the ideology of intensive mothering will buy things not despite, but because they are expensive, embodying the "status symbol" that some merchandise has acquired. This makes sense partly because of the prevailing notion that the well- being of our children depends almost entirely on their upbringing, which is still the domain of the mother by default. It also makes sense due to the kind of activities children are exposed to, and the aggressive marketing of products that enable those activities. The things that mothers buy for their children become a reflection not only of their mothering style, but also of how they want to be perceived by others. Shopping is increasingly becoming a form of self-expression. The products we buy for our children or for our work of care as mothers are thus not just products, but have symbolic value as images of ourselves; they help construct a persona of the kind of mother we see as ideal and we would like to be seen as embodying. Thus, in making purchasing decisions relating to our children, we participate in the capitalist consumer culture that commodifies intensive mothering practices.

These forms of conspicuous consumption are intended to demonstrate not only that mothers are very accomplished and competent, but also that they belong to a particular class of people who consider these kinds of products and behaviors desirable and even necessary. Wealthy mothers demonstrate their power, superior competence as mothers and a place in society by the results of their shopping. They also demonstrate the direction and place in society where they would like to see their children fitting into, and how they differ from those mothers and children who are not of the same group. The subtle psychology behind these displays is the assumption that mothering based on conspicuous forms of consumption is inherently better or superior to other forms of mothering not based on the same model. The presumption to superiority rests on the idea that the children of affluent mothers are by default better provided for, and raised in ways that will result in their naturally making them feel confident, superior and entitled to the lifestyle in which they were raised.

Mothers seek to gain social status and power not only via the "careful presentation and display of consumer goods" (Bourdieu), but they also seek respectability through the appropriate display

of the bodies of their children, and other aspects related to their work of care as mothers (cf. Skeggs; Casey and Martens). Perhaps even more revealing is the fact theorized by some scholars of consumption, that children themselves can be used as objects of display conferring the desired social status. For example, Thorstein Veblen argues that

> the incidence of lower birth rate among the privileged classes stems from their need to use children as statements of their class status. The conspicuous consumption and the consequent increased expense required in the reputable maintenance of a child is very considerable and acts as a powerful deterrent to having many children. (133)

Sometimes a form of competition is embedded in a kind of "one-up-man-ship" frequently displayed by mothers in one social group, whereby they seek to demonstrate their superiority over other mothers and assert their form of mothering as better and more correct through carefully phrased verbal assertions about their children's personalities and accomplishments and their own mothering practice; these assertions are often centered on purchasing decisions regarding certain products that are in some way superior or that exemplify the mother's ability to make good decisions about her children's health, cognitive development, appearance and general well-being. In this model of behavior intended to display and perform intensive mothering, the opposition posited by Hays, between the pursuit of "self-interested gain in the context of a competitive market system and the emphatic pursuit of nurturing personal relations in the context of a system of mutual obligations and commitments" (16) as two central and contradictory cultural frameworks, is redefined and renegotiated in a way that alleviates the tension between the two. Mothers, like "good capitalists," have adopted the language and attitudes of the competitive "outside" world in the pursuit of self-interested gain. While they may not be "consciously calculating the most efficient means of raising children—that which would offer them the highest personal returns based on the least amount of effort" (Hays 12), they do seek to position themselves competitively by

consciously calculating how to gain the highest personal returns in the form of social status or peer respect based on the effort they invest into childrearing.

It is clear that consumption is also linked to a sense of belonging to a particular class or social group. Sociologists tell us that one of the most important human needs is to feel a sense of belonging to one or more groups in life (Pooler 110). Membership in a group is often defined through the purchasing of goods and services. Buying and owning certain things ultimately leads to the achievement of a feeling of membership in a given social group. Shopping in these cases is a means to a certain end (Pooler 111), in complex ways linked to the mothers' desire to have her children meet the demand of social acceptability in the way that is important to their social group. At the same time, membership in a group can be achieved by other means or activities that distinguish "good" from "bad" mothering, such as for example, mothering based on a particular set of beliefs. This kind of membership is also linked to particular forms of consumption and the presentation and display of consumer goods. One example of this would be groups of mothers, usually but not exclusively stay at home moms, who actively define themselves and their ability to mother in relation not only to their being there for their children 24/7, but also in terms of their adherence to a regime of shopping of particular foods and products that have in recent years become labeled "green," "organic," "socially sustainable," "local" or "made from recycled materials." These moms self-actualize their belief in the nature of the "good" mother through their often militant adherence to a particular consumption ideology that validates them and reflects them as socially conscious mothers whose mothering, in their eyes and in the eyes of their particular cultural group, is inherently superior to that of other mothers who may not embrace the same ideology. In terms of class, these mothers may belong either to the affluent or middle class, those who can and choose to buy expensive organic food and products that are labeled "green" or made of sustainable materials. But members of this group may also be low-income mothers with a developed social vision. Very often these mothers are not defining themselves in terms of class belonging, but rather in terms of their subscription to a particular

set of beliefs. Given the high cost of much organic food, this form of group membership can also be maintained through becoming connected to local farms and farmer's markets that often provide better prices for organic produce than large supermarket chains where most of those goods are imported. For many of the mothers who espouse this ideology of consumption, having little disposable income, in addition to their firm belief system, in fact constitutes a way to fight some aspects of the capitalist consumer culture and is a lifestyle choice. Being a "green mom" as a group of likeminded mothers call themselves, "means taking steps toward living a life that promotes health, happiness, and family time, while choosing to reduce our carbon footprints on our planet. No one is perfect and neither are we four, but everyone has to start somewhere."[5] What is common to mothers in all of these groups is their belief that through these particular forms of belonging they embody the imperative of intensive mothering to act in the best interest of their children, to love and care for their children in selfless, unconditional ways and to spend time, energy and money on making the "right" child-rearing choices.

The examples of intensive mothering in relation to consumption discussed thus far pertain primarily to lower and upper middle class mothers, that is, mothers from social groups with a sufficient amount of disposable income that allows them to make purchasing decisions based on factors other than need. It is important to recognize that consumption practices do embody class relations in the same way that class relations are formed by the forces of production (Giles 17). For working class and poor mothers consumption is equally linked to their view of themselves as good mothers able to take good care of their children, and has been so since the post-war era, when the commodification of the home and the view of woman/wife/mothers as a consumer were being established. Then and now, low-income mothers view children "as the repositories of hope, for whom safe places—homes with particular characteristics" are needed, which would represent the realization of their material and maternal aspirations and bolster their feelings of self-worth and dignity (Giles 27).

When many working class and poor mothers recall the impoverished conditions in which they grew up, their focus is on poverty

and the lack of power to buy things, rather than ill health and disease, which were equally prevalent in their domestic environments (cf. Giles 27). In a society where the consumerist ideology dominates, and which presents shopping and the acquisition of various goods and services as part of the possibilities and entitlements of modern life in the global age, it is not surprising that working class women always speak of their aspirations for their children in terms of material belongings, while at the same time expressing dissatisfaction with their current financial situations. Their dreams for a "better future" for their children are articulated in the language of material commodities, and the desire to belong to and share in the promises of a consumerist society (Giles 28; cf. Casey 134). Similarly, children from households where money is tight "have a much stronger desire for money and possessions" (Nairn, Bottomley and Ormrod 205).

This psychological dynamic reveals that the commercialization of mothering and consumer culture affects the feelings of self-value of mothers at the margins of society, threatening to cast them as "bad" mothers in their own eyes and the eyes of others if they cannot enable their children to take part fully in the dominant consumer-oriented way of life. While feelings of guilt and anxiety over not being a good-enough mother, or not doing enough for one's children may be common to mothers across various classes, in working class mothers these feelings may be compounded by the general anxiety that mothers feel about debt and financial security. Many working class mothers experience guilt and concern that, due to their lack of financial resources, they are not providing their children with the same life chances that they could if they had the money to do so. Many low-income mothers find different strategies to help define themselves as good mothers and their mothering as "good-enough" in a consumer culture, such as being very knowledgeable about where and when to shop for bargains, and actively negotiating their children's expectations as to what can and cannot be bought (Casey 134). Hays' analysis of the social bases of variations in mothering remains valid and consistent in this regard. Although her discussion of the mothers' social class in relation to the ideology of intensive mothering is meant to acknowledge and highlight differences

among mothers, it also demonstrates "important underlying similarities in child-rearing beliefs": "No matter how different the circumstances and beliefs of the mothers in my study, my interviews suggest that almost all mothers recognize and respond to this ideology.... And this dominant model of child-rearing is almost precisely the same model as is found in the manuals of Spock, Brazelton and Leach" (72).

In conclusion, just as mothers across social classes recognize and respond to the model of intensive mothering as the culturally dominant model of correct child rearing, mothers across classes recognize and respond to consumerism as it increasingly defines and shapes the demands of intensive mothering in a capitalist context. The fact that the ideology of intensive mothering corresponds to the ideology of appropriate child rearing found in child rearing manuals points to two things. One, that these manuals and other culturally prevalent images of motherhood and mothering prescribe desirable forms of mothering by encoding some traditional attitudes toward mothers and children as "professional" and "expert" advice. Two, that there are complex interactions and inter-dependencies among mothers and prescriptive texts, mothers and the world of capitalist marketplace logic, and the texts themselves as a originating from within and mirroring this world and its logic. Both mothers and their mothering practices and the texts that seek to encode those practices exist within and are defined by the larger social, cultural and economic milieu.

In light of the increasing interdependence between the dominant discourses on motherhood and the dominant socio-cultural context defined by the marketplace logic driven by a consumerist orientation—a context in which mothers live, work and raise their children—Hays' contention that the ideology of intensive mothering must be understood as "one form of a larger cultural opposition to the ideology of rationalized market societies" (154), appears no longer tenable. While on a symbolic level mothers may still be "engaged in an explicit and systematic rejection of the logic of individualistic, competitive and impersonal relations" (Hays 154), as Hays could claim twenty years ago based on her research, the current reality points to the fact that the tensions between the two then competing ideologies is actually being resolved through

the pervasive influence of consumer culture on the relationships between mothers and children, and the images of good motherhood promulgated in a ubiquitous manner through media and the advertisement industry. The ideology of intensive mothering and the profit driven marketplace logic of contemporary capitalist societies are no longer opposing ideologies, held separate by their irreconcilable interests. While mothers' love for their children, as a powerful emotion in its linguistic form may still be seen to exist above and beyond the cold world of the capitalist market logic, the ways in which mothers choose to express that love, or act on their belief about what it means to be a good mother, is increasingly defined by their active and willing participation in consumer culture embedded in the competitive capitalist pursuit of profit in a free market exchange.

[1]While acknowledging the existence of competing ideologies, many studies since Hays' have identified intensive mothering as an ascendant ideology in North American contexts. See Arendel; Hallstein; Avishai; Douglas and Michaels (*The Mommy Myth*); Hattery; Thurer.
[2]Parts of this research appear in Tatjana Takševa, "The Commercialization of Motherhood and Mothering in the Context of Globalization," *Journal of the Motherhood Initiative for Research and Community Involvement* 3.1 (2012): 134-14, and are reproduced here with permission.
[3]For this and other examples see http://www.parenting.com/article/how-raise-gifted-children
[4]Green Mom is the name of a website and blog created by Fredrica Syren a.k.a. Green Mom. The Website address is: http://greenmom.com/.
[5]This data was gathered from publically available sources of Statistics Canada, the U.S. Department of Labor, and the UK Office of National Statistics respectively.

WORKS CITED

Alexander, John, Tom Crompton and Guy Shrubsole. *Think of*

Me as Evil? Opening the Ethical Debates in Advertising. Public Interest Research Centre (PIRC) WWF-UK., 2011. Web. Accessed November 18, 2014.

Arendel, Terry. "Conceiving and Investigating Motherhood: the Decade's Scholarship." *Journal of Marriage and the Family* 64. 4 (2000): 1192-1207. Print.

Avishai, Orit. "Managing the Lactating Body: the Breastfeeding Project and Privileged Motherhood." *Qualitative Sociology* 30 (2007): 135-152. Print.

Asa Berger, Arthur. *Ads, Fads and Consumer Culture: Advertising's Impact on American Character and Society.* Lanham: Rowman & Littlefield Publishers Inc., 2000. Print.

Bailey, Maria T. *Mom 3.0: Marketing with Today's Mothers by Leveraging New Media & Technology.* Deadwood, Oregon: Wyatt-MacKenzie Publishing, Inc., 2008. Print.

Belisle, Donica. "Toward a Canadian Consumer History." *Labour / Le Travail* 52.(2003): 181-206. Web. April 4, 2012.

Bourdieu, Paul. *Distinction: A Social Critique of the Judgment of Taste.* London: Routledge and Kegan Paul, 1984. Print.

Casey, Emma. "Gambling and Everyday Life: Working Class Mothers and Domestic Spaces of Consumption." *Gender and Consumption: Domestic Cultures and the Commercialization of Everyday Life.* Eds. Emma Casey and Lydia Martens. Aldershot: Ashgate, 2007. 123-140. Print.

Casey, Emma and Lydia Martens, eds. "Introduction." *Gender and Consumption: Domestic Cultures and the Commercialization of Everyday Life.* Aldershot: Ashgate, 2007. 1-14. Print.

Coffey, Tim, David Siegel and Greg Livingston. *Mom and Kid: Marketing to the New Super Consumer.* Ithaca: Paramount Market Publishing, 2006. Print.

Cohen, Ruth. *Hardship Britain: Being Poor in the 1990s.* London: Child Poverty Action Group, 1992. Print.

Cross, Gary. "Valves of Adult Desire: The Regulation and Incitement of Children's Consumption." *Childhood and Consumer Culture.* Eds. David Buckingham and Vebjørg Tingstad. Basinstoke: Palgrave Macmillan, 2010. 17-30. Print.

Douglas, Susan J. and Meredith W. Michaels. "New Momism." *Maternal Theory: Essential Readings.* Ed. Andrea O'Reilly.

Bradford, ON: Demeter Press, 2007. 617-639. Print.

Douglas, Susan J. and Meredith W. Michaels. *The Mommy Myth*. New York: Free Press, 2004. Print.

Doyle Roche, Mary. *Children, Consumerism, and the Common Good*. Lanham: Rowman & Littlefield Publishers, Inc., 2009. Print.

Garey, Anita. *Weaving Work and Motherhood*. Philadelphia: Temple University Press, 1999. Print.

Giles, Judy. "Class, Gender and Domestic Consumption in Britain 1920-1950." *Gender and Consumption: Domestic Cultures and the Commercialization of Everyday Life*. Ed. Emma Casey and Lydia Martens. Aldershot: Ashgate, 2007, 15-32. Print.

Hallstein, D. Lynn O'Brien. "Second Wave Silences and Third Wave Intensive Mothering." *Mothering in the Third Wave*. Ed. Amber Kinser. Bradford, ON: Demeter Press, 2008. 107-118. Print.

Hattery, Angela. *Women, Work and Family: Balancing and Weaving*. London: Sage, 2001. Print.

Hays, Sharon. *The Cultural Contradictions of Motherhood*. New Haven, Conn.: Yale University Press, 1998. Print.

Horwitz, Erika. *Through the Maze of Motherhood: Empowered Mothers Speak*. Toronto: Demeter Press, 2011. Print.

Kimmel, Michael and Jaqueline Holler. *The Gendered Society*. Don Mills, ON: Oxford University Press, 2011. Print.

Nairn, Agnes, Paul Bottomley and Johanne Ormrod. "'Those Who Have Less Want More. But Does It Make Them Feel Bad?' Depravation, Materialism, and Self-Esteem in Childhood." *Childhood and Consumer Culture*. Eds. David Buckingham and Vebjørg Tingstad. Basinstoke: Palgrave Macmillan, 2010. 194-210. Print.

Nethersole, Reingard. "Models of Globalization." *PMLA: Publications of the Modern Language Association of America* 116.3 (2001): 638. Web. 11 Apr. 2012.

O'Reilly, Andrea. *Rocking the Cradle: Thoughts on Feminism, Motherhood, and the Possibility of Empowered Mothering*. Toronto: Demeter Press, 2006. Print.

Pooler, Jim. *Why We Shop: Emotional Rewards and retail Strategies*. Westport: Praeger, 2003. Print.

Rudick, Sara. *Maternal Thinking: Toward a Politics of Peace*. New York: Ballantine Books, 1989. Print.

Skeggs, Beverly. *Formations of Class and Gender: Becoming Respectable.* London: Sage, 1997. Print.

Sklair, Leslie. *Globalization: Capitalism and Its Alternatives.* Oxford: Oxford University Press, 2002. Print.

Stearns, N. Peter. *Consumerism in World History: The Global Transformation of Desire.* New York: Routledge, 2006. Print.

Takševa, Tatjana. "The Commercialization of Motherhood and Mothering in the Context of Globalization: Anglo-American Perspectives." *Journal of the Motherhood Initiative for Research and Community Involvement* 3.1 (2012): 134-148. Print.

Thurer, L. Shari. "The Myths of Motherhood." *Maternal Theory: Essential Readings.* Ed. Andrea O'Reilly. Bradford, ON: Demeter Press, 2007. 331-344. Print.

Timimi, Sami. "The Commercialization of Children's Mental Health in the Era of Globalization." *International Journal of Mental Health* 38.3 (2009): 5-27. Print.

Veblen, Thorstein. *The Theory of the Leisure Class.* New York: Penguin, 1972. Print.

Intensive Mothering, Elimination Communication, and the Call to Eden

MADELINE WALKER

IN HER CALL FOR PAPERS for this volume, editor Linda Ennis asked, "In a world where independence is encouraged, why are we still engaging in 'intensive motherhood'?" I expand on her question: If, according to Sharon Hays, "the logic of the market should be winning out and the ideology of intensive mothering fading away" (153), why is it that today, intensive mothering norms are widely accepted, and these norms comprise the "prevailing parenting paradigm in the United States" (Damaske 436)? Not only is intensive mothering our predominant parenting paradigm, there is a growing subset of mothers who adhere to even more extreme forms of intensive mothering. The continuum concept of attachment parenting, first described by Jean Leidloff in 1975, requires that parents follow the evolutionary continuum of keeping infants close and responding quickly to their needs, and this subset of mothers practise all or a combination of home birth, extended breastfeeding, co-sleeping, and elimination communication (diaper free parenting). Far from being surprised at this trend, I often wonder why more Western mothers do not flock to these extreme forms of intensive mothering to try to assuage a sense of loss of the "natural" in modernity. That path, though seductive because it seems to promise a recovery of what was lost, is also misleading because while ancient practices can be replicated, they are often at odds with contemporary North American culture. That mismatch may create undue stress on mothers trying too hard to achieve the Eden of perfect parenting.

I argue in this essay that a small but articulate minority of moth-

ers romanticize childrearing in traditional or "primitive" cultures and, in particular, the practice of Elimination Communication or Natural Infant Hygiene, whereby parents (usually mothers) respond to infants' need to urinate or defecate rather than diapering their babies. Elimination Communication and Natural Infant Hygiene are considered synonymous in this essay, and I will refer to both as EC for the sake of brevity.[1] Proponents argue that ultimately such practices create more independent children, teens, and adults. The language used in describing EC, however, reveals the proponents' utopian desire to return to a simpler, preindustrial time and to a less developed geographical place where the mother-baby dyad operates outside of time and economics.

Although I do not criticize EC as a practice, I claim that Laurie Boucke and Ingrid Bauer,[2] authors of seminal books about EC, idealize other cultures, lift parenting practices out of socio-economic contexts, mistake necessity for virtue, and use language that implicates an a priori concept of "natural mothering." EC discourse, I argue, may contribute to an exclusionary ideology because this practice is considered part of attachment parenting that parents, but especially mothers, should follow to honour natural bonding and development opportunities. In other words, if you do not or cannot practice EC, you are not doing the best by your child. This pressure to succeed at attachment parenting thus exacerbates consequences of intensive mothering noted in the research: mothers' stress, anxiety, guilt, and fatigue (Wall 253).

I start by summarizing the books I draw from, Boucke's 2000 *Infant Potty Training: A Gentle and Primeval Method Adapted to Modern Living* and Bauer's 2001 *Diaper Free: The Gentle Wisdom of Natural Infant Hygiene*. I then discuss how Boucke and Bauer, although careful to include anthropological accounts, do not adequately take up how social and cultural contexts of parenting and elimination practices in the countries they use as evidence are different from contemporary North American society. Second, I take up the idea of how language in the two books relies on an a priori understanding of what is natural for baby and mother. The use of words "natural," "ancient," "primeval," and "traditional" romanticize and idealize this practice. I draw on the work of feminist Cressida Heyes and her Wittgensteinian view against essentialism,

i.e., that there are some essential qualities of being a mother/ baby dyad that exist prior to language. EC is a compelling alternative to diapering babies and toilet training at the conventional age; however, valorizing this practice as somehow better, deeper, and leading to superior communication between baby and mother is not helpful to already overburdened mothers. Just as mothers who choose not to breastfeed sometimes feel shamed and outcast and breastfeeding promotion has been viewed as tyrannical (Humphries 11), EC may also stigmatize mothers who are already trying to do reconcile the demands of family and work.

EC was developed by Boucke in 1991 with first an 80-page booklet, *Trickle Treat: Diaperless Infant Toilet Training Method*, and followed by the 2000 book now in its third edition. Ingrid Bauer's book followed a year later. Both Boucke and Bauer counter the traditional Western practice of "toilet training" starting at around 18 months, arguing that this is a culturally constructed rather than a biologically driven practice, and that babies are actually "ready" at birth (Bauer 71). As anthropologist Marten DeVries writes in his introduction to Boucke's book, "infants are capable of an immense repertoire of behavior at birth," and are shaped by the family and culture's expectations (xi). When mothers pay attention to early cues such as grunting, body movements, and cries, they can then respond by placing baby over the toilet or a bowl to catch urine or feces. Adapted from other cultures in hot countries where diaperless babies simply "go," EC is described as a way of being, a lifestyle rather than a parenting technique (Bauer 27). As you spend the time attuned to and responding to baby's needs immediately, you invest in the baby's well-being and feelings of satisfaction and contentment. EC is presented as a rich opportunity for intuitive bonding and part of the attachment parenting continuum that may include unmedicated gentle birth, breastfeeding, and co-sleeping. The practice emphasizes babies' universal need for continuous contact with the mother, who will respond to various requirements for food, interaction, and elimination.

Both books include sections reporting cross-cultural anthropological research and mothering anecdotes, all used to underpin the authors' view that EC has its roots in ancient wisdom and are viable and desirable parenting methods. Whereas Hays's descrip-

tion of intensive mothering that emerged from her data included reliance on the experts as a central ingredient, this more extreme version of intensive mothering values other mothers (especially from more "traditional" cultures) as experts. Both writers show that in many countries mothers practise communicating with their newborn infant to pick up on elimination cues. Bauer prints a partial list of these countries (79), which includes many South Asian and African countries. Bauer and Boucke claim that there is no imperative that says the way we do in the West is better; in fact, they claim our usual practice of waiting for toileting "readiness" is not scientific and does not respect the needs of the infant, who would like to avoid wearing diapers and stay clean if he or she had any say in the matter. Their arguments are made to persuade Western mothers that the time spent listening to baby's cues is time well spent, as it will mean rapid use of the toilet (generally by one year), few diapers used, a happier and more independent child (and, ultimately, adult), and closer mother-child relationships.

Elimination Communication carries with it two assumptions. First, there should be a stay-at-home caregiver or an extended group/ family of caregivers for the first months and years of the baby's life to respond to elimination cues. Second, the practice is superior to using diapers until a child is able to use a toilet on his or her own because it is "natural"; promotes better bonding and communication; takes advantage of the first "window" for toileting (Boucke 5); is more hygienic, less expensive, and more eco-friendly; and baby is more content, more in touch with his body, and eventually more independent.

In spite of the value of these books and the method they describe, I am troubled by their utopian vision. I realized some of the dissonance came from my own sense of endless striving toward perfection, or in this case, the Eden of parenting. I discovered that Jean Leidloff's 1975 book *The Continuum Concept*, a classic in attachment parenting circles, described the source of that Eden. In her book, Leidloff documents her experiences living with South American Indigenes and the way babies were treated in that context. Leidloff begins her book with a conversion story. At the age of 8 during a nature walk, she experiences an epiphany. In a glade populated by a fig tree, a knoll, and "luminous green moss," the young Leidloff "felt

the anxiety that colored my life fall away. This, at last, was where things were as they ought to be. Everything was in its place—the tree, the earth underneath, the rock, the moss" (4). She goes on to describe the feeling of completeness: "I felt I had discovered the missing center of things, the key to rightness itself, and must hold on to this knowledge which was so clear in that place" (5). The Glade (with the capital letters) becomes Leidloff's symbol of wholeness and, although she does not make the parallel explicit, analogical to the Garden of Eden. This unchanging, pre-lapsarian, bountiful place, complete with fig tree to supply Adam and Eve with leaves to cover their shame, prompts Leidloff to later go to South America and live with Yequana Indians, observing their way of life and developing—from those observations—her theory of the continuum concept. The continuum concept means that all human beings share the same needs for early continuous contact with mother, appropriate discharge of energies, and socialization by a loving extended family. And, as Boucke puts it when she describes Leidloff's concept, "the fulfillment of these innate expectations [by baby] leads to emotional security, a sense of inner well-being, self-reliance, and joy" (23).

Leidloff's vision is an important one because it informs the tenor of the arguments about EC as a natural extension of the continuum concept, although Leidloff's work predates development of EC from the models of other cultures. What I mean by "tenor" here is that the general thrust of Leidloff's, Bauer's, and Boucke's books is that, regardless of the culture they are born into, babies' needs remain universally the same with attachment as an evolutionary requirement for later security and success. Some cultures do a better job of continuously responding to those needs. That space/place of proper attachment and suitable response to baby's needs is configured as a space/place out of time: an Edenic location that exists pre-civilization and now in "civilized" postmodern cultures, a location to be attained. In order to attain Eden, however, you will need to unlearn many of the mainstream parenting practices and get back in touch with what is eternally "natural." Why, I wonder, does this message trouble me so?

Although derived from ancient cultures, EC is treated by Boucke and Bauer as an advanced cultural view of excrement and elimi-

nation. The baby stays clean early and does not have to sit in wet, mushy, or smelly diapers, a practice that seems archaic. Parents tune into a sophisticated pattern of cues from baby, and thus hone early communication with their offspring. There is no shame about elimination and their products. Why wouldn't we want to transport these seemingly progressive practices from other cultures to our own? My argument does not condemn the practices in any way, but here I ask for a fuller understanding of the practices as they are embedded in their home cultures and ask how historical, geographical, and social-cultural-class and gender contexts affect this transfer. I will confine my example to one country, India, that both writers include in their exploration of toileting in other cultures. One of Bauer's model mothers from India, repeats the words "clean" and "cleanliness" in her story several times, saying her children got used to feeling clean and associated eliminating regularly with being clean (not sitting in a diaper) and also eliminated once early in the day so "they were then fresh for the day." She writes, "I have never understood why Westerners, who are so adept at other things, could not have more control over their bowel habit" (93).

Although EC may well be advanced in the sense that it is progressive, the practice of responding to baby's cues, as practiced in India, is also embedded in a culture where open defecation is common, a practice that might be seen as backward, and has created many health problems including polluted drinking water. Although this mother may have taught her children to keep their colons clean through habits of elimination, the Ganges is singularly unclean, receiving 2900 million litres of raw sewage each day ("Ganga receives," 2012). Furthermore, and as mentioned in a *New York Times* article, diapers are not readily available in parts of India, thus making this necessity (diaperless babes) into a virtue (although, I acknowledge, cloth diapers are readily available). More importantly, Bauer and Boucke omit to examine that diaperless babies are embedded in the cultural context of a lack of sanitation infrastructure in this huge country.

Unicef and World Health Organization (WHO) report that "15 percent of the world's population practice open defecation, defined as defecation in fields, forests, bushes, bodies of water or other

open spaces" (15), and in Southern Asia, 692 million people—41 percent of the population—continue to practice open defecation (18). Thus Bauer's and others' description of EC has to be examined in light of its transfer to North America as a neutral practice. In fact, the practice is rooted in the economy, geography, and cultural complexity of countries struggling to meet sanitation and drinking water targets set by the World Health Organization. I point out that Boucke and Bauer may be romanticizing EC by unlinking it from the conditions that surround it and at the same time appealing to a naturalistic fallacy; that is, if it's natural it must be good.

Bauer writes that "parenting practices lost within our own history are still evident in cultures that live closer to the earth, to their hearts, and to their children, community, and families" (22). Again, when other cultures are depicted as being more earthy, loving, and connected, it is easy to forget that these idealized cultures may also be patriarchal, suffer from poverty and lack of sanitation, and be troubled by gender inequality. Furthermore, parenting practices in North American cultures can and do encourage loving communication between babies and parents. Who is to say that the quality of interchange between an American father and his baby during a diaper change or bottle feeding is inferior to the communication between a mother and her baby in a Taiwanese village during breastfeeding or elimination?

Transporting a cultural practice from, say, rural India where extended families are the norm, and plastic diapers are rare and unaffordable, to a Brooklyn brownstone (see Hartocollis on EC's popularity with mothers in NYC's "hipper precincts") is possible and perhaps even desirable. However, the upper-middle class New York City mother is exercising a choice in practising EC with her baby. EC may not be a choice but a necessity for the mother in rural India, Conversely, EC is not really a choice for a poor working single mother in North America, unless she has a network of extended family and friends willing to assist in this endeavour. Just as white, upper middle class subscribers to the voluntary simplicity movement are frequently unaware of how race and class privilege have enabled their choice of a simple life (Grigsby), so contemporary EC'ers may not see how their decisions are underpinned by relative wealth and the alternatives it buys.

Nonetheless, I believe that in a culture that insists on conformity around parenting practices, Boucke, Bauer and Leidloff's efforts are admirable. By valorizing what they deem as better practices because they are more "natural," these writers assume some a priori essences about the mother/ baby dyad. Said another way, their books demonstrate a belief that there are essences that reside forever in nature, are immutable, and existed before language, that is, in this case, the needs of the baby and the relationship between baby and mother. In other words, these authors "essentialize" the mother/baby dyad across all time and all cultures, that is, they assume a universal essence or master narrative about mothering. In doing so, these writers do a disservice to North American parents operating in the twenty-first century where diapers and toilet training between 18-36 months are not only an accepted practice, but enable babies to be placed in daycare, allow mothers to do paid work outside the home, and create the context for women to enjoy many freedoms.

Feminist scholar and philosopher, Cressida Heyes, helps me to make my argument about essentialism. In her 2000 book, *Line Drawings*, Heyes argues for anti-essentialism that allows us to generalize about women, yet at the same time pay attention to differences and discursive constructions of "women." Heyes's work is relevant here because, rather than "considering language as revealing truths about the world" (85), she asks us to examine specific linguistic usage. In other words, instead of seeing EC as revealing truths about how to handle infant elimination (or "the truth"), I am interested in the linguistic usage of such terms and the meaning content they bear (i.e., assumptions and biases about women, babies, and culture).

Heyes writes that Wittgenstein "viewed essentialism as a linguistic phenomenon entailed by the claim that members of a particular class share a common key property by virtue of their common name. He rejects the notion of a single 'essence' to these classes, where 'essence' implies a statement of the necessary and sufficient conditions for the application of a particular term" (82). One of Wittgenstein's objections to linguistic essentialism, and one that interests me for my purpose in this argument, is that it relies on "a priorism at the expense of empirical inquiry" (82). In

other words, in linguistic essentialism, meaning is assumed to be constructed prior to use of language. Heyes employs Wittgenstein to argue that this same a priorism is at work when people make broad claims about women "based on the experiences of only some women" (82). Her objection is that this kind of a priorism elides the differences of women, but more importantly for my argument, ignores that women's identities are born from particular social locations. Boucke and Bauer seem to assert that women's specified characteristics of "naturally" communicating with baby exist prior to the application of the term "women" or the terms "natural infant hygiene" and "elimination communication"—that is, there is an assumption that Western mothers would be getting back to some essential quality that exists a priori to the map that culture and social values overlie, and that this same quality can be excavated if the mother can return to some ancient call of mothering. Although we cannot interview newborns to ascertain whether they are all experiencing the same thing, we can assume a general set of needs and yet we can also assume that mothers in their localized contexts have different mothering experiences and can respond to those baseline needs in a variety of ways that will ultimately produce healthy children and adults who are well adjusted to their own culture.

Just as Adrienne Rich drew our attention to the "glib romanticizing" of "primitive" (130) women giving birth without pain, there is a parallel strain here, in theories of EC, of reductionism in assuming the simple transferability of cultural practices and using as their means of persuasion another assumption about the rightness, universality, and desirability of what is "natural," "ancient," and "traditional." Let's look, for example, at use of the word "natural" in Bauer's term "Natural Infant Hygiene." Here, she seems to want to have it both ways; she uses the word to try to make it so, and at the same time to signal some universal good in parenting. In a section called "It's Natural" she first acknowledges the word has "different meanings to different people," but that her desire is to have the diaperless method be viewed someday as natural, therefore "normal, ordinary, or logical" and "not supernatural or strange" (49), citing the *Collins English Dictionary* for these meanings. Thus, she is not so much examining the word as it is

used (linguistic usage), but imposing a future understanding for the adjective—she hopes that someday, babies going diaperless and mothers communicating to babies about eliminating will be normalized (i.e., "natural") practice in North America as it is in other cultures. Second, she calls on graduate student Lindsay Chauvin, who is interested in ontogeny, as a spokeswoman for EC; presumably Chauvin's knowledge authenticates her words. Chauvin says, and I quote at length to convey the full flavour,

> If we haven't changed since the Pleistocene where there were no diapers, no strollers, no separate nurseries with cribs, why are they deemed necessary now? What are the repercussions of having altered child-rearing practices that have existed and shaped us for thousands and thousands of years? Who are we to mess with this? ...Elimination Communication is a connection that I want with my baby to help her (and myself) on her way, and to experience our life together at its fullest. I hate using the word 'natural' as it has so many different meanings and degrees for people. But there it is.... Elimination Communication is natural. (49)[3]

What Chauvin, and by extension Bauer, do not account for here is the complex yet undeniable dance of nurture and nature in our social and cultural shaping. We have changed since the Pleistocene era. Our brains, bodies, and behaviours have changed, and each social and cultural location in which a mother finds herself, she is working with a mixture of the ideologies or social constructions at hand, her own individual history, the collective history and imprint of her culture, and the physical and emotional needs of both herself, her family, and her baby. We are always adapting our child-rearing and other practices. For example, Hays's Chapter 2 on "The Historical Construction of Intensive Mothering" describes the shift from corporal punishment and a view of the child as "demonic" (22) in the Middle Ages to contemporary child-centered practices resulting from a view of the child as innocent and needing protection. Thus, what Bauer and others also mostly tend to ignore here, are the very real local economic and gender locations for women living in North America in the twentieth and

twenty-first century. To read about EC in their books is to read an ahistorical account of mothering—as if we can ignore not only the requirement of living in a late capitalist economy, but more importantly the desire and requirement for women to have careers and to contribute financially to their families. While babies' needs have likely remained remarkably stable over the centuries, societies have changed dramatically over time and place, from largely rural to mostly urban, from heavily agricultural to industrialized, and from religious to largely secular.

A similar ahistoricism is described by Dorothee Schreiber, who teaches courses on Indigenous peoples and the environment. In her account, her settler-Canadian students view Indigenous knowledge as "values" or "convenient containers in which culture can be carried around" and used by anyone at any time; "They simply swirl around in a timeless manner, bringing the inner kernel of humanity back to us westernized moderns" (38). These students simplify and idealize Indigenous knowledge and unlink Indigenous peoples from their history, land, and economic and political disputes. I argue Bauer and Boucke similarly pay anthropological homage to natural mothers in ancient societies without contextualizing how the parenting practice of EC fits in with the life of those regions but may not slot so easily into lives of North American women. Elimination communication, then becomes a "convenient container" for a truer, more humane cultural practice for "westernized moderns" to adopt and adapt. While there is no significant harm in this adoption and adaptation, there are several blind spots (essentialism, romanticism, cultural borrowing without context) and one casualty being the hapless mother searching for a lost Eden of perfect motherhood.

I started this paper by saying I am not surprised intensive mothering is still de rigueur. In fact, I wonder why more do not join the more extreme forms of intensive mothering in an attempt to regain some lost Eden. In my own perfectionist quest for the most "natural" way to mother, I opted for a home birth (highly successful after two hospital births), cloth diapers (labour intensive, but I felt good about it), extended breastfeeding and child-led weaning (too much stress and exhaustion; if I could do it again I would breastfeed with some limitations), and co-sleeping (a practice

that alienated my husband and was bad for my marriage). I was not aware of EC at the time I was raising my three boys, but I no doubt would have tried that too. My point here is that my results in following what was perceived as "natural" were mixed, and I wish now that I had chosen not to try to meet some standard of "natural" and an essentialist construction of what babies should have to grow up healthy. As a La Leche League leader, I swallowed the organization's philosophy whole without casting a skeptical eye over their conservative Christian beginnings and examining how their child-centred philosophy can limit the lives of women. A wiser me would have chosen practices according to what felt good to all of us, recognizing the limitations and benefits of living in this particular time and culture.

As for EC, we don't always have the required societal arrangements to support some of those practices, a network of extended family and friends, for example, and our economic considerations and individual aspirations are very different from the ancient cultural configurations from which many of these practices originated. The good news is that children are resilient and manage to grow up well with many varieties of early child experiences, as long as there is plenty of love, which is another cultural construction, I acknowledge. The bad news is that many mothers are still stuck in the no-win situation described by Hays as they experience the tension produced by "increased workforce participation and increased mothering standards" (Damaske 436). Hays writes that the model of intensive mothering places far too much of the burden of raising a child on individual mothers, or "superhuman women," which has become "increasing hard to maintain as the ethos of rationalized market society invades the home" (177). As EC gets added to a long list of intensive mothering practices, mothers press on, feeling exhausted and inadequate, continuing to strive for some lost Eden that does not exist.

[1] Also called Infant Potty Training (IPT) by Laurie Boucke; see title of her second book.
[2] I do not include discussion of Christine Gross-Loh's 2007 book *The Diaper Free Baby* in this paper because she mostly repeats methods

and information in what I consider the two fundamental books on EC — Boucke's and Bauer's. I commend Gross-Loh, however, for her emphasis on adapting this practice to the twenty-first century family, and her description of how to practice EC part time.

[3]Bauer quotes Chauvin in the edition of her book published by Natural Wisdom Press; in another edition by Plume (same year, 2006), Bauer leaves out this quotation.

WORKS CITED

Bauer, Ingrid. *Diaper Free! The Gentle Wisdom of Natural Infant Hygiene.* Saltspring Island, BC: Natural Wisdom Press, 2006. Print.

Boucke, Laurie. *Infant Potty Training: A Gentle and Primeval Method Adapted to Modern Living.* Lafayette, Colorado: White Boucke Publishing, 2000. Print.

Boucke, Laurie. *Trickle Treat: Diaperless Infant Toilet Training Method.* Colin White and Laurie Boucke. 1991. Print.

Damaske, Sarah. "Work, Family, and Accounts of Mothers' Lives Using Discourse to Navigate Intensive Mothering Ideals." *Sociology Compass* 7.6 (2013): 436-444. Web. 4 Oct. 2013.

De Vries, Marten W. Introduction. *Infant Potty Training: A Gentle and Primeval Method Adapted to Modern Living.* By Laurie Boucke. Lafayette, Colorado: White Boucke Publishing, 2000. xi-xii. Print.

"Ganga receives 2900 million ltrs of sewage daily." *Hindustan Times* 17 April 2012. Web. 4 Oct. 2013.

Grigsy, Mary. *Buying Time and Getting By: The Voluntary Simplicity Movement.* Albany: State University of New York Press, 2004. Print.

Gross-Loh, Christine. *The Diaper Free Baby.* New York: Harper Collins. 2007.

Hartocollis, Anemona. "Baby's Latest: Going Diaperless." *New York Times* 18 April 2013. Web. 4 Oct. 2013.

Hayes, Sharon. *The Cultural Contradictions of Motherhood.* New Haven: Yale University Press. 1996. Print.

Heyes, Cressida. *Line Drawings: Defining Women Through Feminist Practice.* Ithaca: Cornell University Press. 2000. Print.

Humphries, J. "Breastfeeding Promotion." *American Journal of*

Nursing 111.12 (2011): 11. Web. 4 Oct. 2013.

Rich, Adrienne. *Of Woman Born: Motherhood as Experience and Institution*. London: Norton & Company. 1986. Print.

Schreiber, Dorothee. "'They Had a Deep Respect for the Earth': Teaching Ethnoecology in the Settler-Canadian Classroom." *New Proposals: Journal of Marxism and Interdisciplinary Inquiry* 3.3 (2010): 32-40. Web. 18 Sept. 2013.

Wall, Glenda. "Mothers' Experiences with Intensive Parenting and Brain Development Discourse." *Women's Studies International Forum* 33 (2010): 253-263. Web. 27 Sept. 2013. Print.

Unicef and World Health Organization. *Progress on Drinking Water and Sanitation: 2012 Update*. 2012. Web. 4 Oct. 2013.

Intensive Grandmothering?

Social Policy, Social Class and Intensive Mothering in Post-Communist Poland

JUSTYNA WŁODARCZYK

THIS ARTICLE WAS SPARKED by my experience of commuting to work. Three times a week I take a commuter train into the capital city of Poland, Warsaw. On a train crowded with morning commuters it is hard not to overhear the conversations taking place in a small enclosed space. Most of my fellow commuters are women and most talk about their children. A theme that kept coming up in these conversations was childcare. It seemed as if the majority of these women left their babies and toddlers with their own mothers, the children's grandmothers. And almost all of those who did, complained about this arrangement. This complaining had a ritualized aspect: it met with sighs of understanding from other women, who, in turn, shared their own stories. The more I looked, the more stay-at-home grandmothers I noticed: my next door neighbors' mother commuted from Warsaw to our suburb for three full years to take care of her daughter-in-law's baby, my own mother-in-law spent a full five years taking care full-time of my sister-in-law's two young daughters. This led me to investigate the reasons for such arrangements, particularly in relation to the concept of intensive mothering, which has become a visible trend in both social policy and in popular culture. It seems as if the media and politicians are working together on keeping young women out of the labor market and in the home, while the result is not more stay-at-home mothers but an increase in the number of stay-at-home grandmothers.

When I speak of "intensive mothering," I am referring to the trend in parenting first described by Sharon Hays in her 1996 book,

The Cultural Contradictions of Motherhood. The most important tenet of "intensive mothering" is the assumption that "the child absolutely requires consistent nurture by a single primary caretaker and that the mother is the best person for the job. When the mother is unavailable, it is other women who should serve as temporary substitutes" (Hays 8). The purpose of this essay is not to delve into the intricacies of the definition of the term but to strategically accept Hays's concept in order to point out that in post-1989 Poland, intensive mothering has become both the institutionalized model of motherhood and an increasingly stronger cultural trend. Yet, at the same time, it is a model which, in Poland, is available to even fewer women than it is in North America. Intensive mothering is a philosophy of privilege. It is unavailable, as a lifestyle choice, for those who are poor, work minimum-wage jobs and, obviously, for those whose families lack a substantial second income which makes such a choice possible, unless they live in a well-developed welfare state. This article is about mothers (and grandmothers) trying to cope with the institutionalized and cultural pressure to mother "intensively."

Tracing the appearance of intensive mothering in Poland on the level of social policy is not a difficult task. There exist statistics, gathered by the Central Statistical Office (GUS), on the availability of childcare in public nurseries (children up to three years old) and public preschools (children above three years of age). After 1989 we can see a very sharp drop in the number of nurseries and preschools and a corresponding drop in the number of children attending them. The Feminoteka Foundation estimates that close to one half of public nurseries were closed in the 1990s, after the systemic transformation in 1989. In 1992, 30 percent of children up to three years of age were enrolled in public childcare institutions, while 65 percent of children between three and seven attended preschools. According to GUS statistics published for 2010, only three percent of children up to three years (32,500) were enrolled in institutionalized childcare, taking into account both public and private institutions. It should also be mentioned that statistics reveal a very strong urban/rural discrepancy: it is predominantly children from large cities and metro areas who are enrolled in nursery schools. In fact, according to GUS statistics, in 2010 there

were no public nurseries outside of areas zoned as urban. Why did Poland go from being one of the European leaders in the availability of institutionalized childcare pre-1989 to trailing miserably in the ranking in the first decade of the twenty-first century?

The answer is a combination of political, social and economic factors. As several Polish scholars from the field of cultural studies have said (see, for example, Graff 2001), the period of communism was perceived as a deviation from the "natural" order of society, also in terms of gender relations. Women were encouraged to take up paid work and the availability of publically operated preschools was one of the signs of this trend. The year 1989 symbolized a restoration of the "natural order" and of traditional gender relations. Women began to be encouraged to assume the domestic role. Additionally, the 1990s were a period of the sudden rise of unemployment. According to GUS statistics from the period, Poland went from a 0.3 percent rate of unemployment in January 1990 to 16.9 percent in July 1994. This high percentage was later topped in February 2002 with 20.2 percent. Policy-makers saw persuading women to remain at home with their children as a logical response to the growing rate of unemployment. Other forms of "gentle persuasion" included shortening paid maternity leave and lengthening optional unpaid childcare leave.

The cultural pressure of intensive mothering began to be felt quite strongly in the 1990s. However, warnings about the supposed evils of preschools were first uttered by right-wing politicians and religious leaders. It must be noted that the position of the Catholic church was particularly strong in the 1990s in Poland. The church had supported the democratic opposition in the preceding decades. It expected (and obtained) special privileges in result of its accomplishments. While the Catholic church's position most certainly reflected the basic tenet of Hays's definition of intensive mothering, that it is the mother who should fully devote herself to being the primary caretaker of her baby, I would refrain from conflating this traditional religious argument with the influence of "intensive mothering" as a media-fuelled and very modern phenomenon.

While a complete discussion of the distinction between the figure known in American nineteenth-century as "the moral mother"

(Bloch), somewhat resembling the traditional Polish figure of "Matka Polka" (Mrozik), and the contemporary concept of intensive mothering remains beyond the scope of this article, I would venture to say that intensive mothering sells itself as an appealing lifestyle—which does not make it any less coercive as an ideology—through capitalizing on its association with "coolness" in popular culture and modern media. Ideological subjects who wish to engage in intensive mothering – even though they may be unable to—do so not because they feel they have a duty to the country or to God but because they are interpellated by an ideology that is thoroughly modern and thoroughly secular. In the Polish context, I would venture to say that intensive mothering post 1989 is a discourse that was largely imported with other Western cultural discourses, not "homegrown." The cultural pressure to mother intensively appeared in the late 1990s and early 2000s and can be discerned in attitudes expressed by celebrity moms who claim they take their babies to work and breastfeed them on the filmset, in the increasing popularity of books which advocate attachment parenting, mostly translated from English, and in the predominant discourses on childrearing in mainstream parenting magazines. It is clear this is an ideology which mixes well with traditional Polish discourses of motherhood but is not identical with them.

All these factors, namely, cultural pressure on women to remain at home, social policy moves aimed at keeping women out of the labor market and high unemployment, should have resulted in a very high rate of stay-at-home mothers. Surprisingly, they did not. If we examine the available official statistics (Central Statistical Office) on women's employment, we may notice a slight decrease in women's employment throughout the 1990s but this drop correlates with the steep rise in overall unemployment post 1989. The trend does continue into the twenty-first century but the rate of women's employment never plummets. In 2008, women constituted 45 percent of all employed people and 60 percent of women of employment age were employed in 2010. It is important to mention that these statistics refer only to persons employed full-time under so-called labor contracts. Women predominate among persons employed on a part-time basis and under temporary short-term contracts, often referred to as "trash contracts." The discriminatory character of

this situation, particularly because short-term "trash contracts" do not guarantee health and social benefits, has been noted by Polish scholars (Jo czyk). Faced with these two contradictory facts, the low availability of institutionalized childcare and the relatively high level of employment among women, it is difficult not to wonder about what happens to the children of working mothers who do not or cannot enroll their babies and toddlers in public (or even private) nursery schools. My hypothesis was that they are placed in the care of nannies and relatives, particularly grandmothers.

There exists no official research on the predominance of grandparental care in Poland, mostly because such arrangements are usually unofficial and it is difficult to establish the scale of the phenomenon. It should be noted that the new 2011 Law on Childcare theoretically facilitates the formal employment of grandmothers as nannies. A parent who wishes to formalize the childcare arrangement and pay wages to the grandmother for her services, is exempt from paying social security but the employee (grandmother) is not exempt from paying tax on her own wages.[1] Because the grandmothers caring for children in the family are usually retired and, as such, already receive retirement pension and are entitled to healthcare, this does not seem to be an attractive solution for any of the key players. Even those few parents who do pay some form of wages to their own mothers and mothers-in-law find it much more advantageous to remain in the so-called gray sphere of employment. The grandmothers most certainly wish to avoid paying income tax on the money they potentially earn providing childcare.

Additionally, should the grandmother's wages combined with her retirement pension exceed a particular sum, the deal stops making any financial sense at all, because then the employer (usually, her daughter) does have to pay her social security. While there do not yet exist any official statistics on the functioning of this new law, I am relatively certain that the scale of the formal employment of grandmothers is absolutely marginal. In other words, rather than actually creating a viable solution, the legislator acknowledged the predominance of grandparental care and created a media stir surrounding the issue. As the law was being introduced in 2011 all major dailies ran articles on the new possibility of formal-

ly employing grandmothers. Some of the headlines were quite misleading: "State to Pay for Grandmas!" (*Fakt*, Oct 11 2011), "Granny = Nanny. Everybody Wins" (*Gazeta Wyborcza Finanse*, Nov. 22, 2011).

My research consisted of carrying out interviews with women who reside in Poland (not all of them were Polish nationals), who are mothers of children up to three years of age; who are employed either full-time or part-time and whose mothers or mothers-in-law are alive. All of my respondents lived in the Warsaw metropolitan area, though some in the suburbs. Two of the women were single mothers. One was legally married but practically separated because her husband had been working abroad for over a year at the time of the interview. The interviews consisted of some closed and some open questions concerning the care provided for their children by their own grandmothers. In accordance with my expectations, the women were very keen to share their experiences and some of the interviews often continued for hours, sometimes turning into long rants about how difficult life is for young mothers. While research of this scope (twenty respondents) is clearly not extensive enough to actually establish the exact scope of grandparental care, it does provide a certain general idea on the prevalence of such arrangements.

Ninety percent of the women I interviewed admitted to using at least occasional childcare (up to five hours a week) provided by the child's grandmother. Those who did not, mostly lived more than one hundred kilometers from their parents or in-laws. In one case, the grandmother moved from the countryside into the parents' city apartment to care for the new baby. However, the opposite arrangement was more common: three of the twenty women lived together with their in-laws or parents. For 70 percent of the interviewees, their mothers or mothers-in-law spent between five and fifteen hours a week caring for their child or children. In 45 percent of cases, the grandmothers provided between fifteen and forty hours of childcare a week. 40 percent of the women listed their mothers or mothers-in-law as the primary caretaker of their child or children, that is as providing at least forty hours of childcare a week. The results do include two non-Polish nationals whose children remained outside of Poland.

The women who relied on at least fifteen hours of childcare provided weekly by grandmothers, described their decision as "a necessity," "the only possible way," "the only financially viable option" or as "just natural." One mother said, "If I could avoid leaving [the baby] with mom, I would. I love my child. But let's not kid ourselves, there's no way we could survive on just my husband's salary." This last statement suggests that the woman has internalized the media (and political) message that the mother's place is with her child. Nevertheless, most women had explored the possibility of enrolling the child in a nursery school but were not able to secure a place for their child or could not afford the cost of tuition. In most cases, the exceptions being non-Polish-born women and one Polish woman, the grandmothers did not receive regular remuneration for the services they provided. None of the mothers employed the grandmothers legally. Sometimes, the women would provide their mothers with small gifts, clothing or food in lieu of payment. Most refunded the grocery purchases made by the grandmothers during the day, which is not surprising as financial issues were listed as the main reason for asking the grandmother to "help out." In two cases, the grandmothers retired after the birth of a grandchild, leaving paid work specifically to care for a baby.

All of the women who relied on over fifteen hours of grandparental care a week, had mixed emotions about the ethical dimension of their situation. On the one hand, they felt the grandmothers were expecting expressions of gratitude. On the other, the grandmother's constant presence with their child aroused issues of jealousy, guilt and harsh words of criticism related to the grandmother's childrearing practices. Many women avoided dealing with the ethical dimension of this childcare arrangement by belittling the grandmother's role, as can be seen in their use of the phrase "to help out" to describe the services provided by the grandmothers. Even in cases where the grandmothers served as full-time "employees," the women referred to the work provided by the grandmother as "helping out" and saw it in terms of a certain generational "obligation." Many women used the term "duty" to describe the grandmother's carework. The negative evaluation of the grandmother's role increased if the caretaker

was the woman's mother-in-law. One woman said the following about her mother-in-law:

> *When I look at how she interacts with our son, I begin to understand my husband's shortcomings. I love [my husband] but I'd like our son to grow up to be a different man. It's like she does everything for him, she's turning him into a very egoistic little boy. I'd love to be available more but this is just not possible. I'm really looking forward to the time when [the son] turns three and I can send him to preschool.*

In this case, as in several others, the conflict centers around different views of gender roles. The grandmothers' perception of what is considered acceptable behavior for boys and for girls was more conservative than the mothers'. Some conflicts, particularly related to caring for toddlers, centered around differing expectations of polite behavior, interactions with strangers and family members. In these cases, the grandmothers clearly pushed for more structured interactions and advocated traditional and communal norms of propriety.

However, the most intense conflicts centered around food and dress, or rather the mother's perception that the grandmother was overfeeding and overdressing the baby. One mother said:

> *At first it all looked so beautiful. I went back to work right after maternity leave and my mother-in-law stayed with the baby. Now [the baby] is nine months old and I know that it is going to be very difficult. My mother-in-law has a difficult character, she's very authoritarian. Sometimes I learned that she expanded our son's diet from my husband. He'd say: "You know, mom gave [the son] a piece of bread or a banana." The worst thing is that my husband supports her. I tell him that babies don't tolerate gluten and it's like water off a duck's back. They both claim I'm oversensitive.*

Almost all the mothers complained about what they perceived as the grandmothers' inappropriate food choices and about the

grandmothers dressing the children too warm for the weather: "She makes him wear a hat even if it's 15 degrees [Celsius] outside!" Breastfeeding was also the bone of contention in several cases, with grandmothers pushing for the early weaning of a baby and mothers attempting to breastfeed longer. One particularly angry mother said: "She feeds [baby] right before I come how from work so he's full when I get back and doesn't want to take the breast. I've asked her not to do it so many times but she just won't listen."

Generally, while most of the women admitted that the birth of their own baby intensified their contacts with their own mothers and mothers-in-law, they all admitted that it made these relationships much more complicated. All were looking forward to the time in the future when this arrangement would end. Interestingly, one of the women who did not rely on her own mother at all also recounted a story of intergenerational conflict. The thirty-two-year old respondent, who had a three-year-old child at the time of the interview, noted that her relationship with her mother deteriorated when the grandmother refused to provide full-time care for her grandson after his birth. The respondent, a married lower-level office worker, said that while she did feel uneasy requesting her mother's services, she saw it as the only financially feasible solution. However, her mother's refusal, on the grounds of her ill health, strained their relationship to the extent where the respondent stopped all contact with her own mother for a period of over twelve months. While she did end up using other paid childcare options, she also decided not to have a second baby and explicitly blamed her own mother for forcing her to make such a decision.

My interviewees also included two non-Polish-born women (both Ukrainian), working in Poland as domestic care providers. Specifically, one was employed as a nanny and one as a maid. In both cases, the primary caretakers of their own children (aged between one and fifteen years) were the women's mothers, who remained in the Ukraine. While my interviewees declared that they were providing financial support for their families, they were all physically separated from them. Had I expanded the geographical focus of my research to include Polish nationals working outside of Poland, I expect I would have encountered

Polish mothers living abroad who left their children in the care of grandparents in Poland. However, I did not need to conduct a study of my own: Polish media have published numerous articles on the phenomenon of so-called "euro-orphans" (eurosieroty) and the topic has also caught the eye of psychologists and sociologists. While publications addressed to psychologists (Walczak; Nowak, Gawęda, Janas-Kozik) mostly attempt to tackle the problem from a clinical perspective, that is to suggest specific techniques for working with children in the custodial care of grandparents, sociologists (Urbańska) analyze the media stir as a contemporary moral panic. Sylwia Urbańska writes, "the expert discourse surrounding euro-orphans, which exploded in 2007, immediately after Poland's accession to the European Union, became an opportunity to remind each parent, but particularly the mother, that her place is in the home and that her absence creates the risk of irreparable damages to the child's psyche" (Urbańska 61). Within the framework of this moral crusade, non-custodial mothers become stigmatized as inadequate and unnatural.

The highly contested term "euro-orphans" has been coined to describe children separated from their parents during the new wave of economic migration after Poland's accession to the European Union in 2004. Bartłomiej Walczak quotes estimates of the Central Statistical Office according to which in 2007 every tenth Pole of working age left the country for a period of at least two months out of a year (7). While men constitute the overall majority of migrants, women do predominate in the group of seasonal migrants (12). Seasonal migrants and migrants performing physical labor are the least likely to be accompanied by their children. Walczak writes, "Very often—particularly if it is the mother who leaves or if both parents are absent – the grandparents assume the paternal role" (16). Even if the mother goes abroad and the children are left with his their father "it can be clearly seen that quite often the children point to their grandparents as the primary caretakers. If the period of separation between mother and child exceeds six months, a definite majority of children point to their grandparents as primary caretakers" (16). The very dynamics of this process—the mother leaves, the father is supposed to take over but does not—suggests that the term grandparents is something

of a euphemism. It is quite clear to all involved that it is almost exclusively women who bear the burden of responsibility for the well-being of the "euro-orphans."

It is not surprising that when women leave the country to work as domestics abroad, children remain in the care of relatives. Numerous studies about domestic workers in the U.S. and in Canada confirm this (for example, Macklin 1994, Salazar Parrenas 2003). However, what makes the situation in Poland different is that, according to Walczak, "a definite majority of children" are cared for by their grandparents. In the research carried out by Salazar Parrenas on Filipino women, none of the women left their children in the care of their mothers or mothers-in-law. To a certain extent this results from family size, in that Polish women statistically have fewer siblings than Filipiono women, but also have a different understanding of obligations within the family unit. In Poland, since the bonds of reciprocal obligation between adult siblings are almost nonexistent, it would be considered a huge impertinence to ask one's brother or sister to take over the raising of one's child, while it is perceived as a "natural" obligation of one's mother to happily step in.

There have existed and still exist societies in which grandparental care, or communal care of children is the norm and does not cause intergenerational strife. On the contrary, it contributes to intergenerational understanding and solidarity. However, most studies carried out in post-industrial western nations suggest that grandparental care is on the decline (Presser; Gray). Furthermore, its persistence is stronger in lower earning segments of society. If a woman cannot afford a nanny, she turns to her grandmother for help. Additionally, there is also a strong correlation between short paid maternity leave and the popularity of grandparental care (Kurowska). Polish women are caught in the whirlpool of cultural and economic changes. On the one hand, they experience strong cultural pressure to stay at home to be with their children, exerted both by socially conservative Catholic politicians and by the more modern discourse of intensive mothering. On the other hand, the economic reality of life in post-communist Poland, means that few can even attempt to live out the model of being a stay-at-home mother.

Conflicts, nagging and constant bickering between mothers and grandmothers result from the non-voluntary nature of such childcare arrangements in Poland. The mothers would like to be able to take care of their own children but cannot. The pressure generated by this situation blows up in one-on-one encounters between women or is vented in informal support groups, such as the one on my commuter train. This is an understandable psychological mechanism: the discontent which should be directed at those responsible for the problem is displaced onto individuals who happen to be close by, particularly if it is difficult to identify persons who can be held accountable for the situation related to the level of social policy and popular culture. After all, how can one blame the media or celebrities who breastfeed while shooting a new movie?

The conflicts between mothers and grandmothers can also be seen as yet another way that a patriarchal society pits women against each other. In the interviews I conducted, this was best exemplified in the attitude expressed by the woman who felt that it was her mother's refusal to provide full-time childcare that prevented her from having a second baby. The conflict with her own mother had blinded her to the true reasons for difficulties in accessing childcare: lack of state support for mothers, the closing down of public nurseries, low wages and problems with sharing care duties with her partner. The outrageousness of her position is glaring to anyone from the outside. Yet, she is so enmeshed in the dynamics of the blame game, that she cannot transcend it. It cannot be negated that there does sometimes exist a genuine power struggle between the mothers and grandmothers, but it would be a gross oversimplification to read this conflict solely in terms of a clash of generations and temperaments. The roots of these conflicts are not just personal but also institutional and cultural.

Polish mothers of young children who feel they are forced to take up paid work, which is usually poorly remunerated middle or lower-level work (otherwise, they would be able to afford hiring a nanny), often experience feelings of guilt connected to leaving their children at home with grandmothers. They also resent not being modern, or at least see themselves as forced into living out

what they perceive as a family arrangement, which they would not have voluntarily chosen. In their eyes, intensive mothering is a practise that they would like to emulate, yet they see it as available for wealthy Western women. While it may come as surprising that staying at home to raise children can be considered the non-traditional arrangement, one cannot forget the role fifty years of communism played in Poland.

In 2001, Agnieszka Graff, in *World Without Women: Gender in Polish Public Life,* famously diagnosed the state of gender roles in Poland after the systemic transformation as a "return to normalcy." According to Graff, in the 1990s public opinion (and politicians who used to be involved in Solidarity, the underground opposition in communist Poland) viewed the period of communism, when women were encouraged—and sometimes even forced—to take up paid work and send their children to nurseries and preschools, as a time of aberration. The turn to democracy and capitalism also entailed within itself a promise of the noncompulsory character of women's employment. Capitalism seemed to guarantee the viability of single-income families. As a result, being able to stay at home and be involved in intensive mothering can be viewed as part of the allure of the Western lifestyle.

My research suggests that Polish mothers would like to see themselves as modern in how they carry out the work of mothering. Parenting books, magazine articles and television programs available on the Polish market are largely based on texts originally created in English or published in Western Europe. In effect, the parenting techniques employed by the Supernanny, Sandee Hathaway, Heidi Murkoff or even Benjamin Spock—none of whom could actually be described as propagating intensive mothering in the American context but all of whom are hugely popular in Poland—are associated with being modern: particularly in their approach to discipline, food, toilet training, but also relations between family members. For example, the families presented in these texts are rarely multigenerational; deference to the authority of older or more distant family members is not automatic but is the result of consciously applied methods and corporal punishment is uniformly scorned. Consequently, it is not surprising that the conflicts between the mothers and the

grandmothers are connected to features of the "modern" outlook on life namely, gender roles, politeness, and degree of formality in social interactions.

Conflicts about food can also be read as related to mother's aspirations for both social advancement and modernity. Traditionally, the Polish mother was responsible for preparing and distributing food among family members. As Sławomira Walczewska wrote in 1995, the traditional Polish mother's strong domestic position was related to her preoccupation, maybe even obsession, with making sure no one is ever hungry. Walczewska wrote: "The kitchen is her territory. She prepares the meals and she serves them.... She decides who can eat what and when" (Walczewska 44). Many of the women who are mothers today see such obsessions with food as backwards and express their dissatisfaction with the feeding schedules imposed by their mothers on their children. They do not wish to feed their children as they were fed and do not wish to see them stuffed, overfed. A story that recently (August 2013) made headlines on all Polish news channels concerned a five-year-old boy, who was removed from the care of his custodial grandmother and placed in foster care simply because he was too fat. The story's popularity, as the case was televised on every major news network, is yet another illustration of how the media feeds on maternal fears, in this case the fear of grandmothers turning children into monsters. The mothers would like to raise their children as citizens of a modern democratic state and erroneously see the grandmothers as holding them back from the progress of civilization.

I am keenly aware that my research clearly lacks the grandmothers' perspective. The theme of why women agree to care full-time for their grandchildren and how they perceive their own carework is one that deserves scholarly attention. While such investigations have been carried out in other countries (Cotterill; Musil et al.), this is still a topic that remains to be analyzed in Poland. Nevertheless, the analyses presented in this article already suggest that the caregiving grandmother's position within the family structure is a very ambiguous one and that she must also be struggling to find her way within the often contradictory cultural discourses.

[1]The major deductions from an employee's gross wages in Poland are: compulsory public health insurance, a deduction in lieu of future retirement pension and income tax. The first two deductions are usually referred to as social security deductions. Even though healthcare in Poland is theoretically universal, only those who are employed, minors, retired persons and persons receiving disability pension are entitled to public healthcare.

WORKS CITED

Bloch, Ruth. "The Rise of the Moral Mother, 1785-1815." *Feminist Studies* 4.2 (1978): 100-125. Print.

Cotterill, Pamela. "'But for Freedom, You See, Not to be a Babyminder': Women's Attitudes Towards Grandmother Care." *Sociology* 26.4 (1992): 603-618. Print.

Graff, Agnieszka. *Świat bez kobiet. Płeć w polskim życiu publicznym* [*World Without Women: Gender in Polish Public Life*]. Warsaw: WAB, 2001. Print.

Hays, Sharon. *The Cultural Contradictions of Motherhood*. New Haven and London: Yale University Press, 1998. Print.

Gray, A. "The Changing Availability of Grandparents as Carers and Its Implications for Childcare Policy in UK." *Journal of Social Policy* 34.4 (2005): 557-577. Print.

GUS Central Statistical Office. "Stopa bezrobocia w latach 1990-2013" ["Unemployment Rate 1990-2013"]. GUS Information Portal. 2013. Web. May 20 2013.

GUS Central Statistical Office. "Żłobki i kluby dzecięce 2011" ["Nurseries and Baby Clubs 2011"]. GUS Information Portal. 2011. Web. May 20 2013.

Jończyk, Jan. "Rodzaje i formy zatrudnienia" ["Types and Forms of Employment"]. *Praca i zabezpieczenia społeczne* 6 (2012): 2-7. Print.

Kurowska, Anna. "Regularna opieka dziadków nad wnukami a instytucjonalne uwarunkowania opieki nad małymi dziećmi—analiza w krajach konserwatywnego modelu polityki społecznej" ["Regular Grandparental Care and Institutionalized Childcare: An Analysis in Countries Representing the Conservative Model of Social Policy"]. *Problemy polityki społecznej* 18 (2012):

145-154. Print.
Macklin, Audrey. "On the Inside Looking In: Foreign Domestic Workers in Canada." *Maid in the Market. Women's Paid Domestic Labour*. Eds. Wenona Giles and Sedef Arat-Koc. Halifax: Fernwood Publishing, 1994. 13-39. Print.
Mrozik, Agnieszka. "Motherhood as a Source of Suffering. On the Contemporary Discourse of Maternity." *Mapping Experience in Polish and Russian Women's Writing*. Eds. Maria Rytkonen, Kirsji Kurikijarvi, Urszula Chowaniec and Ursula Phillips. Newcastle: Cambridge Scholars Publishing, 2010. 214-239. Print.
Musil, Carol M, Susan Schrader and John Mutikani. "Social Support, Stress and Special Coping Tasks of Grandmother Caregivers." *To Grandmother's House We Go and Stay. Perspectives on Custodial Grandparents*. Ed. Carole B. Cox. New York: Springer Publishing Company, 2000. 56-69. Print.
Nowak, Marta, Agnieszka Gawęda and Małgorzata Janas-Kozik. "Zjawisko eurosieroctwa a kierunki pracy terapeutycznej i leczenia psychiatrycznego—prezentacja przypadku" ["The Phenomenon of Euro-Orphans and Directions of Therapeutic Works and Psychiatric Treatment—A Casy Study"]. *Psychiatria Polska* 46.2 (2012): 295-304. Print.
Parrenas, Racel Salazar. "The Care Crisis in the Philippines: Children and Transnational Families in the New Global Economy." *Global Woman: Nannies, Maids and Sex Workers in the New Economy*. Eds. Barbara Ehrenreich and Arlie Russell Hochschild. New York: Henry Holt & Company, 2003. 39-54. Print.
Presser, Harriet B. "Some Economic Complexities of Childcare Provided by Grandmothers." *Journal of Marriage and the Family* 51 (August 1989): 581-591. Print.
Urbańska, Sylwia. " 'Cała Polska liczy euro sieroty'. Panika moralna i płeć w wykluczeniu oraz stygmatyzacji rodzin migrantów." ["All of Poland Is Counting Euro-Orphans. Moral Panic and Gender in the Exclusion and Stigmatization of Migrant Families"]. *Kultura i społeczeństwo* 54.3 (2010): 61-88. Print.
Walczak, Bartłomiej. "Migracje rodzicielskie" ["Parental Migration"]. *Szkoła wobec mobilności zawodowej rodziców i opiekunów*. Eds. E. Kozdrowicz and B. Walczak. Warsaw:

Centrum Metodyczne Pomocy Psychologiczno-Pedagogicznej, 2008. 7-20. Print.

Walczewska, Sławomira. "Matka Gastronomiczna" ["Gastronomic Mother"]. *Antologia współczesnej polskiej myśli politycznej.* Eds. W. Wojdyło, G. Radomski and A. Meller. Toruń: WN UMK, 2012. 41-45. Print.

Part III:
Intensive Mothering:
Staying, Leaving or Changing?

The Best I Can

Hope for Single Mothers in the Age of Intensive Mothering

J. LAUREN JOHNSON

As a psychologist, I am often asked what theories and techniques constitute "best practices" for a particular clinical issue or population; for instance, what constitutes best practices for mothering? Many psychologists and child development experts agree that despite the myriad ways women have globally and historically chosen to parent their children, there indeed exists one universal best mothering practice: intensive mothering.

Intensive mothering, defined as a "child-centered, expert-guided, emotionally absorbing, labor-intensive, and financially expensive" (Hays 8) approach to mothering, originated in the later years of the Second World War. The timing of its inception is suspicious, given the policy, media, and social pressure at the time to push women out of the work force and back into the home following their mass exodus from domestic duty during the war. Gleason directly linked the rise of intensive mothering to social engineering: "in order to preserve the social order, women were told by social engineers, such as psychologists, that they needed to be good wives and mothers in order to fit normally into post-war life" (53). Intensive mothering required women to abandon ideas of continuing to work beyond the war years because their time and attention was needed elsewhere: in the home, by their children.

When I first encountered the concept of intensive mothering as best practices, I was a single doctoral student with a toddler and no proximal family to help support me. I could not help but take it personally that I was supposedly an unfit mother because I was

inherently incapable of intensive mothering in my circumstances. I had neither the time nor the money to engage in these "best practices," and if I could not provide the best for my child, what kind of mother was I? Now, as a professional psychologist who largely specializes in working with Indigenous girls and women, I am further distressed that the culture-bound practices of intensive mothering cannot possibly apply to some of the remarkable and capable women I work with, who must then by default also be labeled unfit mothers. It occurred to me that intensive mothering cannot be the only way to be a good mother. There may exist these "best practices," but I argue that a different perspective ought to be considered: that of "the best I can" practices.

Intensive mothering is a social construction of what motherhood ought to look like, and this reflects a white, middle class, privileged perspective of motherhood and child rearing. However, not all mothers fit this definition, and importantly, children do not inherently require this style of parenting. In this chapter, I argue that the concept of intensive mothering—and the research that supports it—constitutes an institutionalized form of discrimination against single, poor, and minority mothers that seeks to "other" and shame women who cannot and/or will not mother this way. Further, I argue that mothering involves a complex, dynamic relationship between people and context that cannot possibly be distilled into one universal best practices formula. Finally, I argue that perhaps a more functional and hopeful perspective on parenting, one that is more applicable to the wide variety of mothers and children that exist in the world, is to move away from the concept of "best practices" and move towards "the best I can" approach to mothering.

A MYRIAD OF MOTHERS

The sisterhood of mothers is ripe with diversity, representing a great heterogenous mix of racial, ethnic, cultural, socio-economic, religious, and sexual identities. As a group, it would be impossible to talk about mothers in either local terms (i.e., using white, married, straight, middle class American women as the norm) or universal terms (i.e., suggesting that any generalized

truths can be applied to all mothers regardless of their socio-historical context).

One non-traditional category of motherhood that is underrepresented in discussions of intensive mothering is the single mother, the category of motherhood in which I am a member. Single mothers are unique in that we typically have a financial obligation to work because we are not supported by a second income, which is an obligation that may also tie in with socio-economic status and race. As Karen Christopher found in her study of working mothers: "women of color and low-income women often experience and interpret motherhood differently than white, class-privileged mothers. For instance, because historically women of color have had to work for pay to support their families, they often hold integrative views of motherhood and paid work" (77).

In Canada, female-headed lone-parent households constitute 12.8 percent of all Canadian families (Milan and Bohnert 4), or 16 percent of families with dependent children (compared to 27 percent in the U.S.) (Ambert 6). In addition to marital status, single mothers work within a particular economic context: as Ambert noted, "in 1997 in Canada, 56 percent of the [one-parent families] headed by women were poor compared to 24 percent of those headed by men and 12 percent of those with two parents" (7). Canadian single mothers earn an average of $42,300 per year versus single fathers' average of $60,400 (Williams 9). In addition, visible minority women are overrepresented in the category of single motherhood (Ambert 6). These various contextual factors—race, ethnicity, marital status, and economic status—interact in dynamic ways and influence single mothers' capacities and desires to raise our children in the "labor-intensive and financially expensive" (Hays 8) style of intensive motherhood. As Ambert summarizes; "*families are largely stratified by marital status* ... the poorest members of society and the most powerless ones are found among [one-parent families], particularly those belonging to segregated minority groups" (7, italics in original). Unable to perform the "best practices" intensive standard of motherhood, what hope is there for single mothers and our children? As I intend to make apparent in the following pages, there is still hope for us yet.

J. LAUREN JOHNSON

AN ARGUMENT AGAINST INTENSIVE MOTHERING AS "BEST PRACTICES"

The hope that remains for single mothers and our supposedly disadvantaged children is that, luckily, psychological literature does not necessarily support the conclusion that intensive mothering is a universal standard of best practices for children. One can begin to unravel the intensive mothering arguments by looking at the psychological literature in the fields of attachment and resiliency factors.

ATTACHMENT THEORY

Being the "ascendant ideology" on maternal caregiving in North America (Christopher 75), intensive mothering is assumed to assure the best outcomes for children. In the field of Psychology, one measure of child outcomes is the development of healthy attachment patterns, which describes the nature of the relationship between a child and its primary caregiver as measured by the child's responses to separation from an attachment figure. Healthy attachment is typically associated with secure attachment (as opposed to the three types of insecure attachment: avoidant, ambivalent/resistant, and disorganized), as secure attachment is the most common attachment pattern throughout the world (van IJzendoum and Kroonenberg 147).

What is noteworthy is that despite the universal prevalence of secure attachment, parenting styles differ by culture, which is a phenomenon seen both between and within countries. For example, pioneering parenting style researcher Baumrind noted that within the US population, African-American parenting styles differed from the European-American standard, stating; "Viewed from a white liberal middle-class context, the black family in the United States frequently appears to be disorganized, authoritarian, lacking in intellectual values, and therefore changeworthy.... The fact that many black preschoolers demonstrate remarkable qualities of competence is either not noted or not attributed to the socialization practices of their parents" (261).

Additionally, Fred Rothbaum, Gilda Morelli, and Natalie

Rusk reviewed attachment research from around the world to conclude that parenting variables associated with healthy attachment outcomes may be "universally valued," but the meaning of those variables within each culture is up for interpretation (167). Thus, their conclusion stated, "What is universal, we suggest, is the potential to become attached in particular ways in particular contexts. What is different, we suggest, are the particulars, their meanings, and the ways they are organized within situations and settings" (156).

If parenting style varies by culture, but the prevalence of the secure attachment pattern is universal, one may argue that specific parenting approaches – for instance, intensive mothering – may not directly lead to specific attachment outcomes. Indeed, attachment researchers contend that attachment is dyadic and, as such, any research on attachment ought to consider the contributions of both the child and the parent in the dyad under question (Prosada and Lu 104). Others (e.g., Baumrind; Mead "Theoretical" "Cultural"; Rothbaum, Morelli, and Rusk) contend that issues of culture and socio-historical context ought to be considered in attachment research as well. Indeed, I would argue that many contextual factors ought to be considered within and without the parent-child relationship before drawing conclusions about the causality of a particular parenting style on a particular child outcome.

Despite this, attachment research is still dominated by assumptions and biases. As Prosada and Lu note; "[a]ttachment researchers hypothesize that maternal caregiving continues to be a central factor in shaping and maintaining, or changing, the organization of secure-base behavior throughout childhood ... [s]urprisingly, the topic remains relatively unexplored" (96). This statement recalls for me Weisstein's impassioned assertion that "[p]sychology has nothing to say about what women are really like ... because psychology does not know" (197), which is a failure that is largely attributable to clinicians and psychiatrists theorizing about a topic without "consider[ing] it necessary to have evidence to support their theories" (198).

It is clear that in addition to understanding that cultural differences exist in the development and expression of attachment patterns, it is important to note that the role of the mother in her

child developing an appropriate attachment style has been overstated in the literature. Much focus has been placed on maternal parenting style and how this affects child development, even when attachment research originator John Bowlby himself noted that children's attachment styles are determined by a dynamic, bi-directional relationship between parent and child (Prosada and Lu 88) rather than the linear, mother-to-child relationship that is often implied in the literature.

RESILIENCY FACTORS IN CHILDREN

In the previous section, I presented an argument against the position that intensive mothering directly leads to positive child outcomes as measured by attachment style. In that argument, I established that parenting style is culture-bound and attachment patterns are determined by a dynamic, bi-directional relationship between parent and child. If this is the case, then, we would be remiss not to consider the child's contribution to this dynamic relationship. As such, another factor to consider when evaluating the prospect of intensive mothering as the standard for best practices is the fact that child outcomes are not just influenced by parenting style, but by the child him/herself, including characteristics within the child such as resilience factors. One may wonder why it is that some children can grow up with intermittent parental guidance and frequent exposure to violence and become upstanding adults (indeed, as a psychologist I have encountered a number of these remarkable people as clients), while other children grow up with exceptionally skilled parents but somehow become maladjusted adults. One of the factors that may contribute to these vastly differing outcomes, in addition to other social and historical contextual factors, is the presence of resilience factors that exist within the child.

Our understanding of resilience, first identified simply as "stress resistance" (Masten and Tellegen 347), developed over the course of decades of research to eventually be defined as "the capacity of a dynamic system to withstand or recover from significant threats to its stability, viability, or development" (Masten 494). As such, when applied to child development, it may be understood as a child's capacity to withstand or recover from adversity. Research-

ers have explored the many internal and external resources that children use to cope with difficult situations, and in doing so have isolated some protective factors that contribute to a child's level of resilience. Suniya Luthar synthesized five decades of research to conclude that the two categories of protective factors that continually emerge in the research on childhood resilience are effective cognitive functioning, including high intelligence and good cognitive self-regulation, and positive social relationships.

Bonnie Benard noted that resiliency resources are found in characteristics within the child, the family, the child's school, and the community. For example, she noted that within-child resources include social competence, problem solving skills, autonomy, and the child's sense of purpose and future. As for without-child resources, Benard identified factors such as the child's access to caring adults who clearly communicate their high expectations for the child and opportunities for the child to participate as a meaningful and valued member to the life of the family, school, and community. We understand these factors to be important because they are associated with positive outcomes in adulthood. According to Ann S. Masten and Auke Tellegen: "[g]ood outcomes in early adulthood had childhood roots in competence in multiple domains, in personality and other individual differences, and a range of family qualities, from socioeconomic advantages to warmth and structure. Adaptive children generally became adaptive adults..." (357).

What is clear from the resilience literature is that although parenting style may very well contribute to a child's outcomes, there are a myriad of other factors that help determine whether a child struggles or thrives. Internal protective factors such as personality and intelligence may be attributable to both biological and environmental sources. In addition to those, a number of external factors such as living in a healthy, supportive community influence a child's capacity to cope with adversity.

In considering this literature, it becomes apparent that focusing on mothering practices to the exclusion of other relevant factors is problematic for a number of reasons. Firstly, it puts undue pressure on women to be "perfect" mothers, as it implies that a child's outcomes are largely dependent on its mother. "A mother

is not allowed to make many good efforts but be humanly flawed; she has to be perfect, because so much is at stake – the physical and mental health of her children, for which she is assumed to be totally responsible" (Caplan 69). According to intensive mothering, being the "perfect" mother requires privileging the mothering role above all else in a woman's life, essentially disappearing as a person behind a role that requires all efforts to be aimed at another person, her child.

Secondly, allowing mothers to shoulder all of the responsibility for child outcomes detracts attention from the necessary considerations of other environmental factors that contribute to child outcomes. For example, research suggests that healthy communities contribute to the development of healthy children, but by focusing on mothering practices as the main contributing factor in a child's outcomes we shift the social policy and research conversations away from a necessary but difficult discussion about how to develop healthier communities. This, in turn, oversimplifies a complex social problem into an issue of personal responsibility that is shouldered by mothers alone.

Thirdly, focusing on mothering practices to the exclusion of other criteria unfairly negates the meaningful contributions that other parties—including fathers, extended family members, and children themselves—make to positive child outcomes. Psychologists have only recently begun shifting the focus of parenting research towards a more inclusive, gender-neutral perspective that includes consideration of fathers' contributions. One example is research on single mothers, where attention has only recently been paid to the role of fathers and the impact of father absence on the children in those circumstances (e.g., McLanahan, Tach, and Schneider), rather than looking exclusively at the connection between mothering practices and child outcomes. Particularly when considering the ethnic diversity of families in North America where the family unit may include extended family members and other kin, it may be misguided to focus exclusively on mothers without considering the diverse family relationships that may impact child outcomes.

When one considers the breadth of psychological literature on child outcomes, it becomes apparent that arguments in favour of

intensive mothering as "best practices" may be misguided and demonstrative of an overarching bias against women that harkens back to the earliest days of the psychology of women. Indeed, a critical perspective may call into consideration the historical context of the development of intensive mothering and accuse the intensive mothering movement of being politically motivated propaganda intended to keep women in the home. Regardless, there are many reasons to reconsider the sanctity of the research supporting intensive mothering as best practices, particularly as it relates to single mothers for whom the ideal of intensive mothering is an impossible goal.

A HOPEFUL ALTERNATIVE FOR SINGLE MOTHERS: "THE BEST I CAN"

In the previous section, I critiqued some of the conclusions drawn about the prospect of intensive mothering as the standard of best practices in mothering. As a single mother and psychologist, I make this argument particularly in support of single mothers, working mothers, and others who either cannot or will not practice intensive mothering, despite the intense social pressure to do so. As Guendouzi noted; "[a]lthough women with degrees are likely to work full time, the labor patterns in the UK suggest that 'women take a greater responsibility for the care of children than fathers'....A question arising from [this] is whether these working trends are because women choose to stay at home and contribute more to child care or because the social pressure of conforming to the traditional model of intensive mothering is still hard to resist" (901). If intensive mothering is intended to inflict social pressure on women to stay home with their children, it does appear to be working.

So, if intensive mothering is less a reflection of "best practices" and more a reflection of biased research intended to socially pressure women to prioritize domesticity, what can we do as single and often working mothers to ensure our children have the best possible outcomes? Most working single mothers have been doing this already; research shows that they have adapted their mothering style to reflect their own realities: "[s]ingle working mothers

reframe the concept of 'good mothering' and focus on extensive mothering rather than intensive (i.e., extensive mothering is when they 'delegate substantial amounts of the day-to-day child care to others, and reframe good mothering as being 'in charge' of and ultimately responsible for their children's well-being')" (Christopher 73).

Reflecting what single working mothers already do as summarized above, I propose that single mothers and their children may be better off when mothers are given permission to set their own standards of what constitutes "best practices" within the confines of their particular cultural, personal, socio-economic, and contextual situations. The "best I can" parenting style stresses a mother's right to choose the content and order of her own priorities as a multifaceted subject, and to practice these priorities in her own culturally appropriate and contextually relevant way. The "best I can" parenting style assures that mothers are doing the best they can at any given time, and even if objective outside observers judge their mothering as inadequate, these mothers understand that they are doing the best they can for their circumstances. Importantly, the "best I can" parenting style implies an understanding that perfection is impossible, and that even when children receive mothering that is less than perfect (because it is, after all, only the best a mother can do), they are resilient enough to thrive despite this because children have more internal and external protective resources than we typically give them credit for. I propose that single mothers, working mothers, and other mothers for whom the intensive mothering approach does not fit with their personality, circumstances, or lifestyle, disengage from the prospect of "best practices" and instead embrace the concept of "best I can" practices for mothering.

CONCLUSION

I wrote this chapter as a single mother, as the daughter of a single mother, and as a psychologist and co-worker of many single mothers. I wrote this chapter because we are generally wonderful mothers and incredible role models for our sons and daughters; and yet, according to much psychological research, we are inad-

equate because we cannot follow the socially constructed best practices of mothering that cannot possibly apply to us. As such, in this chapter I have advocated on behalf of single mothers and working mothers and those for whom intensive mothering does not apply. In proposing a different perspective on mothering—the "best I can" approach—my hope is to shed some light on how culture-bound and discriminatory the "best practices" model is, and why psychological literature does not necessarily support it as a universal model. I hope we begin to acknowledge the remarkable resilience that children are capable of, and all the protective resources that are available to them outside of their mothers, and hopefully alleviate some of the pressure that has been unfairly put on women to be everything to everybody in our families. I hope my intentions for this chapter are realized, but even if they are not, I take comfort in knowing that I did the best I can.

WORKS CITED

Ambert, Anne-Marie. "One-Parent Families: Characteristics, Causes, Consequences, and Issues." *Contemporary Family Trends Series*. Ottawa: The Vanier Institute of the Family, 2006. 1-34. Print.

Baumrind, Diana. "An Exploratory Study of Socialization Effects on Black Children: Some Black-White Comparisons." *Child Development* 43.1 (1996): 261-267. Print.

Benard, Bonnie. *Fostering Resiliency in Kids: Protective Factors in the Family, School and Community*. Portland, OR: Northwest Regional Educational Laboratory, 1991. 1- 27. Print.

Caplan, Paula. *Don't Blame Mother: Mending the Mother-Daughter Relationship*. New York: Harper & Row Publishers, 1989. Print.

Christopher, Karen. "Extensive Mothering: Employed Mothers' Constructions of the Good Mother." *Gender and Society* 26.1 (2012): 73-96 Print.

Gleason, Mona. *Normalizing the Ideal: Psychology, Schooling, and the Family in Postwar Canada*. Toronto: University of Toronto Press, 1999. Print.

Guendouzi, Jackie. "'The Guilt Thing': Balancing Domestic and

Professional Roles." *Journal of Marriage and Family* 68 (2006): 901-909. Print.

Hays, Sharon. *The Cultural Contradictions of Motherhood.* New Haven, CT: Yale University Press, 1996. Print.

Luthar, Suniya S. "Resilience in Development: A Synthesis of Research Across Five Decades." Eds. D. Cicchetti and D. J. Cohen, *Developmental Psychopathology.* 2nd Ed. Vol. 3: *Risk, Disorder, and Adaptation.* Hoboken, NJ: Wiley and Sons, 2006. 739–795. Print.

Masten, Ann S. "Resilience in Children Threatened by Extreme Adversity: Frameworks for Research, Practice, and Translational Synergy." *Development and Psychopathology* 23 (2011): 141-154. Print.

Masten, Ann S. and Auke Tellegen. "Resilience in Developmental Psychopathology: Contributions of the Project Competence Longitudinal Study." *Development and Psychopathology* 24.2 (2012): 345-361. Print.

McLanahan, Sarah, Laura Tach, and Daniel Schneider. "The causal effects of father absence." *Annual Review of Sociology* 39 (2013): 399-427.

Mead, Margaret. "Some Theoretical Considerations on the Problem of Mother-Child Separation." *American Journal of Orthopsychiatry* 24 (1954): 471-483. Print.

Mead, Margaret. "A Cultural Anthropologist's Approach to Maternal Deprivation." *World Health Association, Geneva, Health Papers* 14 (1962): 45-62. Print.

Milan, Anne and Nora Bohnert. *Portrait of Families and Living Arrangements in Canada: Families, Households and Marital Status, 2011 Census of Population.* Ottawa: Statistics Canada, 2011. 1-20. Print.

Prosada , German and Ting Lu. "Child-Parent Attachment Relationships: A Life-Span Phenomenon." *Handbook of Life-Span Development.* Eds. K. L. Fingerman, C. Berg, J. Smith, T. Antonucci. New York: Springer, 2011. 87-115. Print.

Rothbaum, Fred, Gilda Morelli, and Natalie Rusk. "Attachment, Learning, and Coping: The Interplay of Cultural Similarities and Differences." Eds. M. J. Gelfand, C. Chiu, and Y. Hong, *Advances in Culture and Psychology* (Vol. 1). New York: Oxford

University Press, 2011. 153-215. Print.

van IJzendoum, Marinus H. and Pieter M. Kroonenberg. "Cross-Cultural Patterns of Attachment: A Meta-Analysis of the Strange Situation." *Child Development* 59.1 (1988): 147-156. Print.

Weisstein, Naomi. "Psychology Constructs the Female; or the Fantasy Life of the Male Psychologist (with Some Attention to the Fantasies of his Friends, the Male Biologist and the Male Anthropologist)." *Feminism and Psychology* 3.2 *(1993):* 195-210. Print.

Williams, Cara. "Economic Well-Being." *Women in Canada: A Gender-Based Statistical Report.* 6th ed. Ottawa: Statistics Canada, 2010. 1-34. Print.

The Cultural Contradictions of Fatherhood

Is There An Ideology of Intensive Fathering?

HALLIE PALLADINO

IN HER CONCLUSION to *The Cultural Contradictions of Motherhood*, Sharon Hays calls for "greater paternal participation in child rearing" in the hope that this may "ease women's burden." At the same time she cautions, "Such social revisions will simply mean that *both* men and women will experience in their daily lives the contradictions in modern society that now plague women primarily" (177). Her prediction has proven to be strikingly accurate. Even though fathers have significantly increased the number of hours they devote to family work, channeling most of it into focused time with children, they are nevertheless as likely as working mothers to feel as if they don't spend enough time with their children (Milkie et al. 757; Bianchi, Robinson and Milkie 55, 87).[1]

Hays describes the cultural contradictions of motherhood thusly: "The same society that disseminates an ideology urging mothers to give unselfishly of their time, money and love on behalf of sacred children simultaneously valorizes a set of ideas that runs directly counter to it ... the cultural model of a rationalized market society" (97). In this chapter I will first establish that a parallel set of cultural contradictions exists for fathers. I will then take up the question of whether there is an emerging ideology of intensive fathering that meets Hays' criteria for intensive mothering: child-centered, expert-guided, emotionally absorbing, labor intensive and financially expensive (8). Finally, I will distinguish between egalitarian fathering and intensive fathering, arguing that while the former does have real potential to "ease women's burden" the latter can only increase it.

NEW FATHERHOOD: EVOLVING CULTURAL NORMS

Fathers, like mothers, are increasingly living child-centered lives, sacrificing outside pursuits including leisure, social activities and time alone with their partners in favor of parenting, in many cases prioritizing their children's activities ahead of their own (Bianchi, Robinson and Milkie 170).[2] Socially appropriate norms of childrearing now dictate that fathers work hard to provide for their family, while at the same time staying fully engaged with their children and taking on an equitable share of the unpaid domestic labor at home.[3] They must be nurturing and knowledgeable about baby care, but at the same time, careful to conform to cultural norms of masculinity.[4]

In his book, *The Modernization of Fatherhood*, historian Ralph LaRossa tracks the origins of this particularly modern style of fathering, which is sometimes referred to as New Fatherhood (5).[5] New Fatherhood as a cultural phenomenon, he argues, started to gain traction in the 20s and 30s, which he attributes to modernism, the social upheaval of the period between the two World Wars, and the impact of the Great Depression on family life. During the Depression, out-of-work fathers were forced to redefine their role in the family and often found engaged fathering to be an accessible way to affirm their masculinity and regain a sense of purpose. He laments that there is a contemporary misperception that this more engaged style of fathering has only been around since the late seventies. This renders invisible the commitment of earlier generations of fathers to active fathering, while additionally making it seem as if norms of fathering have changed faster than they actually have. "While it may be gratifying for men in the late twentieth century to believe that they are the first generation to change a diaper or give a baby a bath," he remarks dryly, "the simple truth is that they are not" (LaRossa 3).[6] Although the New Fatherhood of the machine age and the New Fatherhood of today are not identical, they are both premised upon the idea that a father's most important job is to care for and relate to children. Most importantly, LaRossa stresses, New Fatherhood didn't replace the Old Fatherhood model in which family work was assumed to be entirely the mother's responsibility, rather they

coexist in conversation with each other, sometimes even in the same text (6). The ways in which the new contains elements of the old is where contradictions in the discourse around fathering begin to emerge.

New Fatherhood discourse for men can be understood as the mirror image of having-it-all for women. The Having-it-All discourse insists that intensive mothering need not be incompatible with full time participation in the labor force as it is currently structured, therefore casting the inevitable conflicts as individual problems, not structural ones.[7] The New Fatherhood discourse insists that good fathering requires maximizing focused time with children, disregarding the huge amount of peripheral work that is required to get children through the week.[8] Both of these discourses expand the scope of parents' roles to include both nurturing and breadwinning; both exist in tension with older cultural models of men and women's complimentary family roles, such as the increasingly unattainable post-war era breadwinner/homemaker arrangement, but neither offers real solutions to the work/family conflict. Just as mothers may attempt to live up to the ideology of intensive mothering only to come up against the cultural contradictions of motherhood, fathers also encounter contradictions when they try to live up to the standards of New Fatherhood within a system developed under Old Fatherhood.[9]

Sharon Hays makes an important distinction between the ideology of intensive mothering and "the extent to which mothers attempt to live up to it" (97). The question of how men attempt to live up to standards of intensive fathering in the real world is inexorably linked to their class, profession and employment status. Interestingly, the cultural expectations of New Fatherhood can function to both empower and constrain fathers in this regard. Hays found that both stay-at-home mothers and employed mothers shared ideals about intensive mothering although each differed in what they emphasized, putting more value on those aspects they were able to provide and deemphasizing the trade-offs associated with their choices. Similarly, breadwinner fathers may emphasize the providing aspect of their role, while fathers who log more hours directly caring for children, can conversely argue that this is the true measure of a father's worth.[10]

THE LASTING IMPACT OF PATERNITY LEAVE

Parents tend to establish their care-taking dynamic early. Some researchers claim this happens in the first few weeks after becoming parents (Miller 371-373). One short-term factor that can impact men's patterns of involvement is the availability of paternity leave. For instance, Miller argues: "The learning and practicing of caring skills together in the early postnatal period, offer an important glimpse of how parental caring could be organized and practiced" (376). In *Care in Context: Men's Unpaid Work in 20 Countries, 1965-2003,* Jennifer Hook found that in countries where paternity leave is offered to men, men contribute over two extra hours of unpaid work each week (653). Conversely she reports; "The results show that policies that free women from work for child care—for example, parental leaves [for mothers only]—depress men's contributions in the home, and that extending parental leave to men increases men's contributions" (656).

Even when leave is available, men might face pressure not to take advantage of it. Williams recounts the experience of a young Berkeley professor who was denied paternity leave by a sneering department chair who ruthlessly ridiculed a colleague who had taken time off to be with his baby (Williams 81). While preventing fathers from taking leave is illegal, it is difficult to imagine a situation in which mounting a legal challenge over this issue would be a smart career move. Instead, when their babies are born, fathers in countries where paternity leave is not well established are dependent upon the workplace culture and the personal attitudes of their superiors as to whether their desire to take leave will be supported. This is echoed in Miller's study of UK men's attitudes about parenting before and after becoming fathers. Many of the men cited the attitudes of employers and co-workers—in addition to the lost income—as factors determining the duration of their leave (371).[11]

As might be expected, when and where the trade-offs associated with leave-taking are least costly, men tend to take advantage of it in much higher numbers. Rehel conducted a study of 85 white-collar fathers working for the same company in three cities with very different paternity leave policies: Montreal, Toronto and Chicago. Ten out of 15 fathers in Montreal with the most

generous paternity leave policy took advantage of it, compared to just five out of 17 in Toronto and only four out of 18 in Chicago. Rehel additionally found that the greater the length of time men stayed home after the birth of a baby, the more involved they continued to be as their children got older. Staying home longer than three weeks seemed to be the tipping point (8). She concludes that when "the transition to parenthood is structured for fathers in ways comparable to mothers, fathers come to think about and enact parenting in ways that are similar to mothers" (1).

Both Miller and Rehel found that as much as many American, Canadian and British fathers would like to take time off when their children are born and look forward to sharing the work of childcare with their partners, they just can't afford the lost income or risk the resentment they might incur at work by staying home for more than a couple of days. Conversely, as Bergman and Hobson show in their discussion of the extremely progressive Swedish paternity leave system, differences in policy can go a long way to supporting fathers' early involvement. Sweden has a mandatory month of flexible paternity leave termed "The Daddy Month" with an accompanying public relations campaign designed to promote involved fathering. This is part of a larger nationwide strategy to make paternity leave and equal parenting a normalized part of the culture (108). But regardless of whether a father is home for three days or three weeks when his children are born, he will likely find himself being pulled in two different directions once he goes back to work.

THE STIGMATIZED CARETAKER: COMBINING BREADWINNING AND FATHERING

> A father that discloses he has family care responsibilities faces sizable job risks. One study found that men are often penalized for taking family leave, especially by other men. Another found that men with even a short work absence due to a family conflict were recommended for fewer rewards and had lower performance ratings. (Williams 80)

The dilemma of how to combine market work with caring for chil-

dren has until rather recently been framed as a problem particular to women. The persistent assumption that women are primarily responsible for children has done damage not only to women's opportunities in the labor market but also it has made combining care-taking and work incredibly challenging for men across a diverse spectrum of employment contexts. Men face challenges on several levels as they attempt to combine providing with parenting. There is the issue of access to reliable, quality childcare, an issue that disproportionately impacts duel-income working class families (Williams 5). There is the problem of paternity leave, which is not always available, and often involves trade-offs fathers may be unable or unwilling to make (Miller 364; Williams 81; Rehel 9). There are additional challenges specific to a man's employment status and class.[12] These conflicting cultural pressures are apparent in the way that the workplace rewards fathers who fit the ideal worker/breadwinner model with the so-called "daddy bonus," while men who let on they have childcare obligations face a very real stigma in the workplace (Hodges and Buldig 718; Williams 81). All this is compounded by the fact that North American fathers, for a variety of financial and cultural reasons, work longer hours than childless men (Bianchi, Robinson and Milkie 166).[13]

Care-taking emergencies, often involving an illness or the collapse of a childcare arrangement, can have a serious impact on a father's job security.[14] In her book *Reshaping the Work-Family Debate: Why Men and Class Matter*, Joan Williams shines a light on the problems fathers face when their care-taking and work responsibilities conflict. She devotes a chapter of her book to a study, *One Sick Child Away from Being Fired*, published by the Center for WorkLife Law of which she is the director. Williams describes the very fragile web of childcare that working class and poor American parents must devise in the absence of acceptable daycare options. Many parents in this situation deal with childcare problems by working staggered shifts so they can take turns caring for their children in the absence of reasonable alternatives. She notes that grandparents are often secondary caretakers but they too are likely to be employed, and outside babysitters may have children of their own. This whole structure is extremely vulnerable to disruption. When a father, whose partner is unavailable to fill

in for him at home, is suddenly called into work on short notice and no backup can be found, may have no choice but to stay home and risk job loss.

This is exactly what happened to many of the fathers in William's study. These dads lost their jobs when they were unable to work because of sudden changes in childcare arrangements or unexpected changes in their work schedules, including mandatory overtime shifts. One father was fired because he had to leave eight hours into a twelve-hour mandatory overtime shift that had only been announced when he arrived at work. He kept telling his supervisor he had to leave to pick up his children and was ignored. Finally he just left. Another father who worked a night shift was fired after his babysitter's car broke down and he couldn't make it into work as scheduled. A father who worked as a UPS driver was fired for twice overstaying his lunch break by an hour when he went to check on his wife who was home alone recovering from childbirth and caring for their two year old. She had developed mastitis and was running a dangerous 104-degree fever. To top it off, their toddler was sick with the flu. "My intention was [to be] there for my family but not to steal time, as I was accused of," he told the arbitrator when he tried to get his job back, but his dismissal was upheld (Williams 56-58).

While middle-class fathers might enjoy the advantage of less precarious day-to-day childcare arrangements, it does not mean that they are immune to these types of conflicts. On the contrary, professional men often work in jobs, such as law or academia, designed on the assumption that there is someone at home to take care of the children.[15] When advancement is related to the number of hours an employee can log, fathers may be understandably hesitant to cut back on time at the office, even if it means getting home well after their children are in bed (Williams 82). To counterbalance this time away, working fathers, like working mothers, have gotten very good at making children their biggest priority.

In *The Time Squeeze*, Melissa Milkie et al. address the question of how parents are feeling about time with their children. "Time poor families," they report, have a "desperate yearning for togetherness" (740). It is hardly a surprise then, that parents, especially perhaps

fathers who spend more time away from home than mothers (on average), are highly motivated to make every moment of parenting count. This sense of scarcity of precious time—childhood after all is fleeting—combined with the feelings of conflict, both logistical and emotional, between work and home comprise the soil in which the seeds of intensive fathering are planted.

TIME CONSUMING, EMOTIONALLY ABSORBING AND FINANCIALLY EXPENSIVE

> Mr. Williams, after a week of working until midnight preparing for a trial, spent Sunday driving Alexander to baseball practice, home for a quick shower and change, and then off to a school play. Mr. Tallinger flew across the country on a red-eye, had a short nap, went to work, and then was out late at soccer practice on a chilly spring evening, yearning for the event to be over so he could get some sleep. (Lareau *Childhoods* 258)

If intensive mothering is a shift from a family-centered lifestyle to what Hays so vividly describes as a child-centered lifestyle, then it is no surprise that fathers too get swept up. Fathers, like mothers, can enact intensive parenting in ways that are highly time consuming, expensive, labor intensive—relative to the fewer hours that men have available to participate in childrearing—and emotionally absorbing. Intensive fathers, like intensive mothers, become emotionally absorbed by the *activity* of parenting.

Although employed fathers are often less able than mothers to spend time with their children during the workweek, on the weekends, as Yeung et al. have emphasized, today's fathers, especially those who live with their children, devote much of their time and energy outside of work to parenting. Bouts of heavy weekend involvement with organized children's activities are a hallmark of intensive fathering (139).[16] Among middle and upper middle class families, fathers are actively engaged in the process that Lareau terms *concerted cultivation*. All the middle class and affluent families she studied while she was writing *Unequal Childhoods* had their children enrolled in multiple enrichment activities (72). Concerted

cultivation gives men an opportunity to enact intensive fathering in a way that is easy to jump into as soon as they get home from work—thanks to the many behind the scenes hours of planning and organizing generally done by mothers.

In *Playing to Win,* Hilary Levey Friedman delves into the hyper-competitive culture of children's extra-curricular activities. Her theory of "competitive kid capital" extends Lareau's theory of concerted cultivation, zeroing in on the widespread trend of children, even very young ones, participating in organized competitive activities. She attributes this to the pressure parents feel to make sure their children attain the educational credentials required to get ahead. She interviewed many fathers who were heavily emotionally absorbed in their children's competitive efforts. One man confessed; "'I never would have thought I'd spend my weekends in a cafeteria basement, waiting around for my son.'" Nevertheless, he admits, he and his wife both "want to, if not hunger to, participate in [their son's] ups and downs"(3-4).

These sorts of organized children's activities are also an example of how financially expensive intensive parenting can become. With both fathers and mothers spending time and money on organized activities, the cost of intensive parenting can only increase. Families who can afford it, and even those who can't, may find themselves spending thousands of dollars a year on extra-curricular activities. This reflects not just the cost of enrollment but also the added costs of transportation, uniforms and equipment and the incidental costs of picking up food on the go, or bringing post-game snacks for children's team members (Lareau *Childhoods* 267).[17] When there is an upward trend in how much parents are willing to do to give their children a competitive advantage, it impacts the baseline of what constitutes socially appropriate norms of childrearing. Friedman observes that parents are often reluctantly pulled into this type of competitive parenting for fear their children will fall behind. Many of the parents in her study were ambivalent about the amount of time their children spent practicing and competing but they were afraid to scale back and risk falling behind.

Fathers at the opposite end of the economic spectrum do not have the means to engage in concerted cultivation, but middle class norms of intensive parenting still influence the way they

think about and enact fatherhood. In their book *Doing the Best I Can: Fatherhood in the Inner City*, Kathryn Edin and Timothy Jon Nelson shed light on the parenting ideology of unmarried fathers living in poverty. Like many contemporary fathers, the men they studied said they valued aspects of both Old and New Fatherhood, believing that fathers should be providers as well as nurtures, but they put a greater emphasis on the "importance of investing in time with one's children" (140-141). There is broad consensus that when fathers are emotionally engaged, it is hugely positive for children, so there is much to be said for the way that the discourse of New Fatherhood has offered poor fathers a way to feel validated for their non-monetary contributions. Still, though the fathers in Edin and Nelson's study lavished love, shared leisure time and spent what little money they had on gifts and treats for their children, only a few of them were giving the mothers of their children any real practical support. Instead, they were enacting their own version of intensive fathering in a way that was completely peripheral to the less romantic daily work of combined breadwinning and childrearing that they left, almost entirely, up to mothers.

EXPERT-GUIDED BY PROXY

Many books about fathering and the experience of fatherhood were published in 2012, but few books written for fathers give explicit parenting advice (Rotella). Even popular books that purport to be for both parents can reveal themselves on closer examination to be directed at mothers.[18] Fathers may be influenced less by traditional childrearing manuals and more by advice from peers who are self-positioned experts, due to the fact that they themselves are fathers of young children. Evidence for this can be found in the explosion of fathering blogs and message boards. The web now is full of self-proclaimed parenting experts, in conversation with legions of readers who post their own advice and opinions. Still, fathers are likely to rely highly upon mothers as their personal experts in residence. As Lareau observed:

Fathers felt they were involved in their children's lives. As

a result, they reported high levels of activity. When pressed for details, however, it became clear that often these men were relying on their wives as a source of information. (*Problems* 411)

As long as mothers remain the default household managers, fathers will be limited in the amount of initiative they feel they can take as parents. They will find themselves deferring to mothers as sources of information about children's lives outside of the house—such as school, sports, social life—as well as inside of it—what children should be fed, or whether they need to bring anything special to school the following day.

The added responsibilities of household management might also factor into a woman's decision to leave the workforce or scale back on work. As Suzanne Bianchi notes, maternal employment in North America remains heavily part-time (407). It is doubly hard for families in which a mother works part time or not at all for fathers to find opportunities to participate in the higher level household management that would put them in a position to be better informed decision makers in daily matters. Rehel claims that heterosexual parents often fall into a manager/helper dynamic. She believes that this is often the reason that childcare duties tend to be divided in such a lopsided manner. This is a revealing way to understand why the burden of intensive mothering is not decreased by the sizable increases in father-care. If mothers are always left in charge of household management, fathers may constantly feel as if they are awaiting instruction and mothers might feel that they are still on duty even when fathers are caring for the children.

INTENSIVE FATHERING: A WRONG TURN ON THE ROAD TO GENDER EQUALITY

It would be a mistake to interpret the increase in paternal involvement with children as a trend toward more egalitarian patterns of parenting as defined as an equitable division of family work, even though many men do aspire to this ideal (Bulanda 43). Fathers have increased the amount of time they spend doing childcare, but

so have mothers (Bianchi, Robinson and Milkie 177). Partnered fathers spend only about eight percent of their childcare hours parenting solo, meaning mothers are almost always present when fathers are with their kids (Craig 272).[19] Fathers may not see their children as frequently as mothers due to their longer work hours. When they are home they understandably tend to prioritize quality time with children over housework (Craig and Mullan 838). This leaves the less valued and often less enjoyable work of household management to mothers (Milkie 751). Hence, "men may enjoy a disproportionate amount of the more pleasurable aspects of caring, and women a disproportionate amount of the more demanding aspects of caring" (Craig 264). Additionally, research that factors in the multitasking habits of mothers versus fathers indicate that women tend to pile childcare and domestic labor on top of each other so that they are often doing two or more of these jobs simultaneously, adding to their overall stress levels (Offer and Schenider 828).

Thus, the reassignment of childcare related work alone will not remedy the cultural contradictions at the heart of the work/family conflict. Although the equitable distribution of household responsibilities is a vital change that can help parents maximize their time and resources at home while supporting each other's ability to work outside the home, the myth that there is some kind of magic equation which would balance the demands of work and parenting if men just did a larger share is symptomatic of a mindset that ignores the fact that the work/family conflict needs to be addressed both at home and in the workplace.

Referring to *The Second Shift*, Hays expresses concern that the ideological revolution called for by Arlie Russell Hochschild in 1989, "shifting the focus from intensive mothering to *intensive parenting*—is only a partial solution to the contradictions between the demands of home and work, and one that does not begin to address the larger cultural contradictions" (4-5). In the introduction to her updated edition of *The Second Shift* in 2003, Hochschild herself reflects on how her book has been received and clarifies that the revolution she is calling for is a change both at home and at work. She says: "I wonder if a deeper solution to the problem of the second shift doesn't require a roll-back of national work

hours, paid parental leave, family-friendly workplace policies that people actually use, and a major cultural shift—a 'second' shift toward value on care" (xxiii).

Intensive fathering is not a viable solution to either the problem of gender equality between individual couples or the problem of work/family conflict, but rather it may further perpetuate a model in which impractical methods of childrearing are normalized, leaving many parents feeling they can never measure up. In truth, these ideals are attainable only by families who have substantial financial resources, unusually flexible schedules and a formidable amount of cultural capital to wield on behalf of their offspring, and perhaps, not even then.

CONCLUSION

In *The Unfinished Revolution*, Kathleen Gerson proposes what she sees as a new way forward for families. The families who make things work in the long term, she argues, are flexible. They are adaptable about who does what both inside the home and in the marketplace. They make adjustments as necessary.

Fathers, like mothers, are motivated by love of their children and delight in family. While there is no one formula that is going to magically erase the entrenched contradictions parents grapple with, there is some evidence that family friendly workplace policies can inhibit turnover, boost morale, save businesses money and improve the quality of family life (Williams 87). Policies that recognize men's involvement in family life as legitimate and important may go a long way to remedying some of the inequalities in our system, which disadvantage both fathers and mothers.

Of course, these types of changes don't address the core problem of intensive parenting ideology. The standards that constitute socially appropriate norms of parenting should be publicly debated and reconsidered. Even children may agree. In her *Ask the Children* survey Ellen Galansky asked parents what they assumed their children would wish for if they could have one wish about their parents. Over half of the six-hundred parents assumed that their kids would say, "I wish I could spend more time with my parents." Some did, but they were actually much more likely to wish that

their parents were less tired or less stressed out (xv).

Children care about their parents' happiness in a way that parents often don't consider. Parental happiness, as Gerson shows, is a key factor in determining the perceived quality of a person's childhood.[20] It appears then that children do not benefit either when parents spread themselves too thin trying to meet the demands of today's child-centered parenting ideology.[21]

[1]Married fathers spend the most time with their children. See also Williams for a description of the many ways two job couples "tag team" childcare (*Reshaping 46*).
[2]Lareau observes families following this pattern in *Unequal Childhoods*. There are variations according to class.
[3]Lareau observes many fathers with egalitarian aspirations consequently over-estimate their actual involvement with children; probably they are doing this because they genuinely feel they are involved and tend to consider their wives' parenting as an extension of their own. Citing Press and Townsley's findings about an over-reporting bias, she speculates that perhaps this bias is driven by men's commitment to an egalitarian ideology, even when their contributions are more limited. She remarks, "fathers appear to be ideologically committed to the *idea* that they should play an active role in their children's lives. In other words, fathers embraced the vision that they were engaged parents" (*Problems 419*). One man who was widowed for instance remarked that when his wife was living he thought he made dinner every Sunday, but after she passed away he realized he only made the meat, she had quietly made all the other components of the meal (420). For more theories about the time use/ideology disconnect see Hochschild; Hook; Bulanda; Miller.
[4]For a compelling argument about how masculine norms in the workplace negatively impact fathers see Williams 2011.
[5]The term New Fatherhood is not coined by LaRossa. Writing in 1997, he remarks, "there is a lot of hoopla about New Fatherhood." He is however the first to write a historical account of this thread of American fatherhood ideology. He further locates New Fatherhood as an urban and middle class trend that

slowly became more mainstream. This is consistent with Hays's observations that historical trends in mothering start as middle class norms.

[6]This is a view might seem to fit with Gershuny's theory of lagged adaptation, except for the fact that LaRossa says fatherhood like history does not have a linear trajectory but it changes from group to group and era to era.

[7]Having-it-All is typified by the mythical 80s career-woman/super-mom described on the opening page of the *Second Shift*, and her many incarnations in the quarter-century since, a recent version is the one being promoted by *Lean In* author Sheryl Sandberg. Susan Douglas and Meredith Michaels critique the Having-it-All discourse in *The Mommy Myth*. The woman wearing half a business suit with a child on her opposite arm pictured on the cover of *Cultural Contradictions* is a visual commentary on this ideal. These sorts of cultural messages frame the work/family conflict as an individual problem that can be overcome by careful planning and hard work.

[8]See Lareau (*Unequal Childhoods*) for a portrait of how married mothers almost always end up doing the work of household management. For theories about what factors contribute see also Rehel's discussion of the manager/helper dynamic that is established when couples become parents. She argues that this effect may be mitigated when men take extended paternity leave.

[9]Gerson (70) uses the term "modified traditionalism" to describe the patterns most couples fall into due to these factors.

[10]The surprising truth is that the difference in focused time spent with children appears to be about the same whether or not parents work or stay home, see Bianchi. See also Randles. For a discussion about the way self-described stay-at-home fathers construct their gender identities, see Smith.

[11]Miller observes that when fathers sense they are, "Becoming 'a bit more secondary' signals the beginning of a *domino effect* as the process of acquiring and practicing caring responsibilities together becomes a singular endeavor which reinforces particular styles of maternal and paternal involvement. This then leads to proficiency being developed by the mother who in turn appears to 'instinctively' know how to respond to the baby's demands and

so that father becomes even more secondary."

[12] Lareau demonstrates this in *Unequal Childhoods*.

[13] See Bianchi, Robinson and Milkie: "Fathers in the United States and Canada also do slightly more paid work than childless men ... but that is not true in the Netherlands, France, or the United Kingdom" (166).

[14] Recall Rachel's predicament in *Cultural Contradictions of Motherhood*. Rachel was a married, upper middle class career woman. When her daughter was hospitalized, Rachel had a conflict with her childless female boss who couldn't understand why Rachel felt compelled to leave work to be with her daughter at the hospital. Luckily, Rachel managed to care for her daughter without losing her job. Lupe, a mother in opposite circumstances, wasn't so fortunate. When Lupe's childcare arrangement turns out to be dangerous to her children due to an abusive caretaker, she felt compelled to give up her job and go on welfare.

[15] Of course there are reams of literature about the challenges of professional women who have full time working partners.

[16] Yeung et al. also stress that fathers (like mothers) are often available to children (in the next room) even when they aren't directly engaged with them. At other times they might be emotionally available and reachable by phone. (140)

[17] Enacting this kind of parenting is a luxury available for people who have the time and energy to do it, and often the means to outsource the other types of domestic work that consume all the time and energy of less well-off parents.

[18] The parenting advice books of William and Martha Sears are a glaring example of this.

[19] Single fathers who live with their children or divorced fathers with shared custody are an exception. They tend to do the same kind of work that mothers do when they are in charge of a household with children.

[20] Is there a backlash brewing against extreme forms of concerted cultivation? Films like *The Race to Nowhere* critique the culture of high intensity preparation for college admissions while a new wave of popular books like *The Over-Scheduled Child: Avoiding the Hyper-Parenting Trap* advise parents to stop pushing kids to participate in so many hours of extra-curricular activities. Of course

this might just lead to a trend in under-scheduling which may be become another variation of middle class "hyper-parenting" within the framework of intensive parenting ideology.

[21]This paper focuses on fathers who are involved with their children's lives, but this is not the whole picture. While fathers who live with their children are spending more time than ever doing childcare, many fathers do not live with their children and struggle to stay connected. This is easier for fathers of means than it is for fathers who have very little. Sadly, this fathering gap is both a symptom and a cause of inequality.

WORKS CITED

Bergman, Helena, and Barbara Hobson. "Compulsory Fatherhood: The Coding of Fatherhood in the Swedish Welfare State." *Making Men into Fathers: Men, Masculinities and the Social Politics of Fatherhood*. Ed. Barbara Hobson. New York: Cambridge University Press, 2001. 92-124. Print.

Bianchi, Suzanne M. "Maternal Employment and Time with Children: Dramatic Change or Surprising Continuity?" *Demography* 37.4 (2000): 401-414. Print.

Bianchi, Suzanne M., John P. Robinson, and Melissa A. Milkie. *Changing Rhythms of American Family Life*. New York: The American Sociological Association's Rose Series in Sociology. Russell Sage Foundation, 2006. Print.

Budig, Michelle. "Activity, Proximity or Responsiblity: Managing Parental Childcare Time." *Family Time: The Social Organization of Care*. Eds. Nancy Folbre and Michael Bittman. London: Routledge, 2004. 51-64. Print.

Budig, Michelle J. and Nancy Folbre. "Has Parental Time Devoted to Children Remained Unchanged?" September 2002. Web.

Bulanda, Ronald E. "Paternal Involvement with Children: The Influence of Gender Ideologies." *Journal of Marriage and Family* 66 (2004): 40-45. Print.

Craig, Lyn. "Does Father Care Mean Fathers Share? A Comparison of How Mothers and Fathers in Intact Families Spend Time with Children." *Gender & Society* 20 (2006): 259-281. Print.

Craig, L. and K. Mullan. "How Mothers and Fathers Share

Childcare: A Cross-National Time-Use Comparison." *American Sociological Review* 76 (2011): 834-861. Print.

Edin, Kathryn, and Timothy Jon Nelson. *Doing the Best I Can : Fatherhood in the Inner City*. Berkeley: University of California Press, 2013. Print.

Friedman, Hilary Levey. *Playing to Win: Raising Children in a Competitive Culture*. Berkeley: University of California Press, 2013. Print.

Galinsky, Ellen. *Ask the Children: What America's Children Really Think About Working Parents*. New York: William Morrow and Company, Inc., 1999. Web.

Gershuny, Jonathan I. *Changing Times: Work and Leisure in Postindustrial Society*. New York: Oxford University Press, 2000. Print.

Gerson, Kathleen. *The Unfinished Revolution : How a New Generation Is Reshaping Family, Work, and Gender in America*. Oxford; New York: Oxford University Press, 2010. Ebook

Hays, Sharon. *The Cultural Contradictions of Motherhood*. New Haven: Yale University Press, 1996. Print.

Hochschild, Arlie Russell. "Understanding the Future of Fatherhood; The 'Daddy Hierarchy' and Beyond." *Sociology of Families: Readings* (1999): 195. Print.

Hochschild, Arlie Russell and Anne Machung. *The Second Shift*. New York: Penguin Books, 2003.

Hook, Jennifer L. "Care in Context: Men's Unpaid Work in 20 Countries, 1965–2003." *American Sociological Review* 71 (2006): 639-660. Print.

Lareau, Annette. "My Wife Can Tell Me Who I Know: Methodological and Conceptual Problems in Studying Fathers." *Qualitative Sociology* 23 (2000): 407-433. Print.

Lareau, Annette. *Unequal Childhoods: Class, Race, and Family Life*. 2nd ed., with an update a decade later. Berkeley: University of California Press, 2011. Print.

LaRossa, Ralph. *The Modernization of Fatherhood: A Social and Political History*. Chicago: University of Chicago Press, 1997. Print.

Milkie, Melissa A. et al. "The Time Squeeze: Parental Statuses and Feelings About Time With Children." *Journal of Marriage and*

Family 66 (2004): 739-761. Print.

Miller, Tina. "'It's a Triangle That's Difficult to Square': Men's Intentions and Practices around Caring, Work and First-Time Fatherhood." *Fathering: A Journal of Theory, Research, & Practice about Men as Fathers* 8 (2010): 362–378. Print.

Offer, Shira, and Barbara Schneider. "Revisiting the Gender Gap in Time-Use Patterns Multitasking and Well-Being Among Mothers and Fathers in Dual-Earner Families." *American Sociological Review* 76 (2011): 809-833. Print.

Randles, Jennifer M. "Repackaging the 'Package Deal': Promoting Marriage for Low-Income Families by Targeting Paternal Identity and Reframing Marital Masculinity." *Gender & Society* 27.6 (December 2013): 864-888. Web.

Rehel, Erin M. "When Dad Stays Home Too: Paternity Leave, Gender, and Parenting." *Gender & Society* 28.1 (February 2014): 110-132. Web.

Rotella, Mark. "Raising Dad: Books For A New Kind of Fatherhood." *NPR.org*. Web. 22 Oct. 2013.

Shaw, Susan M. "Family Leisure and Changing Ideologies of Parenthood." *Sociology Compass* 2 (2008): 688-703. Print.

Skenazy, Lenore. *Free-Range Kids, Giving Our Children the Freedom We Had Without Going Nuts with Worry*. Wiley. com, 2009. Web.

Smith, Jeremy Adam. *The Daddy Shift : How Stay-at-home Dads, Breadwinning Moms, and Shared Parenting Are Transforming the American Family*. Boston: Beacon Press, 2009. Print.

Wall, Glenda, and Stephanie Arnold. "How Involved Is Involved Fathering? An Exploration of the Contemporary Culture of Fatherhood." *Gender & Society* 21.4 (August 2007): 508-527. Print.

Williams, Joan. *Reshaping the Work-family Debate : Why Men and Class Matter*. William E. Massey Sr. Lectures in the History of American Civilization. Vol. 2008. Cambridge: Harvard University Press, 2010. Print.

Yeung, W. Jean, et al. "Children's Time With Fathers in Intact Families." *Journal of Marriage and Family* 63.1 (2001): 136-154. Print.

Skinny Jeans

Perfection and Competition in Motherhood

KRISTEN ABATSIS MCHENRY AND DENISE L. SCHULTZ

IN CONTEMPORARY AMERICAN CULTURE, understandings of good mothering create an environment where mothers engage in competitive behavior, which often works against women's empowerment and equality. Competing to be the perfect mother, the best dressed, host the coolest birthday parties for our children, pack the healthiest lunches, and be the skinniest mom at the park has become the norm. Intensive mothering is more intense than ever in contemporary American culture, and the competition among women is endless. In this article, we add to Susan Douglas and Meredith Michael's analysis of new momism in *The Mommy Myth*, by interrogating their three principles of "new momism", which construct motherhood in ideal and perfect terms. The principles of new momism include the notion that no woman is complete unless she has children, women are the best caretakers of children, and to be a good mother one must devote herself to her children 24/7. We argue a fourth principle of new momism, which we identify as performance and competition. In other words, part of new momism is proving and demonstrating that being a mother is, in fact, being a good mother. By using online blogs, websites, and articles relevant to competitive mothering, we use lesbian feminist theory as a location for understanding the impact such negative interactions between women can have, but also the power that valuing women to women relationships could have for our contemporary society. In the media, competitive mothering is often referred to as an Olympic sport or even as a war. Of course, this is no accident that we would view mothering as a competitive sport

or a battle, where there is a winner and a loser. Lesbian feminist theory articulates an alternate view that engaging in competitions with other women keeps us from freedom.

MOTHERHOOD AS PERFECTION

Adrienne Rich's *Of Woman Born* introduces the idea that motherhood is a patriarchal institution and prefers the verb "mothering", which values women's experiences of mothering. Rich's argument that motherhood is an institution and an experience, provides a useful context for which to understand contemporary understandings of motherhood and specifically a cultural trend toward intensive mothering. In today's culture, motherhood as an institution reinforces patriarchy. Patriarchy defined as a system of male privilege is sustained in multiple ways, one of which is the institution of motherhood. In this article, we discuss the expectations of new momism and argue that it creates unrealistic expectations, which sustain gendered labor divisions of childcare and patriarchy itself.

Two of the prevalent discourses of motherhood are "new momism" and "intensive mothering." Sharon Hays uses the term "intensive mothering" in her book *The Cultural Contradictions of Motherhood*, where she explores what it means to be a good mother. For example, intensive mothering requires women to be good mothers who are nurturing and selfless at home, and competitive at work. Hays argues that these expectations set women up for failure as they are unrealistic and in conflict. She argues the pressure to be the perfect mother is often demonstrated by highlighting the accomplishments of our children. For example, mothers will compare their child's sleep and eating habits, language aptitude, reading skills among other things to demonstrate the child's advanced development and therefore the mother's good mothering.

In *The Mommy Myth*, Douglas and Michaels extend the notion of intensive mothering coining the term "new momism." They argue "new momism" advocates:

> The insistence that no woman is truly complete or fulfilled unless she has kids, that women remain the best

primary caretakers of children, and that to be a remotely decent mother, a woman has to devote her entire physical, psychological, emotional, intellectual being, 24/7, to her children. The "new momism" is a highly romanticized view of motherhood in which the standards of success are impossible to meet. (4).

This "new momism" is deeply troubling for many reasons mentioned by Douglas and Michaels, first of which is that in this construct, women are set up to fail. No mother can be perfect and certainly no mother can be available 24/7 to her children in the way that new momism expects. Within the construct of new momism, mothers are destined to fail because of the impossibility of attaining it. In fact, new momism is best understood as a form of feminist backlash. This ideal is reinforced through various cultural and media sources relentlessly. We look specifically at media sources such as websites and blogs, yet new momism is reinforced through traditional media such as films and television.

Lynn O'Brien Hallstein and Andrea O'Reilly argue that intensive mothering rests on at least three core beliefs: "1) children need and require constant and ongoing nurturing by their biological mothers who are single-handedly responsible for meeting these needs; 2) in meeting those needs, mothers must rely on experts to guide them; and 3) mothers must lavish enormous amounts of time and energy on their children" (7). While we agree that intensive mothering and new momism rests on these three core beliefs, we also contend that a fourth core belief must be added to this list that addresses the performative aspect of new momism.

The first core belief identified by Hallstein and O'Reilly sets women up for impossible standards because it is virtually impossible for any mother to be constantly twenty four hours a day, and single-handedly meeting their children's needs. Moreover, this core belief is divisive in that it alienates working women who have time constraints with their children and therefore unable to fulfill this aspect of new momism. It also implicitly makes the case that nannies, and child-care workers should not be caring for one's children. In this first belief of new momism, working mothers and mothers who use outside care in the form of family or paid

workers are by definition failing at this version of motherhood.

The second core belief of intensive mothering argues that mothers must rely on experts to guide them (Hallstein and O'Reilly 7). "In fact many of the mothering blogs and websites demonstrate their reliance on experts to guide parenting. Douglas describes this: "It's a highly romanticized myth of the perfect mother. It's a role no woman can ever attain. Her 'to do' list includes: piping Mozart into her womb, using algebra flash cards with her 6-month-old, teaching her three-year-old to read James Joyce, driving five hours to a soccer match, and oh, yes, being sexy and cheerful through all of this" (Douglas cited in Morales).

The third core belief of intensive mothering insists that mothers "lavish enormous amounts of time and energy on their children" (Hallstein and O'Reilly 7). This core belief of intensive mothering insists that mothers always put their children first and never their own needs and empowerment. It defines motherhood as complete sacrifice by insisting that women devote the bulk of their time to their children.

The fourth core belief of intensive mothering should be that mothers must demonstrate these three abilities to other mothers by showing they are the main nurturers of children, use experts, and spend the majority of their time and energy on their children. In other words, we argue that part of new momism is centered around showing other women that we tirelessly nurture and meet our children's needs, consult the best experts, and give enormous amounts of time and energy to our children. As a result of this fourth core principle, women engage in competitive mothering, because they must meet these standards and show other mothers when they do. As women demonstrate their competence in new momism, they engage in competitive communication aimed at showing women how good a mother they are, for example, when communication between mothers is aimed at making other women feel inferior in their ability to be good mothers.

There are countless articles published in newspapers, magazines, blogs and websites, which acknowledge the prevalence toward a competitive behavior between mothers. Titles include: "Motherhood is the most competitive sport, ever! Vent!" or "Competitive Mothering: The New Olympic Sport." One example is a wikihow

entitled "How to Stop Competing With Other Moms," providing advice on how to avoid competitive mothering. In step 1 we are told, "Listen to experts before your friends. Moms like to boast about how quickly it took to potty train their children or how quickly their child learned to read. In some cases it's a backhanded way of saying that the mom is smart; in other cases, it's about proving that the child is smarter than other children" (Wikihow). In this narrative, experts are positioned as more knowledgeable than other mothers, and mothers' motives for sharing information are questioned. This site discusses women's acknowledgement of competitive motherhood. Moreover, as Hallstein and O'Reilly summarized the literature on new momism, it tells women that they must consult experts. In "How to Stop Competing with Other Moms," on first glance we might read this as a resistance to new momism. However, instead of encouraging mothers to analyze the problems of competitive discourse, it suggests that women only listen to experts as opposed to women, which reinforces new momism. Scientific expertise comes to replace mothers' expertise and thereby women's connections between each other are undermined.

Sheryl Sandberg, in her now popular book, *Lean In,* tackles some of these very issues. While acknowledging the gender wars that exist in the business and leadership sphere, it is compelling that the stories Sandberg shares relate exactly to this phenomenon. Sandberg herself admits to being intimidated by stay-at-home mothers and attempts to refrain from judgment and asks the same of them. One woman Sandberg mentored followed up with her a couple years after meeting. She writes:

> A few years ago on a visit to the U.S. Naval Academy, I met an extraordinary woman who was about to join the U.S. Submarine Force as one if its first female officers. She was nervous about her new role and aware that there were risks in being an office and not a gentleman. I asked her to let me know how it went. A year later, she followed up with a heart-felt email. "Truthfully, I was prepared for opposition and the possibility of being discounted," she wrote. "But it did not happen. I was respected the moment

I stepped on board and I can truly say that I am a valued part of the crew." Unfortunately she told me that she encountered resentment from another source—the navy wives. At an onshore welcome dinner, the wives of her colleagues pounced and accused her of being a "bra-burning feminist out to prove a point." (168)

Sandberg's book *Lean In,* articulates the experience of the woman who is accepted in a male dominated work force, but met with hostility by other women.

New momism is constructed both interpersonally and through social media. For example, Maria Kang a mother and fitness blogger posted a photo of herself on Facebook in 2012, which has recently gone viral and has been the subject on major news outlets including Fox and CNN. The photo in question features Kang in bikini style fitness clothes, who is very thin with toned abs, next to her three children under the age of five. The heading of the photo reads, "What's your excuse?" ("Fit Mom's"). The debate has centered on whether this image is trying to imply that mothers who do not meet the ideal body type, are not trying hard enough. The backlash against Kang has been significant. She has been called a bully, harmful to other women, and a bad mother. In various blogs and online discussion threads, Kang is accused of neglecting her children to achieve her ideal body type. She was also criticized for emphasizing personal fitness and body type. The emphasis for mothers to meet the beauty ideal has become part of new momism. When mothers are also expected to have perfect bodies, and live up to ideal beauty through makeup, fitness, and clothes like yoga pants and skinny jeans, while actively mothering at soccer or at the park, then women who do not meet these standards are often shamed, as a result of this engagement in competitive discourse. Criticized mothers responded by asking if those other women had ever received a Ph.D. or learned another language. Here we clearly can see the competition among women, and challenging Kang for not being ambitious or intellectual *enough*. Kang's photo and media response serve as interesting example of new momism, because she symbolizes the perfectionism of it. Kang is a business owner,

a mother, and physically fit. Despite vast amounts of criticism, Kang makes no apologies for her photo or the message it sends. In fact on her Facebook page she states:

> I've been getting an influx of new followers, emails and comments (on my profile pic) recently. Some saying I'm a bully, I'm fat shaming and I need to apologize for the hurt I've caused women.... What I WILL say is this. What you interpret is not MY fault. It's Yours. The first step in owning your life, your body, and your destiny is to OWN the thoughts that come out of your own head. I didn't create them. You created them. So if you want to continue "hating" this image, get used to hating many other things for the rest of your life.

Kang's comments address head-on the type of backlash she faced, but she did not choose to address the accusation of being a bad mom. Yet, the title of her picture "What's your excuse?" was divisive, to say the least and prompted a discussion about the way women and mothers compete about being ideal mothers. Kang's implied laziness to non-fit moms is an example of the construct women everywhere must work to deconstruct. In new momism, Douglas and Michaels do acknowledge that above all, women must prove that they embody the ideals of new momism, and as we can see media provides one outlet where women can perform new momism and thereby prove their success. Social media examples like Kang's and mommy blogs, demonstrate one of the ways women prove or perform their ability to meet the standards of new momism. Much like Judith Butler's notion of gender performance in *Gender Trouble*, motherhood is similarly performed. Butler argues that gender is constructed through repetitive performance verbally and non verbally. In other words, we construct our gender throughout our day as we engage in feminine or masculine behavior, dress, and in our non-verbal cues. In this way, gender is a constructed identity and is constantly being recreated. Similarly, new momism is performed through repetitive acts and discourse. New momism is as much a maternal gender performance that mothers engage in when communicating with other mothers. One of the ways new

momism as a gender construct is performed is through competitive communication between women, which maintains the notion of femininity as nurturing and natural.

The media is certainly one of the methods for constructing ideal motherhood and setting up norms of competitive communication. However, individuals play an important role as well. In "A New State of Surveillance? Applying Michel Foucault to Modern Motherhood," Angela Henderson, Sandra Harmon and Jeffrey Houser argue it isn't just the media that perpetuates perfectionist understandings of motherhood, but rather mothers themselves. Henderson, Harmon, and Houser use Foucault's concept of surveillance to argue that mothers are surveilling on an individual level (232). Significantly, they find that new momism is perpetuated at the individual level more than the structural level.

On an individual level, new momism is perpetuated in our everyday spaces such as playgrounds, grocery stores, libraries, and parks. In "Baby Talk: Is Mommy Blogging a Vital Support System or a Virtual Overshare?" Marissa Hermanson states; "But the mommy blogging culture isn't all sunshine and cinnamon toast. A whole world of snark has grown up around it that, in its worst moments, involves cases of Internet bullying and online voyeurism" (2013). In fact, the snark is seemingly a normal mode of communication among mothers both in the virtual and the face-to-face world.

For example, in "Competitive Mothering: The New Olympic Sport," Naomi de la Torre writes:

> How many times have you been suddenly sideswiped by perfectly manicured talons of Alpha Mom during playgroup when you thought you were just having friendly conversation? "Oh," she says while eyeing your child who is currently having a standoff with the broccoli served at lunch. "Did I tell you that my little Ashton just LOVES vegetables? I just can't keep enough edamame and brussell sprouts in the house for him." Or the lady who you met while casually standing in line at the grocery store, "Oh really? You only breast fed for three months? That's probably why your baby has that terrible cough now." (She Knows)

These encounters between mothers are all too common and

often revolve around establishing the perfection of children as a demonstration of one's mothering. Yet, the discussion threads related to the Torre's article aim to challenge new momism and demonstrate a desire to connect with women. Lesbian feminist theory becomes a helpful analytical tool to demonstrate the power positive women to women relationships can have.

Lesbian feminist theory argues that patriarchy works in tandem with heterosexism. Liberal feminist theory and Marxist/Socialist feminist theory, for example, focus attention on the male-female relationship. Whereas Lesbian feminist theory analyzes the relationship between females and this makes it particularly useful for understanding the dynamics among mothers and the nature of new momism. As a theory, it hypothesizes that lesbianism is the key to women's liberation. In this article, we use lesbianism and the idea of women-centered-women as a political identity and a corresponding conceptual tool for understanding the way patriarchy functions in relation to motherhood. In "Compulsory Heterosexuality and Lesbian Existence," Adrienne Rich argued lesbianism is more than a sexuality, but also a political term. She argued that connections between women (not necessarily sexual connections) held the ability to dismantle heterosexism. Lesbian feminist theory asks that women-to-women bonds be celebrated and seen as a source of strength and support (Wheelhan 91). This idealized theory would enable women to celebrate their communication and bonds as women and as mothers. By using the theoretical understanding of women-centered-women, we point out the ways that mothers can challenge both new momism and patriarchy. In fact, if mothers could practice the ideals of women-centered-women, this would be a feminist act. To be clear, we are arguing an ideal vision or strategy for deconstructing new momism and patriarchy.

Radicalesbians offers us an innovative perspective that women must construct their own knowledge of women and their own identities, and directly challenge the gender socialization that sees women and femininity as inferior. In this way, lesbian feminist theory articulates that women should be "women identified." According to Radicalesbians, a lesbian is a woman who refuses to understand herself in relation to a man, whereas a woman-identified-woman prioritizes other women's ideas, needs, and desires.

A woman-identified-woman in the context of motherhood is counterintuitive to new momism. Rather than demonstrate their ideal motherhood and superiority, women would deconstruct these attitudes, and support women who choose to disrupt these rigid constructions of motherhood. According to Rich, "Woman identification is a source of energy, a potential springhead of female power" (296). It is in friendship, love, and honor that women can find freedom and power. Now to be clear, some radical lesbian feminists argued that heterosexual women are dependent on men (Echols 216). As such, the Radicalesbians wished to challenge heterosexuality and that feminism required lesbianism (Echols 216). Here, we diverge from the lesbian feminist thinking and only wish to engage conceptually with the idea that women must direct their energy toward supporting women (Echols 216). The result of a woman-identified-woman is that there would be significantly less competition among women, and stronger bonds. We argue that there are certainly mothers who practice this ideal, or at least desire to do so and are dissatisfied with the unrealistic ideals that new momism insists upon. Lesbian feminist theory is useful for understanding competitive motherhood, because it theorizes that women are taught to see themselves and other women as inferior. Yet, in the discourse of motherhood found in online sites, we see a willingness to challenge the notion that women are inferior and remind women that competitive mothering is problematic. In other words, it is equally possible to use online spaces to challenge new momism and practice a strategy suggested by lesbian feminist theory that women should value and find strength in other women.

In the discussion threads related to the article "Competitive Mothering: The New Olympic Sport," Amber writes, "Thank you for reminding all of us that competitive parenting is useless. I know that I fall into this trap as well, but I am consciously trying to remember that I'm not perfect—and neither are my friends. However building each other up is so much more important than tearing each other apart" (Amber, Comments Section on *She Knows* 2010). Here we see a sentiment that Rich identifies as a source of power, where Amber advocates the need to prioritizes building women up. Lesbian feminist theory articulates that women to

women relationships are a source of strength and an opportunity to do as Amber advocates which is to promote women. Similarly, Truthful Mommy responds; "Parenting is hard work and we all need to try to foster sisterhood through Motherhood, so we can have support in our times of need. We don't need another person in our lives to make us feel guilty!" (Truthful Mommy, Comments Section on *She Knows* 2010). While, this is an important sentiment that some mothers do not desire to engage in the type of competitive mothering that new momism demands, it still doesn't challenge sources of new momism, but seeks change on an individual level. In fact lesbian feminist theory as understood by Radicalesbians advocates that until there is social revolution, individual level action where women's desires and needs guide women. In other words, we need to see changes in the way that media portrays mothers, and a feminist movement that restructures caretaking gender roles where men and women can equally participate in caregiving.

This can also be seen in Anne-Marie Slaughter's article "Why Women Still Can't Have It All." In one of the most popular articles ever in *The Atlantic* magazine, Slaughter discusses both the inner conflict women and mothers have about working in the home or outside the home, and also the judgment received from other mothers in either camp. Slaughter has framed this as a zero sum game and it continues to fuel the fires of new momism and keeps us farther from the utopian society Rich envisioned where women support women bar none. The "having it all" debate, along with theories promoted by Sheryl Sandberg and Deborah Spar, the President of Barnard College, suggesting women need to work and try harder to be successful, continues to blame women for struggles the patriarchy reinforces and mandates. Spar writes:

> Why is this happening? Because women born in the wake of feminism—women like Sandberg, Slaughter, and me—have been subtly striving all our lives to prove that we have picked up the torch that feminism provided. That we haven't failed the mothers and grandmothers who made our ambitions possible. And yet, in a deep and profound way, we are failing. Because feminism wasn't supposed to make us feel guilty, or prod us into constant competitions

over who is raising better children, organizing more cooperative marriages, or getting less sleep. It was supposed to make us free—to give us not only choices but also the ability to make these choices without constantly feeling that we'd somehow gotten it wrong.

There is inherently within this space and debate, an issue with the very notion of choice—something that feminists have fought for decades—not purely in the reproductive rights vein, but freedom to choose the way you live your life, preferably one free of the shackles of patriarchy. Yet, here we have three highly successful women, Sheryl Sandberg, Anne-Marie Slaughter, and Deborah Spar, all mothers, with endless resources and privilege continuing the debate of how to have it all. For many struggling mothers, depressed, or just having a down day because of the new momism pressure, the fact that Slaughter, Sandberg and Spar are not happy with the choices and guilt, does not make them feel better. Instead, it can lead to an overwhelming obstacle and even mounting pressure to try even harder to be the best mom, best worker, and most of all, ambitious female. In the new momism rhetoric women are told that if they are not happy or succeeding at this version of motherhood then they must try harder to "do it all."

The website *She Knows* is a site that aims to empower women through articles and discussion of women's issues. On this site, the publication of "Competitive Mothering- The New Olympic Sport," Amber's and Truthful mommy's, who are two women who commented on competitive mothering, we can see a desire to melt the divisive barriers and seek empowerment and solidarity among women. Yet, as they note, this is extremely difficult given the power of new momism. Consider the notion that women's solidarity is desired by mothers like Amber and Truthful mommy. Lesbian feminist theory interprets the importance of such desires for solidarity.

Radicalesbians state:

> In the primacy of women relating to women, of women creating a new consciousness of and with each other, which is at the heart of women's liberation, and the basis for the

cultural revolution. Together we must find, reinforce, and validate our authentic selves. As we code this, we confirm in each other that struggling, incipient sense of pride and strength, the divisive barriers begin to melt, we feel this growing solidarity with our sisters. We see ourselves as prime, find our centers inside of ourselves. (157)

New momism directly challenges and makes it difficult for women to achieve a level of solidarity, sisterhood and empowerment. Yet, many mothers are looking for ways to create a new consciousness of motherhood, which as the Radicalesbians suggest, is at the heart of women's liberation.

Lesbian feminist theory offers us a useful conceptual ideal for challenging new momism. Ideally, we can implement the notion of identified women when we challenge discourses of new momism and engage in honest responses to the challenges of motherhood by demonstrating alternative choices women make that move us beyond the restrictive notion of new momism. We have argued the power that new momism holds in contemporary society and demonstrated locations where we can see examples of mothers performing these ideals. We suggest that it is the performance of new momism that is key to constructing unrealistic expectations of motherhood. We contend that new momism is detrimental to women's sense of self and women's relationships with other women. Most importantly, we argue that new momism is a tool of patriarchy that highlights Rich's notion of patriarchal motherhood.

WORKS CITED

Douglas, Susan J. and Meredith W. Michaels. *The Mommy Myth: The Idealization of Motherhood and How It has Undermined Women.* New York: Free Press, 2004.
Echols, Alice. *Daring to Be Bad: Radical Feminism in America 1967-1975.* Minneapolis: University of Minnesota, 1989. Print.
"Fit Mom's Facebook post, 'What's your excuse?' brings out the bullies." *Fox News* 17 Oct. 2013. Web.
Hallstein, Lynn O'Brien and Andrea O'Reilly. *Academic Moth-*

erhood in a Post-Second Wave Context: Challenges, Strategies, and Possibilities. Ontario: Demeter, 2012. Print.

Henderson, Angela, Sandra Harmon and Jeffrey Houser. "A New State of Surveillance? Applying Michel Foucault to Modern Motherhood." *Surveillance & Society* 7.3/4 (2010): 231-247. Print.

Hermanson, Marissa. "Baby Talk: Is Mommy Blogging a Vital Support System or a Virtual Overshare?" *C-Ville*. 08 Jan. 2013. Web.

Kang, Maria. *Facebook*. Web 15 Oct. 2013.

Morales, Tatiana. "The Mommy Myth." *CBS News* Video, 5 February 2004. Web.

Radicalesbians. "The Woman Identified Woman." *The Second Wave: A Reader in Feminist Theory*. Ed. Linda Nicholson. New York: Routledge, 1997. Print.

Rich, Adrienne. *Of Woman Born: Motherhood as Experience and Institution*. New York: Norton, 1995. Print.

Rich, Adrienne. "Compulsory Heterosexuality and Lesbian Existence." *The Lesbian and Gay Studies Reader*. Ed. Henry Abelove, Michele Aina Barale and David M. Halperin. New York: Routledge, 1993. Print.

Sandberg, Sheryl. *Lean In: Women, Work, and the Will to Lead*. New York: Alfred A. Knopf, 2013. Print.

She Knows Parenting. "Competitive Mothering: The New Olympic Sport." Web. 17 Oct. 2013.

Spar, Debora. "Why Do Successful Women Feel So Guilty." *The Atlantic* June 28, 2012. Web.

"Stop Competing with Other Moms." *WikiHow*. Web. 15 Oct. 2013.

Slaughter, Anne-Marie. *"Why Women Still Can't Have It All." The Atlantic* June 13, 2012. Web.

Transpersonal Motherhood

A Practical and Holistic Model of Motherhood

FAITH GALLIANO DESAI

ALL HUMAN CULTURES have recognized motherhood as one of the most important identities for women. The felt meaning of motherhood varies from mother to mother and in a mother, from one time to another and is influenced by one's culture. The transition into motherhood often has a significant impact on a mother's view of herself, and her emotional well-being as it involves a change in her health, role identity, relationships, spiritual awareness, and external environment (Meleis). More importantly, motherhood is often a threshold for intimacy with self. As such, there is a growing body of research validating what many mothers have shared, that motherhood provides tremendous opportunities for psychological and spiritual growth and counterbalances the contemporary cultural view of motherhood as demanding, oppressive, and stressful (Glenn; Hays; Athan and Miller; Galliano Desai). This is not surprising because motherhood is a rich time for intense and often violent emotions to erupt and consume mothers' consciousness, and according to Anthony James, such strong emotions "are extremely potent in precipitating mental rearrangements.... And emotions that come in this explosive way seldom leave things as they found them" (James and Benedek 198). One could say these emotional challenges with mothering may not only transcend the suffering inherent in parenting but also perhaps more importantly produce a contentment more cherished than one that is devoid of such trials.

One of the most common emotional challenges that motherhood brings is cognitive dissonance between a mother's expectations and her lived reality that can affect how she integrates multiple, and

at times competing roles, such as wife, mother, professional, and sexual being into her identity. Furthermore, a mother's existential life including her life purpose and contentment, is intimately entwined with mothering experiences and is often the source of conflict in her struggle to become a good mother, to feel confident in her mothering ability, and to fulfill her other roles and responsibilities. Such dissonance and distress is, at least in part, a result of contemporary Western ideology of mothering specifically intensive mothering that have articulated assumptions about what constitutes good-enough mothering (Garey; Hays; Shuffleton). Intensive mothering contends that responsibility for child-rearing falls primarily on the mother and requires an exorbitant amount of time and energy.

Although scholars such as Sharon Hays, Amy Shuffleton and Shari Thurer have pointed out how problematic intensive mothering is for mothers, they have not proposed alternative models of mothering. There is an urgent need for an alternative model of mothering that is more practical and holistic that integrates all aspects of mothering, helps understand the innumerable experiences of motherhood and fosters the unfolding of the full potential of motherhood in all its dimensions. Transpersonal motherhood can be one such alternative model.

TRANSPERSONAL MOTHERHOOD

I have defined transpersonal motherhood as any enduring felt state or lived experience during motherhood reflecting expansive ways of being and knowing beyond the mother-child dyad, which encompasses all living systems. As such, transpersonal motherhood encompasses a number of dynamic and organized characteristics that arise from within a mother and embody an expanded sense of motherhood. It manifests in three key inter-related themes: identity expansion beyond the ordinary notions of motherhood; integrative living involving a deep sense of wholeness, unity, interconnectedness and interdependence with the universe; and transformation.

Transpersonal motherhood is an ever-evolving and changing journey. As transpersonal motherhood develops, it moves from

moments of experiencing its qualities to more enduring, felt states, in which mothering takes on a greater meaning beyond the mother-child relationship. It becomes a way of connecting with self, life, and all beings.

The emergence of a transpersonal motherhood brings awareness that there is no experiential differentiation of separate parts of our identity and that improving self-understanding and understanding one's child go hand in hand. Cultivating a relationship with one's self that is mindful and compassionate is intimately intertwined with being that way with one's child, and from there in ever expanding circles towards others and life. Mothers often compartmentalize parts of their identity such as wife, mother, daughter, friend, sexual being, professional, and citizen depending on the context. By integrating various parts of her identity, the mother opens herself up to an experience of self that has expanded beyond the personal ego (I self) and the roles she plays (expansion of identity). The focus has shifted from these individual pieces to a synthesis until the whole is experienced.

Many have described the experience of wholeness as a sense of internal balance, presence, spiritual equilibrium, alignment, and centeredness (Netzer and Brady). Integration therefore involves achieving wholeness through opening ourselves by becoming more permeable to our body, to different parts/aspects of our self, to others and to nature. Transpersonal motherhood reflects this integration as well as integration of painful feelings associated with many aspects of mothering. By recognizing other influences on the development of the child, for example temperament, peer relationships, and media influence, besides mother-child dynamics, the burden of having to be a "perfect mother" and solely responsible for the child's wellbeing is lifted with a mother's acknowledgment of the complexity of child rearing and imperfections inherent in mothering. Transpersonal motherhood enhances this recognition that we are dependent on each other and on the environment for our survival and wellbeing. This reflects a shift from I to We.

In the context of motherhood, mother's transformation begins with efforts to re-parent herself by recognizing and addressing her own emotional needs. This involves unlearning habitual ways of perceiving and reacting so that a mother is open to new experi-

ences, information, understanding and insights even if it contradicts previously held beliefs. In this sense, from a transpersonal mothering perspective, parenting challenges that are encountered are not problems to be fixed or tragedies to despair over but are opportunities to access the greater potential within. Such a transformation often corresponds with the development of transpersonal values such as intuition, creativity, mindfulness, compassion, altruism, and forgiveness. These values reflect deeper awareness and connection to self, to others, and to nature. Cultivating these values over a lifetime promotes a sustainable and compassionate evolution of individuals, society, cultures, and the natural world.

It is important to recognize that transpersonal motherhood is not superior to other philosophical and practical approaches to motherhood. As a pathway, transpersonal motherhood does not claim that this is what real motherhood should be. Rather, it is a description of possible ways of being for a mother and recognition of the full potential contained in this archetypal state of being. This model recognizes that motherhood is a complex experience on personal, interpersonal, and transpersonal levels, and affirms life changing and transformative processes inherent in mothering.

THEORETICAL AND EMPIRICAL SUPPORT FOR TRANSPERSONAL MOTHERHOOD

At its deepest level, motherhood can be considered a cosmic principle and the Universal Mother or nature in this sense reflects the creative impulse that elaborates and expresses matter in myriads of manifestations, both living and non-living (Assagioli). At a human level, our intuitive associations of motherhood in the form of Mother Earth may have their origins in prehistoric mothers. In prehistoric times, motherhood was considered as sacred (Thurer). Life came from the Great Mother and hence she was worshipped above everyone else (Barstow). The mother Goddess was immanent within each woman and within nature, not above them or transcendent (Sjoo and Mor). In the Western world, during ancient times before Greek civilizations, the Earth was called Pandora (Ashton) and in Greek mythology, the first woman is named Pandora meaning *all gifts* and symbolically *all-giving* (Bullfinch; Graves).

Pandora represents the archetypal ground of motherhood; a life force that creates all life and it is from this archetypal ground that, by stages, the archetype of the Great Mother emerges (Ashton). In this sense, the expansion of identity during motherhood for some women would involve a deep experience of connection with one or more archetypes of mother (Universal Mother, Great Mother, Mother Nature, Pandora) and may embody the characteristics of mothering described in world mythologies and spiritual traditions such as procreation, creativity, love, commitment, and protectiveness (Assagioli).

Jung has stated that the range and variety of aspects of the mother archetype are almost infinite and these aspects have both positive/ constructive and negative/ destructive qualities. Jung believed various symbols/images represent the mother archetype including literal symbols such as the personal mother and grandmother as well as figurative symbols such as Mother Earth, Great Mother. The central core of many figurative mother archetypes is a *suprapersonal* woman who rules over all humans and controls cycles of time and nature, and is found in almost all of the religions and mythologies that have been studied (Harding). It is conceivable that the experience of the mother archetype even for brief moments in both literal and figurative forms has the potential to transform mothers' ways of being and knowing and thus of expanding her identity beyond the ordinary notions of personal motherhood.

Transformation, constant creation and recreation by transforming and replacing one's parts, is a fundamental property of all living systems (Capra) and by extension, of the mother-child dyad, conceptualized as a living system, and occurs in the biological, psychological, and spiritual domains. Freud is credited for pointing out that all behaviors and by extension, mother's behaviors, are determined by conscious and unconscious forces and believed that infant attachment to mother was the consequence of a need to satisfy various drives. Freud may have been intuitively trying to describe motherhood as an opportunity for a woman to try to fulfill her unmet needs as a child. Motherhood in this sense is an expression of a mother's ongoing journey toward making herself whole. This involves her ability to integrate her unmet needs into her consciousness and not project those conscious and unconscious

needs onto her child. This integration is not easy because it requires a mother to actively take time to care for herself. Failures in mothering are often due to the mother neglecting to care for herself. Brady has emphasized how essential it is for the mother to engage in self-care and reparenting of self and this is as important as caring for the child. Such efforts of a mother to know herself better allows her to develop new subpersonalities, parts of herself with different and distinct personal characteristics such as being more mindful while letting go of over-critical ones that no longer serve her. This transformation represents mother's spiritual and psychological growth.

Maternal thinking often provides distinctive ways to imagine and create nonviolent ways of living with self, children, others, and nature (Ruddick). The evolution of transpersonal motherhood involves becoming more complex and this involves expansion of self from the personal to the transpersonal to borrow from Wilber's three modes of human development: prepersonal (no conscious sense of self or a very rudimentary physical one), personal (strong egoic personality), and transpersonal (expansion of personality beyond the egoic realm). As transpersonal motherhood evolves, new emergent properties arise reminiscent of Capra's evolution of living systems that were not present or present at a rudimentary level at the lower level of complexity. For example, at personal level, compassion involves a small circle of self, family, and friends and at the transpersonal level, it encompasses larger and larger circles of humanity and other living systems. As these ways of being and knowing evolve and become more complex, transpersonal motherhood moves from moments of transpersonal motherhood to more enduring felt states that are reminiscent of plateau states (Maslow), sustained ecstatic states with themes of interconnectedness and harmony.

There is a growing body of empirical research suggesting the considerable impact motherhood has on mother's concept of identity, specifically, its growth, evolution, and expansion (McMahon; Smith; Athan and Miller; Hager; Galliano Desai). Martha McMahon, through her research involving lived experiences of 59 mothers, has shown how motherhood involves the deepening of a mother's identity as a woman, as well as becoming a more

caring and responsible person. Motherhood offers opportunities to realize that the self and others are inextricably linked (Smith) and not separate. Interviewing first-time mothers, Aurelie Athan and Lisa Miller, described the "intense emotional experiences inherent in mothering" (17) that led to an acceleration of mother's spiritual growth. Hager, in deconstructing her personal myth of motherhood, has described vividly how she felt terrified, dazed, alienated, and pained after she became a mother to her twins. At a deeper level, this could be a reflection of experiencing the negative/destructive qualities of the mother archetype as something that destroys, devours, and terrifies (Jung). Such feelings may arise during ordinary day-to-day events such as a child's temper tantrum or in the midst of traumatic experiences, especially post partum depression.

My research involved investigating non-pathological mothering experiences in the context of intensive mothering. Participants were a fairly homogenous group of highly educated women, ranging in age from 36 to 47, who were able to articulate their unique mothering experiences and the influence of these experiences on their identity, mothering approach, and philosophy of life.

The essence of the participants' narratives revolved around expressing their realization that mothering was a journey of self-discovery. The prominent themes that emerged were confronting one's trauma past and/or present, healing, and the effect mother influence had on the participant's evolving identity including integration of shadow material (aspects of personality one has disowned), and conscious efforts to be a better mother than her own mother. These themes manifested as increased efforts to re-parent self, facilitate unconditional acceptance of self and child, and adopt a more mindful and collaborative parenting style. In addition, the participants recognized how intimately intertwined the process of reparenting, especially separation and individuation, was to fostering the innate potentialities of the child. Most participants also articulated increased awareness and engagement in their communal role and responsibility including towards ecology and how this sense of shared responsibility afforded positive interactions with their children and with other mothers. Subordinate to the dominant themes, but critical to

the participants' lives, were themes of learning from one's child, increased compassion towards one's mother, repairing fractures in the mother-child relationship and integration of disowned shadow. As a result of considerable alteration of identity, subtle but significant shifts were seen in parenting style in the form of more consistent, sensitive, and responsive, development of compassion for self, child, and other, and unlearning habitual ways of perceiving and reacting.

This study provided some empirical evidence to support certain aspects of the model of intensive motherhood. For example, all participants expressed that child rearing fell primary on their shoulders and that their own interests and needs were routinely set aside in order to nurture and expand their child's intellectual and athletic potential. Most participants also struggled with being imperfect mothers in their own eyes and with wanting to be more than just a mother. Where this study diverged from this model is that it provided evidence that mothering can be a life-changing process that brings with it an evolving expansion of identity and tends to foster a mindful and collaborative parenting style.

Most participants indicated that motherhood was a surprisingly vulnerable time in their lives that altered their self-concept and also altered their perception of the accompanying maternal role expectations. Initially, the self-concept was restricted to self-as-mother. Emerging from the analyses was a commonly held view where the woman thinks that her role as a mother has to take precedence over her sense of self. This view can be attributed to a process of acculturation including ideas obtained since childhood from mother to daughter, other mother figures, media, and culture (Zwelling). For the participants, this resulted in considerable distress as they experienced the conflicting duality of being a mother, protecting and nurturing their child, and a woman, protecting and nurturing the self. Such distress often manifests as intense negative feelings of frustration, inadequacy, guilt, and rage that are a direct result of mother sacrificing her own identity (Forna) and is often accompanied by feeling as if she needs to be more than she is (Gordon). As one participant reported; "I felt like I had to be more than a mother.... I had to be everything to her." This mother felt compelled to embrace the mothering role externally

yet she felt inferior within. There was a strong desire to let go of the deep-rooted ideas about what mothering entailed.

Certain unique mothering experiences produced a change in how the participants viewed themselves as women, as an individual, and as mothers, and facilitated dynamic movement towards expansion of identity. The primary form expansion of identity took was descending expansion that involved integration of subpersonalities into a more cohesive self, although ascending expansion involving connectedness with a higher reality, and or horizontal expansion involving connectedness with others and nature was also evident in most participants. These findings of identity expansion validate previous empirical studies that suggested that experiences during motherhood are associated with descending expansion of identity (Hager; McMahon) and horizontal expansion (Hager; Smith) but go further by providing a deeper understanding of the role of integration of subpersonalities and the influence of transpersonal mothering experiences on mother's identity.

In addition, the findings of this study are in keeping with the only previous empirical research study (Athan and Miller) that illustrated the considerable impact extraordinary/transpersonal mothering experiences often have on mother's identity. Athan and Miller found that extraordinary experiences such as experiences of profound unconditional love and a sense of unity with a protective guiding force fostered inner growth and transcendence of self-imposed preconceived limitations of personal ego. These findings from empirical studies to date propose that there is more to the mothering experience than what is usually described in the literature.

CONTRASTING INTENSIVE MOTHERHOOD WITH TRANSPERSONAL MOTHERHOOD

Adrienne Rich has described how society has constructed and fostered the development of the image of a good mother as a person who has no other identity but that of being a mother. Motherhood in some ways has become a psychological police state (Douglas and Michaels) and is reflected in personal views and behaviors of others, both conscious and unconscious, that

are projected onto mothers and impose considerable conscious and unconscious burdens and judgments. Even some intentionally childless women have experienced being negatively judged by their faith community as well as their own family members (Brooks), indicating that mother may be the most important identity for all women. The focus on mother-child bonding in academic literature has been one of the factors influencing the gradual expansion of motherhood to eventually include the notion of maternal indispensability (Jones). This notion has fostered one dominant contemporary view, at least in the Western world, of what constitutes a good mother. The good mother is expected to be selfless, put her child's needs over her own all the time, provide the best possible environment and opportunities for the child so that the child can grow to his/her own maximum potential (Warner), to focus only on her own child/children and on nothing else, not her own life, nor her husband/partners nor children that are not hers (Shuffelton). This concept of good mother and the corresponding cultural ideology of "intensive mothering" has taken on many characteristics of a profession that requires an exorbitant amount of time and energy, a radical change in identity only allowing for self to be defined as mother, and has its own standards and goals (Hays; Shuffelton). Such an ideology may severely constrain the joy of mothering by putting immense pressure on mothers to try to conform to this ideology of what a good mother should be. Intensive mothering has the potential to not only harm the mother by causing immense stress due to the maternal dilemma and denying many aspects of her identity but also the child by taking away the opportunity for imaginative play and capacity to become responsible due to minimal exposure to unstructured activities and boredom. It also prevents creation of a sustainable society where all children are provided with an optimal environment for health, happiness, and personal growth as each mother focuses solely on the growth of her own children (Shuffelton). For motherhood to involve conjoint activity, awareness of a communal life and its implications, the current culture of intensive mothering needs to be replaced with a better model that I propose needs to include the feminist perspective, as well as a more holistic approach. This model would not only

recognize, at both personal and collective levels, the propensity to escape from painful feelings but also to embrace the need for experiencing and integrating painful feelings such as guilt and inadequacy associated with many aspects of mothering including intensive mothering.

From the feminist perspective, achieving wholeness and integration is a fundamental aspect of transpersonal living and involves opening ourselves by becoming more permeable to our body, to others, and to nature (Wright). Mothers in many indigenous cultures embody this reality. The Ketchua Indians in Peru welcome newborns into life by burying part of their umbilical cord and planting a tree on that spot so that the tree, symbolic representation of heaven, and the cord, symbolic representation of the child's soul, are eternally linked (Fine and Fine). Cohen (*Wisdom of the Heart: Inspiration for a life Worth Living*) provided an example of women in an African tribe who upon discovering their pregnancy, gather women friends, and go into the wilderness to pray and meditate until they hear the song of the unborn child, a special song that expresses the child's unique flavor and purpose. The mother and the tribe sing this song to the child, during happy and painful times throughout his/her life. There have been a few personal accounts of women in Western culture who share aspects of the feminist perspective of the transpersonal. Some women during pregnancy have expressed how intensely attuned and permeable they are to both their inner world and the outer world, and experience the two worlds as continuous and interconnected, not polar and disconnected (Jessner, Weiger, and Foy; Lewis; Rich).

A more holistic view is that there are infinite delicate interactions between mother and child that have a profound influence on the child's and the mother's psychological and spiritual development in complex and quite unpredictable ways except in extreme cases such as abuse or neglect. I feel transpersonal motherhood can be that better model as it incorporates both the feminist perspective and a holistic view (see table 1).

Transpersonal motherhood recognizes and integrates a variety of factors that lie outside the mother-child dyad, namely, inborn temperament (Kagan & Snidman; Pinker), individuation needs

Table 1

Comparing the Four Domains of Intensive Mothering to Transpersonal Mothering

Domain	Intensive Mothering	Transpersonal Mothering
Employment	Stay home to care for child. Work only if income is needed. Non-employed is ideal	Mother may or may not work depending on a myriad of complex circumstances and mother's own aspirations
Responsibility	Childcare is mother's responsibility	Responsibility of both parents supported by family, friends, and community
Protection	Protecting children from outside influences is mother's job. Mother is ultimately responsible for how child turns out	Responsibility of everyone including parents to protect all children from outside negative influences and environments
Self-sacrificing	Mothers should always place children's needs before their own	Mother's wellbeing is intimately intertwined with child's wellbeing so it is as important for mother to attend to her own needs as it is for her to attend to her child's needs.
	Being a mother is the most important thing a woman can be	May or may not be

especially separation-individuation (Mahler), other close relationships including with father, siblings, and friends, family dynamics, social factors such as influence of peers, socioeconomic status, and neighborhood (Harris), one's ethnic and prevalent culture, and ecology. It also recognizes the importance of engaging in actions to counteract cultural, social, and economic forces that negatively impact the parent-child relationship and to promote secure attachment in all children, not just one's own (Karen). Examples of such strategies include becoming role models for other parents, valuing the time parents spend with their children for fun and leisure activities, urging employers to support parents who take time off from work for childcare activities, and supporting training of teachers so that teachers can engage more constructively with anxious children.

During motherhood, Hager shared feelings of losing her identity: "the adult woman with her needs and desires, and that she or I was becoming obliterated and disappearing" (42). Intensive mothering hinders some mothers' realization that automatic maternal love may not exist (Badinter), that mothers may experience boredom, and even long periods of isolation (Hager). Transpersonal mothering not only allows mothers to recognize such real emotional states, but also encourages mothers to actively foster awareness and integration of the "shadow" of motherhood. These efforts also help the child recognize mother as a real, separate, and independent entity, an important developmental milestone (Winnicott; Klein). Such confrontation of the darkness deep within our psyche helps us develop psychologically and spiritually (Washburn).

IMPLICATIONS OF TRANSPERSONAL MOTHERHOOD ON FUTURE RESEARCH

Subtle but significant shifts are beginning to emerge within the mothering literature. In particular, meaningful investigation into the emancipatory potential of motherhood by exploring the themes of experience and identity in the field of motherhood studies has started to emerge (O'Reilly). The non-pathological lived experience of mothers is beginning to be represented in empirical studies on

identity and psychological wellbeing in mothers. The reality of the lived experience of motherhood has many points of intersection in particular mother influence, cultural expectations, past and present trauma, societal pressures, and compartmentalization of identity, that often constrain mother's sense of self and influence her parenting style. Through inquiry into the lived experience of deconstructing and reconstructing maternal identity in contemporary Western culture, what emerges is the enormous complexity of mothering that necessitates elucidation of new models to represent the journey of self-discovery and expansion of awareness motherhood brings with it.

Any research studying mothering experiences needs to be cognizant and empathetic regarding these intrinsic challenges in all mothers' journeys and the host of external factors including child's health, social, and financial resources that can influence the mother's ability to align with her values and aspirations. Future research needs to explore the dynamics between maternal roles, identity, and transpersonal dimensions of motherhood in Western as well as other cultural settings. In addition, mothering experiences that reflect transpersonal motherhood need to be included in research on identity and parenting.

I believe studying the lived experiences that reflect transpersonal motherhood of mothers may begin to dissolve the walls between different mother groups especially those based on socioeconomic class, culture, sexual orientation, age, and illness to create a more inclusive and integrative image of the collective lived experience of mothers in Western culture, and eventually, mothers in all parts of the world. This is because I believe mothers in different cultures are more similar than different joined by the humanity they share and the desire to provide the best possible environment for the child to grow and the majority of mothering experiences are as universal as love and grief. Such similarities in no way reduce or erase the uniqueness of the mothering experiences in each mother and in each culture.

Perhaps, through future research that explores the dynamics between cultural ideas of mothering, maternal roles, identity, and transpersonal dimensions of motherhood across diverse sociocultural backgrounds, a new conversation can begin. The knowledge

gained from studying the authentic voices of mothers needs to be shared beyond the confines of academia so that it begins to enter the dialogue and depictions of mothers in mainstream society in order to serve the institution of motherhood and family better. It is my ardent hope that research to date on transpersonal motherhood will contribute to and further this dialogue.

CONCLUSION

Research to date on the non-pathological lived experiences of motherhood provide a more nuanced and dynamic picture of motherhood that may help shift the current cultural images of motherhood as either oppressive or blissful towards a more healthy, balanced view of motherhood that for many mothers may be easier to relate to. In addition, by providing an opportunity for some validation of mother's beliefs and behaviors, the practice of transpersonal motherhood may help some mothers maintain or increase life satisfaction during motherhood. Transpersonal mothering varies significantly from mother to mother and in a mother, from moment to moment indicating that it is not a singular practice, and transpersonal motherhood is not a monolithic entity.

This holistic model of transpersonal motherhood allows a mother and child to be imperfect, to embrace difficult emotions and feelings that motherhood brings with honesty and self-compassion. This opens the door for a mother to consciously integrate the disowned parts of herself by working with her inner child to develop comfort with uncertainty, humility, and unconditional self-acceptance, thus fostering healing and resilience. This is a fluid and dynamic model that allows free movement between a mother's inner and outer world, between her personal, interpersonal, and transpersonal worlds in order to enhance her capacity to be present for her child and for herself with a lessening of negative judgments and reactivity. The most obvious outward manifestation of transpersonal motherhood is the manner in which a mother parents her child, in a mindful and collaborative way, allowing the child's innate potentialities to bloom. In this way, transpersonal motherhood promotes a consistent, sensitive, and responsive parenting style that is essential for a child's and mother's wellbeing.

WORKS CITED

Anthony, E. James, and Therese Benedek. "The Development of Parental Attitudes During Pregnancy." *Parenthood: Its Psychology and Psychopathology*. Boston: Little Brown, 1970. 209-244. Print.

Ashton, Paul W. "Dina and the Great Mother: A Story Viewed Through the Lens of Neumann's, 2002, Screenplay by Herbjorg Wassmo and Ole Bornedal, Based Upon Herbjorg Wassmo, Trans. Nadia Christensen, London: Black Swan, 1989. Directed by Ole Bornedal." *Jung Journal: Culture and Psyche* 4.1 (2010): 151-160. Print.

Assagioli, Roberto. "The Psychology of Women and Her Psychosynthesis." *Psychosynthesis Research Foundation* 24 (1968): n.pag. Web.

Athan, Aurelie, and Lisa Miller. "Spiritual Awakening Through the Motherhood Journey." *Journal of the Association for Research on Mothering* 7.1 (2005): 17-31. Print.

Badinter, Elisabeth. *The Myth of Motherhood: A Historical View of the Maternal Instinct*. London: Souvenir (E & A), 1981. Print.

Brady, Mark. *A Little Book of Parenting Skills: 52 Vital Practices to Help with the Most Important Job on the Planet*. Los Altos, CA: Paideia, 2006. Print.

Brooks, Christine. *"Being True to Myself": A Grounded Theory Exploration of the Process and Meaning of the Early Articulation of Intentional Childlessness*. Diss. Institute of Transpersonal Psychology, 2007. n.p., n.d. Print.

Bullfinch, Thomas. *Myths of Greece and Rome*. [S.I.]: Allen Lane, 1980. Print.

Capra, Fritjof. *The Hidden Connections: A Science for Sustainable Living*. London: Flamingo, 2002. Print.

Cohen, Alan. *Wisdom of the Heart: Inspiration for a Life Worth Living*. Carlsbad, CA: Hay House, 2002. Print.

Douglas, Susan J. and Meredith W. Michaels. *The Mommy Myth: The Idealization of Motherhood and How It Has Undermined Women*. New York: Free, 2004. Print.

Fine, Jeffrey L. and Dalit Fine. *The Art of Conscious Parenting: The Natural Way to Give Birth, Bond With, and Raise Healthy*

Children. Rochester, VT: Healing Arts, 2009. Print.

Forna, Aminatta. *Mother of All Myths: How Society Moulds and Constrains Mothers*. London: Harper Collins, 1999. Print.

Freud, Sigmund. *The Unconscious*. London: Penguin Books, 2005. Print.

Galliano Desai, Faith. *Transpersonal Experiences and the Emergence of Transpersonal Motherhood*. Diss. Institute of Transpersonal Psychology, 2012. Print.

Garey, Anita Ilta. *Weaving Work and Motherhood*. Philadelphia: Temple University Press, 1999. Print.

Glenn, Evelyn Nakano. "Social Construction of Mothering: A Thematic Overview." *Mothering: Ideology, Experience and Agency*. 1st ed. Ed. Evelyn Nakano, et al. New York: Routledge, 1994. 1-29. Print.

Gordon, Tuula. *Feminist Mothers*. New York: New York University Press, 1990. Print.

Graves, Robert. *The Golden Fleece*. London: Cassell, 1944. Print.

Hager, Tamar. "Making Sense of an Untold Story: A Personal Deconstruction of the Myth of Motherhood." *Qualitative Inquiry*, 17.1 (2011): 35-44. Print.

Harding, Mary Esther. *Women's Mysteries: Ancient and Modern: A Psychological Interpretation of the Feminine Principle as Portrayed in Myth, Story, and Dreams*. New York: Harper & Row, 1976. Print.

Harris, Bonnie. *When Your Kids Push Your Buttons: And What You Can Do About it*. New York: Warner, 2003. Print.

Hays, Sharon. *The Cultural Contradictions of Motherhood*. New Haven: Yale University Press, 1996. Print.

Jones, D. M. "Enmeshment in the American Family." *AFFILIA* 6.2 (1991): 28-44. Print.

Jung, C. G. *Four Archetypes: Mother, Rebirth, Spirit and Trickster*. London: Routledge, 2003. Print.

Kagan, Jerome, and Nancy C. Snidman. *The Long Shadow of Temperament*. Cambridge, MA: Belknap of Harvard University Press, 2004. Print.

Karen, Robert. *Becoming Attached: First Relationships and How They Shape Our Capacity to Love*. New York: Oxford University Press, 1998. Print.

Klein, Melanie. *The Psycho-Analysis of Children*. London: Hogarth, 1949. Print.

Lewis, Abigail. *An Interesting Condition: The Diary of a Pregnant Woman*. Garden City, NY: Doubleday, 1950. Print.

Mahler, Margret. *The Psychological Birth of the Human Infant*. New York: Basic Books, 1973. Print.

Maslow, Abraham. *Religions, Values, and Peak Experiences*. New York: Penguin, 1994. Print.

McMahon, Martha. *Engendering Motherhood: Identity and Self-Transformation in Women's Lives*. New York: Guilford, 1995. Print.

Meleis et al. "Experiencing Transitions: An Emerging Middle-Range Theory." *Advances in Nursing Science* 23.1 (2000): 12-28. Print.

Netzer, Dorit, and Mark Brady. "Parenting as a Creative Collaboration: A Transpersonal Approach." *Journal of Creativity in Mental Health,* 4.2 (2009): 139-51. Print.

Olsen, Carl. "The Prehistoric Goddess." *The Book of the Goddess: Past and Present: An Introduction to Her Religion*. 1st ed. Ed. Carl Olsen. New York: Crossroads, 1983. 12-14. Print.

O'Reilly, Andrea. *Twenty-First Century Motherhood: Experience, Identity, Policy, Agency*. New York: Columbia University Press, 2010. Print.

Parker, Rozsika. *Torn in Two: The Experience of Maternal Ambivalence*. London: Virago, 1995. Print.

Pinker, Steven. *The Blank Slate: The Modern Denial of Human Nature*. New York: Penguin, 2002. Print.

Rich, Adrienne. *Of Woman Born: Motherhood as Experience and Institution*. New York: Norton, 1976. Print.

Ruddick, Sara. *Maternal Thinking: Toward a Politics of Peace*. London: Women's, 1990. Print.

Shuffelton, Amy. "High Stakes Motherhood: School Choice." *Journal of Educational Controversy* 5.2 (2010): n. pag. Web.

Sjoo, Monica, Barbara Mor, and Monica Sjoo. *The Great Cosmic Mother: Rediscovering the Religion of the Earth*. San Francisco: Harper & Row, 1987. Print.

Smith, J. A. "Identity Development during the Transition to Motherhood: An Interpretative Phenomenological Analysis." *Journal of Reproductive and Infant Psychology* 17.3 (1999): 281-99. Print.

Thurer, Shari. *The Myths of Motherhood: How Culture Reinvents the Good Mother*. Boston: Houghton Mifflin, 1994. Print.

Warner, Judith. *Perfect Madness: Motherhood in the Age of Anxiety*. New York: Riverhead, 2005. Print.

Washburn, Michael. *Embodied Spirituality in a Sacred World*. New York: New York University Press, 2003. Print.

Wilber, Ken. *Up from Eden: A Transpersonal View of Human Evolution*. Garden City, NY: Anchor/Doubleday, 1981. Print.

Winnicott, Donald. "Transitional Objects and Transitional Phenomena." *International Journal of Psychoanalysis* 34 (1953): 89-97. Print.

Wright, Peggy. "Gender Issues in Ken Wilber's Transpersonal Theory." *Ken Wilber in Dialogue: Conversations with Leading Transpersonal Thinkers*. Eds. Donald Rothberg and Sean M. Kelly. Wheaton, IL: Theosophical Pub. House, 1998. 207-236. Print.

Zwelling, Elaine. "Childbirth Education in the 1990s and Beyond." *Journal of Obstetric, Gynecology, and Neonatal Nursing* 25.5 (1996): 425-32. Print.

Epilogue

Balancing Separation-Connection in Mothering

LINDA ROSE ENNIS

As I CLOSE THIS COLLECTION on "intensive mothering", I am contemplating how separation and connection operate in conjunction with each other and how this relates to this issue. Further to this, how can we apply this model to "intensive mothering" moving forward?

Separateness-connectedness, or "a distinction-union structure is a kind of DNA-RNA of experience, whereby every micro-moment or "cell" of experience is made of these moments, although either may be more dominant at any moment" (Eigen). There is an intricate interaction between states of independence and dependence that is likely being played out in the developmental crisis of "intensive mothering". In this final chapter, the epilogue, I wish to apply this separation-connection model, as it may relate to "intensive mothering."

In my research on combining motherhood with employment (Ennis), I postulated that, in order to fully comprehend the experience of working mothers, it is critical to have a deeper understanding of how states of separateness and connectedness interact, how early losses have an impact on this organization, and how a more integrated approach to this area should be all-encompassing enough to contain all the pieces of this puzzle. Only then can employment and motherhood be intertwined in a harmonious balance. "Two opposing drives operate throughout life: the drive for companionship, love and everything else which brings us close to our fellow men and the drive toward being independent, separate and autonomous" (Storr xi). In this context, I would suggest that the

same dynamics may apply to intensive mothering.

In mothers' ways of thinking about work-family balance, I found three types of mothers- the splitting mother, the integrating mother, and the transitional mother. The splitting mother splits the work-mothering experiences into two, either-or thinking, where one takes precedence over the other. The integrating mother is a both-and thinker, who tries to integrate the two experiences by retaining a picture of both simultaneously. The transitional mother utilizes bridging to link the two experiences in the form of telephoning, e-mailing, skyping with her child, in addition to having reminders in the workplace such as pictures of the children as a link to the motherhood experience. She realizes the importance of extra-curricular activities for her child in that it is a constructive way to be and not be with him/her in this intermediate space between separateness and connectedness.

Intensive Mothering is an example of either-or thinking, which overemphasizes connection in the mother-child relationship. It focuses on the needs of children of all ages, at the expense of the parent. While there is no dispute as to whether the young child's needs are imperative and the impact of a child's experiences with his/her mother is critical, intensive mothering is a skewed form of parenting, which can be excessive or smothering. While this form of mothering may have originated as genuine attachment models, as well as the myth of motherhood praising the all-giving mother, it seems to have morphed into a way for a patriarchal society to demand that its mothers be preoccupied with their children, in conjunction with the expectation that mothers work outside of the home, which has resulted in enormous ambivalence for mothers. In addition, there is a huge disparity between society's encouragement of independence from the family and mothers' grasping for connection with their children. What needs to be further explored is why there is a need to stress the connectedness model. It might be postulated that intensive connection becomes necessary when there is excessive disconnection in our families and in our society, at large, thereby explaining the need to be continually connected electronically. As a result, because individuals are so invested in being connected in this way, they suffer in their off-line relationships (Turkle). Perhaps in the same way we are excessively connected

electronically, we are intensively mothering our children. When we are with our children, we need to do so in a non-distracted way to prevent compensation for under- involvement by over- involvement. Mothers are aware, perhaps subconsciously, that there is no future payout from their children, as they assumed historically, but nevertheless persist in being connected to their children's success as a way of still feeling connected to them, sometimes in the form of being their friend rather than a parent.

In the context of intensive mothering, as suggested above, this method of mothering has become excessive or intensive, aside from the neoliberal influence, because of an inadequate or non-existent connection with family and extended family. While Early Childhood specialists, such as John Bowlby and Mary Ainsworth (Ainsworth, Blehar, Waters and Wall), emphasize the importance of the mother-child bond, theorists alternatively stress the importance of separation-individuation throughout the lifespan (Mahler, Pine and Bergman), thereby suggesting that a healthy balance between connection and separation needs to be struck. Perhaps it is no coincidence that mothers choose to enroll their children in many extra-curricular activities. It may be more about it providing a transitional space (Winnicott) between separation and connection to be with one's child where guilt is appeased more than a way to educate and prepare one's child for a rich future. One of the best ways to be an intensive mother is by introducing and involving one's child in many extra-curricular activities, even if one can't afford to do so or even if one is physically and emotionally drained. Why would anyone choose to be involved in this form of intensive mothering? This is the place where you can be with your child and feel good about your involvement, yet not be with him/her and do your work preparation or reading, or have a little time for yourself. You have both benefits at the same time and can still be, by definition, an intensive mother.

In addition to the above, intensive mothering is a non-dialogic relationship. Contrary to Daniel Stern's description that children, early on, differentiate themselves and progress through states of relatedness, intensive mothering centers on the child's needs to excess and reinforces a self-centeredness in the child at the expense of the other, which may persist throughout the lifespan. While certainly

parentification of the child is not recommended, a balanced form of relatedness, with authentic connection, is suggested, an interactive relationship respecting both mothers' and children's needs.

In seeking maternal empowerment as a redefinition of motherhood, an additional potential alternative to intensive mothering, if we want one, lies in bringing the separation-connection model into a sustainable balance, into a state of equilibrium. Doing away with intensive mothering is not the answer but rather understanding its origins and why it persists, as well as relating to one's children in both a connected and separate manner when and where the circumstances dictate. The relationship between mothers and especially adult children needs to be one that encourages synchronicity in moments of connection and separation that respects the comfort levels of both parties.

Self-centeredness in children developmentally is reduced in mid-adolescence (Elkind) and should not be reinforced further than that unless their needs dictate it. The aim would be to relate to our children in an intersubjective way, which promotes this balance of connection and separation and not model excessive dependency nor isolation.

Even if we chose to educate mothers to balance connection with separation, intensive mothering would likely continue to persist because it serves the function of appeasing all of the stresses described above and will likely do so for many years to come as long as the patriarchal philosophy exists and imposes unrealistic expectations on mothers, which are absorbed by them. All the goodness, badness and everything in between is then projected onto our children and mothers need to take those projections back to be whole again, the result being that they will not feel enormous emptiness when their children leave home. The fallout remains to be seen over time as to the impact of intensive mothering on mothers, as well as on their children. Mothers need to begin with themselves on an individual basis, effecting change within the family, which will hopefully resonate with and emanate outward into our society's view of women and motherhood.

In closing, this volume has updated the issue of "intensive mothering" introduced by Hays, through three sections: Understanding & Assessing Intensive Mothering; Intensive Mothering Today; and

Intensive Mothering: Staying, Leaving or Changing. The central issues included how intensive mothering complements Attachment parenting, discouraging ambivalence by encouraging perfectionism; mothers' motivations for intensive mothering, which include buffering and safeguarding children; the interplay of economic influences and individualized mothering practices, as it relates to the perceived selflessness of motherhood and self-serving attitudes of a patriarchal capitalist society; and how intensive mothering affects social class, gender, expanding the term to intensive parenting but to a lesser degree; and ethnicities, which also value intensive mothering but are unable to embrace it. It concludes with suggestions for alternative forms of mothering; discouraging competition among mothers; noting the shifting patterns of family dynamics; realizing how fathers intensively parent, albeit differently than mothers; aiming towards a more holistic form of mothering; and one which balances separation with connection in a meaningful way, while not devaluing "intensive mothering."

It is our hope that this volume has continued the dialogue towards further exploration and an understanding of intensive motherhood on our journey towards a more balanced relationship between empowered mothers and their children in non-patriarchal maternity. Further work is needed to explore the practical and theoretical implications of this volume, which will need to juxtapose the personal needs of mothers and their families, as well as the responsibility of society to support those needs in a meaningful way in the form of government policy changes, socialized childcare, acceptance and/or change of gender ideology roles, and flexible work schedules. There needs to be some realization that intensive mothering is neither good nor bad but rather an interplay of self-sacrificial and self-serving mothering practices due to individual and societal expectations. Finally, there is hope for recognition and respect for mothers' choices as to how they wish to mother their children.

WORKS CITED

Ainsworth, Mary, M. Blehar, E. Waters and S. Wall. *Patterns of Attachment*. Hillsdale, NJ: Erlbaum, 1978. Print.

Bowlby John. *A Secure Base*. New York: Basic Books, 2005. Print.

Eigen, Michael. *Contact With the Depths*. London: Karnac Press, 2011. Print.

Elkind, David. *All Grown Up and No Place To Go*. Cambridge: De Capo Press Books, 1998. Print.

Ennis, Linda. *On Combining Motherhood With Employment: An Exploratory Study*. Toronto: University of Toronto Press, 1997. Print.

Mahler, M. S., F. Pine and A. Bergman. *The Psychological Birth of the Human Infant*. New York: Basic Books, 1975. Print.

Stern, Daniel. *The Interpersonal World of the Infant*. New York: Basic Books, 1984. Print.

Storr, Anthony. *Solitude*. London: Great Britain: Wm Collins Sons, 1988. Print.

Turkle, Sherry. *Alone Together*. New York: Basic Books, 2012. Print.

Winnicott, Donald. *Playing and Reality*. New York: Basic Books, 1971. Print.

Contributor Notes

Lorin Basden Arnold, Ph.D. is a family communication and gender scholar. Her recent work has primarily related to understandings and enactments of motherhood. She is the author/editor of the family communication textbook *Family Communication: Theory and Research* and Dean of the College of Communication and Creative Arts at Rowan University.

Solveig Brown, Ph.D. is an anthropologist who has conducted in-depth interviews with forty middle-class and upper middle-class American mothers, and surveyed one hundred mothers. She has presented her research at the 2011 AAA Meetings, and has written a chapter for Stay at Home Mothers: An International Perspective (Demeter Press, 2013).

Faith Galliano Desai received her Master's degree in Counseling Psychology in 1995 and have worked primarily with children / adolescents and their families as a therapist. In 2012 she received her Ph.D. in psychology with a specialization in transpersonal psychology. Her research involves looking at the wholeness of motherhood including the opportunities motherhood provides for transformation and psychological growth including spiritual growth.

Linda Rose Ennis is a psychoanalytic therapist in private practice, a family mediator and a lecturer at York University. Her education includes a Ph.D. in Psychology and Early Childhood

Education from the University of Toronto. She has written and spoken extensively on her research in her area of expertise, On Combining Motherhood With Employment, which was the first qualitative piece done in this area. She has, more recently, written contributions in the *Encyclopedia of Motherhood,* discussing the "empty nest," the "mommy track," and has published her work on "Contract-Faculty Mothers: On The Track To Nowhere" .

Charlotte Faircloth is a Senior Lecturer in the Department of Social Sciences at the University of Roehampton, London. She is also a Visiting Scholar and founding member of the Centre for Parenting Culture Studies (CPCS) at the University of Kent. She completed her Ph.D. at the Department of Social Anthropology at the University of Cambridge, which explored women's experiences of attachment parenting and "full-term" breastfeeding in London and Paris. Her book, *Militant Lactivism? Attachment Parenting and Intensive Motherhood in the UK and France,* was published by Berghahn Books in 2013, and shortlisted for the British Sociological Association's Philip Abrams Memorial Prize. With colleagues in CPCS, she is co-author of *Parenting Culture Studies* published by Palgrave, and recently co-edited *Parenting in Global Perspective: Negotiating Ideologies of Kinship, Self and Politics,* published by Routledge. She is currently working on a project exploring childcare, couple intimacy and equality.

Christi L. Gross is a Ph.D. student in sociology at Kent State University (USA). Her current research interests include the sociology of mental health, social psychology, gender, post-partum distress, and Welfare-to-Work/TANF programs.

Kim Huisman is an Associate Professor in the Department of Sociology at the University of Maine. Her research areas include immigration and motherhood. She is currently teaching a course entitled The Social Construction of Motherhood.

J. Lauren Johnson is a psychologist and single mother. Her areas of research and practice include pregnancy/motherhood, hope, and the intersection of film and video with psychology. She founded

the Therapeutic Filmmaking Institute and developed videographic inquiry as a qualitative methodology. She currently works on First Nations reserves in Northern Alberta.

Elizabeth Joy is an undergraduate student at the University of Maine pursuing diplomas in sociology and psychology, with a concentration in developmental psychology. Joy is currently doing her senior thesis, titled "Cultural Contradictions of Motherhood Revisited."

Kasey Lansberry is a Ph.D. student in the sociology department at the University of Akron (USA). Her areas of interest include gender, social class, and mothering. Her current research focuses on welfare-to-work program managers and how mothers in poverty navigate the world of welfare participation

Miriam Liss is a Professor of Psychology at the University of Mary Washington. She is a clinical psychologist and is widely published in the areas of feminism, division of labor, and parenting as well as in the area of autism and developmental disorders. She has been interviewed for her work on intensive and attachment parenting for the *Washington Post, MSNBC.com,* and *Live Science.* She was recently named one of *Princeton Review's* Best 300 Professors. Dr. Liss is a co-author of the book *Balancing the Big Stuff: Finding Happiness in Work, Family and Life,* with Rowman and Littlefield Press.

Virginia H. Mackintosh, Associate Professor of Psychology, focuses her research primarily on families under stress. She has written articles on the challenges experienced by mothers of children with autism and other developmental disabilities. Dr. Mackintosh has also worked extensively with children of incarcerated parents, and has taught parenting classes to both mothers and fathers at several prison facilities in Virginia.

Kristen Abatsis McHenry received her doctorate from the University of Massachusetts, Amherst in Political Science. Her current book project, based on her dissertation, examines environmental health

and breast cancer. McHenry also holds a MA in Women's Studies from the Women's Studies Institute at Georgia State University. Currently she teaches as a full time lecturer in Women's and Gender Studies at the University of Massachusetts Dartmouth. Her current research interests include: breast cancer activism, the U.S. women's movement, environment and women's health politics.

Melissa A. Milkie is Professor of Sociology at the University of Toronto. Her expertise lies in the areas of culture (especially linked to social statuses such as gender, ethnicity and social class), family, the work-family interface, and health. She has written extensively about time spent in work and family roles and its implications for health and well-being. Recent projects focus on how the amount of time mothers spend with children relates to health; cultural framings of blame for low father involvement; how parenting time is contested, and changes in the "Mommy Wars" discourse. Dr. Milkie was most recently Professor at the University of Maryland, where she was founding director of The Culture Lab and NSF ADVANCE professor of Inclusive Excellence.

Lisa M. Mitchell's research focuses on social and cultural dimensions of bodies, especially in the context of reproduction and perinatal loss, health and illness, children and youth, poverty, and technology. Her publications include numerous scholarly articles and *Baby's First Picture: Ultrasound and the Politics of Fetal Subjects* (University of Toronto Press, 2001).

Hallie Palladino researches and writes about social trends in parenting. She is a contributor to the upcoming book, *Stay at Home Motherhood: An International Perspective* (Demeter Press) and was a presenter MIRCI's fall 2012 conference on Motherhood and Reproduction. She has a Master's degree from the University of Chicago.

Maya-Merida Paltineau has a Master in Sociology and a Master in European Affairs. She is currently a Ph.D. Student at the EHESS, in Paris. Her thesis focuses on intensive motherhood and on maternal behaviours and norms. She has published her first book entitled

Femmes sans enfants, at the Editions Universitaires Européennes.

Holly H. Schiffrin, Associate Professor of Psychology, specializes in child development, parenting practices, and early intervention. She has had several articles published in professional journals. In addition, she has given numerous presentations at conferences. Dr. Schiffrin recently served as president of the Virginia Academic and Applied Psychologist Academy of the Virginia Psychological Association. She has been interviewed about her research on several radio programs across the nation as well as interviewed for articles on parenting and well-being in *Time.com,* various newspapers, and local parenting magazines. She is a co-author of the book *Balancing the Big Stuff: Finding Happiness in Work, Family and Life,* with Rowman and Littlefield Press.

Denise Schultz is a graduate student at the University of Massachusetts, Boston. Denise has received her undergraduate degree in Women's Studies from the University of Massachusetts, Dartmouth and a graduate certificate from the Program for Women in Politics and Public Policy at UMass Boston. She works at the University of Massachusetts, Boston in the Center for Women in Politics & Public Policy. In addition to women's studies, Denise's interests lie at the intersection of feminism, motherhood and public policy. She continues to research ways to ratify the Equal Rights Amendment.

Tiffany Taylor is an assistant professor of sociology at Kent State University at Kent (USA). In her research, she examines a number of topics related to inequality. Her recent research focuses on policy implementation of programs for poor mothers in North Carolina and Ohio.

Tatjana Takševa is an Associate Professor of English, affiliated with the Women and Gender Studies at Saint Mary's University, Canada, where she teaches courses in English Literature, Cultural Studies and Women and Gender Studies. She has been an active member of MIRCI for over seven years. Her publications include essays on various aspects of literature, pedagogy, motherhood studies, globalization, and cross-cultural studies. She is currently

co-editing a book on mothering in conflict zones for Demeter Press. She is the mother of three: a teenage son and two daughters under the age of five.

Brianna Turgeon is a graduate student at Kent State University (USA). Her current areas of interest include mothering, gender, social psychology, and adolescence. Brianna is involved in research on poor mothers in Ohio who participate in welfare-to-work programs.

Helena Vissing is a Danish psychologist and doctoral student at The Chicago School of Professional Psychology, Los Angeles. She is currently conducting a phenomenological study of the transition to motherhood with special focus on maternal subjectivity and the mother-daughter relationship. She is specializing in motherhood studies from psychodynamic and somatic perspectives.

Madeline Walker, Ph.D., is an Education Technology Support Specialist at the University of Victoria. Formerly, she taught writing and American literature. She is the author of *The Trouble with Sauling Around: Conversion in Ethnic American Autobiography, 1965-2002* (2011) and *birth of the uncool* (2014), a book of poems. Walker's eclectic research and writing interests include race, elimination, post feminism, creative non-fiction, and online pedagogies.

Catharine H. Warner is an affiliate of the Maryland Institute for Minority Achievement and Urban Education. She is currently researching culturally relevant teaching and social status differences in family-school relationships, educational stratification and mental health.

Justyna Włodarczyk is an Assistant Professor at the Institute of English Studies at the University of Warsaw (Poland). She is the author of *Ungrateful Daughters: Third Wave Feminist Writings* and, in addition to contemporary American literature, is interested in comparative studies of popular culture and in reproductive rights. She has collaborated with feminist NGOs in Poland.